Pacific Dreams

ific

antasy in California Art, 1934–1957

eams

Edited by Susan Ehrlich

Major support for the exhibition and this catalogue has been provided by the National Endowment for the Arts, a federal agency, and the Henry Luce Foundation.

UCLA at the **Armand Hammer Museum of Art and Cultural Center**

University of California, Los Angeles

Artists in the Exhibition

Artists in
the Exhibition

Jeremy Anderson

Ben Berlin

Eugene Berman

Wallace Berman

Ruth Bernhard

Dorr Bothwell

Hans Burkhardt

Grace Clements

Will Connell

Salvador Dali

Claire Falkenstein

Lorser Feitelson

Philip Guston

Gerrie von Pribosic Gutmann

John Gutmann

Charles Houghton Howard

Robert Boardman Howard

Jess

Adaline Kent

Madge Knight

Lucien Labaudt

Harold Lehman

Helen Lundeberg

Rose Mandel

Knud Merrild

William Mortensen

Lee Mullican

Gordon Onslow Ford

Wolfgang Paalen

Man Ray

Clay Spohn

Edmund Teske

Gordon Wagner

Edward Weston

Minor White

Beatrice Wood

This catalogue has been published in conjunction with an exhibition organized by UCLA at the Armand Hammer Museum of Art and Cultural Center.

Exhibition Itinerary

The Oakland Museum of California
February 25–June 11, 1995

UCLA at the Armand Hammer Museum of Art and Cultural Center
July 11–September 17, 1995

Nora Eccles Harrison Museum of Art, Utah State University, Logan
October 10–December 11, 1995

Major support for the exhibition and this catalogue has been provided by the National Endowment for the Arts, a federal agency, and the Henry Luce Foundation.

Occidental Petroleum Corporation has partially endowed the Museum and constructed the Occidental Petroleum Cultural Center Building, which houses the Museum.

Front cover: Ben Berlin, *Birds, Sky, Water, and Grass*, 1938 (cat. no. 6)
Inside front cover: Helen Lundeberg, *Double Portrait of the Artist in Time*, 1935 (cat. no. 77)
Back cover: Knud Merrild, *Exhilaration*, 1935 (cat. no. 86)
Inside back cover: Wolfgang Paalen, *Tropical Night*, 1948 (cat. no. 105)

Library of Congress Cataloging-in-Publication Data

Pacific dreams: currents of surrealism and fantasy in
California art, 1934–1957 / edited by Susan Ehrlich.
 p. cm.
 "Published in conjunction with the exhibition held at UCLA at the Armand Hammer Museum of Art and Cultural Center, July 11–September 17, 1995; The Oakland Museum, Oakland, California, February 25–June 11, 1995; Nora Eccles Harrison Museum of Art, Utah State University, Logan, Utah, October 10–December 11, 1995"—T.p. verso.
 Includes bibliographical references.
 ISBN 0-943739-18-7
 1. Surrealism—California—Exhibitions. 2. Fantasy in art—Exhibitions. 3. Arts, American—California—Exhibitions. 4. Arts, Modern—20th century—California—Exhibitions. I. Ehrlich, Susan, 1942– . II. UCLA at the Armand Hammer Museum of Art and Cultural Center. III. The Oakland Museum. IV. Nora Eccles Harrison Museum of Art.
 NX510.C2P23 1995
 700—dc20 94-48299

E 33

Contents

Foreword

Among Los Angeles cultural institutions, UCLA holds a position of primacy in exploring and exhibiting innovative aspects of California art. We believe that the significance of the state's artists and artistic movements within the larger scheme of American art history has often been underestimated, and we hope that our efforts will help redress this imbalance. It is therefore with pleasure that UCLA, now at the Armand Hammer Museum of Art and Cultural Center, presents *Pacific Dreams: Currents of Surrealism and Fantasy in California Art, 1934–1957* to our audience and to those of the Oakland Museum of California and the Nora Eccles Harrison Museum of Art in Logan, Utah.

The exhibition was organized by guest curator Susan Ehrlich, adjunct professor of art history at the University of Southern California and recognized authority in the study of the arts of California. Her innovative research has uncovered new information about the influence of surrealism on artists working on the West Coast which sets them apart from their East Coast peers and gives many of them previously withheld recognition for their accomplishments.

Pacific Dreams provides tangible proof of her scholarship, as does this extensive catalogue, which features an overview of the period written by Dr. Ehrlich as well as biographical-critical studies of each artist in the exhibition written by leading scholars and critics. The publication also includes essays on parallel trends in California photography and experimental film by Terence Pitts and Lucy Fischer, respectively. Its contents should appeal to readers with diverse academic interests since, in addition to providing much-needed information about the artists and their schools of thought, it also delves into psychology, history, and gender issues. Moreover the extensive bibliography will serve as an important resource for those interested in further study of this lively and creative period. It is our hope that this volume will serve as an important companion piece to UCLA's 1989 publication *Forty Years of California Assemblage.*

We are fortunate to have received significant support for this exhibition and publication from several institutions and individuals. The National Endowment for the Arts and the Henry Luce Foundation provided major funding, and we are grateful to them for their generosity. Galen Howard Hilgard and Gerald Buck also supported this project, and we deeply appreciate their commitment and enthusiasm. The generosity of the lenders, whose names appear on page 10, has been extraordinary, and it is they who have truly made this undertaking possible. Finally I would like to thank the directors and staff of the Oakland Museum and the Nora Eccles Harrison Museum for joining us in the presentation of *Pacific Dreams.*

The staff at the UCLA/Hammer Museum have made the production of this complex exhibition appear effortless. Senior Curator Elizabeth Shepherd has overseen the details of the exhibition and the catalogue from the earliest stages. Graduate Research Assistant Mary-Kay Lombino has provided crucial assistance to Dr. Ehrlich in numerous areas of research and exhibition organization and has been the museum's "point person" for this project. Farida Sunada, curatorial assistant, has diligently assisted in all aspects of the production of this publication. Registrar Susan Lockhart has undertaken the complicated task of bringing together the works in the exhibition and coordinating an opening at another venue. Mitch Browning, chief preparator, supervised the installation of the works with great professionalism. Joslyn Treece, director of development, lent her development skills to this project with notable success. Cindi Dale, director of education, has organized outstanding programming in conjunction with this project, and ensuring that the exhibition reaches a wide audience has been the contribution of publicist Anna Graham. We also thank Mitch Tuchman for his careful editing of Lucy Fischer's essay. There are two people who deserve special acknowledgment for their roles in the realization of this publication: Karen Jacobson, for her deft and sensitive editing, and Bryan Coopersmith, for his handsome design.

Henry T. Hopkins
Director, UCLA at the Armand Hammer
Museum of Art and Cultural Center

Lenders to the Exhibition

Lenders to
the Exhibition

Addison Gallery of American Art, Phillips Academy,
 Andover, Massachusetts
Albright-Knox Art Gallery, Buffalo
Mr. and Mrs. Robert Anthoine
The Art Institute of Chicago
Shirley Berman
Tosh Berman
Ruth Bernhard
Braunstein/Quay Gallery
The Brooklyn Museum
The Buck Collection, Laguna Hills, California
James B. and Barbara C. Byrnes, Los Angeles
California Museum of Photography,
 University of California, Riverside
Campbell-Thiebaud Gallery, San Francisco
David and Jeanne Carlson
Center for Creative Photography, the University of Arizona,
 Tucson
Crown College, University of California, Santa Cruz
Claire Falkenstein
Feitelson Arts Foundation
First National Bank of Chicago
Dr. Peter B. Fischer
Galerie Marion Meyer, Paris
The Grunwald Center for the Graphic Arts, University of
 California, Los Angeles
The Estate of Philip Guston, New York
John Gutmann
Sam and Jo Farb Hernandez
Paul Hertzmann and Susan Herzig
Galen Howard Hilgard
Hirschl and Adler Galleries
Hirshhorn Museum and Sculpture Garden,
 Smithsonian Institution, Washington, D.C.
The J. Paul Getty Museum, Malibu, California
Jack Rutberg Fine Arts, Los Angeles
Jane Voorhees Zimmerli Art Museum, Rutgers, the State
 University of New Jersey, New Brunswick
Lee and Eleanor Kendall
Dr. Bernard L. Krause
L.A. Louver Gallery, Venice, California
Harold Lehman

Fannie and Alan Leslie
Los Angeles County Museum of Art
McKee Gallery, New York
McNay Art Museum, San Antonio, Texas
The Menil Collection, Houston, Texas
The Metropolitan Museum of Art
Lee and Luchita Mullican
Munson-Williams-Proctor Institute,
 Museum of Art, Utica, New York
Museum of Fine Arts, Boston
The Museum of Modern Art, New York
National Museum of American Art,
 Smithsonian Institution, Washington, D.C.
Nora Eccles Harrison Museum of Art, Utah State University
The Oakland Museum of California
Odyssia Gallery, New York
Page Imageworks: Merrily and Tony Page
Herbert Palmer Gallery
Parkerson Gallery, Houston, Texas
Paul M. Hertzmann, Inc., San Francisco
Philadelphia Museum of Art
Princeton University
Leland Rice
James and Linda Ries
San Francisco Art Commission
San Francisco Museum of Modern Art
SBC Communications, Inc., San Antonio, Texas
The Schoen Collection, New Orleans
Sheldon Memorial Art Gallery, University of Nebraska, Lincoln
State University of New York, Buffalo
Stephen White Associates
Herbert Stothart
Syracuse University Art Collection
Tobey C. Moss Gallery
University of California, Los Angeles, Department of Special
 Collections, University Research Library
University of Kentucky Art Museum, Lexington
The Walt Disney Company
Gordon Wagner Estate
Beatrice Wood

Several private collections

Acknowledgments

Acknowledgments

A project of this size could not have been realized without the kind and able assistance of many dedicated individuals. I am exceedingly grateful to the lenders, who generously consented to share their works of art with the public. Galen Howard Hilgard provided archival material and conservation, and I extend my special thanks to her, as I do to Gerald Buck, whose gracious support buoyed our endeavors. I am equally obliged to Van Romans, John Hench, David Smith, David Carlson, Tobey C. Moss, Jack Rutberg, Suzanne Royce, Stephanie Dragovich, Mary Ann Helmholtz, and Susan Friedewald for their cordial facilitation of loans.

Leland Rice and Susan Ehrens willingly shared information with us, as did Joseph Browner, Herbert Stothart, Jan von Pribosic, Vilem Kriz, and William Copley. We also appreciate the time and effort that John Gordon, Barbara Haskell, Diane Kelder, Mary MacNaughton, John Pollini, Jeffrey Wechsler, and Geoffrey Gilmore accorded *Pacific Dreams* in its development.

Interviews with Ruth Bernhard, Dorr Bothwell, Hans Burkhardt, Claire Falkenstein, John Gutmann, Jess, Harold Lehman, Helen Lundeberg, Rose Mandel, Lee Mullican, Gordon Onslow Ford, Edmund Teske, and Beatrice Wood afforded me invaluable insights into their art, and I owe them a profound debt. So too did I gain from conversations with James and Barbara Byrnes, experts on California's art history. The assistance of Herbert Palmer, Michael Rosenfeld, Lane Talbot, Richard Lorenz, Mike Glad, Jason Hailey, Will Connell, Jr., Todd Walker, Merry Foresta, James Bigwood, Mimi Horner, Odyssia Skouras, Steven White, Ruth Braunstein, Paul Hertzmann, James Marx, Bill Marx, Shirley Trieste, Jae Carmichael, Jeff Gunderson, Graham Howe, Bruce Baillie, Debra Lehane, Shirley Berman, and Tosh Berman is also gratefully acknowledged.

A collaborative undertaking, this publication has profited from the knowledge, good will, and expertise of the authors who contributed original essays to it. Their thoughtful discussions have enhanced our understanding of the role that California artists played in America's surrealist venture, and we are greatly indebted to Susan M. Anderson, Michael Auping, Anne Ayres, Lisa P. Carlson, Sheryl Conkelton, Lucy Fischer, Ilene Susan Fort, Barbara C. Gilbert, Katherine Holland, Henry T. Hopkins, Deborah Irmas, Susan C. Larsen, Andrea Liss, Diane Degasis Moran, Nancy Dustin Wall Moure, Suzanne Muchnic, Weston Naef, Francis Naumann, Sandra Phillips, Terence Pitts, Merle Schipper, Peter Selz, David Travis, and Amy Winter.

At the Oakland Museum of California, Phil Linhares and Harvey C. Jones committed themselves to *Pacific Dreams* from its inception, and I deeply appreciate their support, as I do the kindness of Abby Wasserman, Karen Nelson, Janis Capecci, and Arthur Monroe. Likewise I wish to convey my thanks to Steven Rosen, director of the Nora Eccles Harrison Museum of Art, and to George Wanlass, advisory board member, for their participation in the exhibition's tour.

Ultimately I want to express my profound gratitude to Henry T. Hopkins, director of UCLA at the Armand Hammer Museum of Art and Cultural Center, whose own ground-breaking exhibitions of California art provided role models and inspiration for my undertaking. His vision, enthusiasm, and unstinting commitment to West Coast creative expression, past and present, helped bring *Pacific Dreams* to fruition. Elizabeth Shepherd, the museum's senior curator, championed the project early on and guided it with wisdom, resiliency, and exceptional expertise. For her consummate care, dedication, good humor, and friendship I am eternally grateful.

Susan Ehrlich, guest curator, with
Mary-Kay Lombino, graduate research assistant

OFFICIAL
HIGHWAY
MAP

OF

San Francisco
and Vicinity

Scale of Miles

0 5 10

Paved Highways
Improved Highways
Secondary Roads

Pacific Dreams

Currents of Surrealism and Fantasy in California Art, 1934–1957

SUSAN EHRLICH

In its exploitation of fantasy and provocation of subconscious thought, surrealism served as a persuasive force in American art in the years that spanned the Depression and the Cold War. Open to personal interpretation and formal experimentation, it appealed to many American artists, who responded with a sense of adventure to the license that it afforded. In contrast to movements such as cubism and de Stijl, surrealism did not nurture a definitive style, permitting veristic as well as abstract invention, and its stress on private mythologies plucked from the recesses of the unconscious pointed the way for an excavation of new psychic frontiers.

Surrealism thus served as a catalyst, providing sanctions as well as techniques for creatively mining subjective data.[1] As they chose among surrealist options, artists in California, like their peers in other parts of the country, wrought new aesthetic syntheses, distinct from their models, yet beholden to surrealism's probe of dream, myth, and illusion.[2] Emboldened by precedents set in Europe, these painters, photographers, sculptors, and filmmakers fashioned exceptional works of art with Psyche as their muse.

Surrealism, a State of Mind

Aimed at liberating consciousness, surrealism arose in Paris in the mid-1920s from the dada movement, whose libertinism it merged with ideas and techniques derived from psychology. Its leader, poet André Breton, sought to free art and thought from the bonds of convention and make them receptive to emanations from the unconscious. A devotee of Sigmund Freud, he strove to apply the associative methods of psychoanalysis to poetry. In 1924 he issued the movement's first manifesto, in which he rhapsodized, "the marvelous is always beautiful, anything marvelous is beautiful, in fact only the marvelous is beautiful," and defined surrealism as follows:

SURREALISM, n. Psychic automatism in its pure state, by which one proposes to express—verbally, by means of the written word, or in any other manner—the actual functioning of thought. Dictated by thought, in the absence of any control exercised by reason, exempt from any aesthetic or moral concern. ENCYCLOPEDIA. Philosophy. Surrealism is based on the belief in the superior reality of certain forms of previously neglected associations, in the omnipotence of the dream, in the disinterested play of thought.[3]

Surrealism thus began as a literary movement that emphasized the free play of dream and ideation. In line with Freudian analysis, it sought through the use of automatic techniques to liberate thinking from reason's restraints. Its concepts were swiftly adapted by visual artists such as Jean Arp, Max Ernst, André Masson, Joan Miró, and Yves Tanguy, who embodied them in biomorphic abstractions. In 1929 Breton inducted illusionist Salvador Dali into the movement, thus granting veristic surrealism sanction, with Paul Delvaux, René Magritte, and Pierre Roy adding their own articulations. Yet whether abstract or naturalistic, surrealism implied a state of mind that sought to unite, in Breton's words, the "seemingly contradictory" states of "dream and reality . . . into . . . a surreality."[4] This call to fuse the fictive and the real sparked new directions in American art after surrealism crossed the Atlantic.

Surrealism in the United States

Like other European movements, surrealism reached America's shores primarily through exhibitions, publications, and collections and secondarily through contact with its practitioners. Although works by surrealists could be seen on the East Coast in the late 1920s,[5] surrealism as a movement made its debut in this country in December 1931 in an exhibition at the Wadsworth Atheneum in Hartford, Connecticut.[6] The following January dealer Julien Levy brought a modified version of the show to his gallery in Manhattan, now with Americans Joseph Cornell, Charles Howard, and Man Ray.[7] During the 1930s and 1940s Levy promoted surrealist expression, presenting solo exhibitions of work by Eugene Berman, Dali, Howard, Wolfgang Paalen, and Man Ray, among others, and publishing a book on surrealism in 1936.[8] A few museums and other New York galleries also provided forums for surrealist art,[9] and through reviews of these shows, surrealism became known on the West Coast.

In 1934 a furor erupted when the Carnegie International exhibition in Pittsburgh awarded an honorable mention to

Dali and first prize to American surrealist Peter Blume, but it was not until the Museum of Modern Art in New York mounted the exhibition *Fantastic Art, Dada, Surrealism* two years later that surrealism made a resounding impact on the national scene. This compendious survey—organized by director Alfred H. Barr, Jr., and accompanied by an illustrated catalogue—granted surrealist art a cachet, a rationale, and an ancestry. Dali, Paalen, and Man Ray appeared with the European contingent, while Lorser Feitelson, Helen Lundeberg, and Knud Merrild (along with the Marx Brothers and Walt Disney) represented California.[10] Appealing to a broad audience, the show attracted throngs as well as extensive publicity.[11] In August 1937 it traveled to the San Francisco Museum of Art, where it struck critic Alfred Frankenstein as "a cross between a three-ring circus and a chamber of horrors." Though Frankenstein lauded surrealist fantasy and its "amusing effrontery left over from dada," he scoffed at its narcissistic self-indulgence, which he cited as proof that romantic individualism had hit a dead end.[12]

The Museum of Modern Art's dual retrospectives for Dali and Miró in 1941 and an influx of European surrealists in the years surrounding World War II did much to heighten awareness of surrealism.[13] Instrumental too in the dissemination of surrealist art and ideas were the series of lectures, attended by displays of works, that Gordon Onslow Ford delivered at the New School of Social Research in 1941[14] and the *Artists in Exile*[15] and *First Papers of Surrealism*[16] exhibitions of 1942. Peggy Guggenheim's Art of This Century Gallery, opened that same year, raised consciousness of the movement,[17] as did the galleries of Karl Nierendorf—which showcased Howard, Onslow Ford, and Paalen in 1946—and Betty Parsons, who featured Adaline Kent three years later.

A spate of new vanguard journals—*View* (to which Man Ray contributed works), *VVV, DYN* (published by Paalen in Mexico), *Tiger's Eye,* and *Possibilities* (a single-issue review edited by Robert Motherwell and Harold Rosenberg)—drew an expanding audience to surrealism and abstraction,[18] as did Sidney Janis's *Abstract and Surrealist Art in America* and several Museum of Modern Art publications.[19]

By 1947 surrealism had gained such momentum that the Art Institute of Chicago heralded it in a large survey, *Abstract and Surrealist American Art,* which mingled European and American surrealists, magic realists, and abstractionists. Among those representing California were Eugene Berman, Hans Burkhardt, Claire Falkenstein, Howard, and Man Ray as well as Feitelson, Kent, Lundeberg, and Merrild, whose *Chain Reaction* (1947; cat. no. 91) earned an honorable mention, as did a sculpture by Robert Howard.[20] Four years later Kent and Charles Howard participated in the Museum of Modern

Art's ambitious *Abstract Painting and Sculpture in America,* which announced the ascendancy of abstraction.

Surrealism on View in California

Surrealism arrived in Southern California in November 1934, when Feitelson and Lundeberg launched their Post-Surrealist movement with a show at the Centaur Book Shop in Hollywood.[21] Joined by Lucien Labaudt, Harold Lehman, Merrild, and Etienne Ret, they set forth a subjective aesthetic intended to serve as a West Coast riposte to European surrealism. The following year Feitelson established a gallery in the Stanley Rose bookshop on Hollywood Boulevard,[22] where he presented modernist art, including that of the Post-Surrealists, now with new members Philip Guston (then known as Philip Goldstein) and Reuben Kadish.[23] A few months later, however, Feitelson quit his post as gallery director, which Howard Putzel, a booster of surrealism from San Francisco, assumed shortly thereafter. Putzel assembled in quick succession individual shows for Dali, Ernst, Miró, and Tanguy and a surrealist group exhibition.[24]

Meanwhile Feitelson, wishing to venture out on his own, opened the Hollywood Gallery of Modern Art across the street from the Egyptian Theater. After featuring Merrild, he displayed works by Paul Klee and then spotlighted the Post-Surrealists.[25] In December 1935 the San Francisco Museum of Art hosted a major Post-Surrealist exhibition, which traveled the following spring to the Brooklyn Museum, where it received positive notice.[26] Buoyed by their East Coast success, the Post-Surrealists regrouped in December 1936 at the Stendahl Galleries in Los Angeles, the site of their final group show two years later. By then Guston, Kadish, and Lehman had relocated to the East Coast, and Feitelson had closed his gallery's doors and was supervising the Federal Art Project, on which Lundeberg and Grace Clements worked.[27]

Across the continent Julien Levy, lamenting that the East Coast market was dry, motored to California in 1941 with a modern art "caravan." With hopes of attracting clients and meeting movie stars, he opened a gallery on the Sunset Strip, where he presented works by Dali, Tamara de Lempicka, and the Neo-Romantics. Sales, however, were woefully scant,[28] so Levy returned to Manhattan, maintaining ties with the West Coast through Berman and Man Ray, who were based there in the 1940s.

A few other dealers tried more earnestly than did Levy to establish venues for modern art in Los Angeles. Among those cordial to surrealism were Frank Perls, who offered works by Berman and Man Ray; Paul Kantor, who represented Lee Mullican; Frederick Kann, whose Circle Gallery show-cased Burkhardt and Man Ray; and Clara Grossman and Barbara Byrnes, successive directors of the American Contemporary Gallery, where works by Falkenstein, Klee, Merrild, and Dorothea Tanning could be seen.[29] Byrnes's husband, James, served as the first curator of contemporary art at the Los Angeles County Museum of History, Science, and Art, a highly conservative institution. He was deeply committed to modern expression nonetheless and in 1951 organized *Contemporary Painting in the United States,* an up-to-the-minute survey that teamed the Southern California avant-garde with European surrealists and abstract expressionists from New York and San Francisco.[30]

During these years the Byrneses socialized with Man Ray, his patrons Paul and Mary Stothart Wescher, filmmaker Albert Lewin, and painter William Copley,[31] a champion of surrealism. In September 1948 Copley, in partnership with his brother-in-law, inaugurated the Copley Galleries on Cañon Drive in Beverly Hills with a show of Magritte, which was followed by exhibitions of Cornell and Matta.[32] In November the gallery displayed works by Tanguy and the next month saluted Man Ray with an ambitious retrospective.[33] Early in 1949 Copley organized a survey of more than three hundred works by Ernst. "Surrealist stuff," critic Arthur Millier huffed, "leaves me ice cold," though he praised Ernst's blue eyes and tan. With this type of commentary by the town's reigning critic, it is hardly surprising that Copley's gallery had trouble surviving, and in March 1949 Millier announced its demise.[34] "It was time," Copley later reflected, "to listen to the lamentations of the bookkeeper.... No one wanted to buy our pies."[35]

Clearly Los Angeles had not yet nurtured a base of collectors sympathetic to contemporary trends. There were, however, a few exceptions, such as Blue Four dealer Galka Scheyer and film director Josef von Sternberg—although they favored German expressionism—and producer-director Lewin, who acquired works by Man Ray and other dada-surrealists.[36]

Lewin's attachment to surrealist art informed his *Picture of Dorian Gray* (1945), which featured a portrait by magic realist Ivan Albright of the hero rotting away. In 1946 Lewin devised an unusual contest in which he engaged eleven surrealistic artists to portray *The Temptation of Saint Anthony,* with the winning canvas—chosen by jurors Alfred H. Barr, Jr., Marcel Duchamp, and Sidney Janis—to appear in his film *The Private Affairs of Bel Ami.* Participants' works were shown in a traveling exhibition, and each artist received $500, except for Ernst, who won the $2,500 top prize.[37] Five years later Lewin commissioned Man Ray to design a chess set and paint a likeness of Ava Gardner, the female lead in his movie *Pandora and the Flying Dutchman.* Steeped in romantic fantasy,

the film, as J. H. Matthews has stated, is quintessentially surrealistic, transporting the viewer "as in a trance, into the world of the fantastic."[38] As in *Dorian Gray,* a portrait assumes a major role in the drama, thereby suggesting that art stands on par with, or even commands, presumptive reality.

While surrealist art formed the core of Lewin's holdings, it constituted only a part of Walter and Louise Arensberg's modernist collection, whose breadth and depth made it a peerless star on the Southern California horizon.[39] Described as "the most intelligently and beautifully chosen collection of 20th-century art in the world,"[40] it was richly endowed with the work of the cubists, Constantin Brancusi, and Duchamp, as well as that of the surrealists and their forerunners. Stunning pieces by Marc Chagall, de Chirico, and Henri Rousseau coexisted with the illusionistic fantasies of Dali, Magritte, and Roy; the organic abstractions of Ernst, Klee, Masson, Miró, and Tanguy; and the Improvisations of Wassily Kandinsky.[41] The Arensbergs graciously shared these visual treasures, opening their home to interested viewers and lending pieces to exhibitions.

To serve the community further, the Arensbergs joined with a star-studded cast of art aficionados—including Fanny Brice, Ira Gershwin, Elsa Lanchester, Charles Laughton, David Loew, Vincent Price, and Edward G. Robinson—in forming the Modern Institute of Art. Opening its doors on Rodeo Drive in Beverly Hills in January 1948, it showcased forty-two works garnered from private collections, with Chagall, Duchamp, Miró, and Rousseau illustrating dada, surrealism, and fantasy.[42] On the heels of this triumphal premier, it assembled another survey, to which Lewin, Brice, the Arensbergs, and Errol Flynn, among others, contributed works. Man Ray figured prominently in this exhibition, as did Berman, Dali, Duchamp, Ernst, and Klee.[43] Surrealistic expression received further attention in a display of selections from the Art Institute of Chicago's *Abstract and Surrealist American Art,* in a Merrild retrospective, and in individual shows of Klee and Chagall.[44]

By March 1949, however, the institute found itself in financial straits and beseeched its twenty-five hundred members to raise their five-dollar annual dues to ten.[45] Unable to garner requisite funds, it officially closed in May. Like Copley's ill-fated venture, whose existence was equally brief, it rose as a bright, meteoric presence, its aspiration of building a modernist mecca in Beverly Hills abruptly and rudely dashed.

In contrast to Los Angeles the Bay Area supported modernism early on. In 1934, the year that the Post-Surrealist movement emerged in the south, surrealism made its debut

in the north with a show of works by Miró curated by Putzel for the East-West Gallery. A few months later Putzel assumed the helm of the Paul Elder Gallery, where he arranged solo exhibitions for Dali and Ernst in 1934[46] and for John Gutmann in 1935.

That same year the San Francisco Museum of Art opened in the Veterans' building in the Civic Center.[47] Under director Grace McCann Morley it hosted seventy shows in its inaugural year, featuring, among others, Miró, Kandinsky, and the Post-Surrealists. It presented works by Tanguy in 1936 and by John Gutmann and Klee the following year, when it also brought Barr's *Fantastic Art, Dada, Surrealism* to California. Surrealist art gained increased exposure at the museum during the 1940s with one-person exhibitions for Tanguy (1940); Kay Sage and Arshile Gorky (1941);[48] Berman, Gutmann, Charles Howard, Isamu Noguchi, and Clay Spohn (1942); and Madge Knight and Clyfford Still (1943). In 1945 the museum introduced Jackson Pollock's totemic pieces, acquiring his *Guardians of the Secret* (1943), and the next year it displayed Mark Rothko's biomorphic abstractions.[49] Concurrently works by David Hare and Jacqueline Lamba (Breton's ex-wife) were placed on view.[50] Between 1948 and 1951 Dynaton artists Mullican, Onslow Ford, and Paalen had group and solo shows there.

During this time, moreover, the museum acquired biomorphic and veristic surrealist works that gave viewers a chance to assess the varied paths that surrealism could take.[51] Not limiting its scope to painting and sculpture, it included photography and film within its purview, spotlighting photographers Barbara Morgan (1945), Minor White (1948), and Rose Mandel (1948) and offering the Art in Cinema series. Directed by Frank Stauffacher and accompanied by an illustrated publication, that program screened dada-surrealist classics and other experimental films.[52]

Modernism also received crucial support from Douglas and Jermayne MacAgy, educators who arrived in San Francisco in 1941.[53] Douglas MacAgy served as curator at the San Francisco Museum of Art from 1941 to 1945 and then as director of the California School of Fine Arts from 1945 to 1950, while Jermayne MacAgy guided the California Palace of the Legion of Honor from 1941 to 1955 as assistant and later acting director. There she devised an eclectic array of exhibitions, presenting commercial products such as weapons, toys, and hats as well as folk and devotional objects from the Americas, Asia, and the South Seas. In doing so, she sanctioned dada-surrealism's negation of hierarchies and its will to view all aspects of visual culture as available sources of inspiration.[54] At the same time she kept a vigilant eye on the latest trends in the United States. In 1946 she instituted the

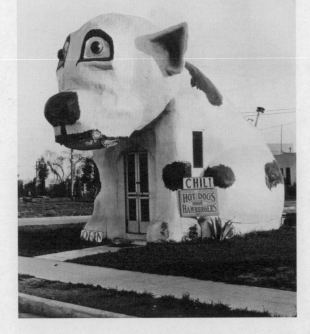

Contemporary American Painting annuals, based on a survey she had gathered the preceding year,[55] and organized a retrospective for Charles Howard, with a catalogue written by her husband. A solo show for Clyfford Still followed in 1947, as did *Mobiles and Articulated Sculpture,* in which Robert Howard's sculptures appeared.

During the second half of the 1940s Douglas MacAgy built the California School of Fine Arts into a thriving institution that counted among its faculty Jeremy Anderson, Dorr Bothwell, Claire Falkenstein, Robert Howard, Clay Spohn, Edward Weston, and Minor White, all of whom are represented in *Pacific Dreams,* as well as Ansel Adams, Elmer Bischoff, Richard Diebenkorn, David Park, and Still, a dominant presence there from 1946 to 1950. Along with colleagues Rothko and Ad Reinhardt (who led summer classes),[56] Still helped establish the school as the West Coast hub of abstract expressionism. The authority of his art and conceptions pervaded Bay Area painting, which, as many writers have noted, came to favor large-scale, darkly encrusted expressive abstractions.[57]

Still's authority notwithstanding, surrealism presumably filtered into the school through lectures by Dali, Charles Howard, and Man Ray in 1945–46 and courses instructed by Anderson, Bothwell, James Broughton, Stanley William Hayter, Robert Howard, and Spohn.[58] A participant in European surrealist circles and a friend of Onslow Ford, the Howards, and the MacAgys, Hayter conducted workshops at the school in the summers of 1940 and 1948. In his 1948 printmaking lab—which Mullican attended—he acquainted students with experimental techniques and automatism.[59]

Concurrently the Oakland Museum made the acquisition and display of works by California artists its mission,[60] organizing solo shows of Falkenstein and Labaudt, among others, in the 1930s.[61] The de Young Museum showcased John

Gutmann in 1938, 1941, and 1947 and his wife, Gerrie von Pribosic Gutmann, in 1949 and 1952.[62] In 1946 Labaudt's widow, Marcelle, transformed his studio into a venue for local artists, and three years later a group of Still's students founded the Metart Galleries, an early artists' space.[63]

In 1950 Douglas MacAgy resigned from the California School of Fine Arts, as did Still and Spohn.[64] While abstract expressionism still dominated exhibitions, it began to intersect with impulses from the burgeoning culture of the beats. Heralding this juncture, the King Ubu Gallery opened in December 1952 as a collaborative venture of artists Jess and Harry Jacobus and poet Robert Duncan. Although it lasted only a year, the gallery—named after the hero of Alfred Jarry's farcical play, which the surrealists adored—exhibited works by regional artists, screened experimental films, and hosted poetry readings. After it closed, Wally Hedrick started the Six Gallery in the same space, which continued to feature Bay Area talent and in 1955 served as the site where Allen Ginsberg performed his poem "Howl."[65]

With Psyche as Their Muse: Artistic Responses to Surrealism in California

Surrealism found fertile ground in California, which, riding the nation's western frontier, attracted free spirits seeking release from conventions entrenched in the East. Experimentation and the urge to take risks had long been identified with the state, fostered not only by its outpost position but also by its ties to the movie industry. As the home of the major film studios, Los Angeles bred a culture of fantasy bent on the production of celluloid tales. With its fixation on make-believe, the region frequently saw, in Bretonian fashion, the line between the fictive and the real effaced, with its denizens dressing as aspiring stars and its buildings mimicking sound stage facades. Homes modeled on Mexican villas, French châteaux, Asian pagodas, and witches' lairs invoked romantic film adventures, while shops and cafés shaped like owls, frogs, donuts, and pups (see fig. 1) echoed the fanciful quality of cartoons. Hollywood fostered a mind-set attuned to facades and a commercial engagement with dreams, and thus it is hardly surprising that surrealist art, which also traffics in myth and illusion, found resourceful exponents there.

Post-Surrealism: Lorser Feitelson, Helen Lundeberg, and Their Circle

Surrealism, by exposing the plastic possibilities of the subjective, has occasioned the birth of Post-surrealism; an art that affirms all that surrealism negates; impeccable aesthetic order rather than chaotic confusion, conscious rather than unconscious manipulation of materials, the exploration of the normal functionings of the mind.[66]

In 1934, stirred by surrealist currents from Europe and by developments in psychology, Lorser Feitelson and Helen Lundeberg formulated Post-Surrealism, one of the earliest replies to European surrealism in the United States.[67] In the tradition of their surrealist precursors, they boldly explored the subconscious, but instead of privileging neuroses, as their peers on the Continent tended to do, they honored the rational mind. The grotesque and bizarre they staunchly avoided, as they did dictates of the libido, preferring to channel desire into contemplative avenues. Toward this end they devised intriguing tableaux imbued with the feel of crystallized dreams and aimed, in the mode of de Chirico and Magritte, to pose philosophical questions in paint.

As they delved into subjective domains, the Post-Surrealists adopted the associative tactics of psychoanalysis. Accordingly they related objects by form, position, and function; focused on feminine symbols; and, giving a nod to Jung, called on microcosmic-macrocosmic concordances. Although the Post-Surrealists shared an interest in psychological content and classical form, they resisted the reign of a single style or of a Bretonian "pope." Feitelson and Lundeberg, who had earlier been teacher and pupil and would later become husband and wife, served as the movement's prime theoreticians but welcomed artists of different persuasions into their group. At various times the Post-Surrealists counted among their members Grace Clements, Philip Guston, Reuben Kadish, Helen Klokke, Lucien Labaudt, Harold Lehman, Knud Merrild, Elizabeth Mills, and Etienne Ret.

A veteran painter who in the 1920s had studied in Paris and showed his art in New York, Feitelson settled in Los Angeles in 1927. Within a short time he became a key figure in the region's small avant-garde, rising as both a respected art teacher and a spokesperson for modernism. By the mid-1930s he had arrived at an aesthetic that partook of magic realism but evinced a calm quite different from the acerbity and urban distress revealed in the works of East Coast contemporaries Peter Blume, Paul Cadmus, Jared French, and O. Louis Guglielmi (see fig. 2). Concerned less with sociopolitics than with eternal verities, Feitelson probed universal themes, particularly that of fertility, in a cosmic Jungian paradigm. In

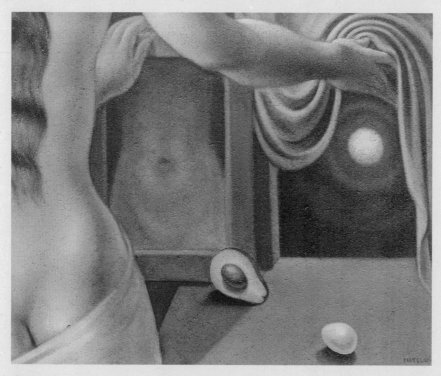

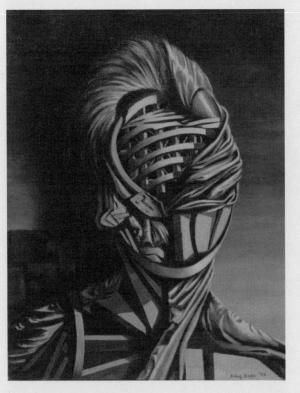

Fig. 4
Kay Sage
(American, 1898–1963)
Small Portrait, 1950
Oil on canvas
14¹/₂ x 11¹/₂ in. (36.8 x 29.2 cm)
The Frances Lehman Loeb Art
Center, Vassar College,
Poughkeepsie, New York,
Gift of Kay Sage Tanguy, 1963.7

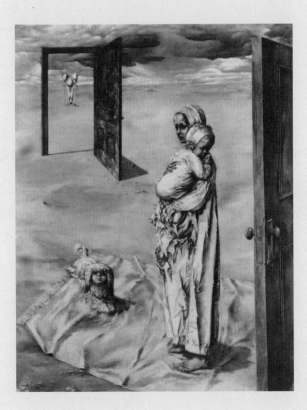

Fig. 5
Dorothea Tanning
(American, b. 1913)
Maternity, 1946–47
Oil on canvas
56 x 48 in. (142.2 x 121.9 cm)
Courtesy of the artist

Genesis, First Version (fig. 3) and *Genesis #2* (1934; cat. no. 34; color plate 4) he celebrates human fecundity and, through a chain of analogies, connects it to cyclical life in the biosphere. Comparably, *Life Begins* (1936; cat. no. 35) commemorates new beginnings, allying the birth of a child with that of a comet and *Life* magazine (which began publication that year) and with the reproductive potential of a peach.

The image of women projected by Feitelson contrasts with that typically seen in European surrealism. Hans Bellmer's dismembered *Poupées* (see fig. 12), for instance, and the maimed mannequins that his colleagues displayed at the 1938 International Surrealist Exposition in Paris evidence a misogyny that the Californian's work avoids. In Feitelson's art, as in that of his Post-Surrealist confreres, women appear in a positive light rather than as eroticized objects of the masculine gaze.[68]

Lundeberg in particular represented women as thoughtful, holistic beings and, in works such as *Double Portrait of the Artist in Time* (1935; cat. no. 78; color plate 1), examined their psychology. Remarkably free of neurosis and angst, the image projects a serenity that characterizes Lundeberg's oeuvre and contrasts with the disquiet that tends to pervade the work of her female surrealist peers. Compared with portraits of women by Frida Kahlo, Kay Sage, and Dorothea Tanning, for example, Lundeberg's work displays none of the psychic torments and sexual fears that bedeviled her contemporaries. One need not be trained in psychology to discern in Sage's *Small Portrait* (fig. 4) and Tanning's *Maternity* (fig. 5) women ill at ease with the world and haunted by anxieties. Sage envisions a shackled soul, unable to eat, breathe, or see, and Tanning identifies motherhood with malaise.[69] Yet while she differed from many women surrealists in her view of the female condition, Lundeberg held a kindred desire to explore a private psychology and to treat lowly things with empathy.

Philip Guston partook of the Post-Surrealist concern with human life cycles, as seen in his *Mother and Child* (c. 1930; cat. no. 39), whose uneasy mood and distorted environs, replete with upended floors and freestanding walls, suggest a debt to de Chirico. Echoes of that metaphysician's *Poet and His Muse* (1925), which Guston admired at the Arensbergs' home,[70] seem to resound in this image of psychic bonding pervaded by incertitude. More exegetic, *Nude Philosopher in Space Time* (1935; cat. no. 40) relates to Feitelson's *Genesis #2* as it calls on a host of symbolic forms, including a lightbulb, to link inspiration to fertility. Guston's taste for arcane allusions resurfaces in a Federal Art Project mural that he conceived with Reuben Kadish for the Los Angeles Tubercular Sanitorium (now the City of Hope National Medical Center) in Duarte, California

Fig. 6
Philip Guston
(American, 1913–1980)
with Reuben Kadish
(American, 1913–1992)
Federal Art Project mural,
1935–36
Fresco
Courtesy City of Hope National
Medical Center and Beckmon
Research Institute, Duarte,
California (Federal Art Project)

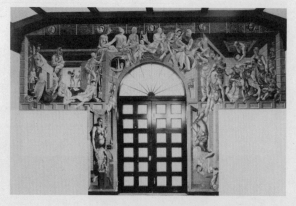

(fig. 6). A latter-day Vanitas piece signifying stages of life,[71] it visualizes a cosmos—akin to that of the hospice whose wall it adorns—besieged by onerous Fate.

A friend of Guston at Manual Arts High,[72] Harold Lehman created engrossing tableaux that addressed issues germane to art and psychology. In *Landscape in Perspective* (1934; cat. no. 73) an unseen painter grapples with Michelangelo's ghost, while the figure in *Surveyor* (1934; cat. no. 75)—recalling William Blake's Newton gauging the earth—tries to calibrate infinite nature so as to touch the divine. As Lundeberg would do in her later *Self-Portrait,* Lehman investigates representation and the models in art and existence on which it relies. Ground planes rushing toward distant horizons and trailing shadows ally his works with those of Guston and Clements and their precursor, de Chirico. Lehman's *Portrait of a Dancer plus a Sculptor* (1934; cat. no. 74) considers the precarious ties between men and women, between plastic art and performance, and between creators and their creations. In an inversion of the Pygmalion myth, the sculptor's hand has turned to stone, thus suggesting the tyranny of art over life. The work prompts one to question the shifting connections of truth and illusion, fact and fantasy, a theme reinforced by the puppet and mask.

Themes of masquerade and illusion also prevail in the Post-Surrealist art of Lucien Labaudt, a San Francisco couturier who painted chimerical fantasies peppered with references to the dressmaker's trade. In his oils gloves, shawls, feathers, and hats coalesce into figures in a way that recalls the compositions of Renaissance fantasist Giuseppe Arcimboldo, whom the surrealists revered. In Labaudt's 1935 paintings *Shampoo at Moss Beach* (cat. no. 70), *Song of the Seas* (cat. no. 71), and *Telepathic Travel to Tahiti* (cat. no. 72; color plate 5), forms emerge like mirages from glistening tides, suggesting the pleasures of life by the sea. Although the artist's dependence on visual double entendres owes a debt to Dali, his disinterest in aberrant sex and psychoses distinguishes him from his more sybaritic predecessor. Never tumultuous or monomaniacal, Labaudt's images speak of a placid existence in California, accented by a penchant for fashion design.

Labaudt's mutating forms allude at once to the process of dreams and to cinematic dissolves. Filmic references also abound in the work of Grace Clements, who argued in a polemical essay published in *Art Front* that painting should leave its ivory tower and speak to the masses through techniques derived from the movies.[73] In *Reconsideration of Time and Space* (1935; cat. no. 23) she adapts aspects of montage by splicing together different scenes. Collapsing near and far in her episodic frame, she allies the simultaneity of cinema with that of collage and modern technology.

During the 1940s Clements advanced a modernist agenda in her writings for *Arts and Architecture* magazine. Among the artists whom she supported was Knud Merrild, who in the 1930s wove symbolic and literal forms into the matrix of cubist collage. His involvement with dada-surrealism led to his invention in the 1940s of flux (see below), his prime contribution to California surrealism.

Although he was not a Post-Surrealist, Ben Berlin worked with Clements, Feitelson, and Lundeberg on the WPA and manifested a similar taste for enigmatic scenarios. As Clements and Merrild did in the 1930s, he layered planes in the mode of synthetic collage and embedded within them allusive forms. *Birds, Sky, Water, and Grass* (1938; cat. no. 6; color plate 8) invokes the pleasures of field and stream, while, in contrast, an untitled canvas of 1939 (cat. no. 7) intimates psychic entrapment. Its nightmarish imagery may contain autobiographical clues: the artist was jailed for alcoholism several times, and his death from hepatic cirrhosis in the year of the painting's creation seems presaged by the skull.[74]

Magic Realism in a Feminine Vein: Dorr Bothwell and Gerrie Gutmann

Post-Surrealism belonged to a broader sphere of illusionistic fantasy loosely termed magic realism. A style pioneered by de Chirico, Delvaux, Magritte, and Roy, magic realism courted enigma through startling junctures of commonplace things. For many American artists of the 1930s and 1940s it offered a flexible means of conveying private ideation while retaining communicability. As art historian H. H. Arnason noted: "The line between Surrealism and what is variously called Magic Realism, Precise Realism, or Sharp-Focus Realism is ... difficult to draw.... In general, the Magic Realists ... created mystery and the marvelous through juxtapositions that are disturbing even when it is difficult to see exactly why. The Magic Realists ... were interested in translating everyday experience into strangeness."[75]

Fig. 7
Dorr Bothwell
(American, b. 1902)
Dorr Bothwell, Artist, 1942
Oil on canvas
43 x 21 in. (109.2 x 53.3 cm)
The Buck Collection, Laguna
Hills, California

Fig. 8
Film still from *Pinocchio,* 1940
The Walt Disney Company

Working in this magic realist vein, Dorr Bothwell composed dreamy narratives born of personal reverie. A friend of Clements, Feitelson, and Lundeberg, with whom she served on the WPA, Bothwell shared their affection for tightly rendered symbolic scenes, structured to stimulate rumination. Like Lundeberg, she dealt with autobiography and empathized with humble things, as seen in her *Table in the Desert* (1942; cat. no. 19; color plate 10), which compares with Lundeberg's *The Mirror (Enigma)* (1934; cat. no. 76) and *Inquisitive Rose* (1942; cat. no. 80).

In *Dorr Bothwell, Artist* (fig. 7) she muses on her role as a painter and, as Lundeberg would in her 1944 *Self-Portrait,* displays the implements of her profession with pride. Both artists portray themselves before a moon, a female symbol, which suggests their connection to cosmic cycles. Bothwell, though, holds a flowering brush, demonstrating the transformative powers of her craft. The cat and the bird[76] seem to serve as alter egos or shamanic helpers, as animals do in a number of women surrealists' works.[77] Felines recur in Bothwell's *The Primrose Path* (1938; cat. no. 16) and *We Sleep with Our Feet at the Head of Our Four-Footed Bed* (1940; cat. no. 18). The disparities of scale in the former bring to mind Disney cartoons (see fig. 8), while the latter, a night view of calliope lions beside a cloaked dreamer, recalls Henri Rousseau's *Sleeping Gypsy* (1897) and points to the artist's symbolist roots. "Beneath what the Freudians ... call the manifest content," one critic remarked of Bothwell's work, "there is an ... epigrammatic ... symbolism ... of the subconscious."[78]

Freudian content pervaded the art of Gerrie von Pribosic Gutmann, which plunged wholeheartedly into psychobiography. Born and raised in Southern California, Gutmann studied in the late 1930s with Feitelson, from whom she absorbed the lessons of Post-Surrealism. The classical poise and introspection characteristic of that movement inform her *Self-Portrait* (1946; cat. no. 41), albeit her work, in contrast to Lundeberg's, exuded despondency. Abandoned in childhood by her father, Gutmann coped with this trauma through a proxy—the "Father Doll" depicted here—which she alternately cuddled and thrashed. Poignantly she seems to allude as well to the burdens of motherhood, as does Tanning in *Maternity*. Chained to a domestic chamber of horrors, Gutmann daydreams as a surcease from webs of duty and sorrowful memory. Revealing "a secret world of strange beauty and exquisite terror,"[79] Gutmann's art intimated the unbearable psychic strains that would impel her to take her own life in 1969.

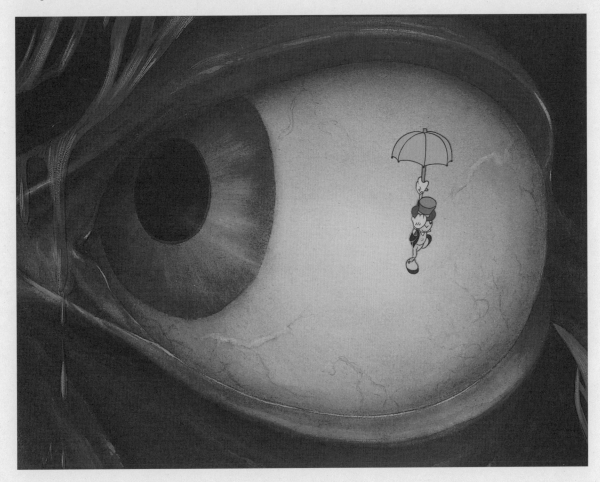

Neo-Romanticism: Eugene Berman

Magic realism tinged with nostalgia characterizes Neo-Romanticism, the movement that Eugene Berman cofounded with his brother Leonid and their friends Christian Berard and Pavel Tchelitchew in mid-1920s Paris. Introspective in tone, Neo-Romanticism revolved around humanistic subjects pervaded by feelings of loss. James Thrall Soby explained: "The Neo-Romantics painted man's spirit. . . . They shared the Surrealists' negation of reason, but their images of man were thoughtful. . . . Man, as they painted him, was a melancholy being, depressed as much by the weight of his own soul as by the complexity of the world."[80] In California Berman's Neo-Romantic aesthetic retained its melancholic mood but in some measure "went Hollywood." Seemingly roused by the brilliant light of desert and beach and the sparkle of movie marquees, his palette and figuration acquired a new comeliness. "Hollywood's influence has been good for Berman," one critic concluded, albeit another carped that West Coast life had dulled "the edge of Mr. Berman's grief."[81] Indeed the artist's theatrical scenes of toothsome muses in war-ravaged lands combine glamour and gloom in a way that parallels studio films. "Berman has been chic at times, mysterious too," one reviewer announced, proclaiming that in his "extravagant" art "a new . . . metaphysics has been born."[82] Clearly Berman struck responsive chords in a public consumed by the war and seeking in art, as it did in the movies, communal release for their dread of a world seemingly on the verge of extinction.

Illusionistic Surrealism: Salvador Dali

Like fellow émigré Eugene Berman, Salvador Dali—who in the 1940s summered at Pebble Beach and stayed for periods in Hollywood[83]—brought surrealist art into commercial domains. Dali distanced himself from the local community, however, and groomed an eccentric persona in order to court socialites and celebrities. His meticulous imagery—"dream illusionism," he called it—sprung from his "paranoiac-critical method," defined as a "spontaneous method of irrational knowledge based upon the interpretative-critical association of delirious phenomena." Mining his delusional fears and erotic drives, he reveled in titillation and shock. "I believe," Dali exulted, "that the moment is at hand when, by a paranoiac . . . advance of the mind, it will be possible . . . to systematize confusion and . . . to discredit completely the world of reality."[84]

In light of his wish to cast doubt on reality, Dali understandably loved Hollywood movies, and in 1932 he penned an essay in which he lauded Mack Sennett and the Marx Brothers as surrealist wits.[85] Happily Dali met Harpo Marx in 1936 and the following year arrived in Los Angeles to work with him on a movie script.[86] While the film did not come to fruition, the visit gave Dali an opportunity to render portraits of Harpo (1937; see cat. no. 28) and Groucho Marx. With graphic aplomb he caught the buffoonery of the celluloid clowns and the sophistries endemic to surrealism and cinema.[87]

Dali revisited Hollywood in 1941 for a solo show at the Dalzell Hatfield Gallery and again three years later to create a dream sequence for Alfred Hitchcock's *Spellbound*.[88] In 1946 he returned to Los Angeles to work on the Walt Disney film *Destino* (see fig. 9),[89] and according to studio artist John Hench, interacted well with the animator despite their minimal dialogue.[90] Reportedly tackling the project with impish delight, the artist conceived it, Jordan R. Young writes, as "a magical exposition on the problem of life in the labyrinth of time."[91] In Dali's surreal cityscape (cat. no. 30) his trademark telephone, now painted a boudoir white, hangs in a frame packed with de Chirico icons: a classical statue and column, a dressmaker's dummy, and an arcaded facade. In another oil painting (cat. no. 29; color plate 12) Jupiter's head evolves from hidden figurations, with a woman forming his nose and brow; a bird, his right temple and cheek; a shell and seaweed, his coiling mustache; and a girl's tresses, his flowing beard. Although Disney decided to table the film, Dali's visit had other rewards. He began a portrait of studio chief Jack Warner (cat. no. 31), which reveals the artist's affinity for Hollywood plasticity.[92]

"He's a mild man with a fierce mustache, a Hollywood flair for publicity," *Look* magazine testified, marveling at Dali's stupendous earnings and zest for self-promotion. Yet despite the wealth and attention that he accrued, the flamboyant eccentric remained a sojourner in California and relocated to Spain in 1948.[93]

Hollywood Photographic Illusions: William Mortensen and Will Connell

Before Dali alighted on the West Coast, photographer William Mortensen had alloyed the libertinism of surrealism with Hollywood glamour and kitsch. A proponent of pictorialism, which he espoused in numerous essays and books, Mortensen valued artifice and manipulation of means. Though fascinated with craft, he felt that it should serve subjective expression and held that photography could rival painting, not by recording prosaic facts, as the "straight" photographers did, but by employing inventive camerawork. In his photographs, which often call to mind stills from horror films, he constructed fictional narratives pervaded by violence and lust. With the panache of a movie director, he used operatic stagings and shrewd projection techniques to dramatize fears and libidinal drives.

No stranger to Hollywood, Mortensen had worked as a set and costume designer in the 1920s and as a film still and portrait photographer. His flamboyance and penchant for titillation, tinged with Freudian trepidation, had much in common with both surrealism and cinema. *Shrapnel* (c. 1934; cat. no. 92), for instance, treats fears of mutilation and, by extension, castration, while *Obsession* (c. 1935; cat. no. 94) deals with paranoia, the emotive fuel of surrealist art and celluloid thrillers. *La Chatte* (c. 1935; cat. no. 93)[94] equates women with sphinxes and cats—a comparison that Bothwell, Leonora Carrington, and Dali also invoked—with innuendos of witchcraft and alchemy.

Mortensen's *L'Amour* (c. 1936; cat. no. 95) seems to mock the surrealists' obsession with *amour fou*, convulsive love charged by irrational passion. Emblematic of his oeuvre, the piece shows a sensual maiden supine at the feet of a driveling gorilla. In its staging, it recalls Merion C. Cooper's *King Kong*, a 1933 fantasy thriller, which J. H. Matthews cites as a surrealist classic.[95] Both *L'Amour* and *King Kong* stage strange encounters of beauty and beast, transgressively hinting of sodomy. At once filmic and surrealistic, *L'Amour* conflates the sensuous and the perverse, its slick, fetishistic veneer allying it further with popular cinema.

Piercing that veneer, Will Connell, a commercial photographer and teacher, utilized surrealist techniques to satirize

the film industry. In a series of photomontages published in his 1937 book *In Pictures,* he lampooned status, contrivance, and power both on and off the screen. Guided by Jonathan Swift, whom Breton had hailed as a surrealist hero, Connell alternately shrunk and inflated his protagonists to serve his satirical ends. In *Props* (1937; cat. no. 26) a coarse, cigar-chomping brute towers over and paws a tiny glass doll, illustrating male domination in a business that treats women as toys. Connell cuts men down to size in *Still Man* (1937; cat. no. 27), in which a photographer cowers beneath Gargantuan legs, and in *Make-up* (c. 1933; cat. no. 24), in which a diminutive cosmetician enhances a starlet's gigantic face. Whereas these works rely on disjunctions of scale, *Opticman* (1936; cat. no. 25) depends on distortion, transforming a prosaic technician into a snouted beast.

Dada-Surrealism: Man Ray, Beatrice Wood, and Clay Spohn

A pioneer of New York dada and vanguard photographer to surrealist Paris, Man Ray, like Eugene Berman, brought the traditions of European modernism to Los Angeles. True to his dada-surrealist roots, Man Ray valued freedom and chance and allowed them to reign preemptively in the various media that he employed. Conceived with wit and imagination, his California paintings, constructions, and Rayographs disclose how commonplace objects, brought into novel amalgams, can yield startling aperçus. Typically they seek to efface the boundaries between art and life, the high and the low. In *Frosted Objects (of My Affection)* (1946; cat. no. 114) staples of house, purse, and pocket appear as phosphorescent specters whose luminescence belies their banality.[96] Made by darkroom manipulations, the piece counters the ethos of "straight" photography propounded by New York photographer Alfred Stieglitz and the Group F.64 in California. Although Man Ray, like the straight photographers, believed in the artistic validity of his means, he pressed his case, as did Mortensen, not by reducing photography to its putative essence, but by stretching its range.[97]

In a series of self-portraits (see figs. 10, 55) Man Ray posed in costume and drag to critique the role playing that movieland fostered. In its examination of cultural signification, the suite foreshadows the costumed self-portraits of Eleanor Antin, Cindy Sherman, and William Wegman, which likewise deconstruct psychosocial stereotypes. Subversion of another sort obtains in *Ruth, Roses, and Revolvers* (1940–49; cat. no. 106), whose accumulation of disparate items upsets expectations of logicality. The piece relates to a script of the same title that Man Ray penned for Hans Richter's surrealis-

Fig. 10
Man Ray (American, 1890–1976)
Self-Portrait with Half-Beard,
c. 1940s
Gelatin silver print
5 x 7 in. (12.7 x 17.8 cm)
Copyright Man Ray
Trust/A.D.A.G.P., Paris, 1992

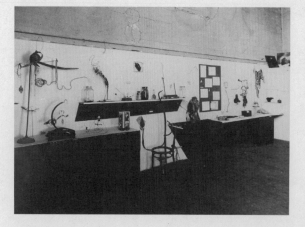

tic film *Dreams That Money Can Buy* (1947).[98] Published in a 1944 issue of *View,* Man Ray's photograph and scenario indulge dadaist non sequiturs and treat objects fetishistically.[99] Two years later Richter's film and Man Ray's early dadaist reels were screened in the Art in Cinema series at the San Francisco Museum of Art. In the accompanying publication Man Ray confessed his desire to make his movies so realistic—replete with temperature shifts and projections of smells—that viewers would enter empathically into his scenes: "The attainment of ultimate realism . . . would seriously compete with everyday life; . . . the spectator would . . . desire to rush . . . outside, live his own life, be the leading actor . . . becoming a poet, an artist himself, instead of being merely a spectator."[100] In his attempt to efface the boundary between art and life, Man Ray sought nothing less than to aestheticize existence itself. In this, he looked forward to the operative ethos of such artists as Michael Asher, Wallace Berman, John Cage, Bruce Nauman, and Robert Rauschenberg.

An acquaintance of Man Ray since their New York days, Beatrice Wood gave dadaism a feminine cast. In the 1910s she had absorbed emanations of dada from the Arensbergs' lively salons and from her close friend Marcel Duchamp, with whom she contributed to the Society of Independent Artists. After moving to Los Angeles in 1928, she began to work in ceramics and rapidly earned high regard for her luminous lusterware.[101] At the same time she created faux-naif drawings and clay figurines in which she exposed human foibles with affable zeal. Her bawdy humor, playfulness, and sly controversion of social mores partake of the spirit of dada, while her focus on erotic desire relates to surrealism. Importantly, though, her art avoids European surrealism's sadistic edge and rather sustains a witty, feminine perspective on personal tribulations and the strains that romantic yearnings can cause.

In *Carte de Noël: What the Doctor Took Out* (1937; cat. no. 137; color plate 13) Wood works through the pain of an opera-

tion by representing her body as a collage and thus gives surrealist viscerality a therapeutic twist. More lighthearted, *Decoy* (c. 1948; cat. no. 138) pokes fun at the ploys women adopt to attract the masculine gaze. One of a few figurative pieces extant from the artist's early ceramic oeuvre, the sculpture expresses with lusty verve her abiding interest in sexual politics.

While Wood and Man Ray kept dada-surrealism alive in the south, Clay Spohn, in the north, infused it with a piquant edge of his own. Spohn had encountered surrealism in the mid-1920s while living in Paris,[102] and his experience there may have abetted his plunge into fantasy in the 1940s, when he created a suite of chimerical works he called Guerrographs (see cat. nos. 117–19). Prompted by nightmares he had about World War II, these pieces envision battles between quixotic robots and war instruments, biomechanical hybrids that stem from dada's conflations of man and machine. "A cross between Paul Klee and Popular Mechanics," Alfred Frankenstein mused, deeming the series "half caricature and half cryptic, an oracular allegory."[103] Indeed Spohn's conceptions embody a lively sense of invention akin to that of Rube Goldberg.[104]

In his constructions, as in his drawings, Spohn projected a dadaist sensibility that aimed to subvert hierarchic convention and reinvigorate perception. As Man Ray had done in his assemblages, Spohn glorified debased items through recontextualization. His *Precious Objects* (c. 1949; cat. no. 120), a jar filled with detritus, celebrates life's residue and the aesthetic stimuli that it affords. Spohn presented this piece, along with other bizarre oddments, in *The Museum of Unknown and Little-Known Objects* (fig. 11), an installation he organized in 1949 at the California School of Fine Arts.[105] This honorific display of junk prefigured later directions in beat and funk.

Photographic Metaphor and Magic Realism

Not immune to the tremors that surrealism unleashed, a number of West Coast photographers tapped the mystery inherent in everyday things. California provided rich subject matter for photojournalist John Gutmann, whose works caught the eerie frisson of the mundane. An émigré from Germany, where he had trained as a painter, Gutmann combined an aesthetic sophistication with an ingenuous feeling of wonder for the visual travesties of his adopted land.[106] Faces lurking in telebinoculars, a zany monument to a hen, and a magician's levitation act were memorialized by his lens, as was a pedestrian who appears to be a walking corpse (see cat. nos. 44–47). "Ugly is free," the artist observed, adding that in America, "nobody was bothered by anything people do. . . .

Fig. 12
Hans Bellmer
(Polish, 1902–1975)
La poupée, 1949, from
Les jeux de la poupée
Hand-colored photograph
5¹/₂ x 5¹/₂ in. (14.0 x 14.0 cm)
Courtesy Virginia Lust Gallery

In Europe people would . . . call the police."[107] Gutmann's portraits of his wife, Gerrie, however, project a different mood. Sensitive to his spouse's troubled psyche, he zoomed in on her beautiful face as she cuddled her Father Doll (see cat. no. 48). Steeped in Freudianism, his image speaks of psychic regression and surrealistically links fetishism and intimacy. Correspondingly *Father Doll Watching Lovers on Swing* (1951; cat. no. 49) maintains a surrealist fascination with toys as cathectic objects and surrogates. How different, though, are Gutmann's conceptions from Bellmer's mangled *Poupées* (see fig. 12).

Gutmann's deployment of toys invites comparison with that of Ruth Bernhard, who understood, as the surrealists did, how to induce psychic vibrations by linking playthings with the macabre. Her disquieting tableaux—in one (cat. no. 15) winsome dolls eye a dead bird—pair preciosity with the perverse. Plucked from their moorings, the glowing hand and foot of a marionette and the head of a doll in a mannequin's palm (cat. nos. 13, 14) embody deracination or surrealist *depaysement.*

Even purist Edward Weston responded to the suggestive power that dolls possess, as seen in his image of mannequins on the MGM lot (cat. no. 130). These effigies can be read as emblems of Hollywood, where values ride on appearances and humans take on personas devoid of depth. In *"Hot Coffee," Mojave Desert* (1937; cat. no. 128) and *Shoe, Moonstone Beach* (1937; cat. no. 129), Weston capitalized on chance and displacement. Unlikely companions, the can of beans and battered shoe meet fortuitously in his frame, recalling Lautréamont's proverbial "chance encounter of a sewing machine and umbrella on a dissecting table."[108] Contrastingly droll, Weston's *Civilian Defense* and *Civilian Defense II* (1942; cat. nos. 132, 133), in which his nude wife confronts us wearing a gas mask, veer toward the surrealistic. Half woman, half extraterrestrial vamp, the figure seems a soul sister to Dali's lobster-loined mermaids and Ernst's bird-headed nudes.[109]

Like Weston, Minor White subscribed to the ethos of straight photography, which he too stretched at times to accommodate magic and metaphor. Although suffused with mystery instead of humor, his *Tom Murphy, San Francisco* (1947; cat. no. 135) can be linked to Weston's *Civilian Defense;* each offers a transgressive view of a nude, tinged with a surreal mix of eroticism and psychic disruption. Dramatically staged and lit, *Tom Murphy* exudes a sensual charge of homoerotic desire. In this, of course, White departed from the heterosexual fixations of European surrealism but concurred with a number of experimental filmmakers in California. As Lucy Fischer writes (see "Spellbound: Surrealism and California Experimental Cinema," below), James Broughton

and Sidney Peterson in the Bay Area and Kenneth Anger in Los Angeles explored homoerotic themes in their films of this time, and White's image of Murphy partakes of their dreamlike quality. Its tenebrous ground invokes the recesses of the subconscious, the depths of the cosmos, and the annihilation of death. Dense with allusions, the piece suggests a surrealistic pas-de-deux of Eros and Thanatos.

Attuned not only to the embrace of love and death but also to the interconnectedness of all things, White suffused his art with an awareness of analogies among organisms and the allusive potential of the man-made. Metallic levers caught in his frame strike one as robotic boxers, while a tractor evokes a mechanical monster akin to Spohn's biomorphic machines (see cat. nos. 134, 136).

A protégé of White, Rose Mandel shared his introspective approach and interest in psychology, having studied with Jean Piaget in Switzerland. Her sensitive essays on storefront windows juxtapose different realities (see cat. nos. 83–85). Forms overlap and melt into each other as images do in filmic dissolves and in the metamorphic illusions of surrealist art. In their evanescence they conjure up thoughts darting in and out of consciousness, bringing to mind both Bergsonian notions of memory coursing through time and Freudian theories of repressed perceptions surfacing from the unconscious. In one work a spectral clock floats as a sign of ephemeral time, while in another a single eye hauntingly implicates inner and deific sight.

Tiers of thought and sight in subjective time recur in the camera art of Edmund Teske, who reveled in darkroom manipulations. A sometime actor, dancer, and set decorator, he engaged surrealist montage to propagate new conjunctions of meaning. His dreamy "composites," made from overlaid images, found confirmation in the photography of Man Ray, whom he met in the 1940s.[110] Teske, however, distinct from Man Ray, steered clear of dadaist humor and rather based his art on a moody romanticism. Blending ideas from Freud, Jung, and Vedanta with a nature mysticism, he layered scenes from the present and past in ways that evoke interior visions filtered by memory. In his mystic attachment to nature, infatuation with Eastern religion, lyric devotion to visual tropes, and inclination to whisper of secret desire, Teske drew close to Minor White and Kenneth Anger, whom he lionized in a sublimely theatrical photograph (cat. no. 123).

Abstract Surrealism in the 1940s
With the advent of World War II, whose horrors defied representation, and with the immigration of European modernists to the United States, abstraction assumed growing promi-

nence in American art during the 1940s. For numerous artists in this country organic surrealism furnished a potent alternative to the naturalism that had reigned during the Depression as well as to purism. At once universal and personal, it enabled them to contribute to international modernism while heeding private fantasy.

In Los Angeles Feitelson, provoked by the terrors of the war and the political tensions left in its wake, fashioned a breed of strange figurations he titled Magical Forms (cat. nos. 37, 38). Shades of Arp, Ernst, and Tanguy coalesced in these ominous beings, which signified the psychic duress of a holocaustal age. Merrild too, in response to the war, devised a type of free-form abstraction that he termed *flux*. Inspired by surrealist automatism—which he may have seen in the Ernsts and Massons in the Arensberg collection—he dashed and spattered liquid enamels used in his house-painting business over a moist base. Seething with vitality, *Perpetual Possibility* (1942; cat. no. 88) predicts the combustive, linear twinings of Pollock's trademark drip paintings and approaches the poured coulages of Onslow Ford, with which Merrild, however, was apparently unfamiliar.[111]

With a kindred effusiveness Hans Burkhardt yoked the painterliness of expressionism to surrealist biomorphism. Treading a path consistent with that of his former mentor Arshile Gorky (who entered Breton's New York circle in the 1940s), he conceived *Abstraction* (1941–42; cat. no. 20) and *Black Cloud over Vineyard* (1953; cat. no. 22), in which tendriled organisms vaguely recalling those of Miró rest in atmospheric grounds.

Spurred by a number of émigré artists and enlightened curators, abstract surrealism thrived in the Bay Area. Gerald Nordland describes the creative ferment of the postwar years: "In San Francisco ... immediately after the war, *View* magazine, *VVV*, Wittenborn's *Documents of Modern Art* and *Problems of Contemporary Art* and later John Stephan's *Tiger's Eye* made the surrealist adventure more readily available. Gordon Onslow-Ford's outstanding collection of surrealist painting was often seen on loan at the San Francisco Museum of Art, giving substance to the ideas, technics, experiments of the movement. ... There was a nervous, anxious excitement about Dada and Surrealism."[112]

Biomorphic fantasy joins constructivist form in the inventive abstract paintings and sculptures of brothers Charles and Robert Howard and their respective wives, Madge Knight and Adaline Kent. The first to delve into surrealism, Charles Howard participated in the 1932 surrealist exhibition at the Julien Levy Gallery in New York and the following year relocated to London, where he moved in surrealist circles. Back in the Bay Area in 1940, he continued to per-

fect his signature style, characterized by smoothly brushed iconic forms in opaque hues poised in ambiguous space. Peopled by protoplasmic beings that distantly nodded to Arp, Miró, and Tanguy, Howard's works conjured up mysterious primal realms. From preparatory drawings, many done automatically, he painted his oils with scrupulous care,[113] thereby conjoining, as has often been noted, surrealism's intuitive freedom with abstraction's control. Likewise he meshed formal oppositions, contrasting tenebrous tones with radiant light, decisive line with equivocal form, and infinite depth with planarity. Resonating with metaphor, his wartime works evoke a cosmos edging toward primeval darkness but relieved here and there by luminous zones that portend a brighter tomorrow.

In these paintings Howard forged a biomechanical ethos that honored surrealism's fusions of man and machine. Consistent, too, with surrealist practice, his works often harbored erotic allusions. In *The Bride* (1942; cat. no. 51), for example, a bronzed groom readies a taut phallus-arm, and a linear figure invoking the sprites of Miró conjures up schematic female pudenda. *Dove Love* (1945; cat. no. 54) and *Chain of Circumstance* (1946; cat. no. 55; color plate 15) too couple the visceral and the man-made, as intimations of eyes and internal organs consort with glimpses of planes, submarines, and blimps. *Bivouac* (1940; cat. no. 50) alludes to the bombs, encampments, and blackouts of war, while *Wild Park* (1944; cat. no. 53) grants zoologic invention free reign. At once elemental and abstruse, Howard's works merged the archetypal and the mundane, external vision and fantasy.

A correlative blend of the otherworldly and the prosaic informs the gouaches of Madge Knight. In *Turret* (1944; cat. no. 69) two steely forms confront each other guardedly as they drift in a space that evokes both an auroral sky and sandy plains of desert and beach. Although the piece edges toward pure abstraction, the psychological charge induced by its strange rendezvous of mechanomorphs keeps it grounded in the surreal.

Adaline Kent also displayed an anthropomorphic inventiveness in sculptures that have a magical aura, touched here by capriciousness, there by enigma. A skilled athlete and former track star at Vassar, she often touched her work with her love of kinetics, as in *Never Fear* (1948; cat. no. 66), whose hand-standing figure, legs thrust in the air, exudes an insouciant buoyancy. Congruently *Gambler* (1948; cat. no. 65) exploits the awkward and idiosyncratic, which Kent felt gave art vitality.[114] Its wayward silhouette stressed by dark bands, it stands as a gawky sentinel of some chimerical breed. Fashioned, like *Gambler*, from magnesite, a material used in the building trades, Kent's *Weathereye* (1948; cat. no. 67) and

White Hand (1951; cat. no. 68) strike oracular notes. One stares omnisciently at the beholder from a long ocular void, while the other grasps animistically into space. Viewed as a group, Kent's sculptures reveal a familial accord, seeming to be members of some genetically engineered species. In their psychological presence and quirky morphologies, they flirt with the surreal, taking their cues, as the artist stated, "from … instincts, intuitions; from the subconscious."[115]

In step with his wife, Robert Howard wrought whimsical zoomorphs, although his constructions, like the mobiles of family friend Alexander Calder, actually move. Built of separate pivoting parts, his "articulated sculptures," as he termed them, tilt, teeter, and sway in response to currents of air and spectators' proddings. Enlivened by this motion, they attain an audacious veracity. Witness the gangling *Miscreant* (1950; cat. no. 60), which wobbles on hobby-horse legs, or the restive *Inspector* (1950; cat. no. 59), a delightfully skittish fowl whose frenetic propulsion calls to mind Road Runner cartoons. More perverse than its avian kin, *Night Watch* (1949–50; cat. no. 58) reigns as a mythical beast with a bulbous fish body spiked by fins and a trunk that periscopes into the sky, while the Jurassic *Scavenger* (1949; cat. no. 57), an anorexic relic of archaeological time, claws the egg of its germinal past.

Howard taught at the California School of Fine Arts, where his colleague Claire Falkenstein also wielded industrial means in totemic abstractions indebted to dada-surrealist precedent. Her elegant *Fertility* (1940; cat. no. 32) taps into surrealism's focus on sex but shuns the exploitative character of many European works. Raucous instead of sleekly reductive, *Big Apple* (1948; see fig. 36) and *Game* (1947; cat. no. 33) exude a jauntiness and penchant for chance. *Game* implies that art, like the X-ray film that acts as the painting's base, can reveal mysterious worlds invisible to the naked eye.

As a student at the California School of Fine Arts in the 1940s, Jeremy Anderson absorbed the anthropomorphic wit of his teachers Robert Howard and Clay Spohn.[116] Engaging surrealism's pliant language of form, Anderson crafted fanciful sculptural beings from wood. In the tradition of Alberto Giacometti they combine the organic with the man-made and, with their phallic projections and glandular spheres, bear erotic innuendos. Importantly, though, in these weird personages Giacometti's sadism has been replaced by a homespun grit, which the whittled wood surfaces reinforce. Grafting the folksy to the surreal, Anderson's humanoid of 1954 (cat. no. 3) flaunts its construction from household goods. In another piece (cat. no. 1) a whimsical pair confront each other in a no-man's-land, he a cylindrical sheath with darts that double as pomaded hair, and she a maiden with several breasts. In works such as these, the artist, as Thomas Albright observed, "forged a unique link between the biomorphic abstraction of Robert Howard [and] Adaline Kent and the dadaesque comedy of Clay Spohn," and foresaw the "Funk surrealism of the 1960s."[117]

The Dynaton

In the postwar years surrealist abstraction gained further momentum from the Dynaton group of European émigrés Gordon Onslow Ford and Wolfgang Paalen, who had been members of Breton's coterie, and American Lee Mullican (see fig. 13).[118] Taking the name of their movement from the Greek word *dyn,* meaning "possible," they sought to express "a limitless continuum, in which all forms of reality are potentially implicit."[119] To a surrealist interest in the subconscious and in automatist methods of probing its contents they joined a regard for Native American art, which they studied and collected, and for metaphysics and science, whose investigations of cosmic vibrations they saw as allied with their own.

In their stress on potential and in their view of art as an enchanted journey into the subconscious, the Dynaton artists held points in common with Knud Merrild and the abstract expressionists. In contrast to the action painters, however, they engaged with their art in a meditative way. Regarded as objects of contemplation, their works took on a spiritual air different from the existentialist tone of much East Coast action painting.

Establishing a profile in the region, Paalen and Onslow Ford had solo exhibitions at the San Francisco Museum of Art in 1948, and Mullican showed there the following year. The three exhibited together at Stanford University in 1950 and at the San Francisco Museum of Art the next year, with *Dynaton 1951*. Installing the show with surrealistic panache, they hung works high and low on the walls, suspended some from the ceiling, and placed others on posts. In homage to their Amerindian sources, they furnished an "Ancestors' Room" with ritual objects from their collections.[120]

The show received a positive review from Alfred Frankenstein, who singled out Paalen for special praise, lauding his "exquisite . . . craftsmanship," "sparkling use of color," and great "range of ideas."[121] These traits resound in Paalen's *The Possible City* (1947; cat. no. 104), which, reflecting his utopianism, proffers a radiant metropole with towers shimmering in the night. "Painting is an adventure into an inner space," the artist exulted, ". . . where the eye of the mind at once beholds worlds gone and come."[122] Envoys, perhaps, of those numinous realms, spied by interior sight, the figures in *Keylords of the Prismatic Situations* (1947; cat. no. 103; color plate 17) alight, Paalen writes, "with . . . fans of molten meteor," talismanic heralds of some futuristic race.[123]

Paalen compared his art with fire—understandably, given his blazing hues and his invention of fumage, an automatist method employing lit candles—and mused, "I have to find the egg of the phoenix, the philosopher's stone is inside."[124] The refulgent winged creatures in *Tropical Night* (1948; cat. no. 105; color plate 18) conjure up such mythical birds, rising with awesome grandeur from a murky abyss. Bred of sizzling motes of light, they hover as if seen in a trance or in a shamanic rite. "I want to paint paintings which sound like a gong," Paalen confessed, "echoing through all our levels of consciousness and . . . linking our secret awareness of the past to our hidden memory of the future."[125] This desire to tap archetypal thought, combined with his reference to alchemy, suggest Paalen's accord with the tenets of Jung,[126] and in his reverberant works of the 1940s he gave sonorous voice to his yearnings to bond with an intuited future and ancestry.

Paalen and Onslow Ford had developed a friendship in Europe, and in a 1939 essay Breton commended them and other young painters for revitalizing automatism with concepts derived from Einsteinian physics.[127] In line with his colleague Matta, Onslow Ford invoked the fourth dimension in crystalline visions that they called psychological morphologies.[128] By 1947, when he settled in San Francisco, having spent the first part of the decade in Mexico, Onslow Ford had evolved a body of work galvanized by surrealism's quest

for the marvelous. In *Fixed Flight* (1946; cat. no. 100) curious biomorphs, or surrealist "personages," roam through multidimensional, fluid terrains patterned with dabs of hues emblematic of earth, water, and sky. The segmented fields and totemic forms reappear in *The Future of the Falcon* (1947; cat. no. 101; color plate 16), where tiny beings steer through whirling pools as lofty wings—signifying the falcon?—soar amid streams of light and rain. Gliding in and out of space, these enigmatic creatures taunt archetypal memory yet resist attempts to pin down their identities.

In the 1950s Onslow Ford, enchanted with the lush, wooded hills and silvery coves of the Bay Area, evolved allusive works such as *Wild Time* (1953; cat. no. 102), which weaves together intimations of foliage and water refracting rays of the sun.[129] Solid and void interpenetrate in a grand pneumatic continuum. Surrealist praxis here intersects with California subject matter and a New Age concern with cosmic infinity.

With a kindred interest in cosmic paradigms, Lee Mullican forged a signature style characterized by densely intertwined lines that cover the ground nonhierarchically and grant occasional hints of organic wraiths. Placed on the field with a printer's knife, these minute striations recall stitchery, sometimes the Amerindian textiles that the artist prized. In *Splintering Lions* (1948; cat. no. 96; color plate 20) they yield an animate surface seething with primal energy. Suggesting electromagnetic fields or currents of water or air, they whirl through space with form-splitting force. Automatically done, the piece, Mullican said, visualizes an "invented world," informed, as its title implies, by leonine speed.[130] *Vestment* (1950; cat. no. 97), by contrast, projects a staid solemnity, which *Ninnekah* (1951; cat. no. 98; color plate 19) blends with the power of *Splintering Lions* in an image of burning vitality, ruled by a radiant sun. While alluding to nature's primordial gifts of heat, fire, light, and maize, the painting further evokes the detonations of the nuclear bomb. Here an atomic age vision synoptically joins a surrealist relish for the subconscious, accessed by automatism, and an awe for the mythic content of native American art. So too does *Presence* (1955; cat. no. 99) alloy the totemic and the surreal, conjuring up a personage and ritual masks of Amerindian and African tribes. In further pursuit of the marvelous, Mullican acted in James Broughton's *Mother's Day* (1948). A surrealistic take on Freudian family ties, the film announces its theme of psychic regression by opening with a shot of Mullican cradled in a statue's arms (fig. 23).

The synergy that buoyed the Dynaton venture could not sustain itself forever, and in 1951 the three artists parted ways. Paalen left the United States and committed suicide in 1959;

Fig. 14
Wallace Berman
(American, 1926–1976)
Homage to Hesse, 1949
(modified 1954)
Wood furniture parts
18 x 24 x 24 in.
(45.7 x 61.0 x 61.0 cm)
Collection of Mr. and Mrs.
Dean Stockwell

Onslow Ford pursued his "Inner-Worlds" in a verdant compound in Inverness, California; and Mullican moved to Los Angeles, where he continues to paint meditative abstractions of a stately authority.

From Surrealist Poetics to the Ethos of the Beats

The disbanding of the Dynaton group signaled the end of one era and the start of another. Harbingers of a new sensibility, Jess, Gordon Wagner, and Wallace Berman linked the ethos of surrealism with that of a rising alternative culture. An introspective dreamer, Jess heeded surrealism's call to mine fantasy, devising an aesthetic predicated on fairy tales. His encounter with Ernst's 1934 collage book *Une semaine de bonté* in 1952 proved crucial, prompting him to create his remarkable paste-ups, painstakingly crafted collages of images culled from discarded books, magazines, and engravings.[131] *Love's Captive* (1954; cat. no. 62) envisions a bucolic scene peopled by beings improbably bred from human and animal parts. Two lesbians, marginalized at right, hint of romantic desire,[132] as do the cupids and heart-shaped faces.

In contrast to these quiet yearnings, *Boob #3* (1954; cat. no. 61), a collaborative piece made with poet Robert Duncan, strikes a raucously dadaist chord. Pictures clipped from old photo journals interact with texts strewn through the field like synchronic remarks in a colloquy. More portentous in tone, *The Face in the Abyss* (1955; cat. no. 63) exploits surrealist double entendres, its metamorphic forms calling to mind those of Labaudt and Dali. Mutations wax slyly sardonic in Jess's *Goddess Because II* (1956; cat. no. 64; color plate 21), which pastiches two advertising campaigns of the time ("Modess . . . because" and "I dreamed I . . . in my Maidenform bra"). With a wink to the latter ad's reference to dreams, it posits an absurd drama in which hybrid deities preside over a topsy-turvy world. Presented in six separate frames that resemble comic strips, the piece begs a sequential reading but

negates cohesion as it proffers a chain of enigmas beyond logicality's bounds.

Jess and Duncan established connections with artists in various fields in the salons that they hosted at their home, in gatherings at the King Ubu Gallery, and in meetings with a group called the Maidens, dedicated to romantic lore. Broughton belonged to their circle, as did film critic Pauline Kael, whose Berkeley residence Jess festooned with murals.[133] Anger used snippets of Jess's collages in one of his films, and Stan Brakhage, who roomed for a time in the Duncan-Jess household, cast Jess as the star of his movie *In Between* (1955; see fig. 22). In that hypnotic "psychodrama,"[134] for which John Cage conceived a musical score, Brakhage conveyed a dreamlike feeling as he tracked his protagonist's psychic journey with dizzying camerawork.

Jess's art has been called "mythopoetic,"[135] a term equally apt to the assemblages of Gordon Wagner, which embody a weathered lyricism. Usually they marry antinomies, coupling a spiritual awe with a carnival glee retained from a childhood in Redondo Beach working at amusement parks and scouting for treasures left in the sands.[136] In their reclamations of junk and figural metamorphoses they acknowledge a debt to surrealism. *"V.R."* (1954; cat. no. 127) conjures up a monocular being, at once comical and foreboding, while an untitled piece of 1950 (cat. no. 125) calls to mind a thin personage whose face transmutes into flexing arms.

A charismatic personality, Wallace Berman stands as a seminal figure in California art history, known for his compelling presence and mesmeric work, particularly his assemblages and Verifax photocollages.[137] A series of drawings of performers made in the 1940s reveals his ties to surrealism[138] even as it looks forward to the new sensibility of the 1950s. Drenched in surreal absurdity, an image of a grinning Jimmy Durante (c. 1943–47; cat. no. 11) brims with visual gags that intimate the comic's dependence on drink and monkey business. More strident in pitch, Berman's drawing of Louis Armstrong (c. 1947; cat. no. 12) depicts the musician blowing a syringe that pierces a nude's derriere. Sex, drugs, and jazz, with their percussive theatrics and nocturnal light, mingle in this symbolic portrait of Los Angeles's nightclub scene. In their imagistic conflations these sketches show curious correlations with Dali's drawing of Harpo Marx (cat. no. 28), which harbors a kindred impulse to shock and to bend media figures to the artist's own renegade will.

During the late 1940s Berman worked as a craftsman at a furniture firm and with scraps salvaged from his job fashioned *Homage to Hesse* (fig. 14), whose staged interplay of totemic poles seems to bow to Ernst and Giacometti. Closer to home, it parallels Anderson's cryptic tableaux of sleek wood-

en figures and the assemblages of Man Ray, whom Berman reportedly met through Teske in 1948.[139] Among the few surviving works of his early years, this piece appeared in Berman's first solo show, in June 1957 at the Ferus Gallery, which his friends Edward Kienholz and Walter Hopps had recently opened on La Cienega Boulevard in Los Angeles. Now legendary, that exhibition was raided by the city's vice squad and closed on grounds of obscenity.[140] Shaken, Berman relocated later that year to San Francisco, where he served as a key figure in the arts underground, as he did again when he returned to Southern California in 1961.[141] Together Berman and his artist friends pursued surrealism's aim of integrating art and life and expanding psychic frontiers, vowing to shun the repressions and conventions of the bourgeoisie. "In our conscious alliance with the critical breakthru of Dada and Surrealism . . . ," Robert Duncan commented, "we began to see ourselves as fashioning unnamed contexts . . . of a new life way."[142]

It is here, with the rise of a counterculture that, while responsive to surrealist precedents, nurtured a new sensibility and shaped new contextual life-styles, that this exhibition concludes its investigation. Specifically it stops in 1957, the year in which Berman made his public debut and the Ferus Gallery opened its doors to usher in assemblage, hard-edge and painterly abstraction, finish fetish, light-and-space, and pop.[143] In that same year Bay Area figurative painting earned a cachet with a show at the Oakland Museum,[144] and Jack Kerouac's *On the Road* was published, giving the phrase "Beat Generation" currency.[145]

Thus, by 1957 the art scene in California vaunted robust and varied streams of expression, and surrealism, having run its course, was subsumed by other trends. Many of its early practitioners had died (Berlin, Kent, Labaudt, and Merrild), left the region (Dali, Guston, Charles Howard, Knight, Lehman, Man Ray, Spohn, and White), or shifted aesthetic directions: Lundeberg and Feitelson had moved to hard-edge abstraction; Burkhardt, to abstract expressionism; Falkenstein, to nonobjective construction; Onslow Ford, to mystic cosmographies; Wallace Berman, Jess, Teske, and Wagner, to counterculture photomontage and assemblage; and Anderson, to funk. Bernhard, Connell, and Mandel pursued straight photography, and Mortensen wallowed in kitsch. Clements is said to have married a guru and plunged into astrology.[146]

What, then, might be construed of the surrealist venture in California? Most noticeably it evidenced a healthy heterogeneity as artists seized in different ways and to varying degrees on the forms, techniques, and conceptions set forth by European surrealism. Some—inspired by de Chirico and Magritte—chose a veristic course, considering philosophical issues, while others—stirred by Arp, Miró, Ernst, Masson, and Tanguy—contrived abstract morphologies. Yet, whether their work was abstract or naturalistic, these artists accepted surrealism's challenge to plumb the oneiric, the mythic, and the fantastic. All shunned imitation and diverged substantially from their counterparts in Europe. Distinctively they held no Marxist or anticlerical agenda, had no dominant leader, refrained from preemptive theorizing, and concerned themselves less with psychoneuroses than with rational thought and transcendent flights of the soul. Furthermore they tended to skirt the sadism and misogyny of European surrealism. Women artists in California—unlike female surrealists in France, who were subordinate to the men in their coterie— helped lead the surrealist enterprise, with Lundeberg and Clements serving as Post-Surrealist theoreticians, Falkenstein and Kent advancing biomorphism with industrial means, and Wood extending dadaist humor into the field of ceramics.

Understandably, too, California artists distanced themselves from their Continental precursors and their American peers in other regions, at times creating art that contained intimations of West Coast life. Resisting the Europeans' grotesqueries and the New Yorkers' urban angst, they often inflected their work with a sense of calm consistent with balmy existence beside the Pacific. A number responded to Hollywood, with Mortensen miming its marriage of terror and lust, Eugene Berman absorbing its plastic glamour, Connell lambasting its politics, and Weston critiquing its empty facades. Clements, Dali, and Labaudt took inspiration from filmic montage and dissolves. Beyond Hollywood's sphere John Gutmann, Weston, White, and Mandel caught California's fantasy aura in their photographic frames, while Charles Howard and Spohn alluded to San Francisco's vessels of war; Burkhardt, to Laurel Canyon's rustic terrain; and Merrild and Onslow Ford, to the region's tide pools and bays. To surrealist automatism Merrild and the Dynaton artists joined an indigenous fascination with transcendental psychology and the mystic sublimities of the Far East, interests shared by Teske and White.

Although this era came to an end, one wonders whether the subjective concerns it voiced ever died or whether they might still be alive in California art of our own time. The explorations of female psychology undertaken by Bothwell, Gerrie Gutmann, Lundeberg, and Wood, for instance, recur in contemporary feminist art, just as Dynaton's transport of thought into cosmic domains reverberates in the aesthetic of light-and-space. The darkroom ploys and contrived tableaux of Bernhard, Connell, Mortensen, Man Ray, and Teske resound in the costumed stagings of Eleanor Antin, Nancy

Barton, Judy Dater, and William Wegman and in the synthetic camerawork of Jo Ann Callis, Eileen Cowin, Robert Heinecken, and Barbara Kasten. In a similar vein the surreal dislocations that John Gutmann, Mandel, Weston, and White discerned in everyday life echo in the odd, deadpan scenes of John Divola and Larry Sultan.

Surrealism's poetics of junk—which Man Ray, Anderson, Spohn, Wallace Berman, and Wagner articulated—bore further fruit in the beat assemblages of Bruce Conner, George Herms, and Edward Kienholz and in the funk constructions of Robert Arneson, Roy de Forest, David Gilhooley, and William Wiley. Clearly it continues to flower today in the installations of Chris Burden, Mike Kelley, Paul McCarthy, Bruce Nauman, and Peter Shelton, which typically dip into surrealistic viscerality. One might add that the collages of Jess—with their surreal blend of nostalgia, humor, and sensual yearnings—foreshadow the narrative art of Carole Caroompas and Alexis Smith.

Arguably, then—if viewed as a "state of mind" given to fantasy, daydream, and play—surrealism finds legatees among West Coast artists of today, whose works refract contemporary California dreams, pacific and otherwise.

Notes

1. I am indebted to Jeffrey Wechsler, *Surrealism and American Art, 1931–1947*, exh. cat. (New Brunswick, N.J.: Rutgers University Art Gallery, 1977); Melvin Paul Lader, "Peggy Guggenheim's Art of This Century: The Surrealist Milieu and the American Avant-Garde, 1942–1947," Ph.D. diss., University of Delaware, 1981; and Barbara Hartmann, "Dynaton and Post-Surrealism," in *Ceci n'est pas le surréalisme: California: Idioms of Surrealism,* exh. cat. (Los Angeles: Fisher Gallery, University of Southern California, 1983).

2. Some of these syntheses led to the birth of abstract expressionism, as probed in the excellent study of Paul Schimmel et al., *The Interpretive Link: Abstract Surrealism into Abstract Expressionism,* exh. cat. (Newport Beach, Calif.: Newport Harbor Art Museum, 1986).

3. André Breton, "Manifesto of Surrealism" (1924), in *Manifestoes of Surrealism,* trans. Richard Seaver and Helen R. Lane (Ann Arbor: University of Michigan Press, 1972), pp. 14, 26.

4. Ibid., p. 14.

5. According to Lader ("Peggy Guggenheim's Art of This Century," p. 64), the Brooklyn Museum organized *An International Exhibition of Modern Art* in 1927, which included works by de Chirico, Ernst, and Miró and traveled to the Anderson Galleries in New York. The Valentine Gallery showed de Chirico that year and Miró in 1928, and the Brummer Gallery showed Roy in 1930 and 1933. See also Hartmann, "Dynaton and Post-Surrealism," p. 9.

6. Wechsler, *Surrealism and American Art,* pp. 21–22; Lader, "Peggy Guggenheim's Art of This Century," p. 65. *Newer Super Realism* included de Chirico, Dali, Duchamp, Ernst, Masson, Miró, Picasso, Roy, and Leopold Survage. For details, see Deborah Zlotsky, "'Pleasant Madness' in Hartford: The First Surrealist Exhibition in America," *Arts* 60 (February 1986): 55–61.

7. Wechsler, *Surrealism and American Art,* p. 22; Julien Levy, *Memoir of an Art Gallery* (New York: G. P. Putnam's Sons, 1977), pp. 79–84, 296.

8. Julien Levy, *Surrealism* (New York: Black Sun Press, 1936; reprint, New York: Arno Press, 1968).

9. Lader cites the Balzac, Pierre Matisse, and Valentine galleries as hospitable to surrealism in the 1930s ("Peggy Guggenheim's Art of This Century," p. 64). Wechsler lists the Boyer, Buchholz, Ferargil, Hugo, Iolas, Norlyst, Perls, Catherine Viviano, Weyhe, and Willard galleries as important venues in the 1940s (*Surrealism and American Art,* p. 22).

10. Ambitious in size and scope, Barr's curatorial enterprise extended back to the Renaissance and subsumed the art of children and the insane, commercial design and cartoons, and fantastic buildings and gadgetry. He coauthored the catalogue with Georges Hugnet (reprint, New York: Arno Press, 1968). Peter Blume, Alexander Calder, Federico Castellon, Joseph Cornell, Arthur Dove, Georgia O'Keeffe, and David Smith were among the American artists included.

11. *Time* placed a photograph of Dali by Man Ray on its cover (14 December 1936, pp. 60–62), and *Life* gave it four pages of liberally illustrated coverage (14 December 1936, pp. 24–27). While the exhibition delighted the popular press, which capitalized on its carnival aspects, it earned scant approval from critics, most of whom carped at its unwieldy size, absence of aesthetic standards, and acquiescence to the perverse. With regard to the latter, see "Aired Obsessions," *Art Digest* 11 (1 January 1937): 22. Keith L. Eggener, however, points out that advertisers were quick to seize on surrealism's attention-getting devices and "soon were invoking its themes ... to pitch such mundane items as cars and cardboard boxes" ("An Amusing Lack of Logic: Surrealism and Entertainment," *American Art* 7 [Fall 1993]: 31).

12. Alfred Frankenstein, "Comment and Cautions Evoked by the Year's Most Sensational Show," *San Francisco Chronicle,* August [?] 1937.

13. See Lader, "Peggy Guggenheim's Art of This Century," p. 75.

14. Martica Sawin offers informative accounts of these presentations in "The Cycloptic Eye: Pataphysics and the Possible: Transformations of Surrealism," in *The Interpretative Link,* pp. 37–41, and "Gordon Onslow Ford," in *Moderns in Mind,* exh. cat. (New York: Artists Space, 1986), pp. 24–25.

15. "Artists in Exile Hold Stimulating Show," *Art Digest* 16 (15 March 1942): 9.

16. On view in October and November at the Whitlaw Reid mansion, the exhibition, which boasted an inventive twine installation by Duchamp, mingled European surrealists such as Onslow Ford with Americans Baziotes, Calder, Hare, and Motherwell; see Lader, "Peggy Guggenheim's Art of This Century," p. 467, and William S. Rubin, *Dada, Surrealism, and Their Heritage,* exh. cat. (New York: Museum of Modern Art; Greenwich, Conn.: New York Graphic Society, 1968), pp. 160, 164.

17. In addition to launching the careers of Jackson Pollock and several other New York school artists, Guggenheim's gallery hosted a solo exhibition for Paalen in 1945 and included Man Ray and Dali in group shows; see Peggy Guggenheim, *Confessions of an Art Addict* (New York: MacMillan, 1960), updated and revised as *Out of This Century: Confessions of an Art Addict* (New York: Universe Books, 1979).

18. The surrealist vehicle *Minotaure,* published in French in the 1930s, was a prime, if less immediately accessible, source. James Thrall Soby's *After Picasso* (Hartford: Edwin Valentine Mitchell; New York: Dodd, Mead, 1935) offered an early, thoughtful study of the movement in English.

19. Beneficial in this regard were the museum's *Art in Progress* of 1944, its release of a third edition of *Fantastic Art, Dada, Surrealism,* and its *Contemporary Painters* of 1948, which mixed the art of Calder, Klee, Matta, and Miró with that of American magical realists and the New York school.

20. Frederick A. Sweet and Katherine Kuh, *Abstract and Surrealist American Art; Fifty-eighth Annual Exhibition of American Painting and Sculpture,* exh. cat. (Chicago: Art Institute of Chicago, 1947).

21. Arthur Millier, "Surrealists Take Time by the Forelock and Stage Exhibit," *Los Angeles Times,* 25 November 1934, sec. 2.

22. Lorser Feitelson, interview with author, 13 December 1977. Rose's popular store, Feitelson mentioned, attracted a polyglot crowd of literati, film personalities, and racketeers.

23. *Post-Surrealists and Other Moderns,* Stanley Rose Gallery, Los Angeles, May 1935. The show included works by Arp, Dali, André Derain, Juan Gris, Karl Hofer, Fernand Leger, Picasso, and Sophie Taeuber-Arp and was accompanied by a brochure with an essay by Jules Langsner.

24. Melvin Paul Lader, "Howard Putzel: Proponent of Surrealism and Early Abstract Expressionism in America," *Arts* 56 (March 1982): 86.

25. Arthur Millier applauded the "distinguished showing," and noted how Feitelson's "painted analogies deepen and widen the effect of a pictorial idea much as literary analogies enrich the impression of verbal thought" ("Paint, Theory, Prints Liven This Week's Art Exhibitions," *Los Angeles Times,* 29 September 1935, sec. 2).

26. *Post Surrealist Exhibition* was on view in San Francisco from 4 December 1935 through 4 January 1936 and appeared at the Brooklyn Museum from April 24 through the summer of 1936 under the title *Oil Paintings and Water Colors by California Artists.* Among the works in the exhibition were Feitelson's *Genesis #2;* Lundeberg's *Plant and Animal Analogies, The Mirror (Enigma), Relative Magnitude,* and *Double Portrait of the Artist in Time;* Labaudt's *Song of the Seas;* Merrild's *Exhilaration;* and Clements's *Reconsideration of Time and Space,* all of which are included in *Pacific Dreams.* Edward Alden Jewell acclaimed the Californians as "universal thinkers ... [who] know how to paint," lauding Feitelson and Lundeberg for wielding their "brushes with cosmic authority" ("Brisk Pace in Museums," *New York Times,* 17 May 1936).

27. Putzel took over Feitelson's gallery in 1936 and there showed Ernst, Klee, Miró, and Tanguy (Lader, "Howard Putzel," p. 86). Lader also notes that in the 1940s Putzel helped curate displays for Onslow Ford's New School of Social Research lectures and for a time directed Peggy Guggenheim's Art of This Century Gallery (pp. 87–89).

28. Levy, *Memoir of an Art Gallery,* pp. 256–58.

29. Barbara and James Byrnes, interview with author, 12 March 1977; Grace Clements, "No. 6727 1/2," *California Arts and Architecture* 60 (February 1943): 26–27; "A Guide to the Galleries," *Artforum* 2 (Summer 1964): 76. Felix Landau, Esther Robles, and James Vigeveno were other important modernist dealers during these years.

30. Of the artists in *Pacific Dreams,* Mullican, Feitelson, Lundeberg, and Eugene Berman appeared in this show.

31. I am grateful to James and Barbara Byrnes for sharing their insights with me. For a rich account of this era, see James Byrnes, interviewed by George M. Goodwin, "Los Angeles Art Community: James Byrnes," Oral History Program, University of California, Los Angeles, 1977.

32. Copley affords a sparkling account of his entrepreneurship in "Portrait of the Artist as a Young Dealer," in *CPLY: Reflection of a Past Life,* exh. cat. (Houston, Tex.: Rice Museum, Institute for the Arts, Rice University, 1979); originally published in French translation in *Paris-New York,* exh. cat. (Paris: Centre Georges Pompidou, 1977).

33. Ibid., pp. 18, 21, 23–24, 29–32.

34. Arthur Millier, "Los Angeles Events," *Art Digest* 23 (1 February 1949): 8; idem, "Los Angeles Events," *Art Digest* 23 (15 March 1949): 6.

35. Copley, "Portrait of the Artist," p. 35.

36. At the time of his death, Lewin's estate contained works by Carrington, Delvaux, Duchamp, Ernst, Matta, Alice Rahon, Tanguy, and Tanning. A one-time English teacher and theater critic, Lewin entered the movie industry in the 1920s, working with Irving Thalberg at MGM, where he produced such classics as *Mutiny on the Bounty* (1935) and *The Good Earth* (1937). See *The Albert Lewin Collection of Primitive and Folk Art, Modern Paintings, and Drawings,* sale cat. (New York: Parke-Bernet Galleries, 1968).

37. See Harriet Janis, "Artists in Competition," *Arts and Architecture* 63 (April 1946): 54.

38. J. H. Matthews, *Surrealism and American Feature Films* (Boston: Twayne, 1979), p. 131.

39. Naomi Sawelson-Gorse offers an excellent discussion of this extraordinary couple, who relocated to Los Angeles in the 1920s, in "Hollywood Conversations: Duchamp and the Arensbergs," in *West Coast Duchamp,* exh. cat. (Miami Beach, Fla.: Grassfield Press in association with Shoshana Wayne Gallery, Santa Monica, Calif., 1991), pp. 24–45.

40. Jo Gibbs, "Arensberg Gives Collection to California," *Art Digest* 19 (1 December 1944): 7.

41. *The Louise and Walter Arensberg Collection, 20th Century Section* (Philadelphia: Philadelphia Museum of Art, 1954). In 1944 the Arensbergs announced that they would leave their holdings to the University of California at Los Angeles, which, in return, was to house the bequest in a new structure. Negotiations collapsed three years later when UCLA did not come forth with a building acceptable to the couple (Les Wagner, "UCLA Dilly-Dallying Deprives L.A. of Great Modern Art Collection," *The Mirror* [Los Angeles], 17 January 1951). Their works went to Philadelphia in 1954, shortly after their deaths.

42. *Modern Artists in Transition,* Modern Institute of Art, Beverly Hills, Calif., 13 February–28 March 1948. Kenneth Ross served as the institute's director, Kenneth MacGowan as president, and Vincent Price as vice president; see Arthur Millier, "Los Angeles Events," *Art Digest* 22 (15 February 1948): 18.

43. *Schools of Twentieth-Century Art,* Modern Institute of Art, 22 April–30 May 1948.

44. *Knud Merrild,* Modern Institute of Art, 2 June–4 July 1948; "The Historical Sequence of Art," *Arts and Architecture* 66 (January 1949): 36–37; Arthur Millier, "Los Angeles Events," *Art Digest* 23 (15 March 1949): 6.

45. Arthur Millier, "Los Angeles Events," *Art Digest* 23 (15 April 1949): 23; Kenneth Ross, "Modern Institute of Art, *Arts and Architecture* 66 (May 1949): 26–27.

46. Lader, "Howard Putzel"; "Surrealism," *Art Digest* 9 (15 October 1934): 17.

47. I am indebted to Katherine Church Holland's excellent introduction to *San Francisco Museum of Modern Art: The Painting and Sculpture Collection* (New York: Hudson Hills Press in association with the San Francisco Museum of Modern Art, 1985), pp. 14–38.

48. Ibid., pp. 15–22; idem, *Resource/Reservoir: From the Collection: The Gifts of Jermayne MacAgy,* exh. brochure (San Francisco: San Francisco Museum of Modern Art, 1983), p. 3.

49. Holland, *San Francisco Museum of Modern Art,* p. 21.

50. Ibid; *Resource/Reservoir,* p. 3.

51. Holland, *San Francisco Museum of Modern Art,* p. 21; Holland, *Resource/Reservoir,* p. 3.

52. Frank Stauffacher, ed., *Art in Cinema: A Symposium on the Avant-Garde Film* (San Francisco: Art in Cinema Society, San Francisco Museum of Art, 1947; reprint, New York: Arno Editions, 1968). This series included *Un chien andalou* by Luis Buñuel and Dali; *Entr'acte* by René Clair; *Emak Bakia* and *L'étoile de mer* by Man Ray; *Anemic Cinema* by Marcel Duchamp (with Man Ray's assistance); *The Blood of the Poet* by Jean Cocteau; *Meshes of the Afternoon* by Maya Deren; *Dreams That Money Can Buy* by Hans Richter; and *The Potted Psalm,* just completed by Sidney Peterson and James Broughton at the California School of Fine Arts.

53. Holland, *Resource/Reservoir,* p. 2; Dominique de Menil, *Jermayne MacAgy: A Life Illustrated by an Exhibition,* exh. cat. (Houston, Tex.: University of St. Thomas, 1968).

54. De Menil, *Jermayne MacAgy,* pp. 14–16. MacAgy's eclecticism extended to her own collection, which contained objects from the Americas and the South Seas and modernist works by Brauner, Cornell, Ernst, Charles Howard, Miró, Matta, Rothko, and Still.

55. Holland states that these annuals were held from 1946 to 1952 (*Resource/Reservoir,* p. 3).

56. Mary Fuller McChesney, in the appendix to *A Period of Exploration: San Francisco, 1945–1950,* exh. cat. (Oakland: Oakland Museum, 1973), lists faculty and visiting lecturers at the school between 1945 and 1950.

57. Thomas Albright, *Art in the San Francisco Bay Area, 1945–1980* (Berkeley and Los Angeles: University of California Press, 1985), p. 28. For a detailed account of Still's art and influence in the Bay Area in the 1940s, see ibid., pp. 15–55, and Susan Landauer, "Clyfford Still and Abstract Expressionism in San Francisco," in *Clyfford Still, 1904–1980: The Buffalo and San Francisco Collections,* ed. Thomas Kellein (Munich: Prestel-Verlag, 1992), pp. 91–102.

58. As cited by McChesney in *A Period of Exploration,* appendix.

59. Susan M. Anderson, *Pursuit of the Marvelous: Stanley William Hayter, Charles Howard, Gordon Onslow Ford* (Laguna Beach, Calif.: Laguna Art Museum, 1990), pp. 14-24; Lee Mullican, interview with the author, 15 April 1993.

60. Dedicated to the art of California, the Oakland Museum also supported international modernism, frequently spotlighting works by the Blue Four from Galka Scheyer's collection. It has presented retrospectives for, among others, Onslow Ford (1977), the Howard family (1988), and Beatrice Wood (1990). For a history of the museum and its holdings, see *The Art of California: Selected Works from the Collection of the Oakland Museum,* ed. Christina Orr-Cahall (Oakland: Oakland Museum; San Francisco: Chronicle Books, 1984).

61. Data courtesy of Janice Capecci, the Oakland Museum.

62. Data courtesy of John Gutmann archives.

63. Albright, *Art in the San Francisco Bay Area,* pp. 12, 31.

64. Ibid., p. 44.

65. Ibid., pp. 85–86; on the beat scene, see pp. 81–109.

66. Jules Langsner, *Post-Surrealists and Other Moderns,* exh. brochure (Hollywood: Stanley Rose Gallery, 1935).

67. I am beholden to Diane Degasis Moran's pioneering, "The Painting of Lorser Feitelson," Ph.D. diss., University of Virginia, 1979, and her *Lorser Feitelson and Helen Lundeberg: A Retrospective Exhibition,* exh. cat. (San Francisco: San Francisco Museum of Modern Art; Los Angeles: UCLA Art Council, 1980).

68. Although Feitelson's *Filial Love* seems voyeuristic and hints at lesbianism, it was intended to treat the physical and emotional bonds between mother and daughter and the inspiration they provide to the artist-husband-father (Helen Lundeberg, interview with the author, 1 August 1990).

69. See Whitney Chadwick, *Women Artists and the Surrealist Movement* (Boston: Little, Brown, 1985); Mary Ann Caws, Rudolf E. Kuenzli, and Gwen Raaberg, *Surrealism and Women* (Cambridge: MIT Press, 1991); and Estella Lauter, *Women as Mythmakers: Poetry and Visual Art by Twentieth-Century Women* (Bloomington: Indiana University Press, 1984).

70. Dore Ashton, *Yes, but . . . A Critical Study of Philip Guston* (New York: Viking Press, 1976), pp. 20–21; Magdalena Dabrowski, *The Drawings of Philip Guston,* exh. cat. (New York: Museum of Modern Art, 1988), pp. 12–15; Alison de Lima Greene, "The Artist as Performer: Philip Guston's Early Work," *Arts* 63 (November 1988): 55–56; Musa Mayer, *Night Studio: A Memoir of Philip Guston by His Daughter* (New York: Alfred A. Knopf, 1988), pp. 15–17.

71. Mayer, *Night Studio,* p. 21, and as quoted in Greene, "The Artist as Performer," p. 56. The piece owes something to Luca Signorelli's frescoes in the Orvieto cathedral, which Guston is said to have admired.

72. Lehman made his professional debut in 1933 in a show with Guston at the Stanley Rose Gallery (see Arthur Millier, "Two Pairs of Painters and Some Singles Offer Shows," *Los Angeles Times,* 17 September 1933, sec. 2). In 1935, after exhibiting with the Post-Surrealists in Los Angeles and San Francisco and individually at Jake Zeitlin's bookstore, to Millier's commendation ("Young Surrealist," *Los Angeles Times,* 26 May 1935), he returned to New York, where, like Guston, Pollock, and Kadish, he established his mature career. I am indebted to Mr. Lehman for providing me with data and insights in correspondence and in telephone interviews on 14 January, 25 April, and 5 August 1993, and with material from his archives.

73. Grace Clements, "New Content—New Form," *Art Front* 11 (March 1936): 8–9.

74. Helen Lundeberg, conversation with the author, 7 June 1988; Ted LeBerthon, "Night and Day," *The News,* 27 June 1940; death certificate, County of Los Angeles Registrar-Recorder, Certification of Vital Record.

75. H. H. Arnason, *History of Modern Art,* 3d ed. (New York: Harry N. Abrams, 1986) p. 298. By 1943 the style had gained recognition in the Museum of Modern Art's exhibition *American Realists and Magic Realists.* In his introduction to the exhibition catalogue, Lincoln Kirstein cited naturalistic treatment of fantastic subjects as its identifying trait (p. 7).

76. In telephone interviews with the author on 4 and 5 August 1993, Bothwell related that the bird singing in her heart signifies her happiness with her profession.

77. Carrington often appears with hyenas and horses; Leonor Fini, with felines and sphinxes; Kahlo, with monkeys and cats; Tanning, with lemurs and dogs; and Remedios Varo, with owls and cats; see Georgiana M. M. Colvile, "Beauty and/Is the Beast: Animal Symbology in the Work of Leonora Carrington, Remedios Varo, and Leonor Fini," in *Surrealism and Women,* pp. 159-81.

78. Anonymous, "Art: San Francisco," *California Arts and Architecture* 57 (September 1940): 12.

79. *Gerrie Gutmann: Paintings and Drawings,* exh. brochure (San Francisco: M. H. de Young Memorial Museum, 1952); courtesy John Gutmann archives.

80. Soby, *After Picasso,* p. 12.

81. "Berman Demonstrates Neo-Romanticism," *Art Digest* 15 (11 March 1941): 21.

82. M.R. [Maude Riley], "Berman's Mythology," *Art Digest* 18 (1 November 1943): 7.

83. According to Meredith Etherington-Smith, beginning in 1941 and until 1948 Dali and his wife spent summers in Pebble Beach (*The Persistence of Memory: A Biography of Dali* [New York: Random House, 1993], p. 209); see also Robert Descharnes, *Salvador Dali: The Work, the Man,* trans. Eleanor R. Morse (New York: Harry N. Abrams, 1989).

84. Quoted in Arnason, *History of Modern Art,* pp. 291–92; see also Dali, "The Stinking Ass," trans. J. Bronowski, in *This Quarter* 5 (September 1932): 49–54, as quoted in Lucy Lippard, "Salvador Dali," in *Surrealists on Art*

(Englewood Cliffs, N.J.: Prentice-Hall, 1970), p. 97.

85. Salvador Dali, *An Abridged, Critical History of the Cinema* (Paris: Babaouo, 1932); quoted by Descharnes, *Salvador Dali,* p. 90. Dali again paid tribute to Hollywood in an article hailing as surrealist Cecil B. de Mille, the mustache of Adolphe Menjou, Gary Cooper, Greta Garbo, and the Marx brothers ("Surrealism in Hollywood," *Harper's Bazaar,* June 1937, pp. 68–70; reprinted as "Spectral and Surrealist Analysis of the Hollywood Heavens," in Descharnes, *Salvador Dali,* p. 156).

86. For a discussion of this project, *Giraffes on Horseback Salad,* see Etherington-Smith, *The Persistence of Memory,* p. 219, and Descharnes, *Salvador Dali,* pp. 148–59.

87. Dali's infatuation with Hollywood stars also inspired *The Face of Mae West Which May Be Used as an Apartment* (1934, Art Institute of Chicago) a metamorphic image of the actress's face in which her nostrils double as rodent holes, her eyes as picture frames, and her lips as a couch. Dali extended this visual pun into three dimensions with his *Mae West Lips Sofa.* His *Shirley Temple, the Youngest Sacred Monster of Contemporary Cinema* (1939) portrays the dimpled moppet as a red sphinx with a hairy chest and conical breasts, with a bat alighting on her head and ringed by the bones of a beast she has devoured; see Descharnes, *Salvador Dali,* pp. 173, 201, 252.

88. Arthur Millier, "The Arts: Dali Coming to Rattle His Art Skulls," *Los Angeles Times,* 7 September 1941, sec. 3. On *Spellbound,* see Ron Haver, *David O. Selznick's Hollywood* (New York: Bonanza Books, 1980), pp. 345–50, and James Bigwood, "Solving a Spellbound Puzzle," *American Cinematographer* 72 (June 1991): 35. A crucial component of the film, Dali's dream sequence opens with a scrim of eyes, a Dalian icon, which an actor cuts with scissors, recalling the opening sequence of the Dali-Buñuel film, *Un chien andalou,* in which a woman's eye is sliced with a blade. A man with a stocking over his face evokes Magritte's *The Lovers* (1928) and Man Ray's *Les mystères du château du dé* (1929) and shows curious parallels with the latter's 1940s photographs of Juliet Browner.

89. Bob Thomas, "Disney Going Long-Hair with Salvadore [*sic*] Dali's Aid," *Citizen News,* 8 April 1946.

90. John Hench, conversations with the author, 27 February 1991, 31 October 1994, and 9 November 1994.

91. Jordan R. Young, "Disney and Dali's 'Destino': A Tale of Two Visionaries," *Los Angeles Times,* 29 January 1989, Calendar section; see also Leonard Shannon, "When Disney Met Dali," *Modern Maturity* 21 (December 1978–January 1979): 50–52.

92. Etherington-Smith, *The Persistence of Memory,* p. 304.

93. "Dali, Crazy Like a Fox," *Look,* 10 June 1947, pp. 95–96, 98; Descharnes, pp. 289, 295.

94. Mortensen reproduced these works in his book *Projection Control* to illustrate elongation, multiple printing, spotting, vignetting, dodging, superimposition of negatives, and montage ([San Francisco: Camera Craft, 1934], pp. 70, 78, 84).

95. J. H. Matthews, "Ernest B. Schoedsack and Merian C. Cooper: *King Kong* (1933)," in *Surrealism and American Feature Films,* pp. 58–79. Matthews cites the film's wild illogic, simulation of dream, and "plunge" into realms of unrestrained feeling as classically surreal.

96. Made the year that Man Ray married Juliet Browner, the piece may refer to his new domestic ties, with the coin purse betokening his bride; the scissors, a cutting of former bonds; the wishbone, hope for a bright tomorrow; the bird, love and peace as well as escape; the belt, trap, and cords, familial constraints; and the keys, the mobility of a car as well as the comforts of home—along with a metaphorical heart. While these suppositions may seem presumptive, they reconcile with the artist's desire to trigger spectators' thoughts through works that invited interpretation.

97. See Man Ray, "Photography Is Not Art," pts. 1, 2, *View,* ser. 3, nos. 1, 3 (April–June, October–December 1943): 23, 77–78, 97.

98. Hans Richter, *Hans Richter,* ed. Cleve Gray (New York: Holt, Rinehart, and Winston, 1971), pp. 50–54; "Surrealist Movie: Six Ultramodern Artists

99. Man Ray, "Ruth, Roses, and Revolvers," *View,* ser. 4, no. 4 (December 1944): 120–23; reprinted in *View: Parade of the Avant-Garde: An Anthology of View Magazine (1940–1947),* ed. Charles Henri Ford (New York: Thunder's Mouth Press, [c. 1991]), pp. 112–16.

100. *Art in Cinema,* pp. 25–26.

101. For lively, informative accounts of this artist's fascinating life and art, see Francis M. Naumann, "The Other Side of Beatrice Wood," in *Intimate Appeal: The Figurative Art of Beatrice Wood,* exh. cat. (Oakland: Oakland Museum, 1989), pp. 23–41, and Beatrice Wood, *I Shock Myself: The Autobiography of Beatrice Wood,* ed. Lindsay Smith (Ojai, Calif.: Dillingham Press, 1985).

102. Terry St. John, *Clay Spohn,* exh. cat. (Oakland: Oakland Museum, 1974); David Beasley, "Life of a Painter: Clay Spohn Remembered," *Bulletin of Research in the Humanities* 86 (Summer 1983): 166–68.

103. Alfred Frankenstein, "Around the Art Galleries: The Inspiration Was War," *San Francisco Chronicle,* 22 March 1942.

104. "Fantastic War Machines to Go on Display, March 15–29," *Oakland Tribune,* 8 March 1942.

105. Mary Fuller, "Portrait: Clay Spohn," *Art in America* 51 (December 1953): 79–85.

106. John Gutmann, in interviews with Margaretta K. Mitchell, "Profile: John Gutmann," *35-MM Photography* (Winter 1977): 30; and with Nancy Stevens, "John Gutmann: Q & A," *American Photographer* 6 (May 1981): 50, 54. Excellent too is Sandra Phillips, *John Gutmann: Beyond the Document,* exh. cat. (San Francisco: San Francisco Museum of Modern Art, 1989).

107. Gutmann, interview with the author, 8 January 1993; and in Mitchell, "Profile: John Gutmann," p. 105.

108. Susan Danly points to the surrealistic aura of this piece in "Edward Weston's Gift to the Huntington Library," in *Edward Weston in Los Angeles,* exh. cat. (San Marino, Calif.: Huntington Library; Malibu, Calif.: J. Paul Getty Museum, 1987), pp. 51–52.

109. See Ernst's *The Attirement of the Bride* (Venice, Peggy Guggenheim Collection) and Dali's Dream of Venus pavilion at the 1939 New York World's Fair (Descharnes, *Salvador Dali,* p. 229).

110. Edmund Teske, interview with the author, 27 March 1991; and in *Images from Within: The Photographs of Edmund Teske* (Carmel, Calif.: Friends of Photography, 1980).

111. Jules Langsner, *Knud Merrild, 1894–1954,* exh. cat. (Los Angeles: Los Angeles County Museum of Art, 1965), p. 8.

112. Gerald Nordland, *Jeremy Anderson,* exh. cat. (San Francisco: San Francisco Museum of Art, 1966), p. 4.

113. Charles Howard, "What Concerns Me," *Magazine of Art* 39 (February 1946): 63–64.

114. Stacey Moss, *The Howards: First Family of Bay Area Modernism,* exh. cat. (Oakland: Oakland Museum, 1988), p. 45; Adaline Kent, *Autobiography: From the Notebooks and Sculpture of Adaline Kent* (Privately printed, 1958), p. 16. Moss points to this awkwardness in her discussion of the piece (ibid., pp. 49–50).

115. Kent, *Autobiography,* p. 66.

116. Nordland, *Jeremy Anderson,* p. 4.

117. Albright, *Art in the San Francisco Bay Area,* p. 148.

118. Seminal here are Henry T. Hopkins, "Visionaries," *Antiques and Fine Art* 9 (March–April 1992): 74–81; Nora Halpern and Amy Winter, *Dynaton: Before and Beyond: Works by Lee Mullican, Gordon Onslow Ford, and Wolfgang Paalen,* exh. cat. (Malibu, Calif.: Frederick R. Weisman Museum of Art, Pepperdine University, 1992); and Sylvia Fink, "The Dynation [*sic*]: Three Artists with Similar Ideas—Lee Mullican, Gordon Onslow Ford, Wolfgang Paalen," *California: Five Footnotes to Modern Art History,* ed. Stephanie Barron (Los Angeles: Los Angeles County Museum of Art, 1977), pp. 35–43.

119. Wolfgang Paalen, "Metaplastic," in *Dynaton 1951,* exh. cat. (San

Supply Dreams for New Film," *Life,* 2 December 1946, p. 86.

Francisco: San Francisco Museum of Modern Art, 1951), p. 22.

120. Lee Mullican, interviewed by Joann Phillips, "Los Angeles Art Community: Lee Mullican," Oral History Program, University of California, Los Angeles, 1977, p. 82.

121. Alfred Frankenstein, "The Local Galleries in Review," *San Francisco Chronicle,* 4 February 1951, This World section.

122. Paalen, "Metaplastic," p. 26.

123. Ibid., p. 27.

124. Ibid.

125. Wolfgang Paalen, *Wolfgang Paalen,* exh. brochure (New York: Nierendorf Gallery, New York, 1946) (artist's file, San Francisco Museum of Modern Art library).

126. See W. Jackson Rushing, "Ritual and Myth: Native American Culture and Abstract Expressionism," in *The Spiritual in Art: Abstract Painting, 1890–1985,* exh. cat. (Los Angeles: Los Angeles County Museum of Art; New York: Abbeville Press, 1986), pp. 274–75.

127. André Breton, "The Most Recent Tendencies in Surrealist Painting," in *Surrealism and Painting,* trans. Simon Watson Taylor (New York: Icon Editions, Harper and Row, 1972), pp. 145–50; originally published as "Des tendances les plus recentes de la peinture surréaliste," *Minotaure,* 3d ser., nos. 12-13 (May 1939): 16–17.

128. Gordon Onslow Ford, "The Painter Looks within Himself," *London Bulletin,* nos. 18–20 (June 1940): 30–31; also quoted in Lippard, *Surrealists on Art,* p. 177–79. See also Gordon Onslow Ford, "The Dynaton," in *Dynaton: Before and Beyond,* pp. 8–10.

129. This work and others of the time spring from an insight that the artist had in 1951, that the "root of painting was made up of Line-Circle-Dot . . . elements" (Onslow Ford, "The Dynaton," p. 10).

130. Lee Mullican, interviews with the author, 22 April 1993 and 29 April 1994, and in "Los Angeles Art Community," p. 159; see also Nan White, "Winning Painter Is Optimist," *San Francisco News,* 15 April 1950.

131. Jess, interview with the author, 18 June 1993. See also Michael Auping, *Jess: Paste-Ups (and Assemblies), 1951–1983,* exh. cat. (Sarasota, Fla.: John and Mable Ringling Museum of Art, 1983); idem, *Jess: A Grand Collage, 1951–1993,* exh. cat. (Buffalo: Albright-Knox Art Gallery, 1993); and Rebecca Solnit, *Secret Exhibition: Six California Artists of the Cold War Era* (San Francisco: City Lights Books, 1990).

132. Jess, interview with the author, January 18, 1993.

133. Ibid.

134. David Curtis, *Experimental Cinema* (New York: Universe Books, 1971), p. 131.

135. Michael Auping, "Songs of Innocence," *Art in America* 75 (January 1987): 121.

136. Anne Ayres, "Gordon Wagner," in *Forty Years of California Assemblage,* exh. cat. (Los Angeles: Wight Art Gallery, University of California, 1989), p. 220.

137. For an illuminating account of Berman's catalytic role in the region, see Anne Bartlett Ayres, "Berman and Kienholz: Progenitors of Los Angeles Assemblage," *Art in Los Angeles: Seventeen Artists in the Sixties,* exh. cat. (Los Angeles: Los Angeles County Museum of Art, 1981), pp. 11–19. Also seminal are *Wallace Berman Retrospective,* exh. cat. (Los Angeles: Otis Art Institute Gallery, 1978), p. 20; *Wallace Berman: Support the Revolution,* exh. cat. (Amsterdam: Institute of Contemporary Art, [1992]); and Merril Greene, "Wallace Berman: Portrait of the Artist as an Underground Man," *Artforum* 16 (February 1978): 53–61. Berman's underground publication, *Semina* (1955–64), served as a vital communicative organ for California's emergent vanguard.

138. The suite also included renderings of Nat King Cole, Slim Gaillard, Harry "The Hipster" Gibson, and Frank Sinatra. Greene relates that Berman admired the surrealist artists and poets whose works he saw in *View* and *VVV* and frequented the Copley Galleries in the 1940s ("Wallace Berman," pp. 54–55); see also Christopher Knight, "Instant Artifacts," in *Support the Revolution,* pp. 33–35.

139. Sandra Leonard Starr, *Lost and Found in California: Four Decades of Assemblage Art,* exh. cat. (Santa Monica, Calif.: James Corcoran Gallery, 1988), p. 64.

140. For discussions of this show, see Ayres, "Berman and Kienholz," and Solnit, *Secret Exhibition.*

141. From then until his death in 1976, Berman perfected the Verifax collages for which he is best known; see Andrea Liss, "Wallace Berman," in *L.A. Pop in the Sixties,* exh. cat. (Newport Beach, Calif.: Newport Harbor Art Museum, 1989), pp. 68–71.

142. Robert Duncan, "Wallace Berman: The Fashioning Spirit," in *Wallace Berman Retrospective,* p. 20.

143. Betty Turnbull, *The Last Time I Saw Ferus, 1957–1966,* exh. cat. (Newport Beach, Calif.: Newport Harbor Art Museum, 1976).

144. *Bay Area Figurative Painting,* organized by Paul Mills, featured Elmer Bischoff, Joan Brown, Richard Diebenkorn, Manuel Neri, Nathan Oliveira, and David Park, among others.

145. Liss, "Wallace Berman," p. 64.

146. Peter and Rose Krasnow, interview with the author, 23 January 1978.

Alternate Currents

Surreality in California Photography

TERENCE PITTS

This intimation of being nearly able to shake free of the incubus of the past and move, as by a giant step, into the future has always been widespread and deep-rooted [in California]. A potent myth, it has been responsible for the extravagant expectations, odd emanations, and almost messianic enthusiasms that many observers have noted over so many years.[1]—Carey McWilliams

In the decade immediately following the end of World War I, American art finally began to break free of the artistic weight of the Old World and take root in the American experience. The new American aesthetic tended to be precise, simple, direct, and unpretentious—a clean, well-lighted art, to paraphrase Ernest Hemingway. It was an art more visual and experiential than conceptual. Precisionism and regionalism in all their forms had their roots in Puritan America, the pioneering spirit of the frontier, in the works of the Mexican muralists, and even in Native American traditions. When European movements such as cubism, dada, and surrealism cast their artistic challenges across the Atlantic, they found a somewhat unreceptive audience. The American mainstream was headed elsewhere for the moment.

The same was true of American photography in the postwar years, but the situation was complicated by the fact that for decades photographers had been attempting to get photography widespread recognition as a serious art form. During the dominance of pictorialism, roughly from the 1890s until well into the 1920s, one of their strategic aesthetic struggles had been against a purely optical realism. A central pictorialist argument was that a "straight," or unmanipulated, print made from a straight negative did not seem to require enough artistic intervention to constitute genuine art. As Robert Demachy wrote in *Camera Work* magazine in 1907, "A work of art must be a transcription, not a copy, of nature." He allowed that "a straight print may be beautiful, and it may prove

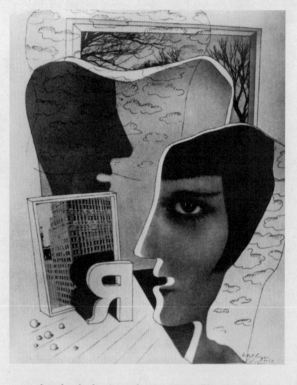

superabundantly that its author is an artist," but, he went on, "it cannot be a work of art."[2]

By the 1920s the authority of pictorialism, which had borrowed heavily from the tradition of academic painting, was beginning to unravel under pressure from a new generation of photographers who were advocating a photography purified of the taint of any other art medium. The mechanical and optical nature of photography and its claim on a particular type of truth and realism became rallying points for the new modernist photography. The "art" in a purist photograph was to be found not in any obvious manipulation of subject or print, but in the truthfulness of the thought or expression conveyed through purely photographic means. As Alfred Stieglitz put it, discussing the remarkable series of cloud photographs that he made around 1922, he intended "through [making photographs of] clouds to put down my philosophy of life."[3]

Throughout the 1920s purist rhetoric reflected a certain antipathy toward any experimentation that might hinder the purification of the medium. Furthermore the purist appeal for a simple and honest photography emphasized the characteristics that were identified as intrinsic to a specifically American aesthetic. This provided little encouragement for any photographer who sought to employ techniques forbidden by the purist dictum, such as combination printing, or who wished to explore pure abstraction or themes such as the unconscious and the imagination. For America's most serious surrealist photographer and artist, Man Ray, the only solution was self-imposed exile in Paris, where he settled in 1921.

In spite of this, a few important, albeit isolated, bodies of experimental photography were produced in this country before the 1930s. Between 1916 and 1919 Paul Strand, a member of Stieglitz's circle who was well aware of cubism and other developments in modern painting, made a number of cubist-inspired images in which his camera turned the visible world into nearly pure abstractions through the compression of space, radical cropping, and unusual perspectives. In 1920 and 1921, at the height of his involvement as a pictorialist, California photographer Edward Weston too adapted aspects of cubism to produce a striking series of photographs that set the heads and figures of friends against the bold, angular lines and varying gray planes of the walls and ceiling of an attic. And probably the earliest American photographs made under the influence of surrealism are some of Walker Evans's very first images, made in 1928 and 1929 after a trip to Paris in 1926. Evans seemed to understand intuitively that surrealism was just as accessible to the camera as was realism. His poetic photographs of New York, with their suggestive juxtapositions and unorthodox camera angles, evoke Eugène Atget's tender yet hauntingly surreal images of Paris.

It wasn't until the 1930s that photography's experimental potential was fully unleashed in America. An increasing number of exhibitions and publications on surrealism appeared, and a growing influx of European artists and photographers brought contemporary European sensibilities to our shores. Atget's work was first shown in New York in 1930. The first broad selection of European surrealist art was exhibited in 1931 at Hartford's Wadsworth Atheneum, followed by *Surréalisme* at New York's Julien Levy Gallery in 1932, a show that *The Art News* described as "a pleasant madness."[4] Included in this exhibition were images by Herbert Bayer (see fig. 15), László Moholy-Nagy, Roger Parry, Maurice Tabard, Umbo, and other significant European avant-garde photographers.

If it took a little longer for examples of this pleasant madness to be seen on the West Coast, usually in the pages of little magazines such as *Transition*, California nevertheless nurtured its share of experimental photographers and radical new styles. Unfortunately the history of photography has tended to overlook this aspect of California photography in the wake of the overwhelming success of the purist style of Ansel Adams, Brett Weston, and others. Part of the goal of the present exhibition is to redress this imbalance and focus attention anew on the strong tradition of experimental and highly individualistic photography that has existed in California since the early 1930s.

History and geography have made the state a laboratory where the new and the old come together, often with dynamic

Fig. 16
Brett Weston
(American, 1911–1993)
Cactus, California, 1935
Gelatin silver print
$9^5/8$ x $5^3/8$ in. (24.4 x 13.5 cm)
Center for Creative Photography,
the University of Arizona, Tucson

results. Isolated by mountains, deserts, great distances, and an ocean, Californians have tended to create much of their culture anew, using a vibrant mix of ingredients. Ironically it can be argued that California's physical and intellectual isolation contributed to the creation of new and distinct species of American photography. There were certain advantages to being far from Europe and Manhattan. Traditions could be more easily overthrown, and new influences from Asia and postrevolutionary Mexico could have an impact.

It was against this backdrop that California photography finally began to come into its own roughly between 1927 and 1932. Edward Weston returned from a lengthy stay in Mexico to have his first New York gallery exhibition and to publish his first book, *The Art of Edward Weston*. Ansel Adams gave up a promising career as a pianist to devote himself to photography, publishing his first portfolio and a book of photographs on Taos Pueblo. And Imogen Cunningham had solo exhibitions at both the Los Angeles County Museum of History, Science, and Art and San Francisco's M. H. de Young Memorial Museum.

On November 15, 1932, an exhibition opened at the M. H. de Young Memorial Museum which defined the mainstream of California photography for subsequent decades: *Group F.64*. The informal group consisted of eleven men and women, including Adams, Cunningham, and Edward Weston and his son Brett (see fig. 16). The photographs in the exhibition defined a now-familiar California iconography: landscapes, plants, rocks, bones, details of nature, some portraits, shipyards, and a variety of close-ups of mechanical and industrial subjects. A manifesto issued at the time of the exhibition contrasted the group's purism with the pictorialists' "devotion to principles of art which are directly related to painting and the graphic arts" and delineated the bond that drew these photographers together: "The members of Group F.64 believe that Photography, as an art-form, must develop along lines defined by the actualities and limitations of the photographic medium, and must always remain independent of ideological conventions of art and aesthetics that are reminiscent of a period and culture antedating the growth of the medium itself."[5]

In addition to its by now familiar iteration of a purist definition of photography, the Group F.64 manifesto also claimed a revolutionary break from the aesthetic conventions of the prephotographic world, which presumably meant repudiating narrative, symbolism, historical reference, and the rest of the premodernist canon. Pure photography, by contrast, was an art rooted in vision and light. As Edward Weston put it: "to photograph a rock [and] have it look like a rock, but be more than a rock. Significant representation—not interpretation."[6] The new California purists, perhaps even more

stridently than their fellow photographers elsewhere in the United States, had set out to purify subject matter as well as technique.

The Group F.64 exhibition exacerbated the battle being waged between increasingly vocal purists and the last generation of pictorialists. When this erupted into the pages of photography magazines such as *Camera Craft*, it created the impression of a completely polarized photography community. In fact things were not so black and white. At the same time that purist photographers across America were emphasizing the limitations of the medium, others were pushing those limits to new extremes and breaking every rule they could. Unfortunately the conventional history of the past half century has told us merely that the purists triumphed, overlooking the extraordinary number of photographers who did not fit into either camp.

The Bay Area was California's artistic capital until, arguably, the 1960s. As poet Kenneth Rexroth remarked, San Francisco was the only city in the United States not settled by "westward-spreading puritanism."[7] The city's long-standing hospitality to culture and to bohemianism, coupled with the presence of the University of California, Berkeley, just across the bay and the artists' colony of Carmel just south along the coast, created a lively support network of active museums, galleries, newspaper reviews and criticism, and much more. For example, every artist in Group F.64 lived in the Bay Area, except for Sonya Noskowiak, Edward Weston, and Brett Weston, all of whom would move there in 1935 and 1936.

Perhaps in part because of this clear dominance of the purist aesthetic in the Bay Area, even the more surrealistic or psychological trends in photography there in the 1930s and 1940s stayed within the realm of the unmanipulated, straight photograph. Experimentation was confined to the areas of image selection and formation and did not enter the domain of the darkroom.

Both John Gutmann, a German artist who fled his country in 1933, and Rose Mandel, a Polish-born émigré who entered this country in 1942, brought European sensibilities and training to their photography. Their work reflects the attitude that luck and chance provide new insights and visions to those who are receptive. Like Atget and Evans, Gutmann and Mandel seemed to realize that photography's inherently documentary nature made it all the more receptive to exploiting the potential of the surreal.

Throughout his career of more than a half century, Gutmann has felt free to work in a variety of styles, sometimes responding with a photojournalist's quick, intuitive eye, sometimes posing everything in the image. At the heart of every Gutmann image is a profound visual or psychological

Fig. 17
Edward Weston
(American, 1886–1958)
Cement Worker's Glove, 1936
Gelatin silver print
7¹/₂ x 9¹/₂ in. (19.1 x 24.2 cm)
Center for Creative Photography,
the University of Arizona, Tucson

Fig. 18
William Mortensen
(American, 1897–1965)
Venus and Vulcan
Bromoil transfer
13 x 11¹/₈ in. (33.0 x 28.3 cm)
Center for Creative Photography,
the University of Arizona, Tucson

mystery. Embedded within his depiction of a developing American idiom of automobiles and jazz, of ethnicity and capitalist kitsch, of violence and eroticism, he has brought to the surface deep-rooted existential issues and often contradictory life forces. In photographs such as *Death Stalks Fillmore* (1934; cat. no. 44) and *Double Portrait* (1938; cat. no. 46), there is an almost Hitchcockian sense of terror in the way that evil seems to emerge from the everyday.

Although her work, like Gutmann's, draws upon the world around her, Mandel worked within a more classical surrealist iconography. A student of both Ansel Adams and Minor White, she had also studied child psychology under Jean Piaget in Europe. On Walls and behind Glass (1947–48; see cat. nos. 83–85), her series of unmanipulated single-exposure images of odd reflections and unexpected juxtapositions—with its recurring use of eyes, hands, and clocks as objects of deep psychological resonance—is clearly heir to the tradition of Atget, Bayer, Salvador Dali, and other European surrealists.

In contrast Minor White was developing an idiom that was both more personal and more universal, less dependent on European art. During the years that he taught at the California School of Fine Arts in San Francisco, as the successor to Ansel Adams, White was constructing a spiritual and emotional vocabulary through photography, based upon personal symbols and his interests in Zen Buddhism, the teachings of G. I. Gurdjieff, and Gestalt psychology among other things. Expanding Stieglitz's notion of the "equivalent," in which pictures become external equivalents for the inner workings of the human spirit and mind, White used photography to probe his deepest emotions and his troubled sexual identity.

In his autobiography Adams noted that White was "just the right foil for the slightly Calvinistic philosophy of the Group f/64 school that my friends and I professed."[8] One of the group's basic purist tenets was to resist any attempt to interpret their work, especially in the personal, psychological manner of White. Nevertheless the work of Edward Weston is especially susceptible to just such an interpretation and offers flashes of humor and fantasy more often than is acknowledged. Although he denied any surrealistic intent in images such as his 1942 photographs of a nude wearing a gas mask, *Civilian Defense* and *Civilian Defense II* (cat. nos. 132, 133), he tended to push the limits of reality more often in his work than most historians have been willing to acknowledge. In photographs such as *Model for Mould* (1936), which depicts an Arp-like piece of wood pulled from the garbage; *Cement Worker's Glove* (1936; fig. 17); and *Shoe, Moonstone Beach* (1937; cat. no. 129), which shows a discarded woman's

shoe next to a Van Camps bean can, Weston elevated evocative bits of trash and found objects to the larger-than-life status that he usually reserved for the human body, vegetables, shells, and rocks.

In comparison to the Bay Area, with its well-established artistic community and traditions, Los Angeles was backward and less hospitable to artists during the first half of this century. Walking around the streets of Los Angeles in 1925, Edward Weston, who lived there between 1906 and 1938, asked himself: "Who were all these drab grey people! . . . What I saw was a parade of Christian Scientists, Angeles Templeites, Movie Stars, Arty people, and Iowa Farmers."[9] Carey McWilliams, one of his state's most astute observers, described the city as "the most priggish community in America after 1900."[10] And Man Ray, who lived in Hollywood from 1940 to 1951, claimed that "New York was always twenty years behind Paris in its appreciation of contemporary art, and California was twenty years behind New York."[11]

Los Angeles's most coherent and visible artistic community was centered around the film industry. Since the early part of the century, Hollywood had been churning fictions and dreams out of the most veristic medium humankind had ever known. And Hollywood, both as an employer and as the source of a new aesthetic, attracted a number of photographers. Some of the basic elements of cinematography could be easily applied to still photography to powerful advantage, especially if one didn't worry too much about the purity of the medium. Narrative, montage, the staging of fictional or historical events, theatrical lighting—everything that photography critic A. D. Coleman was referring to when he coined the phrase "directorial mode"—could all be used to great effect in still photography. And so it is not surprising that multiple printing and other experimental darkroom techniques were far more prevalent in Southern California than in the north.

As someone who had worked extensively in the film industry (notably with Cecil B. DeMille), William Mortensen used the theatrical potential of the studio and the reconstructive possibilities of the darkroom to create a highly distinctive, if sometimes uneasy, cross-breeding of traditional pictorial photography and Hollywood magic (see fig. 18 and cat. nos. 92–95). Looking back from our era of digital photography and the completely constructed photographic works of artists such as Cindy Sherman (see fig. 19) and MANUAL (Suzanne Bloom and Edward Hill), Mortensen's fictions seem prophetic, even if the subject matter is sometimes hokey and strained. Like a cinematographer or novelist, he created fictions in the service of truth (albeit a "truth" greatly belittled by purists), and he felt free to use archetypes, history, art

history, myth, and (some would say) a liberal dose of stereotyping to conjure up pointed visual representations of war and the human condition.

Where Mortensen saw himself as continuing the pictorialist tradition, most other Southern California photographers used pictorialist elements selectively in their work without feeling compelled to carry all the baggage of the pictorialist heritage. For example, Will Connell, a Hollywood hand with a background in commercial photography, wielded the various elements of photography and cinematography as tools rather than ends in themselves (see fig. 20). His 1937 book *In Pictures* makes exaggerated use of dramatic lighting and close-ups both to parody and to pay homage to Hollywood film (see cat. nos. 24–27). He wove a satirically humorous exposé of Hollywood through alternating pages of text and photographs, most of which were produced through the combination printing of multiple negatives. As Tom Maloney notes in the book's introduction, "Connell shows how wide the abilities of the camera are when a thorough technician, a penetrating mind, and the all important satirical impulse are blended in one talent capable of dissecting a national institution with its own instruments of torture."[12]

Edmund Teske is another Los Angeles artist who used combination printing of multiple negatives, but his dark and densely psychological images demonstrate just how different the technique can be in different hands (see cat. nos. 121–24). Unlike Connell's seamlessly melded and sharply focused images, Teske's are layered one on top of another, suggesting the ways in which memory is simultaneously revelatory and obscuring. Teske, who had worked in the theater and in the Paramount studios stills department, became a photographic associate at Frank Lloyd Wright's Taliesen and Taliesen West studios. A melancholy yet heroic portraiture figures strongly in his work, resonating with his interest in spirituality and Hinduism.

Ruth Bernhard has created her own world of images, not through printing techniques, but by photographing nudes in the studio and assembling tableaux specifically for the camera. A strong admirer of Edward Weston and his work, the German-born Bernhard describes her own methodology as highly intuitive: images appear to her and demand to be made. Objects such as dolls, bones, and shells take on an extraordinarily personal significance in her photographs. Carefully observed and marvelously lit surfaces become highly sensual. Like Gutmann's two 1951 photographs that include dolls (cat. nos. 48, 49), Bernhard's photographs derive much of their psychological tension from the juxtaposition of the benign and the threatening: a mannequin's hand holds a detached doll's head, two blank-faced dolls stare at and caress

a dead sparrow (see cat. nos. 13, 15). In Gutmann's works the empty-headed appearance of the "Father Doll" gives him a distinct aura of malevolence. In the dreamlike images Bernhard has created with dolls, however, the source of our unease is less precise and therefore more puzzling.

Even though Edward Weston moved from the Los Angeles area to Northern California in 1938, some of the work in which he demonstrates his most sustained flights of fancy was made during return trips to Los Angeles and Hollywood. In 1939, the year that saw the publication of Nathanael West's biting satire of Hollywood, *The Day of the Locust,* Weston made the first of two trips to photograph the MGM and 20th Century Fox studios, where he found a territory of pure artifice. He clearly enjoyed the irony of photographing a world produced purely for the lens of the movie camera, but rather than offering any social or artistic critique of Hollywood, his photographs of these facades tease our belief in the realism of filmed and photographed images (see cat. nos. 130, 131).

The work of Man Ray won little admiration from Weston, who felt that it suggested too much "striving" and "sweat" to create an effect.[13] But there was no doubt in the 1930s and 1940s that Man Ray was America's best-known surrealist. He returned from Paris to New York in 1940, at the outset of World War II, and landed in Hollywood less than two months later on a fluke, staying a decade. Although he worked prodigiously during these years, he made only transitory connections with the Los Angeles art community, preferring instead a small, close group of friends and the burgeoning jazz scene there. In his photographs from this period one can see the basic elements of his innovative approach to surrealism and how his photography was inflected by his painting and object making. Through combination printing and solarization Man Ray could transform not only reality but the whole concept of line or edge in photography as well. Works such as *Juliet with Crocheted Headdress* (1945; cat. no. 111) and *Ruth, Roses, and Revolvers* (1940–49; cat. no. 106) demonstrate his ability to create a symbiosis between photography and sculpture or assemblage.

By the beginning of the Cold War, California photography had come of age. In the course of a generation or so it had not only produced one hugely influential school of photography in Group F.64 and its followers but had also nurtured many other photographers, including those represented in this exhibition. Photography meant something profoundly different to each of these artists, but all (except perhaps for Mortensen) shared a common feeling that the medium had broken away from an aging, if not obsolete, tradition and was finally free to drift wherever the human mind could take it.

Notes

1. Carey McWilliams, *The California Revolution* (New York: Grossman, 1968), p. 2.

2. Robert Demachy, "On the Straight Print," *Camera Work* 19 (1907); reprinted in Nathan Lyons, ed., *Photographers on Photography* (Englewood Cliffs, N.J.: Prentice-Hall, 1966), pp. 56–57.

3. Alfred Stieglitz, "How I Came to Photograph Clouds," *The Amateur Photographer and Photography* 56 (1923); reprinted in Lyons, *Photographers on Photography,* p. 112.

4. David Travis, *Photographs from the Julien Levy Collection Starting with Atget* (Chicago: Art Institute of Chicago, 1976), p. 16.

5. "Group F.64 Manifesto, 1932," reprinted in Therese Thau Heyman, ed., *Seeing Straight: The f.64 Revolution in Photography,* exh. cat. (Oakland: Oakland Museum, 1992), p. 53.

6. Edward Weston, "Statement, 1930"; reprinted in Heyman, *Seeing Straight,* p. 52.

7. Quoted in Rebecca Solnit, *Secret Exhibition: Six California Artists of the Cold War Era* (San Francisco: City Lights Books, 1990), p. 26.

8. Ansel Adams, *An Autobiography* (Boston: New York Graphic Society, 1985), p. 320.

9. Edward Weston, *The Daybooks of Edward Weston,* vol. 1, *Mexico* (Millerton, N.Y.: Aperture, 1973), p. 113.

10. Carey McWilliams, *Southern California Country* (New York: Duell, Sloan and Pearce, 1946), p. 157.

11. Neil Baldwin, *Man Ray: American Artist* (New York: Clarkson N. Potter, 1988), p. 245.

12. Tom Maloney, "Will Connell," in Will Connell, *In Pictures* (New York: T. J. Maloney, 1937), p. 7.

13. Edward Weston, *The Daybooks of Edward Weston,* vol. 1, p. 69. In 1932 a critic described Weston as "of the Man Ray school," which occasioned a strong denial (*The Daybooks of Edward Weston,* vol. 2, *California,* p. 278).

Surrealism and California Experimental Cinema

Spellbound

LUCY FISCHER

A "Big Toe in Surrealism"

The cinema was for us an immense discovery at the moment when we were elaborating surrealism.[1]

As we learn in *The Shadow and Its Shadow,* Paul Hammond's collection of surrealist writings on the cinema, the French avant-garde of the 1920s was intrigued and excited by the artistic potential of film. Surrealist artists continually declared their love of commercial movies, be they the mysterious *Fantômas* serials; the raucous comedies of Charlie Chaplin, Mack Sennett, or Buster Keaton; the marvelous "trick films" of Georges Méliès; or the sentimental melodramas of Frank Borzage.[2]

The artists spoke as well of their subversive methods of film viewing. André Breton bragged: "When I was 'at the cinema age' ... I never began by consulting the amusements page to know what film seemed likely to be the best. Nor did I inquire about the time when the film began. I ... appreciat[ed] nothing so much as dropping in at a movie house when what was playing was playing, at any point in the show."[3] Likewise, Man Ray described an eccentric mode of spectatorship: "I invented a system of prisms which I glued on my glasses; thus I could see black-and-white films which bored me in color and as abstract images."[4]

In addition to creatively "decomposing" established modes of cinema, the surrealists engaged in their own experimental filmmaking. Luis Buñuel and Salvador Dali collaborated on *Un chien andalou* (1928) and *L'âge d'or* (1930); Man Ray directed *L'étoile de mer* (1928), for which Robert Desnos wrote the poem that appears in the intertitles; and Germaine Dulac and Antonin Artaud created *La coquille et le clergyman* (1928). While for many critics these constitute the only bona fide examples of surrealism in film,[5] others take a broader view. Steven Kovacs wrote:

Fig. 21
Maya Deren in a scene from her
Meshes of the Afternoon (1943)

The heritage of Surrealism cannot be measured by looking for its traces among so many motion pictures. The movement has had too great an impact on our culture for us to be able to account for it by enumerating so many films, directors, or scenes that are surrealistic in inspiration. *In the acceptance and diffusion of the goals of the movement the very notion of Surrealism has undergone a transformation. . . .* Thus, our understanding of the term is related to, but certainly not identical with the movement which appropriated it.[6]

One of the major historical "transformations" of surrealism took place in the United States during the 1940s with the birth of the New American Cinema, a movement based on experimental filmmaking. In writing about *Meshes of the Afternoon* (1943; see fig. 21), one of the first such works, P. Adams Sitney promptly referred to surrealism, noting: "The collaboration of Maya Deren and Alexander Hamid shortly after their marriage in 1942 recalls in its broad aspiration the earlier collaboration of Salvador Dali and Luis Buñuel on *Un Chien Andalou*."[7]

Sitney was not the only critic to make this transatlantic leap. As Rudolph E. Kuenzli noted: "Interest in Dada and Surrealist cinema has been primarily kept alive by experimental filmmakers in America and Europe after 1945. They have found a cinematic vocabulary in these early films as well as useful strategies for their own practice of anti-commercial, art/anti-art cinema."[8]

While this generalization holds true for New American Cinema as a whole, it applies especially to a group of works created in California in the first two decades of the movement. In speaking of his tutelage with filmmaker Sidney Peterson at the California School of Fine Arts, Stan Brakhage remarked: "San Francisco did have a little bit of a toe . . . in Europe; and Sidney, as so many people living in California at

that time, did have his *big toe in Surrealism.* . . . Look at the famous *Andalusian Dog,* by Bunuel and Dali; and then look at [Peterson's] *The Potted Psalm*."[9] No doubt this international connection was facilitated by the famous Art in Cinema series of screenings organized by Frank Stauffacher at the San Francisco Museum of Art (1946–51).

Though influenced by the European avant-garde, *Meshes of the Afternoon* opens with the title "Hollywood 1943," an emphatic marker of its place within American cultural history.

The Dream Factory

I should like a film director to take a fancy to this idea. In the morning after a nightmare, let him note exactly all he remembers and let him reconstruct it with exact care. It would no longer be a matter of logic, of classic construction, or of flattering the incomprehension of the public, but of things seen, of a higher reality, since it opens a new domain to poetry and to dreaming.[10]

One of the major ways in which the New American Cinema invoked surrealism was through its interest in representing states of consciousness, especially dreams. As Maya Deren wrote of *Meshes of the Afternoon,* the film "reproduces the way in which the sub-conscious of an individual will develop, interpret and elaborate an apparently simple and casual incident into a critical emotional experience."[11]

Various aspects of the work proclaim its psychodramatic status. In a signal moment the heroine (Deren) is seated by a window. The camera (shooting through a narrow cylinder) pulls backward, as though sucked into the interstices of her mind. Her world lacks all sense of reality; outside she sees her "double." (Later she will encounter a pair of selves at the dining room table).

Persons and objects are invested with symbolic meaning: she pursues a black-hooded figure with a mirrored face, seemingly an agent of death. In this oneiric world events unfold in magical fashion: a key is produced from her mouth; a knife tumbles from a loaf of bread; later it reappears on the stairs and in her bed.

Logic and causality are torn asunder: though the heroine turns a phonograph off, the next time she passes it, the turntable is spinning. The atmosphere is fraught with menace. One of Deren's doubles lowers a knife to her throat as she sleeps, then seems instantly transformed into a man (Hamid). Later in the couple's bedroom she retaliates, aiming the knife at his face, which is suddenly transformed into a shattered mirror, in whose fragments we glimpse the ocean. Obviously this image has all the paradoxical complexity of a

Fig. 22
Jess in a scene from Stan
Brakhage's *In Between* (1955)

painting such as René Magritte's *Les promenades d'Euclide.* In the film's concluding sequence we are presented with a shot of the Pacific Ocean followed by one of Deren dead in a chair, her throat slit, her body draped with seaweed.

In its themes of sex, dreams, and violence one finds evidence of surrealist concerns. One also senses the atmosphere of such film noir as Alfred Hitchcock's *Shadow of a Doubt* (1943), Billy Wilder's *Double Indemnity* (1944), or John Brahm's *Guest in the House* (1944). It is also reminiscent of such gothics as Hitchcock's *Rebecca* (1941).[12]

Several filmmakers followed Deren in the creation of a somnambulistic cinema, later deemed the "trance film." Their prototype was Jean Cocteau's *Le sang d'un poète* (1932), in which the hero wanders through a bizarre "hotel," opening doors onto a variety of curious tableaux. In 1946, for example, Curtis Harrington made the trance film *Fragment of Seeking,* in which "a young man pursues an elusive blonde girl through a maze of corridors reminiscent of Maya Deren's pursuit of the mirror-faced figure in *Meshes of the Afternoon,* only to discover in the end that she is a skeleton with a wig."[13]

In 1954 Stan Brakhage (who had earlier admitted his debt to Cocteau)[14] shot *The Way to Shadow Garden* (1954) in San Francisco. Like *Meshes,* it concerns an individual's apparent psychic breakdown upon entering a mysterious house (one owned by filmmaker James Broughton and rented by poet Robert Duncan).[15] Once more, as its protagonist (Walt Newcomb) stands beneath a naked lightbulb, the work evokes film noir. When the anguished hero pokes his fingers into his eyes, causing blood to gush, he reminds us of the blood-stained visage of the Man (Gaston Modot) in *L'âge d'or.* As Deren did in *Meshes,* Brakhage experimented with optical effects to create a surreal ambience; when the man finally emerges from the haunted domicile, he is recorded in negative imagery, giving the scene an ethereal aura. This otherworldly mood is enhanced by the sound track, with its wind, moans, and screeches.

The following year, 1955, Brakhage made *In Between* at the same location. Several other artists were also involved in the project: Duncan and the artist Jess (see fig. 22) acted in the drama, and John Cage contributed the musical score. Again the film involves a man entering a residence, one that seems to represent his psyche. Once more the protagonist seems tortured, reminding us of Desnos's call for "films that come up to our torment."[16] Reading in bed, the hero is transported to an outdoor space filled with imposing classical columns. (As Max Ernst once noted, surrealists "move about in the borderland between the internal and external worlds."[17]) The protagonist meanders among the columns as the camera pans vertiginously, catching glimpses of his feet

among the shadows. (The rapid camera movements bring to mind Breton's claim that what the surrealists valued most in film "was its *power to disorient.*")[18] In many respects the film's architectural setting, with its stark, high-contrast lighting, reminds us of the terrain in a Giorgio de Chirico canvas. Certain images seem to have been borrowed from the work of Deren: a scene in which Brakhage's hero seems to crash into walls (as if the world had suddenly tilted) evokes Deren's heroine's unsteady struggle up the stairway in *Meshes;* when he seems to bound from interior to exterior space, one cannot help but think of the jeté in her film *A Study in Choreography for Camera* (1945).

"To Taboo Reality"

To taboo reality—modern civilization has long considered that a crime against mankind, against human society. . . . The film camera has for one of its most neglected functions that of invading and recording realms which have to some degree remained taboo—too private, too shocking, too immoral for photographic reproduction.[19]

Kenneth Anger's *Fireworks* (1947) is another example of the trance film genre, but it is especially noteworthy for having heightened the theme of sexuality, implicit in the work of Deren and Brakhage. (Brakhage's final California trance film, *Flesh of Morning* [1956], was in fact a "masturbation fantasy.")[20] Clearly sexuality also fascinated the surrealists. As Desnos remarked: "One of the most admirable factors of the cinema and one of the causes of hate felt for it by imbeciles is its eroticism."[21] While the surrealists valorized heterosexual relations, Anger depicted homosexual liaisons, certainly a taboo topic in America of the late 1940s. (Homosexuality was also a theme in Harrington's *Fragment of Seeking,* which was shown along with *Fireworks* in San Francisco as part of Art in Cinema, and a motif in Gregory Markopoulos's trilogy *Du sang de la volupté et de la mort* [1948]).[22] While Anger's sexual politics may have countered those of official surrealism, they bespoke its liberatory impulse. For as Paul Hammond wrote: "Man has imposed social, sexual, mental constraints on himself and his fellows. Surrealism wants to tear these artificial barriers down, to create a world where desire will have the first and last word."[23]

Fireworks begins with a dream image: a handsome sailor bearing a limp, unconscious youth (Anger) in his arms. The youth awakens with an apparent erection, which is comically revealed to be a primitive statue held under his sheet. As in the Deren and Brakhage films, we are once more inside a house, one that seems beyond the quotidian order. Curiously the hero finds photographs of his dream icon in his room,

Fig. 23
Lee Mullican in the opening
scene from James Broughton's
Mother's Day (1948)

Fig. 23
Lee Mullican in the opening
scene from James Broughton's
Mother's Day (1948)

perhaps a reference to cinema's capacity to "document" oneir-
ic imagery. With the logic of condensation (which merges
home with bar), the young man disappears through a door
marked Gents but suddenly finds himself on a busy thor-
oughfare. The sources for this door are several: the "interior"
door in *Un chien andalou,* which leads directly to the beach,
and the doors of the Hôtel des Folies-Dramatiques in *Le sang
d'un poète.* The space behind the door is occupied by a mus-
cular sailor, who stands before a phony saloon backdrop, flex-
ing. As Anger smokes a cigarette, the sailor strikes him. More
sailors appear, swinging chains; they pile onto Anger and
strip him. In an image evocative of Modot's close-up in *L'âge
d'or,* Anger pokes his fingers into his nose, and blood pours
out. As the assault continues, we see entrails inside a body in
which a meter takes the place of a heart. Milk (seemingly a
substitute for semen) is poured over Anger's body, mixing
with blood, culminating the sadomasochistic discourse of the
work. In a final comic gesture, a sailor lights a firecracker pro-
truding from his fly. Anger marches around the room with a
candle-topped Christmas tree upon his head (another image
derived from *L'âge d'or*). The film ends with shots of the
oneiric photograph as Anger and a lover lie in bed. Clearly
there is a strain of social satire in this work, one familiar to
surrealist circles. As Anger has written, "This flick is all I have
to say about being seventeen, the United States Navy,
American Christmas and the Fourth of July."[24]

Scenes from under Childhood

*If [a man] retains a certain lucidity, all he can do is turn back
toward his childhood which however his guides and mentors
may have botched it still strikes him as somehow charming.
There, the absence of any known restrictions, allows him the
perspective of several lives lived at once.*[25]

As the surrealists romanticized the realm of childhood, so did
various California avant-garde artists of the 1940s. In this
respect their work expressed a spirit similar to that of the
quaint and "naive" films, boxes, and collages of a contempora-
neous New York artist, Joseph Cornell. While Deren, Anger,
and Brakhage were concerned with the interiority of dream,
James Broughton focused upon "the country of emotional
memory."[26] *Mother's Day* (1948; shot by Stauffacher; see fig.
23) is a nostalgic comedy, which takes a rather perverse back-
ward glance over a youth dominated by the figure of Mother.

Breton's notion of "the perspective of several lives lived
at once" seems particularly apt in characterizing this film,
since it posits the notion of memory encapsulated within
memory. Thus, not only does the film advance Broughton's
remembrance of his childhood, but it postulates simultane-
ously his mother's recollection of her own ambiguous past. In
the filmmaker's own words, the film is about the "impossible
borderline between when one is child and when one is grown-
up, and . . . implicate[s] Mother in the world of the child's
fantasies as being, perhaps, the biggest child of them all."[27]

Because the film charts a subjective domain, its chronol-
ogy is disrupted. We witness a multidirectional temporality
in which events flow both forward and backward. Mother is
seen at one moment young; at the next, old. At one instant she
is outfitted in 1940s couture; at the next, in Victorian garb.
Broughton's aim is to create a sense of psychic simultaneity in
which the mind commutes fluidly among past, present, and
future. He enlists a purely theatrical strategy, that of adults
playing children, to render the dual sense of adults remem-
bering the past and of the children who live on in adults.

Mother's Day is a poignant vision of the life cycle as
articulated through the metaphor of the mirror. At one point
Broughton intercuts shots of Mother gazing at herself in a
hand mirror with those of Mother at an older age within that
mirror frame. Cocteau lurks somewhere beyond the looking
glass, and one is reminded of Heurtebise's line in *Orphée*
(1950), "You have only to watch yourself all your life in a mir-
ror, and you'll see death at work like bees in a glass hive."
Brakhage also sees parallels between the two artists: "Cocteau
was a great inspiration to [Broughton]. Broughton thought of
his own films as cine-poems."[28]

Finally *Mother's Day* enacts a sexual quest, for it is the attempt of an adult male to fathom the awesome sexuality of Mother, a woman who, in Broughton's words, thought herself "a frail Victorian miniature, but [was] actually voluptuous and severe in the flesh."[29] Thus, for Broughton the film is "a malicious rhapsody of the Oedipus complex."[30]

In a sense *Mother's Day* invokes the surrealist idealization of childhood only to tarnish it (recall that Breton talked of childhood being "botched" by its adult caretakers), for *Mother's Day* is a film about repression, and it paints a picture of the artist's youth as one in which the erotic was systematically denied, fit into conventionalized roles, or distilled into saccharine "loveliness." Significantly Broughton recalled:

> It would really be accurate to say that I was perse-
> cuted by my parents for three things: for my innate
> delicacy of manner and feeling, for masturbating,
> and (most wounding of all) for my first intense expe-
> rience of love—since the object of this love was . . .
> [a] strong blond older boy who taught me what recip-
> rocal love could be.[31]

Mother's Day is a melancholy lament for the absence of ideal love in conventional, familial, bourgeois life.[32]

Fortuitous Encounters

The bringing together of distant realities can . . . strike off new sparks; the surrealists never tired of repeating from Lautréamont the "beauty of the fortuitous encounter of a sewing machine and an umbrella on a dissecting table."[33]

Surrealism was known for its radical juxtapositions, be they priests, pianos, and donkeys in a film by Buñuel and Dali or locomotives and fireplaces in a painting by Magritte. This sense of strange and fortuitous encounters is apparent in the films of Sidney Peterson, who also worked in California during this period.

Peterson's first film, *The Potted Psalm* (1946), was made in collaboration with Broughton, followed by *The Cage* in 1947. His subsequent films, *Mr. Frenhofer and the Minotaur* (1948) and *The Petrified Dog* (1948), were shot in Workshop 20 of the California School of Fine Arts, where Peterson's professorial colleagues included Ansel Adams, Richard Diebenkorn, Clyfford Still, and Minor White.[34]

According to Sitney, *The Lead Shoes* (1949) was inspired by a series of serendipitous events.[35] One of Peterson's students suggested that a collaborative class project employ two English ballads, "Edward" and "The Three Ravens." Another volunteered a diving suit, and a third provided hamsters. These unrelated items were all worked into a disorienting scenario.

The film opens with an accelerated image of a woman playing hopscotch and returns frequently to that scene. Sometimes the chalk lines are drawn normally, and sometimes they are reversed (or erased). While Deren, Brakhage, and Broughton achieved their imagery with conventional photography (even when its content approached the surreal), Peterson utilized an anamorphic lens (which he later gave to Brakhage) to "stretch" the image at top and bottom. In this respect he moved further away from a classical surrealist aesthetic, which mistrusted "technical virtuosity and visual abstractions."[36]

If the hopscotch sequences invoke a child's world of play, other moments conjure a bizarre parental universe. Parker Tyler has, in fact, described the film as a "primordial incest tragedy."[37] A character, identified in the credits as Mother, runs through the streets to the beach, where she inexplicably pulls a metal-suited diver from the sea. When she removes his helmet, rodents—perhaps the hamsters—emerge. She drags the diver through the city in a wheeled cart, then hoists him through a window into her room. After she takes off his suit, she lowers his body to the street. When his head hits the pavement, it magically becomes a bounding loaf of bread in what Sitney terms "a ghoulish transubstantiation."[38] A man picks up the bread and begins to eat, whereupon it is transformed into a bone.

Reviewing the disjunctive "synopsis" of *The Lead Shoes,* it is not difficult to comprehend why Brakhage found it an experience of "mental defeat." He notes that "every attempt at symbolic or historic understanding of [it] is bound to destruct against the multiplicity of meanings, leaving the thoughtful viewer with scattered wits—though *not* at wit's end."[39]

Subversive Comedy

It is remarkable indeed that the comic film tends to become uniquely poetic.[40]

It is significant that Brakhage mentions "wit" in relation to *The Lead Shoes,* since the film is informed by a farcical sense of humor. As Brakhage observed: "Laughter is very important to [Peterson] because it counterbalances what otherwise would be extremely heavy metaphor."[41] It was also important to Broughton, and even *Mother's Day* can be viewed as a bittersweet burlesque. It opens, in fact, with a shot of a man asleep in a statue's arms (fig. 23), a clear homage to Chaplin's *City Lights* (1931), but it is in *Loony Tom, the Happy Lover* (1951) that Broughton acknowledges his debt to silent comedy, a debt similarly acknowledged by the French avant-garde. As Brakhage noted: "Broughton attempts to make a bridge

Fig. 24
A scene from Kenneth Anger's
*Inauguration of the Pleasure
Dome* (1954)

between the black humor of surrealism and Freudian humor, all the way to the early comedies of Chaplin, Keaton and Sennett."[42]

Loony Tom concerns a tramp (Kermit Sheets) in gentleman's suit and Chaplinesque derby, who, wandering through the countryside, happens upon numerous women. At each encounter he sweetly, but lecherously pursues the damsel, often stealing a kiss or embrace. When an obstacle presents itself (usually his paramour's suitor), he goes along his merry way until he meets another woman. The film is accompanied by music but has no conventional dialogue. Intermittently Broughton is heard on the sound track reciting a verse that seems derivative of nursery rhymes: "Tum-piddle-um, the milk pail said/La-didi-la, the hydrant chatted." One reviewer described this celebration of libidinal energy as "half Rabelais, half Mack Sennett."[43]

That Obscure Object of Desire

Modern love flows directly from the cinema.[44]

As French avant-garde filmmakers had romanticized the figure of woman (the model Kiki of Montparnasse, for example, in the films of Fernand Léger and Man Ray), so Anger created a vamp in *Puce Moment* (1949), a fragment of a never-completed work, *Puce Woman*.[45] At some point he rereleased the film, synchronizing it to a new musical score.

Puce Moment envelops us in the texture of lush fabrics. Curtains are parted, textiles pulled aside to reveal a woman in theatrical makeup, draped in sequins. Her dress looks like a 1920s chemise, and she sports huge jet earrings. She sits before a vanity, whose surface is covered with antique glass perfume bottles. She reclines languorously on a chaise longue,

which is mysteriously pulled toward the balcony. With the Hollywood Hills in the background, she rises and descends a staircase, escorted by several elegant hounds. The film reeks of glamour, the kind associated with Josef von Sternberg's fetishistic treatment of Marlene Dietrich, a favorite with the surrealists. The film also anticipates the sensibility of camp, with which Anger would come to be identified.

A very different sensibility of love and desire informs Broughton's whimsical *Four in the Afternoon* (1951), based on four poems from his book *Musical Chairs*. The first segment, "Game Little Gladys," shows a woman, dressed like a young girl, repeatedly descending a staircase, a send-up of Marcel Duchamp's painting *Nude Descending a Staircase* and a reference to Léger's film *Ballet mécanique* (1924). On the sound track we hear a female voice reading a verse that asks, Who will "count me his true sweetheart?" In "The Gardener's Son" a man spies on a woman who frolics in the woods amid cupid-like statuary. Again a poem speaks of love and purity. In "Princess Printemps" a marionettelike woman (reminiscent of Columbine) dances around a series of posts and is met by a man in courtly attire. In "The Aging Balletomane" an old man recalls his obsession with a ballet dancer. (Significantly, one of the first dada films, *Entr'acte* [1924], was shown as an intermission for a ballet performance and incorporated dance imagery.)

Myth, Magic, and Archetype

Every myth can have its history and its geography; each is in fact the sign of the other; a myth ripens because it spreads.[46]

While in *Fireworks* Anger had created a trance film and in *Puce Moment* an homage to Hollywood divas, in *Inauguration of the Pleasure Dome* (1954; see figs. 24, 25) he produced a work steeped in myth, magic, and archetype. Prior to making *Inauguration* in California, Anger had lived in France, where he had planned to shoot a film of Lautréamont's *Les chants de Maldoror* (1869), an inspiring literary source of great significance to the surrealists.[47] Because of this French connection, critics have tied Anger's work to the legacy of symbolist poetry. Carel Rowe entitled his book on the American avant-garde *The Baudelairean Cinema* and included Anger among its practitioners: "Many of the tenets of surrealism are similar, and, at times, identical to those of . . . Symbolism; the spark was passed from Lautréamont and Baudelaire to André Breton."[48] For Rowe *Inauguration* is linked with symbolism in its engagement of the themes of death, decadence, and synaesthesia. Beyond this, *Inauguration* is related to Cocteau's *Orphée,* which also drew on a mythic narrative, and to the magic films of Méliès, much beloved by the surrealists.

Fig. 25
Anaïs Nin in a scene from
Kenneth Anger's *Inauguration
of the Pleasure Dome* (1954)

Inauguration of the Pleasure Dome, which was reworked and reissued in 1966, portrays the awakening of Lord Shiva and his engagement with a series of other mythic figures: Osiris, the Scarlet Woman, Lady Kali, and Lilith, among others. Shot in saturated color, all are heavily costumed and choreographed with deliberate movements reminiscent of Japanese Noh and Kabuki theater.[49] Some characters are played by "stars" of Anger's artistic circle: Astarte by Anaïs Nin (see fig. 25); a somnambulist, reminiscent of Cesare in *The Cabinet of Dr. Caligari* (1919), by Harrington. Anger, himself, embodies Hecate. Often the figures are placed against pure black backgrounds, which enhance the hues of their robes. In other scenes they are silhouetted against painted backdrops evocative of those from turn-of-the-century popular theater. Sometimes, in their fetishized costumes of feathers, sequins, and fur, they remind us of actors in the films of von Sternberg. As *Inauguration* progresses, superimposition renders the discrete figures increasingly merged and blurred.

The film is dedicated to the occult master Aleister Crowley; Anger has stated that it depicts a "masquerade party" derived "from one of Crowley's dramatic rituals where people in the cult assume the identity of a god or a goddess." For Sitney the film's meaning is more profound: it is a version "of the primary Romantic myth of the fall of a unitary Man into separate, conflicting figures."[50]

Dali in Hollywoodland

It falls largely to mainstream cinema to express surrealism.[51]

We noted earlier that the European surrealists adored Hollywood film. In the 1920s Buñuel wrote a tribute to Keaton's *College* (1927), and Louis Aragon declared, "I love

the Mack Sennett comedies."[52] In the 1930s Jean Ferry gushed over *King Kong* (1933),[53] and in the 1950s the French Surrealist Group enshrined *Shanghai Gesture* (1941).[54] Subsequently various critics have "awarded" particular mainstream films the surrealist "label."[55] While for Hammond such films as *College, King Kong,* and *Shanghai Gesture* are surreal by dint of "ethics" or "accident," *Spellbound* (1945) was made with specific surrealist intent, since its director, Hitchcock, employed Dali to create effects for its famous psychoanalytic sessions.

Spellbound tells the story of Dr. Constance Petersen (Ingrid Bergman), a psychiatrist at Green Manors. The director of the institution, Dr. Murchison (Leo G. Carroll), is about to retire, and the staff is awaiting the arrival of his successor, Dr. Edwards (Gregory Peck), whom none has met. When Edwards appears, he behaves strangely. Traces left by the tines of a fork on table linen cause him to erupt in anger. Stripes on Constance's bathrobe provoke his anxiety. Soon he confesses his amnesia. In fact he is not Dr. Edwards. Through psychoanalysis he eventually discovers that he is John Ballantine and that his amnesia commenced when he witnessed Edwards's death in an apparent skiing mishap that triggered repressed memories of his own brother's death in childhood. Indeed it turns out that Dr. Murchison himself murdered Edwards in order to remain director of Green Manors.

It is during a psychoanalytic session conducted by Constance, now John's psychoanalyst, that we see Dali's contribution to the film. When Constance asks John to recount a dream, Hitchcock's camera tracks ominously toward John's head. The image dissolves to a strange hall with huge eyeballs painted on the curtains. A man with oversized scissors is cutting the draperies. John describes the hall as a casino. A man with a stocking mask is dealing cards. Later in the dream we enter a barren landscape. A miniature figure falls from a roof; a faceless man drops a bent (or melted) wheel. Another man flees across a desert beneath the shadow of giant wings. It is this oneiric scenario, made concrete through Dali's mise-en-scene, that Constance uses to solve the enigma of Edwards's disappearance and John's misplaced guilt.

Aside from its dream iconography, *Spellbound*'s association of eros with violence and pathology would likely have attracted the surrealists, as would its concern with dream, memory, amnesia, and psychoanalysis. Its theme of *amour fou,* expressed in Constance's erotic fixation on a murder suspect, is central to the drama. When she first realizes her attraction, we see a metaphorical series of doors opening. This figurative moment, outside all narrative logic, also seems Daliesque. Furthermore, in characteristic Hitchcockian fashion, the film presents a world in which the abnormal is

normal and the normal, deranged. At the clinic Constance is harassed by the lascivious Dr. Fleurot (John Emery), whose sexual pursuit seems obsessive. He in turn accuses her of being frigid and repressed. Dr. Murchison, the presumed pillar of sanity, is homicidal.

While classic surrealist texts only evoke the aura of dreams, rather than represent them literally, *Spellbound* nonetheless underscores the manner in which these artists viewed the relation between cinema and consciousness. As Hammond noted: "For the surrealists the film is a paradigm of the mind. It has a conscious and an unconscious dimension."[56] Clearly this notion seems especially apt in *Spellbound*, a work that focuses on a character's mental state. While John's dreams are associated with the surrealist artist through the employment of Dali, Constance's interpretive project is linked with the surrealist critic, whose task it is to "extract the latent dream content from the dream thoughts that make up popular cinema."[57]

Notes

This essay is dedicated to Bill Judson.

1. Philippe Soupault, quoted in J. H. Matthews, *Surrealism and Film* (Ann Arbor: University of Michigan Press, 1971), p. 9.

2. Steven Kovacs, *From Enchantment to Rage: The Story of Surrealist Cinema* (Rutherford, N.J.: Fairleigh Dickinson University Press, 1980), pp. 16, 36; and Matthews, *Surrealism and Film*, pp. 33, 40.

3. Matthews, *Surrealism and Film*, p. 1.

4. Quoted in Rudolph E. Kuenzli, ed., *Dada and Surrealist Film* (New York: Willis, Locker and Owens, 1987), p. 8.

5. Linda Williams, *Figures of Desire: A Theory and Analysis of Surrealist Film* (Urbana: University of Illinois Press, 1981), p. xii.

6. Kovacs, *From Enchantment to Rage*, p. 11 (my italics).

7. P. Adams Sitney, *Visionary Film: The American Avant-Garde* (New York: Oxford University Press, 1974), p. 3.

8. Kuenzli, *Dada and Surrealist Film*, p. 1.

9. Stan Brakhage, *Film at Wit's End: Eight Avant-Garde Filmmakers* (Kingston, N.Y.: McPherson, 1989), p. 56 (my italics).

10. Robert Desnos, quoted in Kuenzli, *Dada and Surrealist Film*, p. 9.

11. Quoted in Sitney, *Visionary Film*, p. 9.

12. Dana Polan, *Power and Paranoia: History, Narrative, and the American Cinema, 1940–1950* (New York: Columbia University Press, 1986), pp. 10–11; and Lauren Rabinovitz, *Points of Resistance: Women, Power, and Politics in the New York Avant-Garde Cinema, 1943–71* (Urbana: University of Illinois Press, 1991), p. 56.

13. Sitney, *Visionary Film*, p. 136.

14. John Wakeman, ed., *World Film Directors*, vol. 2, *1945–85* (New York: H. W. Wilson, 1988), p. 151.

15. Gerald R. Barrett and Wendy Brabner, *Stan Brakhage: A Guide to References and Resources* (Boston: G. K. Hall, 1983), p. 12.

16. Matthews, *Surrealism and Film*, p. 8.

17. Lucy Lippard, ed., *Surrealists on Art* (Englewood Cliffs, N.J.: Prentice-Hall, 1970), p. 135.

18. Matthews, *Surrealism and Film*, pp. 1–2.

19. Parker Tyler, *Underground Film: A Critical History* (New York: Grove Press, 1969), p. 1.

20. Sitney, *Visionary Film*, p. 176.

21. Kovacs, *From Enchantment to Rage*, p. 20.

22. See also David Curtis, *Experimental Cinema* (New York: Universe, 1971), pp. 63, 84.

23. Paul Hammond, ed., *The Shadow and Its Shadow: Surrealist Writings on Cinema* (London: British Film Institute, 1978), p. 19.

24. Sitney, *Visionary Film*, p. 101.

25. André Breton, *Manifestoes of Surrealism* (Ann Arbor: University of Michigan Press, 1972), p. 3.

26. Sitney, *Visionary Film*, p. 61.

27. James Broughton, "Two Notes on *Mother's Day*," in *The Avant-Garde Film: A Reader of Theory and Criticism*, ed. P. Adams Sitney (New York: New York University Press, 1978), p. 81.

28. Brakhage, *Film at Wit's End*, p. 72.

29. "Biofilmography of James Broughton," *Film Culture*, no. 61 (1975): 63.

30. James Broughton files, Anthology Film Archives, New York.

31. Brakhage, *Film at Wit's End*, p. 73.

32. Parts of the discussion of Broughton were originally published in Lucy Fischer, *A History of the American Avant-Garde Cinema* (New York: American Federation of Arts, 1976).

33. William Earle, *A Surrealism of the Movies* (Chicago: Precedent, 1987), p. 35.

34. Brakhage, *Film at Wit's End*, p. 51.

35. Sitney, *Visionary Film*, p. 75.

36. Kovacs, *From Enchantment to Rage*, p. 41.

37. Parker Tyler, "Sidney Peterson," *Film Culture*, no. 19 (1959): 41.

38. Sitney, *Visionary Film,* p. 78.

39. Brakhage, *Film at Wit's End,* p. 63.

40. Desnos, quoted in Matthews, *Surrealism and Film,* p. 31.

41. Brakhage, *Film at Wit's End,* p. 61.

42. Ibid., pp. 75–76.

43. This phrase, credited to *The London Observer,* appears on Facets Video's jacket for the videotape of the film.

44. Desnos, quoted in Kovacs, *From Enchantment to Rage,* p. 54.

45. Sitney, *Visionary Film,* p. 105; and Standish D. Lawder, *The Cubist Cinema* (New York: New York University Press, 1975), pp. 136–37.

46. Roland Barthes, *Mythologies,* trans. Annette Lavers (New York: Hill and Wang, 1957), p. 149.

47. Carel Rowe, *The Baudelairean Cinema: A Trend within the American Avant-Garde* (Ann Arbor, Mich.: UMI Research Press, 1982), p. 76.

48. Ibid., p. 55.

49. Sitney, *Visionary Film,* p. 115.

50. Ibid., pp. 113, 110.

51. Hammond, *The Shadow and Its Shadow,* p. 18.

52. Kovacs, *From Enchantment to Rage,* p. 36.

53. Jean Ferry, "Concerning *King Kong,*" in Hammond, *The Shadow and Its Shadow,* pp. 105–8.

54. French Surrealist Group, "Data towards the Irrational Enlargement of a Film: *Shanghai Gesture,*" in ibid., pp. 115–21.

55. J. H. Matthews, *Surrealism and American Feature Films* (Boston: Twayne, 1974), pp. 11–50.

56. Hammond, *The Shadow and Its Shadow,* p. 21.

57. Ibid., p. 6.

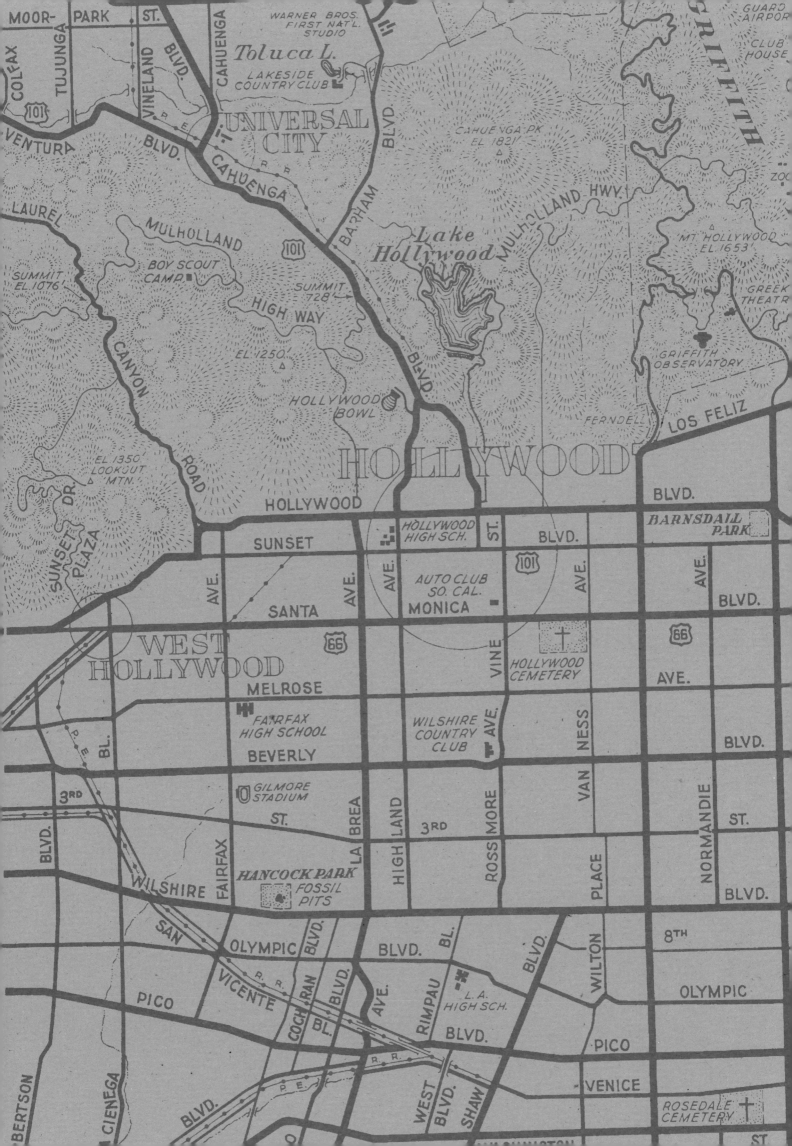

1.
Helen Lundeberg
*Double Portrait of
the Artist in Time*, 1935
(cat. no. 78)

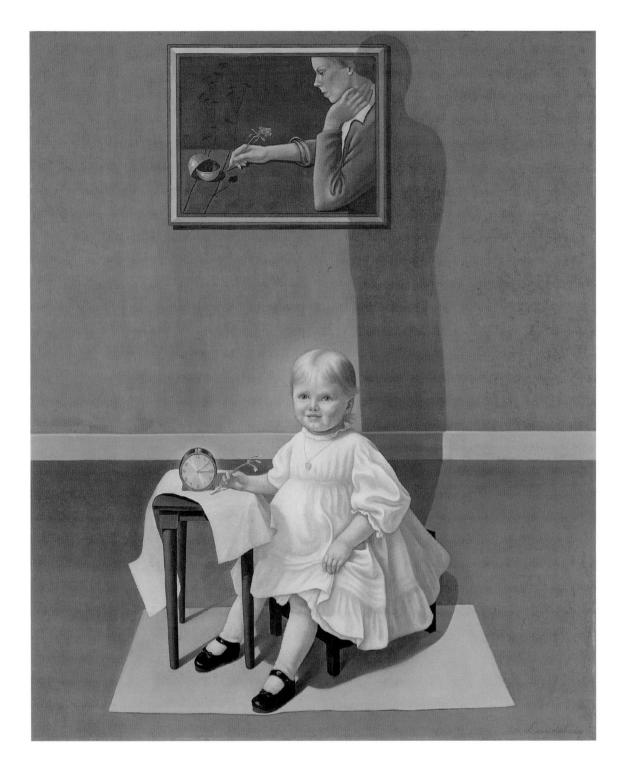

2.
Helen Lundeberg
*Plant and Animal
Analogies*, 1934
(cat. no. 77)

3.
Helen Lundeberg
Relative Magnitude, 1936
(cat. no. 79)

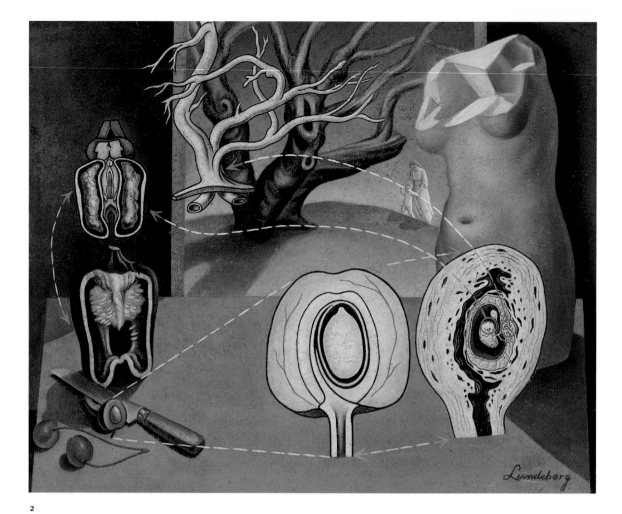

2

3

4.
Lorser Feitelson
Genesis #2, 1934
(cat. no. 34)

6.
Knud Merrild
Exhilaration, 1935
(cat. no. 86)

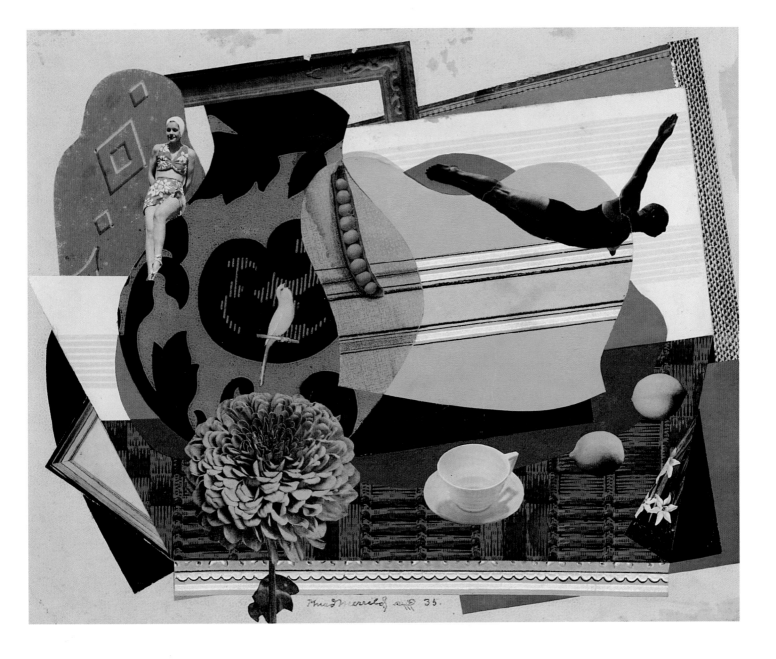

7.
Ben Berlin
Profiles, c. 1937
(cat. no. 5)

8.
Ben Berlin
*Birds, Sky, Water,
and Grass*, 1938
(cat. no. 6)

7

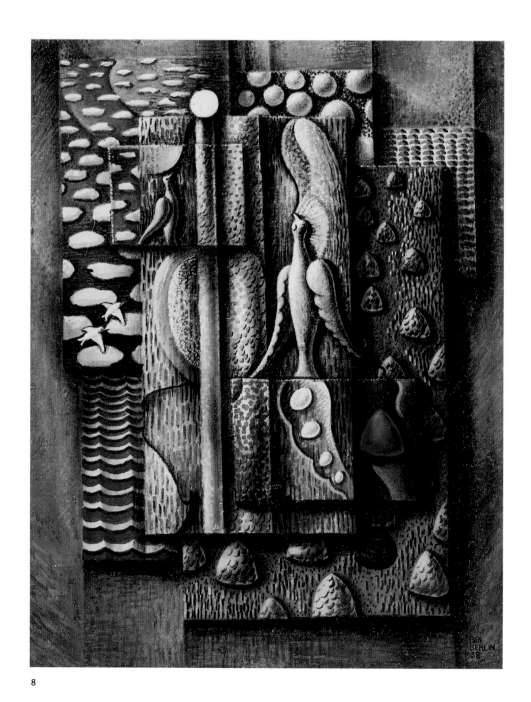

8

9.
Dorr Bothwell
Family Portrait, 1940
(cat. no. 17)

10.
Dorr Bothwell
Table in the Desert, 1942
(cat. no. 19)

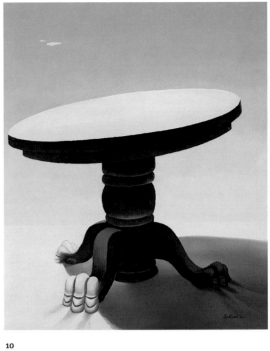

10

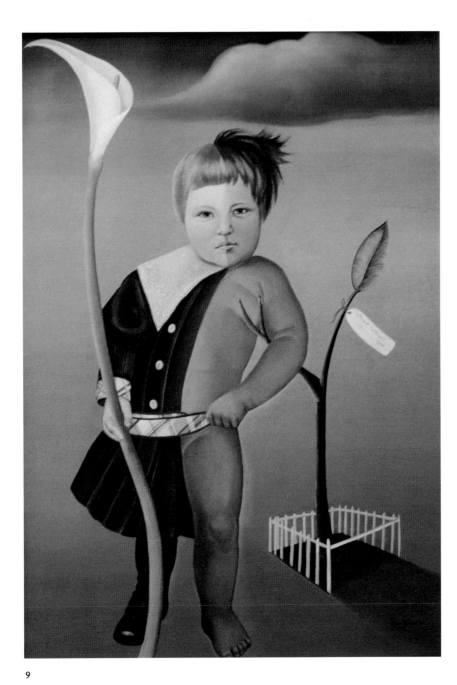

9

11.
Eugene Berman
Nike, 1943
(cat. no. 10)

12.
Salvador Dali
Untitled (Study for "Destino,"
Jupiter's Head), 1946
(cat. no. 29)

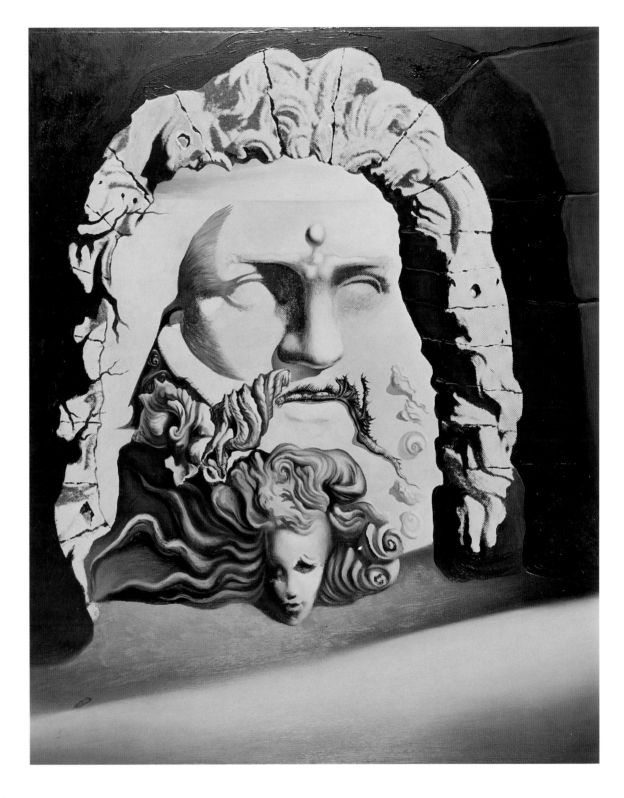

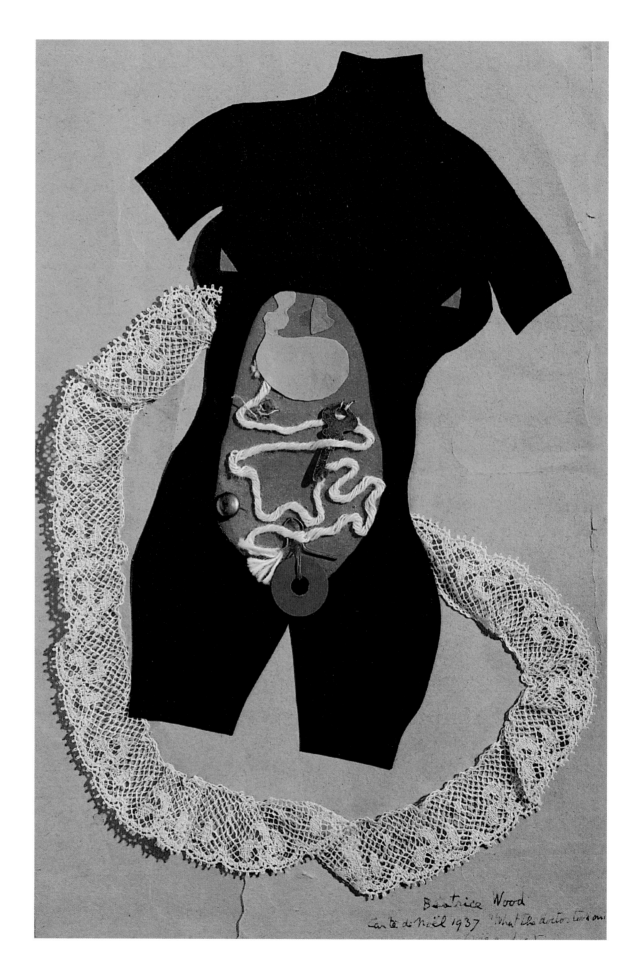

14.
Charles Howard
The First Hypothesis, 1946
(cat. no. 56)

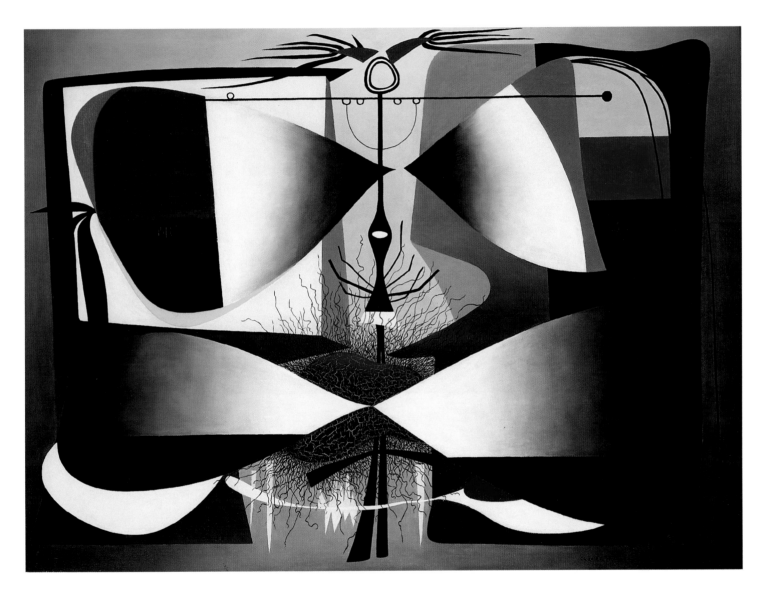

15.
Charles Howard
Chain of Circumstance, 1946
(cat. no. 55)

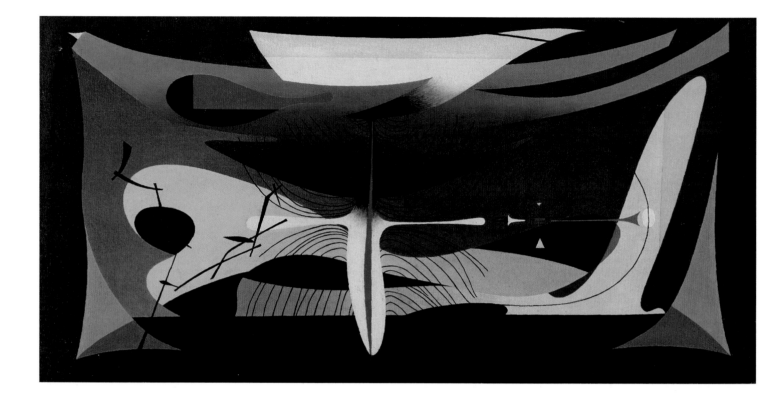

16.
Gordon Onslow Ford
The Future of the Falcon, 1947
(cat. no. 101)

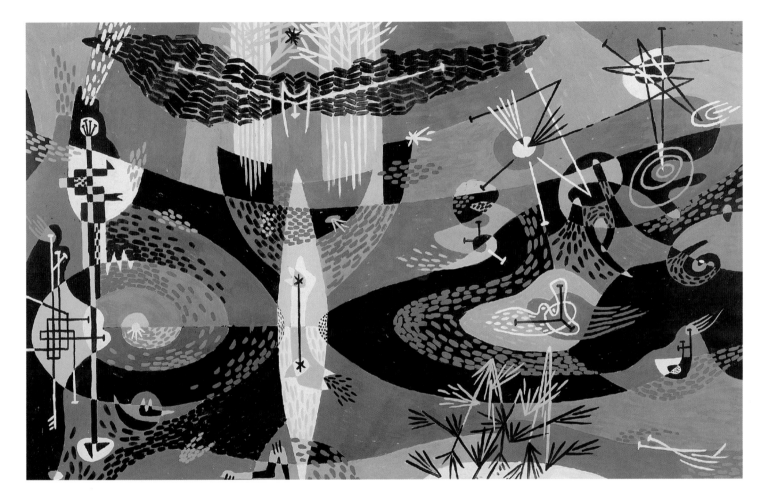

17.
Wolfgang Paalen
*Keylords of the Prismatic
Situations*, 1947
(cat. no. 103)

18.
Wolfgang Paalen
Tropical Night, 1948
(cat. no. 105)

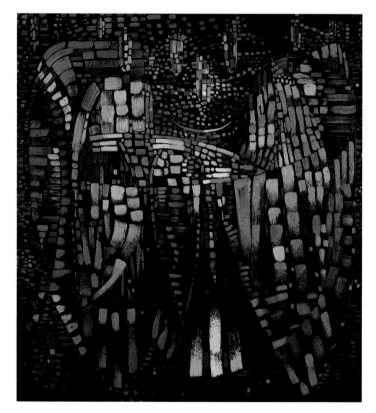

18

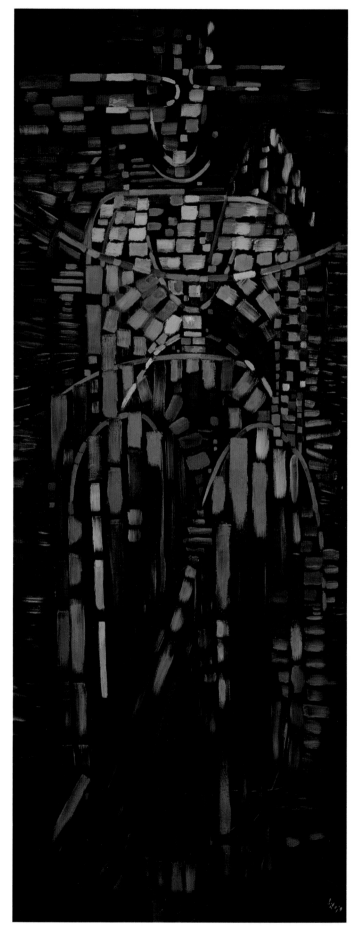

17

19.
Lee Mullican
Ninnekah, 1951
(cat. no. 98)

20.
Lee Mullican
Splintering Lions, 1948
(cat. no. 96)

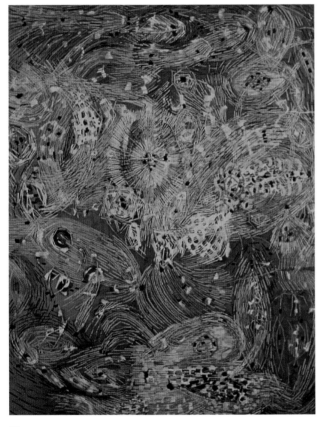

20

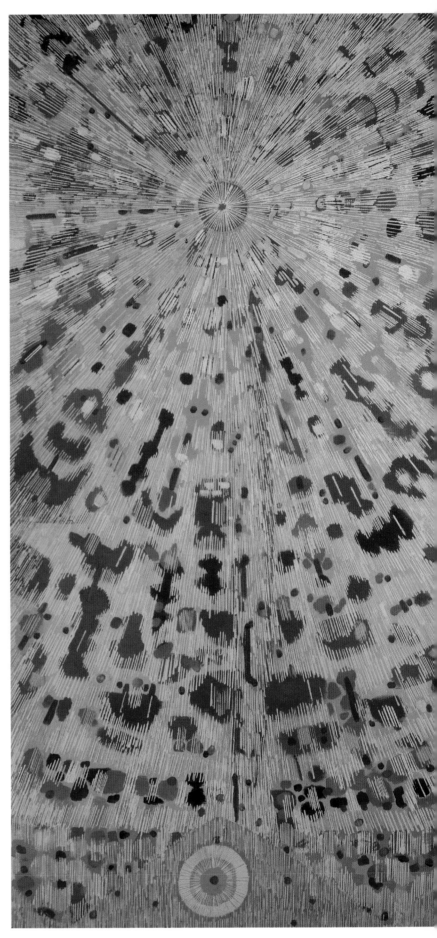

21.
Jess
Goddess Because II, 1956
(cat. no. 64)

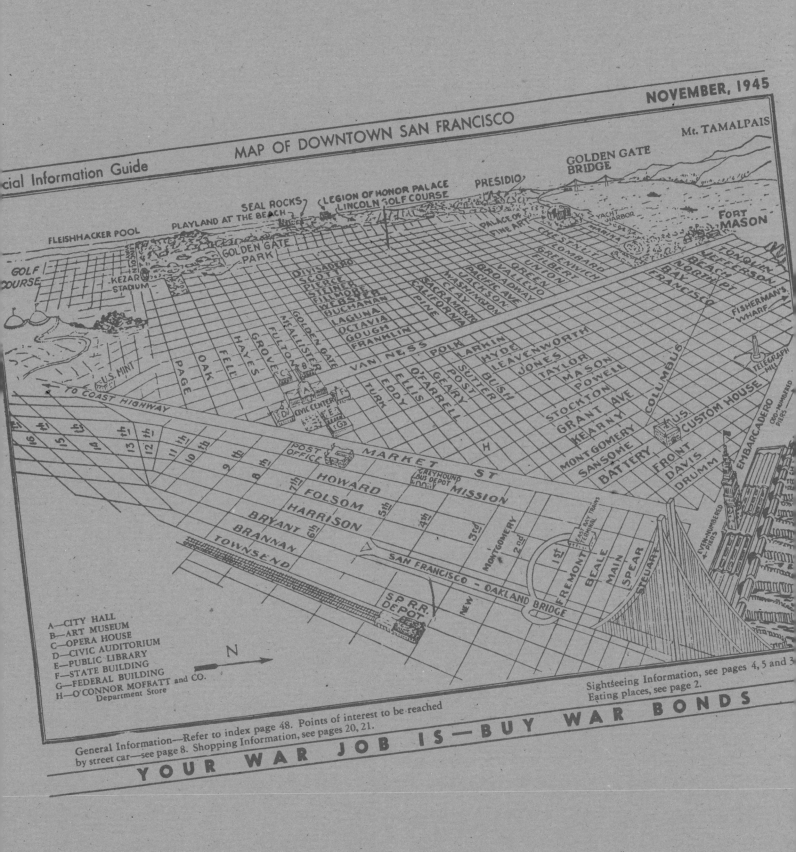

NOVEMBER, 1945

MAP OF DOWNTOWN SAN FRANCISCO

cial Information Guide

Mt. TAMALPAIS

A—CITY HALL
B—ART MUSEUM
C—OPERA HOUSE
D—CIVIC AUDITORIUM
E—PUBLIC LIBRARY
F—STATE BUILDING
G—FEDERAL BUILDING
H—O'CONNOR MOFFATT and CO.
 Department Store

N

Sightseeing Information, see pages 4, 5 and 3
Eating places, see page 2.

General Information—Refer to index page 48. Points of interest to be reached
by street car—see page 8. Shopping Information, see pages 20, 21.

YOUR WAR JOB IS—BUY WAR BONDS

Illustrated Catalogue

Jeremy Anderson
1921—1982

Fig. 26
Jeremy Anderson, 1971
Photograph courtesy
Braunstein/Quay Gallery

Jeremy Anderson was born in Palo Alto, California, in 1921. The son of a Stanford University professor, he grew up with eclectic interests. Initially drawn to engineering in junior college, he also took a figure-drawing class. He served as a sonarman in the Navy during World War II and upon discharge spent time in Tucson, Arizona, making adobe bricks with the Papago Indians. Returning to California in late 1946, he planned to write but enrolled part-time at the California School of Fine Arts. He studied sculpture with Robert B. Howard and drawing with Clay Spohn. He also studied painting with David Park during the painter's brief nonrepresentational period. Clyfford Still was the school's reigning genius, and Mark Rothko taught two summer sessions, one of which Anderson attended. Thus Anderson was at CSFA during an especially exhilarating period, when the European surrealism that emerged in the 1920s and 1930s remained a vital influence for many West Coast artists, when dada playfulness was rediscovered as a potent tool of sabotage, and when New York school abstract expressionism, as represented by Rothko, was still in its early "abstract surrealist" phase.

After receiving a graduate certificate in 1950, Anderson traveled to New York, Paris, and Carnac, Brittany, on a travel fellowship; it was a year when his fascination with myth, ritual, and primitive sculpture was both intensified and placed within the art historical orbit of abstract surrealism. His knowledge of European surrealist masters such as Giorgio de Chirico, Alberto Giacometti, and Joan Miró was freshened by an appreciation of the new American abstract expressionist sculpture of David Hare and the early work of David Smith. Anderson was a sophisticated artist and one of the few abstract sculptors of the period who consciously worked in a surrealist vein.[1] His early scientific bent and his interest in myth, anthropology, and literature were easily brought under surrealism's broad umbrella, where the psychological power of tribal art came together with erotic subversions and allusions to organic growth cycles and exotic landscapes.

Anderson's sculptures of the late 1940s were primarily made of plaster. Related to the forms of Picasso and Miró, these bulbous pieces were meant to be cast in bronze, but Anderson responded to the raw, colorless plaster, with its eerie, bonelike texture, and he exhibited the work in its unmediated form. Around 1952 he turned to making sculptures that were carved and constructed from wood, primarily redwood but occasionally from teak and various fruitwoods. Because of their materials, these sculptures were modest in size and allowed for "radical revision" during the fabrication process;[2] they made a knowing,

sophisticated nod to both surrealist spontaneity and folk art's "amateur" whittling technique.

Five distinct compositional forms explored by Anderson were especially potent for his surrealist-based content: the biomorphic, with slippery transformations among breastlike hemispheres, phallic rods, plant forms, and primitive creatures; the architectural, which provided rooms, cages, and platforms, stage sets for dreamlike encounters; furniture forms, which make reference to the body and offer an uneasy conflation of sculptural legitimacy and domestic bric-a-brac;[3] biomechanical contraptions; and of course weaponry. (One contemporary writer pointed out that the "collection of medieval weapons then on permanent display at the de Young Museum was reflected in forms that alluded to clubs, maces, battle-axes, and catapults."[4]) Anderson's sculpture of the 1950s suggested, as Alfred Frankenstein put it, "worn-out models for wayward, fantastic machines, sometimes of erotic plants, sometimes of exotic plants, sometimes of architecture and landscape."[5]

The spikiness and assembled or "additive" quality of the works of the 1950s—the result of a proliferation of dowels, corkscrew finials, and a variety of bulbous protuberances—is resolved into sculptural form by Anderson's use of a single medium, wood, and a single, unifying stain. Intensifying the wood's natural grain was very important in this organic work: as in much African sculpture, the grain conveys the sense of a fragile veil covering a mysterious but vital inner life. There is also a similarity between the atmospheric quality of Rothko's painterly surfaces and the worked-over, subtly caressed, ever-modulating surfaces of Anderson's carved wood, in which every edge appears softened and every surface is carved with patterns of tool markings or with small concavities. This tactile quality makes the sculpture look very hand-made and also very modest. Eschewing the junky aspects of funk assemblage as well as "found object" theatrics, Anderson's work from this period has great sculptural probity.

An untitled work from 1953 (cat. no. 1) portrays the familiar surrealist subject matter of totemic characters, alluding to a fluid interchange of male and female sexuality. A sculpture from the following year (cat. no. 3) is a single totemic figure, recalling a royal personage or ancient deity, many-armed and powerfully phallic. Both works recall not only sculptures by Max Ernst but also, closer to home, Rothko's early abstract surrealist imagery. *Untitled #100.11* (1953; cat. no. 2) is one of Anderson's "furniture" sculptures. The weirdness of functional, domestic articles was a potent surrealist insight, and here Anderson turns his "chair" into an insectlike creature with threatening jaws (there

1.
Untitled #100.6, 1953
Redwood
26 x 23 x 8 in.
Courtesy Braunstein/Quay
Gallery

2.
Untitled #100.11, 1953
Redwood
20 x 8¹/₂ x 7 in.
Courtesy Braunstein/Quay
Gallery

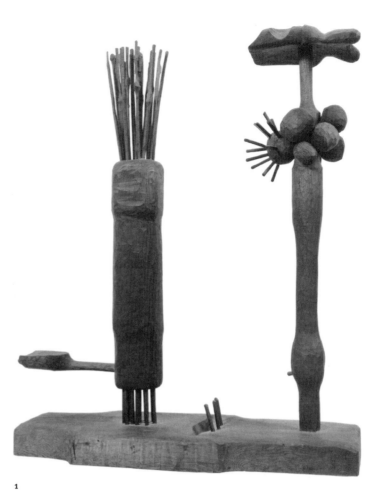

1

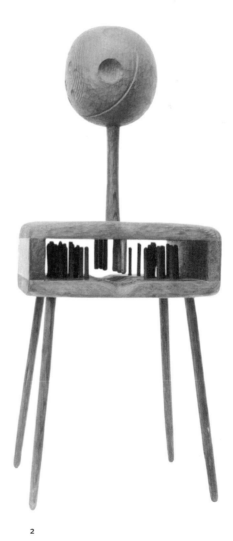

2

is a sexual allusion here as well, to the male surrealist fantasy of the castrating "vagina with teeth") and the probing antenna of a multifaceted, all-seeing cyclopean eye that stares back at the viewer. That the sculpture is small makes it seem all the more subversive in its implied threat. *Untitled #100.3* (1955; cat. no. 4) is a Paul Klee-like landscape where plant and animal life merge. Anderson topples the bird-horse fancy suggested by the "fence" of dowels and the concave eating trough by turning the body of the beast into an advancing, blossoming female breast.

Anderson's brand of surrealism seems informed as much by folk art's personal eccentricities as by tribal art's communal energy. As James Monte wrote in 1967, Anderson's "forms are not used in a threatening manner, on the contrary they seem to have been fed through a 'deintensification' process in the mind of the artist."[6] It is true that his wood sculptures of the 1950s can appear lyrical, even playfully domesticated. With sustained acquaintance, however, the work exudes a sexual charge of controlled desire and fixation, which gives it its poetic power.

In the early 1960s Anderson began to incorporate carved words, usually puns, into his sculpture, as well as turning to industrial materials and bright, glossy surfaces; this body of work forms a bridge between the abstract surrealist sculpture of the 1950s and the sculpture of the 1960s associated with the Bay Area polychrome movement and funk art. His later work focused on the human figure in both life-size wood sculptures and small bronzes; he was also known for maps and drawings with psychological reference points and for small fetish objects.

Anderson died in 1982 in San Raphael, California. He had many solo exhibitions, primarily in the Bay Area; retrospectives were held at the San Francisco Museum of Modern Art (1966), the Pasadena Art Museum (1967), and the University of California, Davis (1984). His work has been included in many survey exhibitions, including *American Sculpture of the Sixties* (Los Angeles County Museum of Art, 1967); *Painting and Sculpture of California: The Modern Era* (San Francisco Museum of Modern Art, 1976); *One Hundred Years of California Sculpture* (Oakland Museum, 1985); and *Forty Years of California Assemblage* (Wight Art Gallery, UCLA, 1989).

Anne Ayres

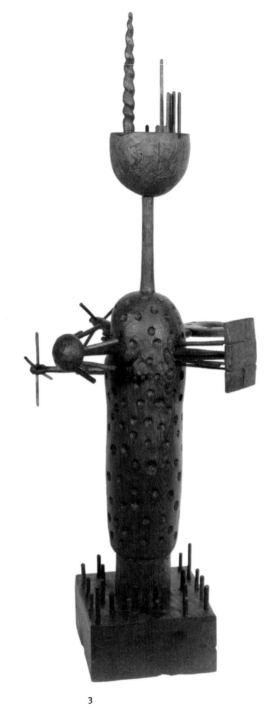

3

Notes

1. James Monte, "Jeremy Anderson, Dilexi Gallery," *Artforum* 2 (March 1964): 47.

2. James Monte, "Jeremy Anderson Retrospective at the San Francisco Museum," *Artforum* 5 (February 1967): 50.

3. Fairfield Porter, "Jeremy Anderson," *Art News* 53 (October 1954): 52.

4. Thomas Albright, "Founding Fathers," *The Museum of California* (Oakland) 6 (July–August 1982): 6–10.

5. Alfred Frankenstein, "'Bottom Jelly,' 'White Fire,' and '4/26/53,'" *San Francisco Chronicle,* 21 August 1955, This World section.

6. Monte, "Jeremy Anderson Retrospective," p. 50.

3.
Untitled #85, 1954
Redwood
41³/₄ x 13 x 17 in.
Sheldon Memorial Art Gallery,
University of Nebraska, Lincoln,
F. M. Hall Collection, 1989
(H-2892)

4.
Untitled #100.3, 1955
Wood
7 ¹/₄ x 14³/₄ x 6 in.
Collection of Sam and Jo Farb
Hernandez; courtesy
Braunstein/Quay Gallery

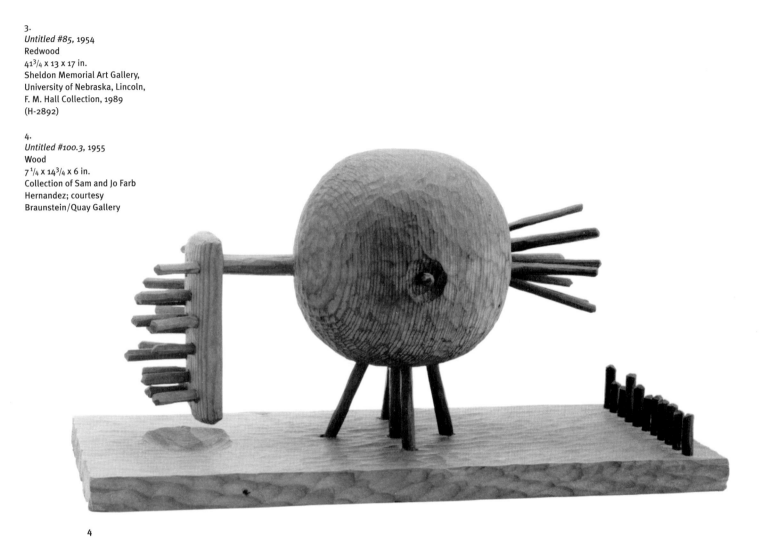

4

Ben Berlin
1887—1939

Fig. 27
Ben Berlin
Self-Portrait, 1917
Oil on canvas
Photograph by Richard Blue;
courtesy Maurine Saint Gaudens
and Thomas J. Turner

Ben Berlin's life is as much of an enigma as the surrealist paintings he created. Born in Washington, D.C., in November of 1887, he lived in San Bernardino, California, during the first decade of this century before moving to Los Angeles to study illustration at the school that John H. Rich and William Cahill opened in 1914. He also attended the Cannon School of Art.

It is not known when Berlin began experimenting with modernism. He was supposedly introduced to modern art through Arthur Jerome Eddy's *Cubists and Post-Impressionism,* first published in 1914. In 1923 Berlin participated in the landmark exhibition of the Group of Independent Artists, held to demonstrate to the public the importance of cubism, dynamism, and expressionism. The following year he was given a solo exhibition at the Potboiler, showing cubist paintings that already conveyed the formalist concerns and interest in metaphysics that would become the hallmark of his mature art.

Despite his progressive orientation, Berlin never completely relinquished representation. From approximately 1929 to 1931 he lived at the Grand Canyon, finding solace in the quiet, majestic landscape. The need for such respite may indicate that the artist was already suffering from a drinking problem. He was gentle, kind, and hypersensitive, and the difficult modernist course that he chose to pursue was not compatible with his temperament but instead seems to have encouraged his descent into alcoholism. His financial situation was always precarious, and as late as 1934 he was obligated to accept commissions for realistic portraits.

After returning to Los Angeles, Berlin joined the literary and artistic circle centered around the home of Margery Winter. The art critic Sadakichi Hartmann, one of its most important members, became an enthusiastic admirer of Berlin's modernist paintings. Berlin spent almost a year and a half in New York. During this time he arranged for the showing of his 1934 cubist portrait of Hartmann at the Ferargil Gallery and became familiar with current trends by visiting the Gallery of Living Art, the Whitney Museum of American Art, and other exhibition spaces.

Berlin's surrealist work dates from the era after his return to Los Angeles in January 1936. The artist probably came back to the West Coast well versed in surrealism, since he had the opportunity to see several exhibitions focusing on the movement and its individual artists which Julien Levy and Pierre Matisse held in their New York galleries. Los Angeles also offered Berlin encouragement. While he was away, Lorser Feitelson and Helen Lundeberg had issued their landmark manifesto, *New Classicism,* which heralded the formation of a surrealist movement in Southern California. Berlin met Feitelson

when he began working on the Federal Art Project (WPA) only seven months after his return to California; the two became friends, and Feitelson often assisted the down-and-out Berlin.

Berlin was one of the few California surrealists to create both veristic and abstract compositions, with the result that his surrealist oeuvre is quite varied. In most of his surreal abstractions, color and form are of paramount importance. Surrealism was also conducive to the metaphysical explorations that he had begun in the early 1920s, when he had exhibited abstractions such as *Glaggle* and *Owngz,* with titles that had no references to the actual world. *Surreal Portrait* (1938), with its transparent planes and multiple heads, evolved from his cubist portraits, but in this later painting the artist transformed the people into skeletons, perhaps a commentary on the fragility of life. In *Profiles* (c. 1937; cat. no. 5; color plate 7) Berlin adopted a popular surrealist motif, the profile, repeating its angular lines in the shape of the tabletop and colored planes; again he focused on the head, the seat of the conscious and the unconscious.

Other paintings suggest that surrealism was a means for Berlin to visualize the irrationality of his own life and his fear of not surviving the endless struggle for sobriety. In the darktoned *Birds, Sky, Water, and Grass* (1938; cat. no. 6; color plate 8) he compressed birds, eggs, clouds, and vegetation into a tight collage that has stylistic affinities with the ominous expressionist paintings of André Masson and the heavily textured frottage experiments of Max Ernst. The symbols of life and freedom—eggs, birds, and clouds—exist precariously, squeezed together in an airless world. In dreamlike fashion Berlin's untitled painting of 1939 (cat. no. 7) captures his nightmarish plight: the path of a prisoner wearing a striped uniform is blocked by a brick building, while a more generic secondary figure is encapsulated in a bottle. Although Berlin was clearly tormented by his frequent alcoholic binges and blackouts in the years before his death in 1939, they did not impede his artistic development. The intriguing surrealist paintings that he produced during this period were the conscious creation of a true modernist.

Ilene Susan Fort

7.
Untitled (Surreal Abstraction),
1939
Oil on canvas
20 x 24 in.
Los Angeles County Museum of
Art, gift of Herman and Regina
Cherry (AC 1992.301.1)

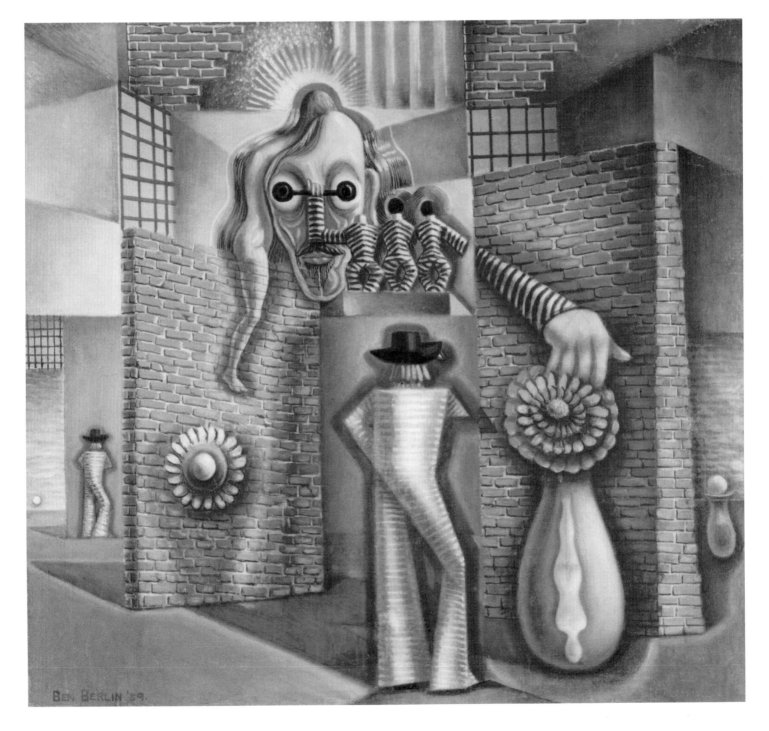

Eugene Berman
1899–1972

Fig. 28
Eugene Berman in his studio,
1949
Copyright Lou Jacobs, Jr.

The Surrealists remontaged man. The Neo-romantic Berman reestablished man and his artifacts—vulnerable, cultured man rather than Cubist man.—*Julien Levy*[1]

Given to dreamy romanticism, Eugene Berman fashioned a magical realist art steeped in nostalgia. The stepson of a prosperous banker, he was born in Saint Petersburg, Russia, in 1899 and educated in Germany, Switzerland, and France. In the wake of the Russian Revolution, to which he and his family lost their home, Berman took refuge in Paris in 1918, training at the Académie Ranson. Contact there with Nabis and intimists Pierre Bonnard, Maurice Denis, Félix Vallotton, and Edouard Vuillard attuned the young Berman to a moody art of metaphor.[2]

In the mid-1920s Berman joined his older brother Leonid, their art-school colleague Christian Bérard, and fellow Russian émigré Pavel Tchelitchew in formulating the Neo-Romantic movement, and in 1926 they staged their group debut at the Galerie Druet in Paris.[3] Like the surrealists, on whose heels they followed, they rebelled against the affective detachment of formal abstraction, seeking to reinject modern art with subjective thought and emotion. Inspired by the Blue and Rose periods of Picasso, they portrayed their human subjects with a poetic melancholy. Berman moreover looked, as did his surrealist peers, to Giorgio de Chirico's example as he reconfigured the visible world into oneiric scenarios. In contrast to the surrealists, however, Berman and his Neo-Romantic confreres favored Western bourgeois culture, eschewing the surrealists' Marxist and anti-Catholic agenda and libertine sexuality.

Six years after Neo-Romanticism was launched in Europe, Berman had his first solo show in the United States, at the Julien Levy Gallery in New York, and in 1936 he moved to Manhattan. Showcased regularly by Levy and commissioned by opera and ballet companies to create scenic designs, Berman attracted an American audience early on. Among others, he won the support of Wadsworth Atheneum Director A. Everett "Chick" Austin and curator-critic James Thrall Soby, who engaged him to create wall panels and furniture for his Farmington, Connecticut, home.[4]

A trip to Santa Barbara in 1938 to execute a mural for collector Wright Ludington prompted Berman to settle in Southern California three years later.[5] Installing himself in the Villa Carlotta apartments on Franklin Avenue in Hollywood, he soon became a key figure in a circle that included his close friend the composer Igor Stravinsky, for whose productions he designed costumes and sets; artists William Brice, Rico Lebrun, and Howard Warshaw; writer Christopher Isherwood; comedian

Fanny Brice; actors Ona Munson and Vincent Price; and stripper Gypsy Rose Lee.[6] Munson, who played Belle Watling, the madame in *Gone with the Wind,* served as Berman's muse and married him in 1950 in the Stravinskys' living room.[7]

Influenced by his work in theater and Munson's in film, Berman's art took on a dramatic panache. In many images costumed models pose on a stage, framed by architectural fragments and swags of tattered fabric that look as if they were gleaned from a props department. Munson posed for a number of works, including *Portrait Fantasy of Ona Munson* (1941–42; cat. no. 8), in which she is haloed by fiery plumes. In *Nike* (1943; cat. no. 10; color plate 11) the subject wears a raspberry gown slung attractively off her shoulders, which resembles the one worn by Belle in *Gone with the Wind.* The statuesque figure turns her back to the viewer as she presides over a landscape of ruins, a goddess of victory whose triumph rings hollow.

Like Berman's Nike, the central figure in *Muse of the Western World* (1943; cat. no. 9) appears in a devastated terrain. In the ravaged worlds they inhabit, these symbolic muses, personifications of cultural virtues, bear lonely witness to civilization's demise. Painted at the height of World War II, when humankind seemed poised on the brink of annihilation, Berman's images speak of bereavement and loss. These emotions were clearly well known to the artist, who at the age of seven suffered the death of his father and in his late teens was forced to flee his native land. Ever the stageman, he frequently garnished his paintings with trompe l'oeil bullet holes and detritus to enhance their sense of devastation.

The theatricality of Berman's muses and their settings suggests that he was not immune to the neon glamour of his surroundings. Inspired by Southern California's culture and light, he populated his scenes with curvaceous women and admitted sensuous hues to his palette. As critic Alfred M. Frankfurter observed, his oils exude a glow reminiscent of "the orange-gold seen in the late afternoon from the corner of Hollywood and Vine."[8]

During his years in Los Angeles Berman maintained a high professional profile, bolstered in the early 1940s by a touring retrospective organized by the Institute of Modern Art in Boston. He had regular exhibitions at Levy's gallery, and his works appeared in numerous group exhibitions, including the Art Institute of Chicago's traveling *Abstract and Surrealist American Art* in 1947–48 and annuals at the Whitney Museum of American Art in New York, the Carnegie Institute in Pittsburgh, the University of Illinois at Urbana, and the Los Angeles County Museum of History, Science, and Art.

8.
Portrait Fantasy of Ona Munson,
1941–42
Oil on canvas
44³/₄ x 34 in.
McNay Art Museum, San
Antonio, Texas, gift of Robert L.
B. Tobin

9.
Muse of the Western World,
1943
Oil on canvas
50⁷/₈ x 37³/₄ in.
The Metropolitan Museum of
Art, George A. Hearn Fund, 1943
(43.159.2)

8

9

Meanwhile his paintings were reproduced in *Art News, Harpers'*
Bazaar, Town and Country, and *Vogue.* In 1947 the Museum of
Modern Art in New York surveyed his stage designs, and Levy
published a monograph on his oeuvre. That same year Berman
joined the prestigious Knoedler Galleries, and by the end of
the decade, when his work was exhibited at the posh new
Associated American Artists gallery in Beverly Hills, his stand-
ing as a leading magic realist was firmly secured.

 Tethered to a particular time, Berman's art addressed a
public traumatized by the Depression and World War II. The rel-
ative peace and prosperity of the 1950s, which gave rise to a
high-tech futurism, augured the obsolescence of the artist's
nostalgic aesthetic. The heartbreak that Berman expressed in
his art reentered his life in 1955, when Munson committed sui-
cide. Distraught, he moved to Rome, where he died in 1972.

Susan Ehrlich

Notes

1. Julien Levy, *Memoir of an Art Gallery* (New York: G. P. Putnam's Sons,
1977), p. 108.
2. Biographical data was obtained from ibid., pp. 106–13, 179–82,
296–310, and from Julien Levy, *Eugene Berman* (Freeport, N.Y.: Books for
Libraries Press, 1947), as well as from James Thrall Soby, *Eugene
Berman: Catalogue of the Retrospective Exhibition of His Paintings . . .*
(Boston: Institute of Modern Art, 1941).
3. As cited by James Thrall Soby, in *Tchelitchew: Paintings—Drawings*
(New York: Museum of Modern Art, 1942), p. 14; Kristians Tonny, J. F.
Laglenne, Pierre Charbonnier, L. de Angelis, and Therèse Debains also
participated in this exhibition.
4. Levy, *Memoir,* pp. 135–47, 110–12.
5. *Los Angeles Times,* 12 October 1941 and 9 November 1941.
6. Howard Warshaw, interviewed by Susan Einstein, in "Los Angeles Art
Community: Howard Warshaw," Oral History Program, University of
California, Los Angeles, 1977, pp. 22–23, 34–40.
7. Marion Gore, conversations with the author, 23 June 1981 and 9
August 1993.
8. Alfred M. Frankfurter, "The Berman of the Western World," *Art News* 41
(15 February 1942): 27.

Wallace Berman
1926–1976

Fig. 29
Wallace Berman in Venice,
California, in the 1950s
Photograph by Charles Brittin

Wallace Berman's art is simultaneously joyous and somber, revelatory and enigmatic, reflecting his own contradictory persona. Indeed the lure of the artist's public and private facades has contributed to the varied critical interpretations of his work. Here is how the late art critic Thomas Albright described him: "I remember Berman from North Beach in the late '50s as a gentle, unassuming, vaguely rabbinical figure who gave away packets of poetry and curious pictures inscribed with Hebraic letters. Those who knew him earlier in Los Angeles sometimes describe a very different picture: a prototypical hipster with zoot suit and long watch chain who had collaborated in writing rhythm and blues tunes with Jimmy Witherspoon in 1946 and hung around the L.A. jazz scene."[1]

It is the latter Wallace Berman who is represented in this exhibition, by visionary-macho pencil drawings of Jimmy Durante and Louis Armstrong (cat. nos. 11, 12). The works were made in the mid-1940s, when Berman was a young adult. Like his later Verifax collages and *Semina* poetry and illustrated books, for which he is better known, these drawings are at once ominous and jubilant. In their fascination with vision, drugs, jazz, and interconnected life forces, these "portraits" precociously insinuate themselves into discourses of resistance against the mass culture of conformity in post–World War II America.[2] Writing about the half dozen drawings of celebrities that Berman produced between 1943 and 1947, Merril Greene noted that they are "desentimentalized and brutally ironic . . . early confirmation of Berman's preoccupation with content and with the use of duplicative processes to expedite the setting up of a formal language to contain his meanings."[3] If Berman's early drawings are surrealistic, even fantastic in their associations, they are more akin to the graphic political satires of German dada than to the dreamlike, fluid images characteristic of French surrealism.

The end of the period covered by this exhibition overlaps the crucial year of Berman's first public exhibition, in 1957 at the Ferus Gallery, run by Edward Kienholz and located on North La Cienega Boulevard in Los Angeles. Berman created a large installation of faux artifacts presented in a devotional environment. His dictum "Art is Love is God" was made material in this exhibition, which included fragments of simulated ancient Hebrew parchments and chamberlike assemblages. One of these sculptural objects, *Temple,* which resembled a confessional, included a small drawing made by Berman's friend Cameron, which depicted a couple in sexual embrace. When the exhibition was shut down by the Los Angeles Vice Squad on grounds of obscenity, Berman refused to withdraw the image.[4]

While *Homage to Hesse* (1949; fig. 14) predates the Ferus installation, it reflects a similar impulse to kindle the erotics of the body and the spirit. Indeed it functions as a miniature monument to the modern German writer Hermann Hesse, whose novels (especially *Siddhartha*) bring together the teaching of a secularized ethics with knowledge learned through the body. Berman made this provocatively sensuous and intellectual work out of discarded parts from the Salem furniture factory in Los Angeles, where he had worked for two years mass-producing copies of Shaker furniture. His transformation of the associative possibilities of common objects marks one of the confluences between surrealism and assemblage in California art. Rather than substituting one hierarchy for another, however, he refused to see any difference between the "high art" surrealist object and its fetishized and eroticized street cousin. His deeper impulse, in *Homage to Hesse* and in his aesthetic philosophy, was to bear witness to the abused beauties in sacred images and in those we often take for granted.

Berman's work has been exhibited in diverse contexts since the 1950s. Following his 1957 exhibition at the Ferus Gallery, he moved to the Bay Area and later opened a gallery with George Herms on a floating houseboat in Larkspur. They named it Semina Art Gallery and showed the work of other artists as well as their own. Berman and his colleagues often chose to exhibit their works in more private venues. In 1958, for example, he presented his photographs of painter and assemblage artist Jay DeFeo in a one-day exhibition at his San Francisco apartment. Despite Berman's selective and guarded stance toward exhibition, or perhaps because of it, his work began to attract wider notice in the mid-1960s. The Jewish Museum in New York presented a solo exhibition of his work in 1968. In 1978, two years after his death, the Fellows of Contemporary Art organized a retrospective exhibition at the Otis Art Institute in Los Angeles. And in the 1980s, with the renewed interest in assemblage art and its historical and theoretical relationships to surrealism and postmodernism, Berman gained new prominence. His work was included in major exhibitions, among them *Different Drummers* (notably organized by an institution outside California, the Hirshhorn Museum and Sculpture Garden, Washington, D.C., 1988); *Lost and Found in California: Four Decades of Assemblage Art* (James Corcoran Gallery, Santa Monica, California, 1988); *Forty Years of California Assemblage* (Wight Art Gallery, UCLA, 1989); *L.A. Pop in the Sixties* (Newport Harbor Art Museum, Newport Beach, California, 1989); and *Proof: Los Angeles Art and the Photograph, 1960–1980* (Laguna Art Museum, Laguna Beach,

11.
Untitled, c. 1943–47
Pencil on paper
14^1/$_2$ x 11^1/$_2$ in.
Collection of Tosh Berman; courtesy L.A. Louver Gallery, Venice, California

12.
Untitled, c. 1947
Pencil on paper
12^3/$_4$ x 10 in.
Collection of Shirley Berman; courtesy L.A. Louver Gallery, Venice, California

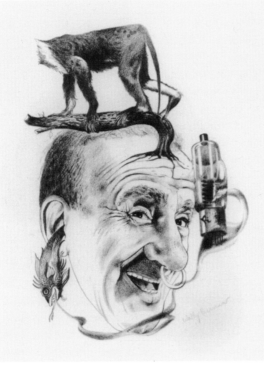

11

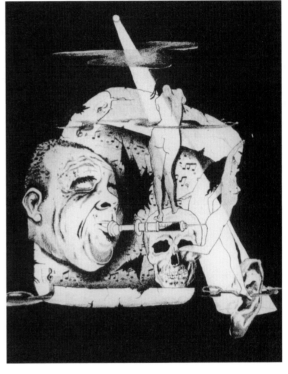

12

California, 1993). Outside the United States the Institute of Contemporary Art, Amsterdam, organized the 1992 exhibition *Wallace Berman: Support the Revolution,* which recognized the political weight of the artist's coded hermeticism.

Berman's eclectic exhibition history is partly the result of how his visual strategies resist categorization, encompassing the irony of pop art, the poetics of surrealism, and the beat pathos of early California assemblage art. The utopian and revolutionary provocations of his art—though most powerfully represented in the cohabitation of repressive, taboo, and liberating images in his majestic Verifax collages—are nonetheless intimated in his early work.

Andrea Liss

Notes

1. Thomas Albright, "Influential Visions of Wallace Berman," *San Francisco Chronicle,* 24 September 1979, Datebook section.
2. The title of this exhibition, *Pacific Dreams,* evokes images of golden light and azure ocean, part of the mythology that drew not only artists to California after the war but real estate developers and potential home buyers as well. Yet it was hardly a dreamland for those who found themselves excluded by the state's racially restrictive housing covenants.
3. Merril Greene, "Wallace Berman: Portrait of the Artist as an Underground Man," *Artforum* 16 (February 1978): 55.
4. For more detailed accounts of censorship and legal proceedings arising from the Ferus exhibition, see Anne Bartlett Ayres, "Berman and Kienholz: Progenitors of Los Angeles Assemblage," in *Art in Los Angeles: Seventeen Artists in the Sixties,* exh. cat. (Los Angeles: Los Angeles County Museum of Art, 1981), pp. 12, 16; Greene, "Wallace Berman," pp. 56–57; Betty Turnbull, *The Last Time I Saw Ferus, 1957–1966,* exh. cat. (Newport Beach, Calif.: Newport Harbor Art Museum, 1976), n.p.; Sandra Leonard Starr, *Lost and Found in California: Four Decades of Assemblage Art,* exh. cat. (Santa Monica, Calif.: James Corcoran Gallery, 1988), pp. 91–93.

Ruth Bernhard
b. 1906

Fig. 30
Ruth Bernhard, 1935
Photograph by Edward Weston;
courtesy Ruth Bernhard

Ruth Bernhard gained much of her formative experience in photography in New York, but working in California had a consolidating effect on her art. Born in Berlin and trained at the academy there, she moved to New York in 1927 and began her photographic career as an assistant in the photography department at the women's magazine *The Delineator,* run by Ralph Steiner. Her tenure there was short-lived, but she went on to do free-lance work, spotting prints for Cecil Beaton and Eric Salomon and photographing for a clientele that included the artists and designers Henry Dreyfuss, Frederick Kiesler, and Russel Wright. She was successful, and her work was exhibited and published; her photographs were included in the 1934 exhibition *The Machine Age* at the Museum of Modern Art and were reproduced in the magazine *Advertising Age.*

Bernhard's early style was very much a synthesis of ideas and influences from the people around her. Her connections to the European circles through which surrealism spread were very strong: her father, a well-known typographer and graphic artist who had settled in New York, was acquainted with many artists, and her own clients, such as Beaton and Kiesler, were part of the surrealist circle in New York. Bernhard's earliest images drew on a number of surrealist motifs and devices, many of which had already been incorporated into advertising and editorial photography. She would often set up simple objects in harsh light against neutral backgrounds, which had the effect of dislocating the objects and creating a disquieting sense of estrangement.

Bernhard met Edward Weston while visiting Los Angeles in 1935 and was struck by the intense transformation of subject in his photographs and by his single-minded commitment to his work. She moved to Los Angeles in 1936, hoping to study with him, but Weston had moved to Carmel in the interim. Instead she set up a small studio and became known for her portraits, particularly of children. She focused on her own art as well, making still lifes that reflected the surrealist values of her New York training. Some, such as *Creation* of 1936 (cat. no. 13), incorporated elements she found in her walks along Hollywood Boulevard or in the doll hospital below her studio. These works clearly had a European, surrealist aspect; unlikely combinations of things, disparities of scale, and unusual, bold lighting were all skillfully utilized to make the familiar seem unfamiliar—not merely exotic but jarring, disjunctive.

As Bernhard continued to work in Los Angeles, the tenor of her images began to shift. The influence of Weston's essentialist works was a definitive factor in this evolution. She began to give up some of the conventions of commercial photography,

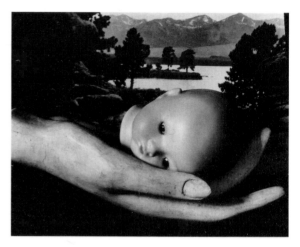

13

replacing them with a recognition of the interpretative aspect of her art. She very much admired Weston's ability to create eloquent images that reflected the essential nature of the things that they pictured. Her *Puppet, Hand and Foot, Hollywood* (cat. no. 14) was made in 1938; treating the elements as graceful, almost living forms, Bernhard abandoned the purely surrealist and approached the lively but simple compositional quality of Weston's photographs of Mexican *jugetes,* or toys. Her later images, particularly the nudes and portraits, reflect this change in emphasis and conception even more strongly.

In 1939 Bernhard moved back to the eastern United States. She became a more active participant in the photography world there but spent much of her time involved in war relief projects. *Dead Sparrow* (1946; cat. no. 15) is an image from late in this period. In it are obvious traces of Bernhard's surrealist interests, but she overcame the artificial, automaton-like character of the dolls by posing them so that they seem to act humanely and sympathetically. The lighting is more diffuse, and the forms are whole rather than isolated or fragmented. They assume a curious peacefulness and an emotional resonance that contrasts with the coldness of some of the earlier assembled tableaux.

In 1947, after the war, Bernhard returned to Los Angeles but became severely ill and for the next ten years made very few photographs. During this time she became friendly with a number of photographers working in San Francisco, Ansel Adams and Imogen Cunningham among them. The Bay Area had a firmly rooted progressive tradition: the second modern art museum in the United States had been founded there in 1935, and in the late 1940s and early 1950s the California School of Fine Arts (later the San Francisco Art Institute) was among the most

13.
Creation, 1936
Gelatin silver print
10$^{1}/_{2}$ x 12$^{1}/_{2}$ in.
Collection of Page Imageworks:
Merrily and Tony Page

14.
Puppet, Hand and Foot,
Hollywood, 1938
Gelatin silver print
7$^{1}/_{2}$ x 9$^{3}/_{8}$ in.
Collection of the artist

15.
Dead Sparrow, 1946
Gelatin silver print
10$^{1}/_{4}$ x 13$^{3}/_{8}$ in.
Collection of the artist

dynamic and innovative art schools in the country—and one of
the most idealistic—with a strong program in photography. The
San Francisco art world proved a fertile ground for Bernhard,
who moved there in 1953. Her contact with other artists, and
with ideas about art which emphasized self-awareness in the
creative process, greatly influenced the direction of her art. She
began to use smaller cameras and to photograph nudes, and
her interest in the expressive personality of her subjects—as
opposed to the artifice expressed in her arrangement of them—
altered the character of her photographs.

Many of Bernhard's best-known images come from this
later period. By this time she had thoroughly synthesized the
influence of Weston's photographs as well as the ideas of
others, including Adams, Cunningham, and Minor White. All
of these artists valued individual creativity and awareness as
much as technique. Bernhard's nudes have a sensuousness
of surface that characterizes the subjects as particular beings,
yet at the same time they seem very idealized. In this transcen-
dence of concrete fact, the harsh observation and disengage-
ment of her earlier work gave way to a sense of spirit and
animate form, and surrealist dystopia was abandoned for
utopian ideal.

Sheryl Conkelton

15

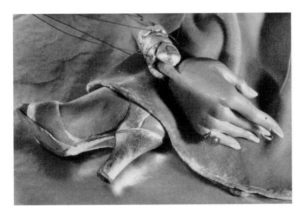

14

Dorr Bothwell
b. 1902

Dorr Bothwell was born in San Francisco, and it was there that she went to art school and began her career as an artist. In 1927, however, she embarked on a nomadic phase, living in Samoa for two years, traveling in England and western Europe for another year, and finally ending up in San Diego, where she married the sculptor Donal Hord in 1932. The marriage lasted only two years before Bothwell moved on to Los Angeles. There she got a job with the pottery manufacturer Gladding McBean and, in 1937, worked on murals for the Federal Art Project (WPA), through which she met Lorser Feitelson and Helen Lundeberg.

Bothwell's symbolist works date from the few years directly following her work on the Federal Art Project through the end of World War II, which she spent in San Francisco. Most give visual form to personal memories or ideas by presenting objects in unusual juxtapositions against a vast, simplified, and empty landscape. This series of figural works grew out of her experience on the Federal Art Project, where she was assigned the job of finishing narrative murals begun by others whose relief time allotment had run out.

The Primrose Path (1938; cat. no. 16), a work from this series, was inspired by a carved and painted Japanese wooden doll given to Bothwell by a friend who had visited Japan. She loved its mystery, not knowing which festival it was dressed for. Without a full plan, but knowing that she did not want to paint a still life, she chose a canvas that she thought was a good size and began sketching the doll a bit larger than life. Feeling the need for yellow to enhance the colors of the doll, she added a ribbon (the "primrose path"). In the background a huge cat's face formed. (Cats are a recurring image in Bothwell's painting.) It is an imaginary Russian gray, one of her favorite breeds because its color seems to make it disappear in the moonlight. The moon represents femaleness and mystery.

Bothwell rarely made preliminary drawings for her paintings. Beginning with an idea, she would "sketch" it on canvas, usually with a brush and ultramarine blue thinned with turpentine to watercolor consistency, intuitively balancing the elements into a composition and carefully crafting the images. Then she filled in the main masses and worked over each section, sometimes with three or four coats of paint. She counted on the juxtaposition of colors to add vibrancy.

We Sleep with Our Feet at the Head of Our Four-Footed Bed (1940; cat. no. 18) is the direct pictorial transcription of one of Bothwell's rarely remembered dreams, from which she awoke chanting the title.[1] She is the sleeping figure on the back of the lion in the foreground. The lighthouse—not actually present on

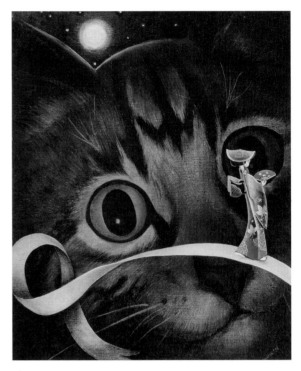

16

the shoreline around La Jolla, California, which is represented in the painting—sends out a beam that she interpreted as a warning to stop wasting her time socializing in Los Angeles and to return to serious painting in San Francisco. To Bothwell the objects in the painting are Jungian symbols. The figure in the cloak represents not death, but her inner artistic "guide." The lions allude to our animal nature; feet, to our understanding; and the ocean, to the subconscious. Later in 1940 Bothwell was financially able to move to San Francisco, and by the end of the war she had found a new technique, screenprinting.

Family Portrait (1940; cat. no. 17; color plate 9) represents Bothwell's younger brother, Stuart. The two children had very different personalities, sharing only a love of the outdoors. Although Stuart was musically gifted—he had perfect pitch and was a self-taught drummer—he led a very conventional life, going into the lumber business like his father and enjoying a stable marriage. Bothwell remembers him as a humorless man. The main image is derived from a family photograph of Stuart at age three or four taken around 1906–7. Stuart wears a dress that Bothwell's English grandmother sent him. The sash is in the hunting plaid of the Stuart clan, with whom the Bothwells intermarried. The naked blue-green half of the child's body refers to the early Britons, who "painted themselves blue with a plant called woad." A tree with one leaf on it (Stuart was the last

16.
The Primrose Path, 1938
Oil on canvas
24 x 20 in.
The Schoen Collection,
New Orleans

18.
*We Sleep with Our Feet at the
Head of Our Four-Footed Bed,*
1940
Oil on canvas
16 x 20 in.
Collection of James and Linda
Ries

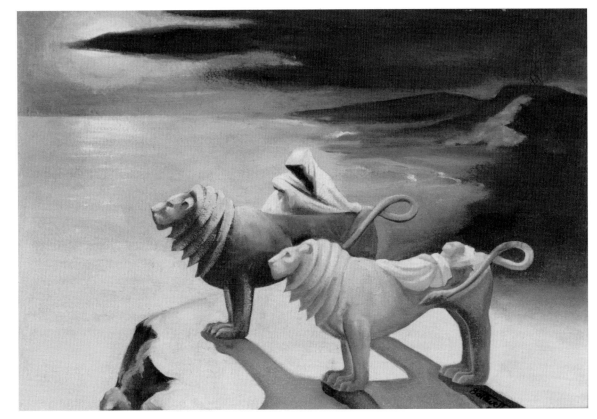

18

male of his branch of the Bothwell line) grows in a fenced-in cemetery. The gray cloud represents Bothwell's view of Stuart's personality, as does the calla lily, a flower grown by her parents, which Bothwell saw as elegant and gracious but lacking in scent and real attraction. Compositionally the opposing curves of the tree and flower balance the child's arched stance.

Table in the Desert (1942; cat. no. 19; color plate 10) was inspired by an actual experience. Driving east of Palm Springs on her way to a desert camping spot, Bothwell was struck by the sight of an oak table with claw feet that someone had abandoned in the desert. She froze, recognizing a perfect painting, wondering if it had been put there as a message for her. She immediately made a rough sketch, and when she returned to San Francisco, she worked up a couple of ideas that included objects on the table but finally decided to paint the image just as she had seen it. To Bothwell the table symbolizes the desert. At first glance it seems empty, yet for one who looks deeper the desert offers an invisible repast of extraordinary peace, a wide expanse of blue sky, and secrets. The exaggerated claw feet represent the determination of life forms to survive in unsympathetic circumstances.

This brief series of symbolic paintings was followed by a career in teaching and work in screenprinting, a medium in which Bothwell was especially successful. Many similar threads run through her figural paintings. Her symbols and messages are concrete, and her works are more spontaneous and intuitive and less cerebral than those of Post-Surrealists such as Feitelson and Lundeberg. It was only upon considering the completed canvas that she realized the meaning of the objects to her, their relationship to one another, and the overall message. Knowing how she interpreted the symbols is crucial to understanding the paintings. In interviews she often uses the words *mystery* and *secrets,* and her paintings are as much a release and expression of her own response to the world's mysteries as they are created mysteries for us to experience.

Nancy Dustin Wall Moure

Notes
1. This painting is discussed at length in *A Time and Place: From the Ries Collection of California Painting,* exh. cat. (Oakland: Oakland Museum, 1990), pp. 162–65.

Hans Burkhardt
1904–1994

Fig. 32
Hans Burkhardt in the 1930s
Photograph courtesy Jack
Rutberg Fine Arts

Like most of the first-generation abstract expressionists, Hans Burkhardt developed his style under the potent influence of surrealism, especially its concern with unpremeditated painting. The Museum of Modern Art's exhibition *Fantastic Art, Dada, Surrealism,* mounted in 1936, had perceptible repercussions on the New York avant-garde, as did exhibitions of work by Yves Tanguy, Joan Miró, and André Masson at the Pierre Matisse Gallery. During World War II, when the United States provided temporary refuge or permanent residence to émigrés, many of the surrealists made their presence felt in the New York art world. When Arshile Gorky exhibited his biomorphic abstractions at the Julien Levy Gallery in 1945, André Breton recruited him as one of the last full-fledged members of the surrealist group. By that time Burkhardt, who had been Gorky's student and collaborator, had long been in Los Angeles, where he settled in 1937. But he recalls Gorky's statement: "'Hans, out of all the young artists I have faith in just two.' That was de Kooning and myself."[1]

Burkhardt was born in Basel in 1904. As a child he was affected by reproductions of Matthias Grünewald's Isenheim altarpiece (completed c. 1515) and Arnold Böcklin's *Isle of the Dead* (1880) and by seeing Ferdinand Hodler's symbolist paintings in the Kunstmuseum in Basel. When he was twenty years old he immigrated to New York, where his father had settled, and began working as a furniture decorator, a craft in which he acquired considerable skill. He was not able to devote himself seriously to the study of painting until 1927, when he enrolled at the Grand Central School of Art, taking a life-drawing class with Gorky. Eventually he shared a studio with his mentor and helped him financially before Gorky joined the Federal Art Project (WPA) to paint the mural *Aviation* for the Newark Airport in 1935. Although the collaboration between the two painters—one born in Armenia and the other in Switzerland—in 1936 and 1937 produced interesting results, Burkhardt decided to leave New York in 1937. He drove to Los Angeles and found work as a furniture finisher while continuing to paint. He was more politically engaged than his erstwhile teacher and most of the New York painters, and he frequently painted pictures with political content, beginning in 1939 with works relating to the Spanish Civil War.

The majority of Burkhardt's paintings of the 1940s and 1950s are, however, in an abstract mode. *Abstraction* (1941–42; cat. no. 20), for example, owes as much to cubism as to surrealism. Biomorphic as well as angular shapes exist in a shallow, airless space created by overlapping forms. At this point Burkhardt's work diverged significantly from Gorky's

contemporaneous paintings, which included plumes of bright colors and organic forms and were greatly indebted to Wassily Kandinsky's early expressionist abstractions. And whereas Gorky worked with thin, washlike applications of paint, Burkhardt's surfaces have more weight and density. Following his own inclination, Burkhardt, painting in Los Angeles, stayed outside the mainstream established by his colleagues in New York. And, as the proprietor of a business in finishing and decorating furniture, he did not have to rely solely on the sale of his art. Even after he received national attention and exhibited his work widely, he enjoyed greater freedom and independence from the art market than many of his contemporaries.

Although influenced by surrealism, Burkhardt's work remains on the margins of the movement. It partakes little of Breton's "convulsive beauty" and even less of Georges Bataille's "amour fou." The Swiss painter's work is much more restrained, his palette of burnished tones creating a quiet harmony. Nevertheless, like many surrealist works, paintings such as *Woman with a Wine Glass* (1947; cat. no. 21) and *Black Cloud over Vineyard* (1953; cat. no. 22) take their inspiration from dreams. By this time Burkhardt was in fact in close contact with the surrealist contingent in Southern California. Not long after his arrival in Los Angeles he met Lorser Feitelson, and beginning in 1945 he exhibited regularly at Fred Kann's Circle Gallery, which also showed work by Man Ray, Knud Merrild, and Eugene Berman.

Burkhardt's paintings are conducive to multiple interpretations, a quality they share with those of the surrealists. Many associations occur to the viewer of a painting such as *Woman with a Wine Glass.* The yellow form toward the upper right is quite possibly a skull, anticipating Burkhardt's extraordinary skull paintings, made during the Vietnam War. This viewer also detects vegetal and insect configurations in *Black Cloud over Vineyard,* which may relate to the artist's boyhood experiences in a Basel orphanage, where he had to tend the garden. Certainly the black cloud in the upper left threatens the quiet harmonies of reds and rusts in the painting. Indeed a sense of trauma and tragedy—if not outright catastrophe—pervades the work produced throughout Burkhardt's almost seventy years as a painter.

Peter Selz

Notes
1. Hans Burkhardt, interviewed by Colin Gardner, in *Hans Burkhardt: The War Paintings* (Northridge, Calif.: Santa Susana Press, 1984), p. 10.

20.
Abstraction, 1941–42
Oil on canvas
48³/₄ x 29³/₄ in.
Courtesy Jack Rutberg Fine Arts,
Los Angeles

21.
Woman with a Wine Glass, 1947
Oil on canvas
37 x 46 in.
Courtesy Jack Rutberg Fine Arts,
Los Angeles

22.
Black Cloud over Vineyard, 1953
Oil on canvas
41¹/₂ x 54 in.
Courtesy Jack Rutberg Fine Arts,
Los Angeles

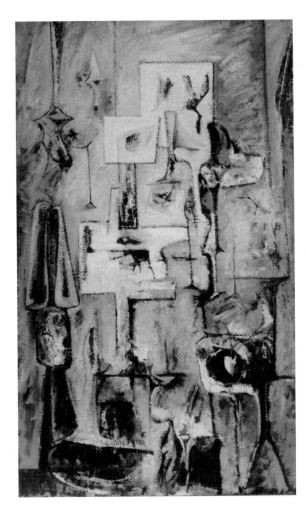

20

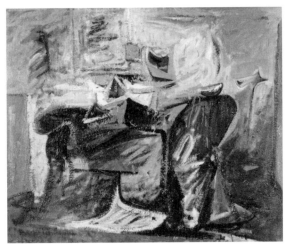

21

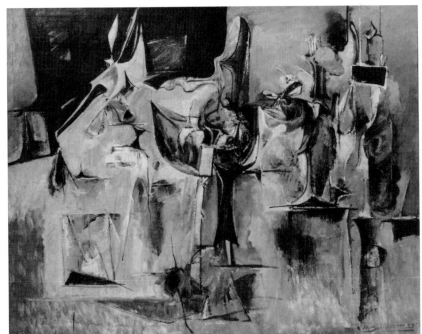

22

Grace Clements
1905–1969

Fig. 33
Grace Clements working on a
WPA mural at Venice High
School, 1938
Photograph courtesy Tobey C.
Moss Gallery

Grace Clements was a painter, graphic artist, and art writer who participated in the Post-Surrealist movement. Born in Oakland, she received her artistic training between 1925 and 1930 in New York, where she studied with Kenneth Hayes Miller and Boardman Robinson. There she was probably also exposed to the synthetic cubism that was brought to the East Coast by the many American painters who had spent time in Paris.

Clements settled in Los Angeles in 1930 and quickly gained a significant position as an exhibiting artist, teacher, and spokesperson for avant-garde aesthetic philosophies in the city's fledgling modern art community. Not long after her arrival in Los Angeles she had a solo exhibition at Jake Zeitlin's Book Shop, a venue known for showing work by both established and emerging artists. Local critics praised Clements for her modernist approach, which distinguished her from the majority of her contemporaries.[1] Just one year later, in 1931, she was honored with a solo exhibition at the Los Angeles Museum. The twenty-one paintings in that exhibition demonstrated the range of her thematic and stylistic interests, including her increasing experimentation with modernism. Included were portraits, figure studies, landscapes incorporating cubist and school of Paris devices, and abstract studies.[2]

Clements's role as a teacher at the Chouinard and Stickney schools and as a private instructor at her studio in Laguna Beach, California, undoubtedly helped her to concretize her artistic position. Opposed to mindless copying and strict adherence to identifiable forms and methods, she encouraged her students to adopt a drawing method based on a flexible range of skills, used by artists at the archaeological sites under the direction of Franz Boas in Mexico. In her suggestion that the student "dream his work out of his own imagination and his production will be unique," Clements first openly took a position linked to surrealist principles.[3] In other writings she championed the Post-Surrealist convictions that simultaneously emerged in her work:

> Modernists do not work with accidents. We have a definite premise on which every painting is built. Reason rather than emotion is our foundation. Contrary to the old belief that the artist's task is to paint moods and inspire sentiment by copying the moods and sentiment of nature, the modern idea recognizes the impossibility and worthlessness of mere copying of natural forms and believes that the first requirement of art is to increase our experience and knowledge of life. The moderns are working on a purely classical idea, that architecture is the mother

of all the arts. We work in terms of formal relationships, line, color, space, solidity. Subject matter is of secondary importance and literary interpretations are looked upon as trespassers to all plastic art.[4]

Post-Surrealism, or subjective classicism, was brought to a national audience, first with Clements's article "New Content— New Form" in *Art Front,* which presented the artists' theoretical position, and then with the landmark exhibition that traveled from the San Francisco Museum of Art to the Brooklyn Museum in 1936. Clements's painting *Reconsideration of Time and Space* (1935; cat. no. 23) was included in that exhibition. She was praised by critics for her ability to apply Post-Surrealist theory to her work:

> Clements is the only one who gives a precise pictorial meaning to her social criticism. In her painting, "1936, Figure and Landscape," a pattern of marching soldiers forms a skeleton under a monument to liberty which is bound around the same rope that is committing a lynching. Her forms are intelligently grouped, her imagination lively and she is temperate in her use of the Dali narcotic. . . . "Reconsideration of Time and Space" is her finest composition. In the others she skilfully adopts elements of cubism and surrealism to express her indignation at the Capitalist program of unemployment, starvation and war.[5]

Reconsideration of Time and Space is indeed a pivotal work in Clements's oeuvre. While incorporating the architectural fragments and trompe l'oeil textural effects of synthetic cubism, she experimented with a range of issues and ideas. Her debt to metaphysical painting is apparent with the inclusion of the small, solitary figure on the right, which casts a looming, ominous shadow. The group of pedestals placed in the center, in front of an opening in a fragment of free-floating wall, reveals the influence of the more psychological tendencies associated with Giorgio de Chirico. Three of the pedestals are eerily empty, while a globe stands on the tallest. The focus on the positive aspects of modern technology—a single-span suspension bridge, radiating communication wires, and a single biplane— indicates a strong note of optimism despite the Depression and the eventual threat of war.

Aerial communication also served as a major thematic and compositional device in Clements's most extensive project, a group of murals and floor mosaics at the Long Beach Airport, carried out in 1942 under the auspices of the Federal Art Project (WPA). The project encompassed twelve hundred square feet of

23.
Reconsideration of Time and Space, 1935
Oil on canvas
41³/₄ x 34¹/₄ in.
The Oakland Museum,
gift of the artist

murals and sixty-three hundred square feet of floor mosaics and marked the culmination of her career as a practicing artist. Clements's marriage in 1938 and eventual move to Northern California may have precipitated her choice of a more private life. From 1943 to 1945 she wrote critical essays and reviews for *California Arts and Architecture,* and as late as 1961 she wrote an essay on a folio of pen and ink drawings by Peter Krasnow, yet there is no evidence that she continued to exhibit her own work.

Barbara C. Gilbert

Notes
1. *South Coast News* (Laguna Beach), 17 October 1930.
2. Merle Armitage, *An Exhibition of Modern Paintings by Grace Clements,* exh. brochure (Los Angeles: Los Angeles Museum, 1931).
3. *South Coast News,* 5 September 1930.
4. *South Coast News,* 17 October 1930.
5. Joe Solman, "The Post Surrealists of California," *Art Front* 2 (June 1936): 12.

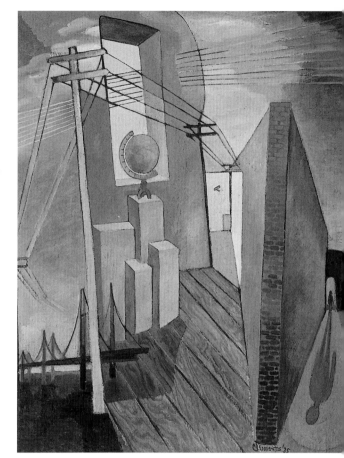

Will Connell
1898—1961

Fig. 34
Self-portrait of Will Connell,
1938
Photograph courtesy
Department of Special
Collections, University
Research Library, UCLA

Will Connell was born in Kansas in 1898. Like many well-known photographers of the first half of the twentieth century, he became fascinated with the medium as a child, when he was given a Brownie camera. Relatively easy to operate, the Kodak camera introduced a means of communication to the twelve-year-old boy, whose future career in photography would include advertising work, teaching, and writing about technical aspects of photography.

Even though he tended more toward experimentation than conformity, Connell followed a conventional photographic path during the early part of his career. In the 1920s, as a member of the Camera Pictorialists of Los Angeles, he practiced the soft-focus romantic style popular during the early decades of this century. While black-and-white photography is in itself a reductive abstraction of reality (three dimensions to two, color to monochrome), pictorialism endeavored to reduce the appearance of the photograph into something even less accurate, less machine made, and thus (in the contemporary view) more artful. By the 1930s, however, Connell began moving toward a more geometric, sharp-focus, modern style. Van Deren Coke has noted that by this time he "had already made a number of well-conceived and executed photograms indicating a level of sophistication that was unusual anywhere in America."[1]

What distinguishes Connell from many American photographers of this era, however, is his use of the photographic montage.[2] A montaged photograph has been described as one that employs either sandwiched negatives or a cut-and-paste reordering of photographed objects and space, which sometimes involves rephotographing for an even, seamless effect. To move from the fictional reality of pictorial photography to photograms and the imaginative use of the montage seems a consistent, even logical shift of vision.

In 1932 Connell began a series of fictional photographs that would be published five years later in a book entitled *In Pictures*. Like many surrealist books, *In Pictures* included a separate text that the forty-eight images did not so much illustrate as intersect. The book tells the story of four writers dreaming up a screenplay. Connell's pictures are satirical character studies of types found in Hollywood. Many of them attest to the photographer's own discouragement in the face of the cold-hearted industry of make-believe. Mike Davis has described the kind of cynicism expressed in Connell's work as "noir": "As the Depression shattered broad strata of the dream-addicted Los Angeles middle class, it also gathered together in Hollywood an extra-ordinary colony of hardboiled American novelists, and anti-fascist European exiles. Together they reworked the

metaphorical figure of the city using the crisis of the middle-class . . . to expose how the dream had become a nightmare. Although only a few works directly attacked the studio system, *noir* everywhere insinuated contempt for a depraved business culture."[3] The surrealistic tenor of this shattered dreamscape pervades *In Pictures*.

No single photograph defines this sensibility better than *Make-up* (c. 1933; cat. no. 24), which was also reproduced on the book's original dust jacket. It is a montaged close-up portrait of a young woman, the left side of whose face is heavily made up. In the corner of the photograph is a toy-sized man standing on a footstool applying mascara to the woman's colossal left eye from a long brush. The enormous disparity in scale between the two figures, together with the vertical split of the natural and made-up halves of the face, creates a formally complicated illustration that is open to various readings. Which figure is actual size? It could be argued that the diminutive man altering the natural image of the woman (and it should be noted that the part of her that is being altered is the eye) is symbolic of the role Connell has assumed as a photographer-storyteller. As the poet Paul Eluard, writing about surrealist poetry and painting, stated: "To see is to understand, judge, deform, to forget or to be lost, to be or to disappear."[4] Connell, the diminutive seer, reappears in *Still Man* (1937; cat. no. 27) carrying a view camera, film holders, and a large, cumbersome equipment case. Here he manifests Eluard's states of being lost and being or disappearing, as his tiny figure is overwhelmed by a forest of gigantic legs.

Such exaggerated shifts of scale are a surrealist tactic often used to convey angst. Connell employs this strategy throughout *In Pictures*, even in straight, single-shot images. In *Props* (1937; cat. no. 26) a large, burly, cigar-smoking man clutches a dainty porcelain figurine of a woman by the legs. By virtue of his size the prop man is the evil brute or "King Kong" squeezing the vulnerable prop. Is Connell again the "prop" waiting to be used? *Opticman* (1936; cat. no. 25), which is formally more allied with constructivism, was omitted from the published book. Like all of Connell's photographs in *In Pictures*, however, it is polished with cynicism. The Cyclopean magnifying glass grotesquely deforms the nose on the face of the "seer," while situating us, the viewers, in the position of being the observed. European in sensibility and form, *In Pictures* won a medal of merit at the Paris Exposition.[5]

While pursuing an active career as a commercial and editorial photographer, Connell also contributed a monthly column on photographic techniques to *U.S. Camera* from 1938 to 1953.

24.
Make-up, c. 1933
Gelatin silver print (printed by
Peter Stackpole, c. 1980, from
original negative)
12¹/₂ x 10 in.
Will Connell Archive, California
Museum of Photography,
University of California,
Riverside

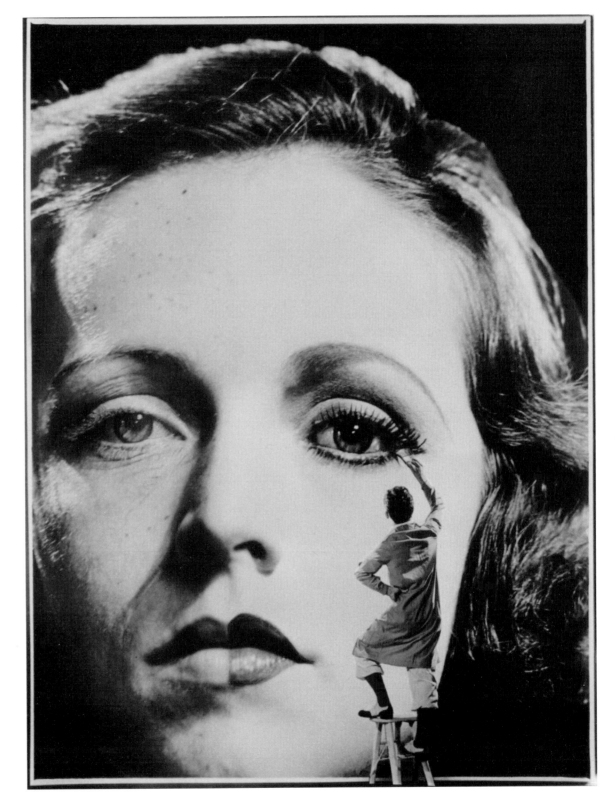

25.
Opticman, 1936
Gelatin silver print
9 1/2 x 7 1/2 in.
Courtesy Stephen White
Associates

26.
Props, 1937
Gelatin silver print
11 1/2 x 9 1/2 in.
Courtesy Stephen White
Associates

As a teacher at the Art Center School in Los Angeles, whose photography department he helped establish in 1931, he passed on his progressive ideas and techniques to several generations of students until his death in 1961.

Deborah Irmas

Notes

1. See Van Deren Coke, *Photographs by Will Connell, California Photographer and Teacher (1898–1961),* exh. cat. (San Francisco: San Francisco Museum of Modern Art, 1981), p. 5.
2. See Sally Stein, "Good Fences Make Good Neighbors: American Resistance to Photomontage between the Wars," in *Montage and Modern Life, 1919–1942,* ed. Matthew Teitlebaum (Cambridge: MIT Press, 1992), pp. 129–89.
3. Mike Davis, *City of Quartz* (New York: Vintage Books, 1992), pp. 21–22.
4. Paul Eluard, "Poetic Evidence," in *The Surrealists Look at Art,* ed. Pontus Hulten (Los Angeles: Lapis Press, 1990), p. 28.
5. David Fahey and Linda Rich, *Masters of Starlight: Photographers and Hollywood,* exh. cat. (Los Angeles: Los Angeles County Museum of Art, 1987), p. 120.

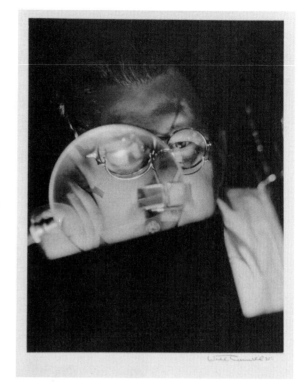

25

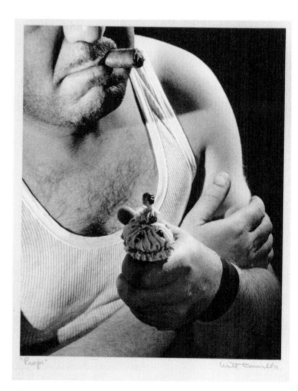

26

27.
Still Man, 1937
Gelatin silver print
13^{1}/$_{2}$ x 10^{1}/$_{2}$ in.
Department of Special
Collections, University
Research Library, UCLA

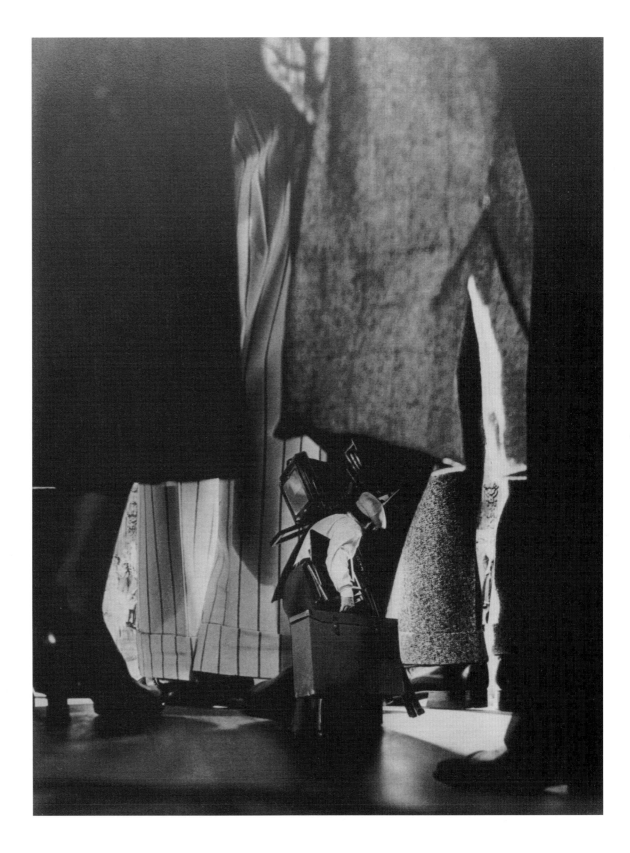

Salvador Dali
1904–1989

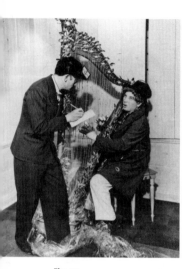

Fig. 35
Salvador Dali sketching Harpo Marx, 1937
Photograph courtesy Hearst Newspaper Collection, Department of Special Collections, University of Southern California Library

With his bizarre imagination, carefully cultivated image, and lifelong fascination with film, Salvador Dali might have been a Hollywood creation. Although this quintessential surrealist was only an occasional visitor to Southern California, it was the film industry and its colorful characters that attracted him.

Dali's first film, *Un chien andalou* (1928), was made in collaboration with Spanish filmmaker Luis Buñuel. Summoned to Paris to work with Buñuel, Dali made contact with other artists who were experimenting with antirational art forms. In 1934 he and his wife, Gala, took their first trip to the United States on the occasion of an exhibition of Dali's work at the Julien Levy Gallery in New York. An additional two years passed before the couple arrived in Hollywood.

Their way was paved by the surrealists' fascination with the Marx Brothers and Dali's particular affinity for the screen persona of Harpo Marx. While other surrealists were content to admire the comedy team on film, Dali pursued his idol in the flesh.[1] In December 1936, shortly after arriving in New York on his second trip to the United States, Dali sent Harpo a Christmas gift of a harp strung with barbed wire. Apparently delighted, Harpo responded with a photograph of himself with bandaged fingers and a cable inviting Dali to visit him in Los Angeles. The *Los Angeles Examiner* documented their meeting in February 1937, publishing a photograph of Dali sketching Harpo as he played the instrument of torture (fig. 35).[2]

Dali had come to Los Angeles with an idea for a movie to be called *Giraffes on Horseback Salad.* He stayed with Harpo, and the two developed a screenplay, but the film was never made.[3] All that remains of their collaboration is about a dozen sketches and some notes for a scene in which Harpo, costumed as Nero and restrained by chains, is put on trial for using money for evil purposes. One pencil drawing from this period portrays a rather beatific Harpo, with a halo of blond curls, strumming a harp (1937; cat. no. 28). Charcoal drawings and watercolors made during the collaboration portray such strange scenes as an outdoor dinner party with burning giraffes towering over a long table of diners. In a work called *Homage to the Marx Brothers,* a concert hall in the shape of a ship's prow sails through a sea of cyclists.

The Dalis traveled frequently in the late 1930s, spending most of their time in Paris, New York, and London.[4] As World War II made it increasingly difficult to lead any semblance of a normal life in Europe, they decided to take up residence in the United States. Arriving in New York on August 16, 1940, they initially stayed with their friend Caress Crosby in Hampton Manor, near Fredericksburg, Virginia. For the next eight years

the couple spent most of their time in Hampton Manor, New York, and California, where they often stayed at the Del Monte Lodge in Pebble Beach.

Dali was a productive expatriate, fulfilling commissions for magazine illustrations, window designs, and ballet costumes and sets as well as exhibiting his paintings.[5] A 1941 show traveled from the Julien Levy Gallery to the Arts Club of Chicago and then to the Dalzell Hatfield Gallery at the grand old Ambassador Hotel in Los Angeles. In 1943 Dali's portraits of American personalities were shown at the Knoedler Gallery in New York.[6] Among his subjects was Dorothy Spreckels, heiress to the California sugar family. She posed for Dali in Atherton, California, but he portrayed her as a dreamy seductress in a surreal seascape. Wearing a draped nightdress hiked up over her bare thighs, she sprawls on a sleek black sea creature, dipping one foot into the water and gazing up at the sky.

Dali's deepest involvement with Hollywood took place from 1944 to 1946, when he worked on two films, Alfred Hitchcock's 1945 psychological thriller, *Spellbound,* and a Walt Disney production called *Destino,* which was never finished. Hitchcock reportedly sought Dali's help on *Spellbound* because he admired the painter's imagination and sought dream imagery that would be more striking than the standard mist and smoke produced by dry ice.[7] In the film Ingrid Bergman stars as a psychiatrist in love with a tortured amnesiac played by Gregory Peck. Dali's task was to illustrate the amnesiac's dreams, which contained clues to his identity and proved that he did not commit a murder of which he had been accused. Dali worked on three different dream sequences for the film, but only one—a vast curtain filled with images of eyes—was used, in a scene that lasts less than three minutes. *The Eye,* an oil-on-wood painting executed in 1945, was probably inspired by Dali's work on the film, but instead of surrounding the viewer with eyes, the painting portrays the piercing gaze of a single eye.

Dali's work with Hitchcock led to an invitation from Walt Disney to work on *Destino,* a film in which real actors and objects were to have mingled with animated characters and settings. Dali worked at Disney's studio for at least two months, but only fifteen seconds of film were completed before the project was abandoned.[8] Among the paintings Dali developed for *Destino* is an image of Jupiter's head (1946; cat. no. 29; color plate 12), which indicates the kind of visual ambiguities he had hoped to incorporate into the film. Inviting multiple interpretations, the central image in the painting can be seen as an arched gateway leading to a barren landscape or, alternatively, an antique sculptural head whose nose is a seated female

28.
Harpo Marx, 1937
Pencil on paper
16^1/$_4$ x 12^3/$_4$ in.
Philadelphia Museum of Art,
Henry P. McIlhenny Collection,
in memory of Frances P.
McIlhenny

30.
Untitled (Surreal Cityscape),
1946
Oil on masonite
19 x 23 in.
The Walt Disney Company

28

30

figure and whose beard is a Medusa-like head. An untitled cityscape of 1946 (cat. no. 30), also painted for the unfinished film, evokes a mood of cultural decay in an eerie pastiche of crumbling walls, broken statuary, a toppling column, and dramatic shadows. It is a forbidding scene, made more ominous by an emaciated figure who leans on a crutch in a desperate attempt to descend a steep flight of stairs and enter the deserted square.

During his Hollywood sojourns Dali became acquainted with various people in the film industry, and some of these contacts led to commissions. He painted a portrait of producer Jack L. Warner's wife, Ann, in 1944 and later painted the film mogul himself (see cat. no. 31). In each of these portraits the subject looms large in a miniaturized landscape. Dali portrayed a pensive Ann Warner with upswept hair, dressed in a scarlet one-strap evening gown. She rests one arm on a garden wall in the foreground of the painting, while a tiny likeness of the Warner mansion sits on a jagged pinnacle in the distance. In his portrait Jack L. Warner appears as a self-satisfied Hollywood businessman. Wearing a blue suit and a toothy grin, he too poses behind a garden wall, but this time it doubles as a desk. As if seated in his office, he holds a letter in one hand and pats his well-groomed dog with the other. His white porticoed palace and its formal gardens stretch out in the background under a Hollywood sky. Both portraits are unmistakably Dali's work, but Jack L. Warner's has the look of a commission that was dutifully executed to illustrate success.[9]

Dali's presence in Los Angeles probably did more for the local press than for his artistic development. While the metamorphic quality of his work was well suited to film techniques, he had already done his best paintings before he arrived in California. If anything, his Hollywood experience appears to have softened his work and to have taken the weird edge off his vision. Had more of his ideas been used in *Spellbound* and had *Destino* been finished, he might have left a dramatically different record. The one that remains is evidence of a fascinating but decidedly minor interlude in a flamboyant career.

Suzanne Muchnic

Notes

1. James Bigwood, "Salvador Dali, Reluctant Filmmaker," *American Film* 5 (November 1979): 63.
2. Robert Descharnes, *Salvador Dali: The Work, the Man* (New York: Harry N. Abrams, 1984), p. 158.
3. Bigwood, "Salvador Dali," p. 63.
4. Descharnes, *Salvador Dali,* p. 225.
5. Ibid., pp. 257–63.
6. *Time,* 26 April 1943, p. 79.
7. James Bigwood, "Solving a *Spellbound* Puzzle," *American Cinematographer* 72 (June 1991): 35.
8. Descharnes, *Salvador Dali,* p. 289.
9. Kenneth Ross, "Maestro Salvadore Dali Reforms; Paints Religious Pictures," *Los Angeles Daily News,* 3 March 1951.

31.
Portrait of Colonel Jack Warner,
1951
Oil on canvas
42$^1/_2$ x 50$^1/_2$ in.
Syracuse University Art
Collection

Claire Falkenstein
b. 1908

Fig. 36
Claire Falkenstein with *Big
Apple,* 1989
Photograph by E. Bruce Howell;
courtesy Claire Falkenstein

A sensibility that echoed dada's repudiation of the rules undoubtedly underlay Claire Falkenstein's response as a junior at the University of California, Berkeley, in the late 1920s, when a visiting professor counseled her, "Look within!" The realization that seized her then—"I can do what I want to do, what I have to do, I'm free!"—was never more evident in her work than it was in the 1940s. The stream of invention that surged from her San Francisco studio over the decade, as she created the work that would serve as the foundation for her later career, demonstrated her independence from local trends. This work did, however, bear a kinship with surrealism.

Falkenstein graduated from Berkeley with a B.A. in art in 1930, the year of her first solo exhibition, at the East-West Gallery in San Francisco. She began studying sculpture with Alexander Archipenko at Mills College in 1933. Her sculptures of the 1930s were abstract ceramic works in which she explored spatial relationships and implied motion. By 1940 she had embarked on wood carving, with work that frequently suggested her exposure to the Northwest Coast Indian tradition in Coos Bay, Oregon, her birthplace and childhood home.

Falkenstein earned significant recognition in the San Francisco art community during the 1940s, winning numerous awards for her drawings, paintings, and sculptures. Her figural drawings in Conté crayon acknowledged her debt to cubism as the formal basis of her work. Yet she was restless, feeling she had exhausted the resources of the Bay Area. "I thought I needed something. I knew [about] Picasso and Arp, I thought of Picasso as my spiritual father, so I went to Paris. Paris was the right place to be."[1]

Falkenstein did not become acquainted with surrealism at first hand until she moved to Paris in 1950, but her affinities with the movement were evident a decade earlier. *Fertility* (1940; cat. no. 32) initiated a series of wood sculptures in which she rejected the traditional technique of carving in an effort to "explode the volume," opening up form to permit light and space to become components of the work.[2] With *Fertility,* however, she did not take up the band saw, as she would for most of the work that followed, but employed manufactured objects. The three vertically joined axe handles assumed a new identity, closer to the tradition reflected in Max Ernst's slatted *Bird* (c. 1916–20) than to Marcel Duchamp's readymades. Importantly, too, Falkenstein did not sacrifice the implications of organic growth already evident in her work, which allied her with Jean Arp. *Fertility,* for example, with its unabashed vaginal allusion, emerged unconsciously—even if it is reminiscent of Georgia O'Keeffe's Jack-in-the-Pulpit paintings (c. 1930).

Fertility marked a major step toward the Suns, the nest-like meshes of thin welded wire that would cap the early phase of Falkenstein's career in Paris in the next decade. The two-dimensional *Game* (1947; cat. no. 33) represented a further stride, engaging a found object in the form of X-ray film, one of the myriad grounds, sandpaper and carbon paper among them, with which she experimented in painting. Here the X-ray image of a torso is partly concealed by a collage of black paper cutouts. A spontaneously rendered linear configuration painted over this in egg tempera provides a third layer. In its Arp-like whimsy the work suggests a basketball game, the dotted line denoting the movement of the ball. Although this effect was unpremeditated—engaging chance, an element that is fundamental to surrealism—*Game* nevertheless addresses issues of time and motion, anticipating the concept of "moving point," which underlies Falkenstein's Point as a Set series of the 1950s.[3]

In entering Falkenstein's vocabulary in the 1940s, surrealism contributed to her later achievement much as it contributed to abstract expressionism. Giving her the freedom to do "what I have to do," it both spurred her evolution and endowed her work with multiple meanings. For Falkenstein this decade served as the opening to a new phase of her career. The work that emerged after her arrival in Paris affirmed her historical position and lent testimony to her influence. Indeed she was lauded by the critic Michel Tapié as a contributor to the new style termed *informel,* the French counterpart of abstract expressionism, the New York movement then reaching its pinnacle. Her experimentation and invention as well as her researches into the properties of materials, already potently demonstrated in works such as *Game,* testify to the extraordinary creative energy that has characterized the artist and her work ever since.

Merle Schipper

Notes
1. Conversation with author, 23 March 1993.
2. According to Maren Henderson, "she took her own sculpture apart in a process she termed 'exploding the volume'"; thus in works such as *Aggressive Figure* (1943) Falkenstein used a band saw to reduce the block to a skeletal form that could be taken apart ("Claire Falkenstein: Problems in Sculpture and Its Redefinition in the Mid-Twentieth Century," Ph.D. diss., University of California, Los Angeles, 1991).
3. Falkenstein's concept of the set, embryonic in the 1940s, referred to a set of signs or units to be repeated, with spaces between them, from the center to the periphery of the work.

32.
Fertility, 1940
Painted ash wood
38 x 12 x 17 in.
Collection of the artist

33.
Game, 1947
Tempera on X-ray film
11$\frac{1}{4}$ x 14$\frac{1}{4}$ in.
Collection of the artist

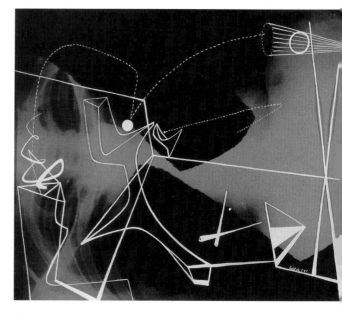

33

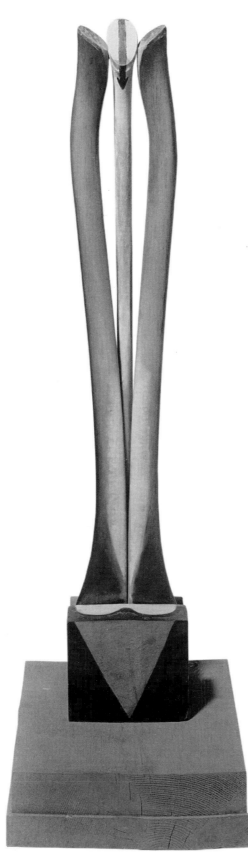

32

Lorser Feitelson
1898–1978

Fig. 37
Lorser Feitelson in his studio,
1949
Photograph by Lou Jacobs, Jr.;
courtesy Tobey C. Moss Gallery

Before the label Post-Surrealism gained currency, Lorser Feitelson and Helen Lundeberg called their movement new classicism.[1] An awareness of this provides insight into the artistic issues that concerned them and helps to clarify some important differences between their work and European surrealism. If classicism is taken to mean a preference for clarity over obscurity, unity over disunity, and rationality over irrationality, the two Los Angeles painters were lifelong adherents to its principles. A classical sensibility was at the heart of their movement.[2]

Upon his arrival in California in 1927, Feitelson began what was to become a lifelong involvement in the Los Angeles art world as an artist, public lecturer, teacher, and gallery director. Born in 1898 in Savannah, Georgia, but raised in New York, he was introduced to art as a youth by his father, an amateur in the old-fashioned sense of the word. Feitelson's early training in New York was academic and highly analytical, but the 1913 Armory Show introduced him to modern art and confirmed his decision to become a painter. In 1916 he joined the Greenwich Village art scene, and in 1919 he took the first of several extended trips to Paris, drawing at the independent Académie Colarossi and traveling throughout Italy to study the work of the Renaissance masters firsthand. He exhibited at the Salon d'automne in Paris and at several modern galleries in New York.

Returning to the United States in November 1927, he traveled to Los Angeles. What was intended as a winter sojourn turned into a permanent stay, and he immediately became a vital presence on the art scene, exhibiting and lecturing throughout Southern California and in San Francisco. He taught a summer session in 1929 at the Chouinard Art Institute and in 1930 took a position at the Stickney Memorial School of Art in Pasadena. In 1944 he began a long and highly respected career as a teacher at the Art Center School (later Art Center College of Design), retiring in 1976.

As a tireless promoter of modern art in a frequently hostile environment, Feitelson served as director of several Los Angeles art galleries, where he showed European and American art and fostered worthy local talent (Stanley Rose Gallery and Hollywood Gallery of Modern Art, 1935; Gallery of Mid-20th Century Art, 1947; Los Angeles Art Association, 1939–78). In 1936 he began work on the Los Angeles Hall of Records mural for the California Federal Art Project (WPA) and in 1937 was appointed supervisor of murals, painting, and sculpture for Southern California by the WPA. In 1956 he began the Sunday afternoon TV series "Feitelson on Art" for KRCA-TV. The program, which continued through 1963, won the Little Peabody Award for excellence. That Feitelson was able to accomplish all

this while building a distinguished career as an artist is a testament to his formidable energy and dedication.

Just as the work of the postimpressionists may be seen as an attempt to rehabilitate impressionism, adopting certain of its innovations while firmly rejecting others, Post-Surrealism was a response to surrealism. As Feitelson stated: "Post-surrealism should in no way be identified with the Surrealists' Dadaistic denial of the universality of the aesthetic. Post-surrealism is the antithesis of the introspective illustration of the popular expressionist-Surrealists. The graphic objectification of conscious and subconscious psychic meanderings in itself does not create art. Only when the introspective activities are integrated into an aesthetic pattern do they become legitimate elements of art."[3] The automatic techniques of the surrealists, which exploited the element of chance, did not interest him. "Science and philosophy contribute materials and methods to the newest and most distinctive arts of our day. In a period when everything around us is the objectification of tremendous cerebral effort, it is logical that our art should be the creation of equal cerebral stress."[4]

This emphasis on the cerebral calls to mind Marcel Duchamp's wish to restore the intellect to art, and although his call for an art in which the eye and the hand would count for nothing precludes further comparison with Feitelson, Duchamp's circle in New York did lead the way to an important new theme for American art: the machine. These Europeans explored it as symbol, analogue, and metaphor, opening the door for a generation of American artists who mined American industry and technology for their imagery during the 1920s and 1930s. Post-Surrealism can be seen as a highly individual expression of this American fascination with science and technology. It can be thought of as a science of signs, a conceptual precisionism, as it were. Feitelson himself said: "The various parts of a machine must be exactly the right size and shape to fit and balance each other. Just so must the parts of a picture fit together. . . . We are building idea-making machines."[5]

In recent years considerable critical attention has been focused on the portrayal of women in art. The surrealists' depiction of females, their notion of woman, and their treatment of the theme of sexuality in general have been cited as egregious examples of misogyny. Especially pertinent then is the contrast Post-Surrealism provides. Feitelson wrote: "Erotic symbolism in a Surrealist painting is almost invariably used for a single emotional objective: to excite lust memories. Almost never will you find a hint that the mystery of sex is at the heart of all organic life. The Post-surrealist sees this organic activity, not merely as

35.
Life Begins, 1936
Oil and collage on masonite
22$^1/_2$ x 26$^1/_2$ in.
Feitelson Arts Foundation;
courtesy Tobey C. Moss Gallery,
Los Angeles

36.
Filial Love, 1937–42
Oil and casein on Celotex
24 x 36 in.
The Jane Voorhees Zimmerli Art
Museum, Rutgers, the State
University of New Jersey, gift of
the Lorser Feitelson/Helen
Lundeberg Feitelson Foundation

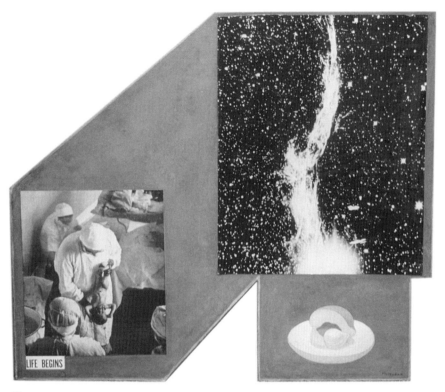

35

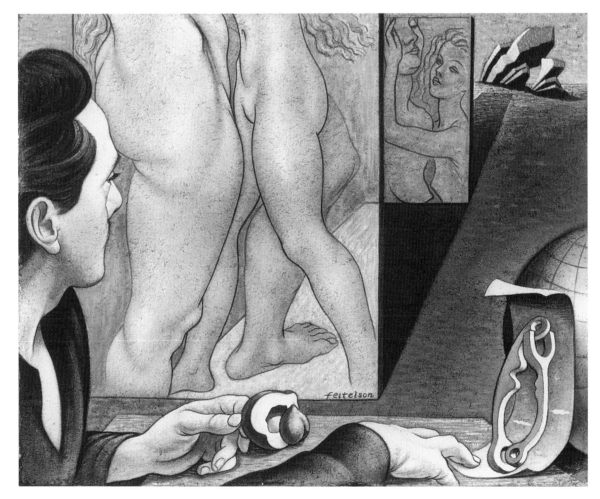

36

an emotional experience, but as important material for an intellectual pattern of universal and cosmic relationships, facts that are older than man, and which are eternal."[6]

In his Peasant series of the early 1930s Feitelson developed what he called a "classicism of suggestion," a phenomenon observed in the paintings of certain late Renaissance masters. He found that the psychological aspects of images powerfully affected the abstract composition as a whole. For example, a face shown looking in a certain direction exerted a subjective, psychological thrust separate from its function as a formal element. In addition he was receptive to the futurists' notion that a picture should be the synthesis of memory and vision, an "emotive ambience" created by links between the exterior (concrete) scene and the interior (abstract emotion).[7] In Post-Surrealism he intended to synthesize theme, structure, and subjective content in an unprecedented fashion.

So critical to the meaning of a painting was the viewer's sequence of perception that Feitelson experimented with the idea of a three-dimensional construction. A drawing from his notebooks labeled "Kinetic Vision: Construction of Genesis #2" shows an arrangement in which three-dimensional objects appear along with painted images on screenlike panels. The idea was that the spectator would view the work progressively while moving past it. Another drawing shows an elaborately shaped flat panel with the objects from *Genesis #2* (1934; cat. no. 34; color plate 4) painted on the surface, and still another shows some of the objects as though painted upon a cylindrical form.

Genesis #2 as it was actually completed includes forms that Feitelson intended to be seen variously as illusionistic images or as schematic symbols of conceptualization. The illusionistic eggshell, conch, and melon are familiar female sexual metaphors: the meaning of the lightbulb and cord remains ambiguous until the eye, directed by the telescope that penetrates a series of masks signifying the stages of life, travels from an image of cosmic illumination to the figure of the Virgin Annunciate. At once one recognizes the lightbulb as a metaphor for impregnation, cosmic life-generating light, and the Christian Divine Light, thus unifying by association the two sides of the painting. A schematic line rendering of a female figure on the right, which echoes that of the Virgin, was intended as a graphic representation of the image formed in the viewer's mind as the process of conceptualization occurs.

Feitelson used format to enhance meaning in *Life Begins* (1936; cat. no. 35), a spare mixed-media composition consisting of birth images of human, cosmic, and plant life. The configuration of the panel accommodates the individual images and links them in a predetermined viewing sequence: the cutaway triangular shape at the bottom directs the viewer's eye upward from the scene of human birth to that of cosmic creation. The photocollages of Max Ernst, Joan Miró, and others may be seen as precedents for the use of commercial photographic images, and irregular formats were used by Jean Arp and by other dadaists for their own antitraditional reasons, but Feitelson's exploitation of the shaped form for the purpose of controlling the viewing sequence evolved directly out of his own experiments in this area.

In *Filial Love* (1937–42; cat. no. 36) the male figure in the foreground, a generalized self-portrait, serves as a surrogate viewer contemplating the theme of procreation in the plant and human worlds. The cropped image of the embracing couple on the nearest grisaille panel is somewhat ambiguous, and the disparity in the figures' size and muscular development suggests that they are male and female lovers. An alternative identity as mother and daughter is quickly proposed in the second panel, however, and the viewer is left to contemplate both erotic and filial love.

Also present are completely abstract, biomorphic forms that echo the theme of the figural panels. Here, as in other Post-Surrealist works, Feitelson did not hesitate to juxtapose abstract forms with realistic ones in order to enrich his meaning. The evocative power of these organic forms led him to turn his attention entirely to their mystical realm in the ideational Magical Forms series of the early 1940s. In *Magical Forms* (1944; cat. no. 37), for example, one notes an unmistakable familial resemblance to those forms that appear in the right-hand corner of *Filial Love*. Thus the works in this series are conceptual extensions, even inversions, of the Post-Surrealist works in the sense that in the latter, through the rational cerebrations of both artist and viewer, the mundane is transformed into a transcendent reality; the Magical Forms are fantasy objects to begin with but seem real and tangible because of their evocative power. Biomorphic abstractions reminiscent of certain surrealist morphologies became attenuated, according to Feitelson, through the influence of Parmigianino, El Greco, and Jacques Callot. His classical temperament had moved into a mannerist phase.

As the series developed, Feitelson exploited the effects of illogical magnitudes and spatial ambiguities. Monumental forms span vast space on styluslike extremities that seem to teeter on multiple horizon lines. The effect on the viewer is unsettling. These experiments with the subjective manipulation

37.
Magical Forms, 1944
Oil on canvas
30 x 36 in.
Feitelson Arts Foundation;
courtesy Tobey C. Moss Gallery,
Los Angeles

38.
Magical Forms, c. 1949
Oil on canvas
30 x 36 in.
Feitelson Arts Foundation;
courtesy Tobey C. Moss Gallery,

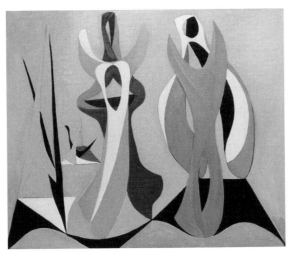

37

38

of space led in the 1950s to a major body of work called Magical **109**
Space Forms and in turn to the Hard Edge paintings, which
gained international acclaim in the 1960s. It is noteworthy that
Feitelson's original name for the latter series was Abstract
Classicism.

Diane Degasis Moran

Notes
1. Beginning in 1934 the loosely associated Post-Surrealist group exhibit-
ed extensively in Los Angeles, at the San Francisco Museum, at the
Brooklyn Museum, and in 1936–37 in the Museum of Modern Art's show
Fantastic Art, Dada, Surrealism. Group exhibitions were curtailed in the
late 1930s by Federal Art Project activities, but Feitelson and Lundeberg
continued to explore the possibilities of Post-Surrealism in their work.
2. Unless otherwise noted, information about Post-Surrealism and other
aspects of his work was provided to the author by Feitelson in conversa-
tions and correspondence between 1974 and 1978.
3. Lorser Feitelson, "What Is Postsurrealism?" *Spanish Village Art
Quarterly* (San Diego) (Spring 1941): 6.
4. Ibid.
5. Transcription of radio interview with Arthur Millier, n.d., Perret Archives,
Archives of American Art, Smithsonian Institution, Washington, D.C.
6. Ibid.
7. "The Exhibitors to the Public," introduction to the catalogue of an
exhibition at Bernheim-Jeune, Paris, 1912; see Herschel B. Chipp,
Theories of Modern Art (Berkeley and Los Angeles: University of
California Press, 1968), pp. 296–97.

Philip Guston
1913—1980

Fig. 38
Philip Guston, 1930
Photograph by Edward Weston;
courtesy McKee Gallery

Philip Guston was the youngest of seven children born to the working-class Goldstein family, who had migrated from Odessa to Montreal. Montreal's Jewish ghetto offered a rich mix of emotion and intellect (with an emphasis on Marxist philosophy), which began to form Guston even before the family moved to Los Angeles in 1919. In 1923, in a fit of depression, Guston's father took his own life, leaving his wife to raise seven children. Despite her responsibilities she found time to encourage Philip, who had a talent for drawing, to enroll in a correspondence course in cartooning. This led to his earliest success as an artist, when his cartoon strip was published in the children's section of the *Los Angeles Times.*

Guston attended Manual Arts High School in Los Angeles, where he became friends with fellow student Jackson Pollock. Their artistic efforts were encouraged until they produced a satirical attack on the English department, which resulted in their expulsion. Pollock returned to graduate, but the incident marked the end of Guston's formal education (except for a brief period in 1930, when he attended Otis Art Institute). A person of enormous intellect, he nevertheless continued to educate himself throughout his lifetime.

After leaving school, Guston occasionally worked as a movie extra while devoting most of his time to his art. In 1930 he was befriended by Lorser Feitelson, who urged him to study the Italian masters and arranged for him to see Walter and Louise Arensberg's important collection of surrealist art. It was his first exposure to the work of Giorgio de Chirico. Guston's *Mother and Child* (c. 1930; cat. no. 39) shows the influence of Feitelson, who was painting exaggerated human forms at that time. The truncated space, stark perspective, and stagelike setting can be traced to de Chirico. These influences are still present in *Nude Philosopher in Space Time* of 1935 (cat. no. 40), which incorporates de Chirico's sense of space as well as visual ambiguities that relate to the Los Angeles-based Post-Surrealist movement newly established by Feitelson and Helen Lundeberg. The softened color and the use of personal symbols such as the naked lightbulb are characteristic of Guston's own style and would follow him throughout his career.

Guston also met Reuben Kadish, who introduced him to John Reed's Marxist theory and encouraged him to abandon "art for art's sake" and to address the plight of the American Negro. Guston became interested in mural painting and went often with Pollock to watch José Clemente Orozco work on his fresco *Prometheus* at Pomona College in Claremont, California. In 1934 he traveled to Mexico with Kadish and art critic Jules Langsner to serve as a mural assistant to David Alfaro Siqueiros. In late

1935, at Pollock's urging, Guston moved to New York, where he joined the mural section of the Federal Art Project (WPA). He was selected to do his first major mural commission for the facade of the WPA building at the New York World's Fair in 1939, which won first prize in the outdoor mural category.

Guston and poet Musa McKim married in 1937. He adopted the name Guston to placate Musa's family, a decision that he would regret throughout his lifetime. In the 1940s Guston taught at Iowa State University and Washington University, Saint Louis, developing a social realist style of painting that brought him national prominence. In 1950 he moved to New York, where he produced his best-known abstract works, which were shown at the Peridot Gallery in 1952. In 1958 his work, along with that of other members of the New York school, was selected for the exhibition *The New American Painting,* organized by the Museum of Modern Art, New York. This showing introduced abstract expressionism to Europe and established America's role in the post-World War II art world. Guston was labeled an abstract impressionist because of his seductive color and brush handling. By 1962 his work had begun to change, and this was reflected in his first major retrospective, mounted that year by the Solomon R. Guggenheim Museum. Imagistic black blobs began to appear in his paintings, suggesting that pure abstraction was not his primary interest.

After a semireclusive decade Guston reemerged in 1970 with an exhibition at New York's Marlborough Gallery, which stunned his audience. Ku Klux Klan figures disported themselves in menacing ways, cruising around the city in convertibles, laughing, drinking, and smoking cigars. Guston had reverted to his earliest ideas about art, combining Krazy Kat-style cartooning and social commentary with brilliant brushwork. Many of his peers rejected the work, but he found a new and devoted following among young artists.

The last few years of Guston's life were highly productive; he seemed to have no doubts about what to paint or how to paint it. All of his ideas about himself and the world came together in a series of works that can be compared to the late paintings of Francisco Goya in their sense of torment and humanity. While viewing his retrospective at the San Francisco Museum of Modern Art in 1980, just before his death, Guston commented, "This is not an exhibition; it is a life."[1]

Henry T. Hopkins

Notes
1. Conversation with the author, San Francisco, 1980.

39.
Mother and Child, c. 1930
Oil on canvas
40 x 30 in.
Private collection; courtesy
McKee Gallery, New York

40.
*Nude Philosopher in Space
Time*, 1935
Oil on canvas
45³/₄ x 24³/₄ in.
Estate of Philip Guston, New
York; courtesy McKee Gallery,
New York

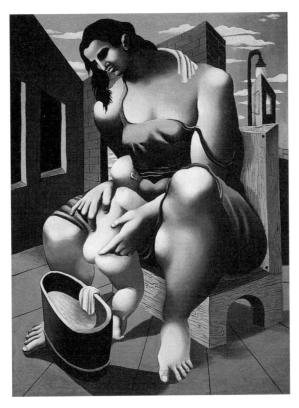

39

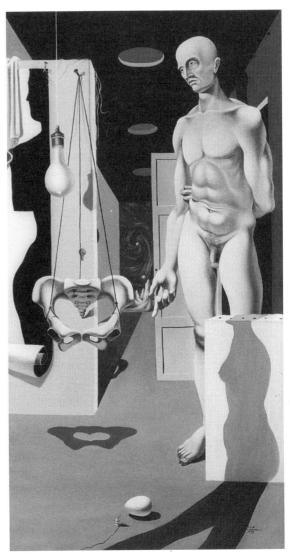

40

Gerrie von Pribosic Gutmann
1921–1969

Fig. 39
Portrait of Gerrie Gutmann *(Very Beautiful in Feather Hat)*, 1951
Photograph by John Gutmann; courtesy John Gutmann

Evident in Gerrie Gutmann's work is the presence of a distinctly feminine visual language adapted from the surrealist voice. Aside from a few art lessons with Lorser Feitelson in the late 1930s, Gutmann was primarily self-taught. She exposed herself to many painting styles, from early Flemish art to the fantastic and the surreal. Through her subscription to *View* and trips to Mexico and Europe, she familiarized herself with surrealist works. During the 1950s, when many West Coast artists abandoned fantastic imagery for abstraction, she rejected the trend and thus isolated herself from other painters. Like many of the women associated with the movement, she utilized surrealism as an escape from reality, as a means of discovering her identity and exorcising personal demons.

Born Gerrie Current in 1921, the artist was raised by her mother, grandmother, and great-aunt in Ventura, California. Her father abandoned the family shortly after the children were born. He reappeared in the late 1940s, and although they developed a friendship, she never overcame her intense hostility toward him. Gerrie's brother, William, born in 1922, was the only male presence in the household.

Gutmann rebelled against the three women who brought her up, as well as her absent father, and married young in an attempt to liberate herself. In 1939 Feitelson introduced her to the artist Victor von Pribosic (1909–1959), whom she married and with whom she had a son. This marriage lasted until 1945, resulting in a custody battle that favored the father. Gutmann's frequent subsequent depictions of motherhood express her sorrow at having to give up her son. Her second husband, the photographer John Gutmann (see cat. nos. 44–49), had a tremendous impact on her life and art during their years together in San Francisco, between 1950 and 1964. These were also her most productive years as a painter; alcoholism ultimately made it impossible for her to continue working. During her marriage to Gutmann, she saw five different psychiatrists to help her cope with her mental instability and multiple attempts at suicide. Following her divorce from Gutmann and a brief marriage to businessman Sacha Bollas between 1965 and 1966, she committed suicide in 1969, at the age of forty-eight.

In the early 1940s Gutmann moved from Southern California to Hood River, Oregon, far from any art center, where she developed her characteristic painstakingly precise drawing technique, which she would later use in her casein paintings. Her often horrific subject matter, depicted in a realistic style, produces an eerie effect, thus achieving her intended goal: "to force people to see the known and impossible—combined to create a believable entity."[1] Utilizing these elements, she created an art that is highly autobiographical.

Gutmann portrayed herself and her current situation in two drawings linked by themes of maternity and abandonment and death and rebirth. *Self-Portrait* (1946; cat. no. 41) shows a decrepit but decorated interior, with cracking walls and a floor and ceiling trim in different geometric patterns. The artist, dressed in a Victorian-style wedding gown, sits in an ornate chair. Her gaze fixed, as if in a contemplative trance, she appears to be made of stone. Her eyes express the only sign of life, suggesting that this portrait is one of deep self-investigation.

The objects in the room refer directly to aspects of Gutmann's life. A recurring motif is the "Father Doll" (see also cat. nos. 48, 49). The top portion of its head is sawed off, and its heart bleeds. The doll refers to Gutmann's difficult relationship with her father, Gene Current. It serves as a symbol of abandonment, recalling both her father's desertion of the family and her feeling that she has given up her own son. This connection is emphasized by the limp, lifeless doll in Gene's hand; it too bleeds.

The artist adorns herself with strange biomorphic forms that suggest female genitalia and thus a birth, or rebirth, process. Distinctive among these forms are seashells bearing a strange resemblance to a scorpion conch. This conch, characterized by its smooth surface on one side and an open mouth with sharp spikes on the other, strengthens the symbolism of the scorpion figure in the right foreground. Connected to a string behind Gutmann are the Father Doll and a scorpion made of plaited hair. This string, originating from a womblike orb, may represent an umbilical cord. In mythology the scorpion refers to death and destruction, giving way to rebirth. It is here symbolic of Gutmann's desire to start over after a difficult period. In the background of the drawing an archway leads to another world, which is inhabited by a mother and child, also a recurring symbol. This configuration represents Gutmann's hopes and dreams, which loom just out of reach in the void. Hovering over the figures are birds, one of the most prevalent motifs in her later work. In this early drawing it is unclear whether they are predators or protectors.

The world that Gutmann depicts in her self-portrait serves as an introduction to her fantasy realm. The drawing includes motifs that appear in many later works: the Father Doll, the mother and child configuration, and the birds. In paintings of the 1950s and 1960s she explored themes of transformation from woman to bird, her animal counterpart.

41.
Self-Portrait, 1946
Colored pencil on paper
16 x 13 in.
Private collection

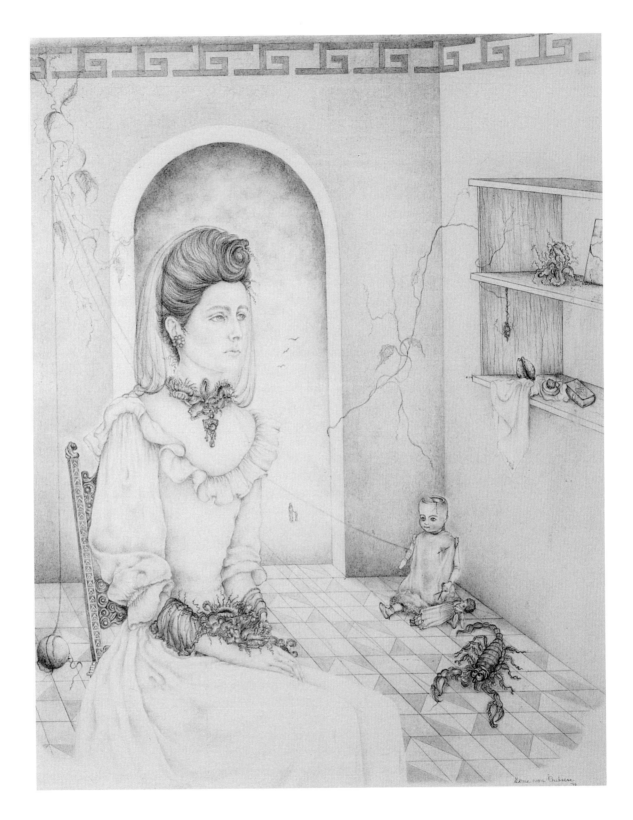

The second drawing, *Jan* (1950; cat. no. 42), a portrait of the artist's son, is a realistic depiction of a seven-year-old boy. His face, which reveals the artist's skill and sensitivity toward her subject, is obstructed by a tree branch that covers his eyes. A piece of paper folded around the branch bears a drawing of the boy's left eye. This may refer to Jan's highly developed creative abilities, as the right side of the brain (creativity) was then believed to control the neural functions of the left side of the body. On the left a tree trunk reveals a scene of Jan drawing a picture in a stormy landscape. The dichotomy between the picture, a symbol of escapism into a fantasy world, and the gloomy sky, foreshadowing stormy realities, may refer to life in a broken home. The right side shows the mother and child motif. This time the mother's expression shows fear and a desire to protect the child. *Jan* reveals a mother's great love for a child whom she feels she is losing.

Finally *Reunion* (1958; cat. no. 43), a collage-style gouache, depicts real and imaginary figures from Gutmann's childhood. While many of the individual portraits appear in other drawings and paintings from the late 1950s and early 1960s, others are copied from antique tintypes. Here Gutmann recapitulates themes explored in *Self-Portrait* and *Jan*.

The issue of abandonment is suggested by the relative absence of male figures. The two that are included may be Gutmann's father and grandfather, although they recall the stiff depictions of tintype photography. The elderly man appears small and weak and does not resemble her grandfather, a corporation lawyer and landowner. It seems more likely that the ghostlike voids symbolize the absence of the father and grandfather.

Gutmann represents the domineering female figures of her childhood in an unflattering way. Her mother's expression is vacant; she stands with the symbolic dead doll in her hand and also appears as a portrait bust. Her grandmother is the hardened figure behind her mother, and the dowdy, withered old woman holding an apple in the background is Great-Aunt Sadie. The apple motif recurs in the drawing *The Apple Eaters* (1962). In that piece the three women sit under a tree; the mother and grandmother are greedily eating apples, while a gaunt, almost skeletal Sadie stares off into the distance. In the background Gutmann's grandfather walks away from the family. The three women are represented in both works as personifications of evil; they are the temptresses of forbidden fruit. In *Reunion* they are accompanied by a vicious two-headed snake, dead dolls, rotting plant life, old women, and freakish young girls. Next to Sadie stands a young Gutmann, who, dressed like her mother,

also stares through blank eyes. She hides her hands as if she has secrets that she chooses not to reveal. By far the most flattering depiction, the head peeking out from behind Gutmann's mother and grandmother, is that of Violet, a radio and later Hollywood personality for whom the grandfather left the family. The remaining figure, a woman exiting the scene, may symbolize Gutmann running from the cast of oddities that she portrays as her family, although it does not resemble her self-depictions in other works.

Gutmann's art provided a release from the difficulties of her life—her abandonment by her father, the loss of her son, failed marriages, and alcoholism—although those problems ultimately closed the door to this brighter world. She lived for, and in, her fantasy world, and when it was no longer accessible, she was unable to cope with reality.

Gutmann did not exhibit her work extensively. In her lifetime she had thirteen shows, in museums and galleries in San Francisco, Los Angeles, Santa Barbara, New York, and Portland. Most noteworthy were her solo exhibitions at the M. H. de Young Memorial Museum in San Francisco in 1949, 1952, and 1962. Although her paintings and drawings received much acclaim for their technical skill, some viewers had difficulty with their horrific subject matter. In 1962 the critic Alfred Frankenstein wrote, "Her pictures are as jeweled as the very jewels of Dali."[2] In 1968 he described her work as "marvelously perverse, theatrical, elegant, and disdainful."[3]

In images woven from fantasy and reality Gutmann revealed herself through intricate familial relationships. She expressed turmoil within her psyche and a spiritual quest for an identity as a woman, an artist, and a mother. Hers was a world of dark dreams, a nightmarish realm, where reality and the unconscious commingle to produce images of horror that challenge conventional standards of beauty. It is a world of destruction and decay, yet it offers a glimpse of ultimate regeneration.

Lisa P. Carlson

Notes
1. Handwritten note, Gerrie Gutmann papers, San Francisco.
2. Alfred Frankenstein, "Three Ladies of Fantasy Share Gallery Billings," *San Francisco Sunday Chronicle,* 28 January 1962.
3. Alfred Frankenstein, "Underground Renaissance Men," *San Francisco Sunday Chronicle,* 16 June 1968, This World section.

42.
Jan, 1950
Pencil on paper
8½ x 11 in.
Private collection

43.
Reunion, 1958
Casein on board
16 x 20 in.
Collection of David and
Jeanne Carlson

42

43

John Gutmann
b. 1905

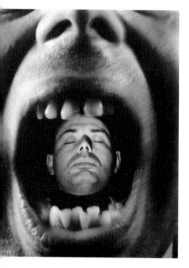

Fig. 40
Self-portrait of John Gutmann
(Death Trap), 1936
Courtesy John Gutmann

John Gutmann arrived in San Francisco in early 1934, a refugee from Hitler's Germany. Before he left Germany, a friend had advised him to bypass New York and visit San Francisco instead, which, his friend said, was a more authentic, raw, perhaps more naive American city. Thus Gutmann escaped being one of many German-Jewish refugees in New York and became one of a handful, inhabiting the more or less unknown (at least to Europeans) territory of a small urban center in the far West.

Of course, the western United States had long attracted Germans. Some of the finest collections of Native American artifacts were gathered by nineteenth-century German explorers. There existed a strong appreciation of the "Wild West" in Germany, particularly in children's literature, and the work of such nativist writers as Jack London was widely read. Gutmann had been an admirer, though perhaps not a dedicated one, of such literary fantasies.

By the time he left Germany, Gutmann was already an articulate and highly educated artist. He had studied with the Brücke painter Otto Mueller, an important expressionist artist who frequently painted gypsies, and he also participated in the sophisticated interwar culture of Berlin—the city that Christopher Isherwood wrote about in his *Berlin Diaries*, the city of exquisitely decadent café life, of vital artistic experimentation in expressionism, constructivism, and Neue Sachlichkeit. It was the city that fostered George Grosz's and John Heartfield's sly, ironic political wit and the proletarian heroes of Bertolt Brecht and Kurt Weill. Although Gutmann was generally aware of the surrealist movement in France, he was not particularly interested in it while in Germany.

Trained as a painter, Gutmann bought a camera essentially as an afterthought, imagining that it might help him in the transition to life in a new country. He contacted a German agency, Presse Photo, promising pictures for magazines and Sunday supplements, but his real intention was to work as an artist, not a photographer—for him then, as now, the distinction was very clear: Photography was record keeping; painting was more personal and self-conscious.

When he stepped off the boat in early 1934, Gutmann found a much smaller, less sophisticated city than the San Francisco of today, one with a regionalist art tradition and a group of photographers interested in converting the photographic medium to a valid and compelling art form. These photographers had recently been given a major exhibition at the M. H. de Young Memorial Museum, and on the occasion of the show called themselves Group F.64. Gutmann knew nothing of

Edward Weston, Ansel Adams, and Imogen Cunningham; nor did they know him until much later.

Gutmann paid scant attention to the local artists and photographers because he was so very taken with the city itself. Coming from fascist Germany, not speaking the language well at first, he was very much the outsider examining a strange new culture. He found many things marvelous: the presence of so many blacks, Asians, and other ethnic groups, a situation entirely unknown in Europe. He saw the frank sexuality of the Tenderloin district and the waterfront; the vitality and crudeness of mass culture and populist circuses (which he explored in *Seance* [1939; cat. no. 47]); Americans' tolerance of different, often bizarre personalities (such as the protagonist of *Death Stalks Fillmore* [1934; cat. no. 44]); the omnipresence of signs, especially fascinating to one learning a new language; the common, straightforward expression of folk art (for example, *Monument to Chicken Center of the World, Petaluma, California* [1936; cat. no. 45]); and that curious oddity to a European, the American individualist, the populist, aggressively self-assertive loner. Gutmann found this strange new city naturally surreal.

Before long, in 1936, Gutmann was offered a position teaching art at San Francisco State College, and to celebrate he took a Greyhound bus tour around the country, indulging his fascination with the unique, vital, and to him very different culture. After he returned to the city several months later, he gradually developed closer ties to the college, and as one of the few artists who had a firsthand acquaintance with European modernism, began to teach his students the history of modern art. He also introduced a film series and became more involved in the intellectual life of the city.

Gutmann had always considered photography a way of making money while documenting the oddities of American life. He also recorded the tense political atmosphere of the waterfront strike and, later, the general strike of 1934. Many of his pictures, including the one of the Petaluma chicken, were sold to magazines abroad, to the German or Dutch equivalents of *Life* or *Look*, although sometimes they appeared in American magazines. But as he continued this work of documentation, Gutmann, who became interested in surrealism through his painting, began to experiment with surrealist photography. He explored photocollage and more explicit symbolic subjects, such as masks and dolls. He turned from recording the strange or marvelous as it was presented to him (as the young surrealist Henri Cartier-Bresson did) to making, or constructing, surrealist pictures (as Man Ray, for instance, did).

44.
Death Stalks Fillmore, 1934
Gelatin silver print
13¹/₄ x 9³/₈ in.
Collection of the artist

45.
*Monument to Chicken Center of
the World, Petaluma, California,*
1936
Gelatin silver print
10¹/₄ x 12 in.
Collection of the artist

In 1949 Gutmann met and married a young, self-taught artist working within the surrealist tradition, Gerrie von Pribosic, who was beautiful, but disturbed. Self-obsessed, she fashioned a doll that she deliberately battered, making it the object of her anger at a father who had deserted her as a child. The doll appears in pictures such as *Father Doll* (1951; cat. no. 48) and *Father Doll Watching Lovers on Swing* (1951; cat. no. 49), which exemplify the surrealist interest in stand-ins for the human figure. The ambiguities that have always fascinated Gutmann as well as photography's ability to find strange juxtapositions or seemingly unreal relationships, which were explored in earlier images such as *Seance* and *Double Portrait* (1938; cat. no. 46), were more consciously articulated in the neurotic and unnatural relationship of this grown woman to her doll. These later pictures are, however, more deliberate, more controlled, perhaps more private than the earlier ones; the subjects were no longer discovered by chance, and the mood is one of detached fascination with the foreignness of what is being presented.

Although Gutmann never stopped making photographs, his creative involvement with the medium became less insistent as he became more involved in teaching. After he retired in 1973, he rediscovered his earlier work, which was then published and widely exhibited, and resumed his experiments with photographic imagery, both constructed and discovered.

Sandra Phillips

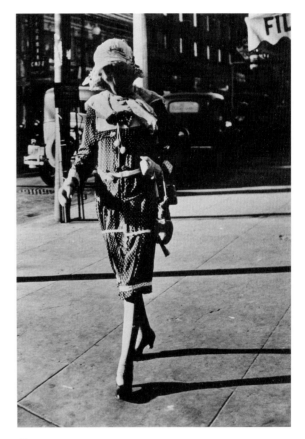

44

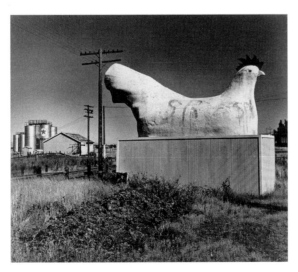

45

46.
Double Portrait, 1938
Gelatin silver print
13¹/₄ x 9³/₈ in.
Collection of the artist

47.
Seance, 1939
Gelatin silver print
13¹/₄ x 9¹/₂ in.
Collection of the artist

48.
Father Doll, 1951
Gelatin silver print
11⁵/₈ x 10¹/₈ in.
Collection of the artist

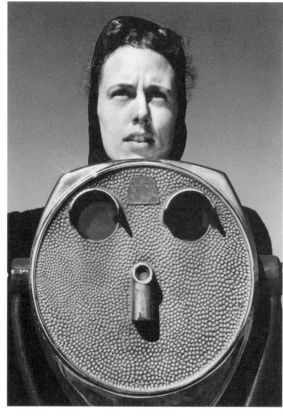

46

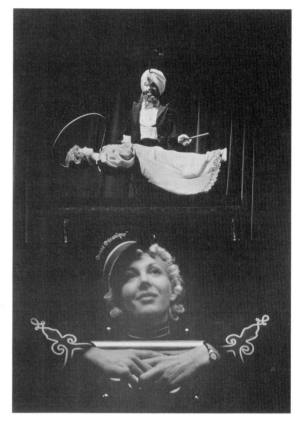

47

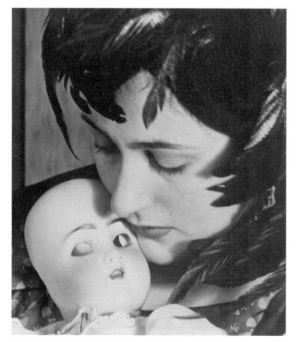

48

49.
*Father Doll Watching Lovers on
Swing*, 1951
Gelatin silver print
13^{1}/$_8$ x 10^{1}/$_8$ in.
Collection of the artist

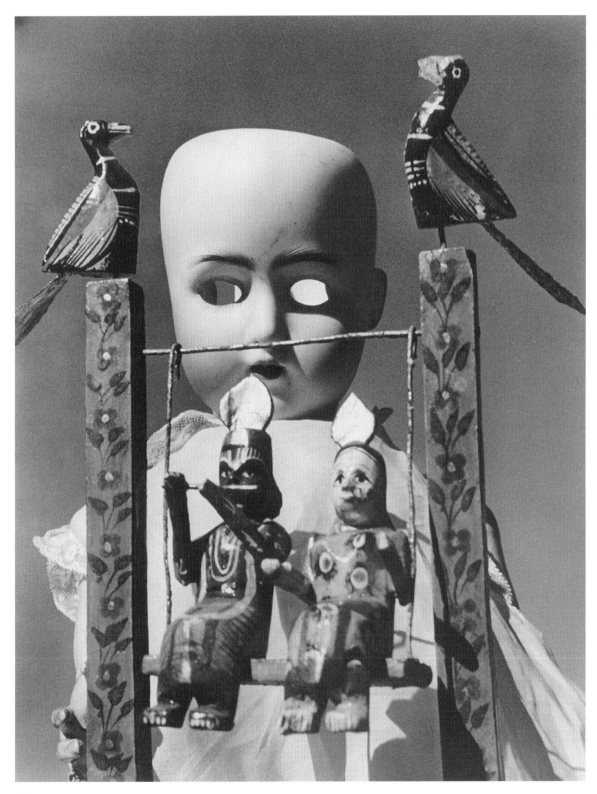

Charles Houghton Howard
1899–1978

Fig. 41
Charles Howard working at
his easel, 1950s
Photograph courtesy
Janette H. Wallace

The abstract surrealist art of Charles Howard describes the dramatic eruption of the sacred into the profane, in a struggle occurring within the microcosm of the self. Howard's work is not only a symbolic representation of the mind's journey into the unconscious, like that of the surrealists, but an exploration of the sensing and feeling self as well. His paintings are windows to an inner world where one becomes reintegrated with one's essential being.

Howard was raised in Berkeley in a prominent family of architects, painters, and sculptors who together contributed significantly to the cultural life of the Bay Area. His father, John Galen Howard, was supervising architect for the University of California, Berkeley. With hopes of being a writer, Charles studied literature at Berkeley, Harvard, and Columbia. After an epiphanic experience in 1924 while touring Europe with artist Grant Wood, he decided to become a painter. By 1932 the New York dealer Julien Levy had presented Howard's work in the landmark exhibition that introduced European surrealism to the United States.[1] Levy included only two other Americans, Man Ray and Joseph Cornell.

The following year Howard moved to London with his wife, the British painter Madge Knight. London was then a center for artists of the international avant-garde fleeing totalitarianism and religious persecution and was home to such innovators as Walter Gropius, Lázsló Moholy-Nagy, and Piet Mondrian. Howard soon became involved in London's most advanced artistic circles, and shortly after his arrival he assisted the painter Edward Wadsworth on a mural for the De La Warr Pavilion at Bexhill. Wadsworth was a member of Unit One, a vanguard group interested in constructive abstraction and grounded in a metaphysics that pursued political transformation; other members included artists Barbara Hepworth, Henry Moore, and Paul Nash and the architect Wells Coates.[2] Active with the English surrealists from 1936 to 1938, Howard participated in the International Surrealist Exhibition, held in 1936 at the New Burlington Galleries, and had a solo exhibition at the Guggenheim-Jeune Gallery in London in 1939.

In London Howard more fully developed the equilibrium that characterizes his art, "a balance between reasoned construction and free intuition."[3] This hybrid art shared the abstract formalism of cubism, constructivism, and de Stijl and the biomorphism and feeling for the transformative found in the work of surrealists such as Joan Miró. It also incorporated a sense of tension and foreboding, reflecting the political climate of the period before World War II. Howard painted *Bivouac* (1940; cat. no. 50), "a curious correlation of war shapes

superimposed against a crenelated fortress wall,"[4] soon after the outbreak of the war and the terror of the early blitzes. The painting's tripartite composition with a centralized "totem," its dialectical opposition of curved lines to straight-edged forms, and its use of opaque, toned primaries with large areas of black, white, and gray are all hallmarks of Howard's style, as are the pristine, crisp edges and technical virtuosity. Some of the forms seem to curve out of the predominantly flat, two-dimensional space into that of the viewer, increasing the ambiguity of figure and ground.

With the outbreak of fighting, Howard and Knight moved back to San Francisco, a wartime oasis for the international avant-garde. Like Man Ray in Southern California, Howard was an important catalyst for art in the region, introducing European approaches into the vocabularies of local artists. Howard's abstract surrealist expression was an important stimulus and agent for change. He was extremely influential in the art community, acting as designing supervisor for the Federal Art Project (WPA) and lecturing on surrealism in a series with Salvador Dali, Man Ray, and the poet Georges Lemaitre at the California School of Fine Arts in 1945. He was at the center of the circle of Bay Area modernists that included Knight, his brother Robert Howard, Adaline Kent, David Park, and Clay Spohn, but he was also nationally recognized. Howard was included in Dorothy Miller's show *Americans 1942: Eighteen Artists from Nine States* at the Museum of Modern Art in New York and in Peggy Guggenheim's inaugural exhibition at her Art of This Century gallery in 1942. His greatest champions locally were Grace McCann Morley, director of the San Francisco Museum of Art, and Douglas MacAgy, director of the California School of Fine Arts. MacAgy supported Howard through exhibitions and writings throughout these years, when abstract expressionism was challenging the primacy of European modernism at the school, and even after Howard had returned to England. His wife, Jermayne MacAgy, organized Howard's 1946 retrospective at the California Palace of the Legion of Honor.

In San Francisco Howard went through an artistic transformation. During the war he worked in a shipyard, where the streamlined forms of the Victory ships and the shapes of twisted metal engaged him; he also spent hours studying books on biology. In paintings such as *The First Hypothesis* (1946; cat. no. 56; color plate 14) he began to combine the "metallic" with the biological. In this image hairlike filaments spill out of an "organ" positioned along a central axis. Organic and visceral, though elegant and polished, the work has a calm and cerebral beauty. Howard developed his shapes—such as the bladelike

50.
Bivouac, 1940
Oil on board
16 x 20 in.
Collection of Dr. Peter B. Fischer

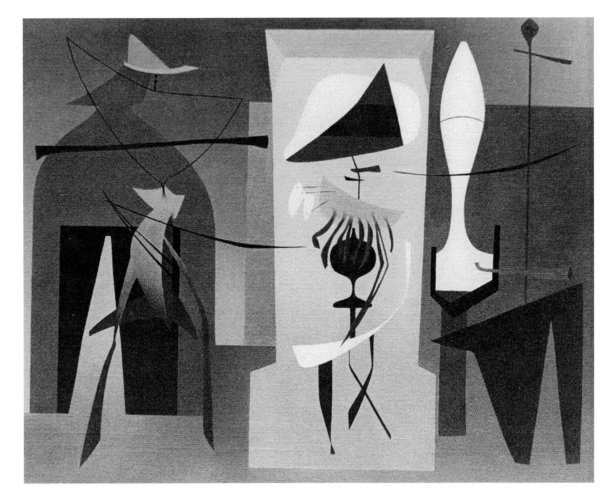

form reminiscent of the symbol for infinity that protrudes into our space—through automatic drawing, allowing for the obsessive recurrence of certain images. He often spoke of his works as variations on a theme.[5] *Chain of Circumstance* (1946; cat. no. 55; color plate 15) contains many of the same conventions and accentuates the framing device, or proscenium, within which Howard enclosed his compositions of the late 1940s. Movement was also a central concern. His timely presences, embodying the values of continuity and change, are like mobile architecture struggling to form a new organic unity.[6]

Howard's creations—a sort of biological machinery for the accelerated enactment of the creative process—are spiritually allied with the work of Marcel Duchamp and Francis Picabia. Howard paid homage to Duchamp's psychosexual machines in his small-scale work *The Bride* (1942; cat. no. 51), an eccentric, deadpan take on a Duchampian bride. A more complex, internalized metamachine, *Dove Love* (1945; cat. no. 54) pulsates with a preconscious glow. Opening out into womblike chambers is a gathering light, threatening and portentous like that of dusk. Howard's paintings enact a *regressus ad uterum,* a symbolic return to one's origins, where womb equals void. In *Dove Love* soaring images are crammed into the space of the painting; forms are torn and bent. The creative process described here—the breaking of the sacred into the profane—expresses both chaos and biological limitation while simultaneously

hinting at the birth of a new order of functioning. Like a recital of primal creation, Howard's work evokes sublime awe before the void.

In the 1951 exhibition *Abstract Painting and Sculpture in America* at the Museum of Modern Art in New York, Howard was grouped with such noted abstract expressionists as Arshile Gorky, Jackson Pollock, and Mark Rothko in the category "Expressionist Biomorphic," not because of his stylistic affinities with those artists, but perhaps because of his powerful kinetic expression of the sublime. Howard's work anticipated the turning away from the more extravagant traditions of surrealism and abstract expressionism in the mid-1950s. When he returned to London in 1946, he began to develop an austere minimalism, using primarily black, white, and gray. He continued to exhibit widely, garnering important retrospective exhibitions at the Whitechapel Art Gallery in 1956, organized by Basil Taylor, and at Roberts and Tunnard Limited in 1963, organized by Bryan Robertson.

Until the mid-1950s Douglas MacAgy championed Howard's work in the United States, writing often about him for such periodicals as *Critique* and *Circle.* Howard left behind an important legacy, particularly in Southern California, where a spatially ambiguous abstract geometric art began to develop in the late 1940s. His abstract surrealism may have contributed to the emergence of "abstract classicism," the hard-edge painting

51.
The Bride, 1942
Oil on canvas
10 x 8 in.
Private collection; courtesy
Parkerson Gallery, Houston,
Texas

52.
Prescience, 1942
Oil on canvas
28¹/₄ x 40¹/₂ in.
The Metropolitan Museum of
Art, Arthur Hoppock Hearn Fund,
1942 (42.163)

of Karl Benjamin, Lorser Feitelson, Frederick Hammersley, and
John McLauglin. It conveys the same dual sense of contempla-
tion and sublime tension.

Susan M. Anderson

Notes

1. Levy had two exhibitions, one of European surrealism at the
Wadsworth Atheneum in December 1931 and another in January 1932 at
his New York gallery. The latter show introduced surrealism to a wider
public and included the three Americans.
2. Charles Harrison, *English Art and Modernism, 1900–1939*
(Bloomington: Indiana University Press, 1981), p. 109; Andrew Causey,
"Unit One—Towards Surrealism," in *British Art in the Twentieth Century:
The Modern Movement,* ed. Susan Compton (New York: Neues
Publishing, 1987), pp. 216–17.
3. Basil Taylor, introduction to *Charles Howard,* exh. cat. (London:
Whitechapel Art Gallery, 1956), p. 9.
4. Gerald Cullinan, "Novel Exhibition Reflects Reactions of San Francisco
Artists to Total," *San Francisco Call-Bulletin,* 10 January 1942.
5. Charles Howard, "What Concerns Me," *Magazine of Art* 39 (February
1946): 64.
6. George Reavey, "Charles Howard," *London Bulletin* 13 (15 April 1939):
14.

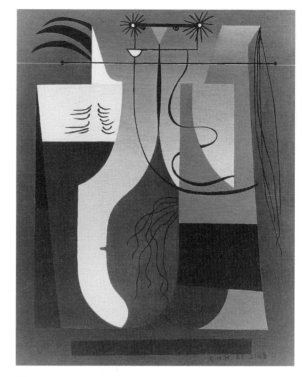

51

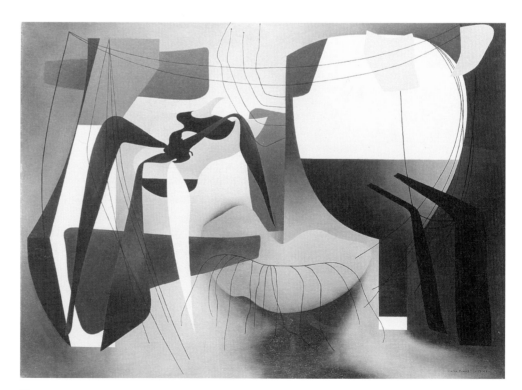

52

53.
Wild Park, 1944
Oil on canvasboard
13⁷/₈ x 17⁷/₈ in.
Munson-Williams-Proctor
Institute, Museum of Art, Utica,
New York

54.
Dove Love, 1945
Oil on canvas
18 x 24 in.
The Menil Collection, Houston

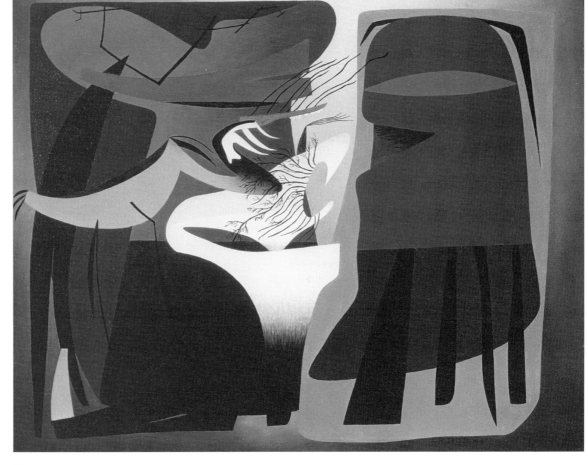

53

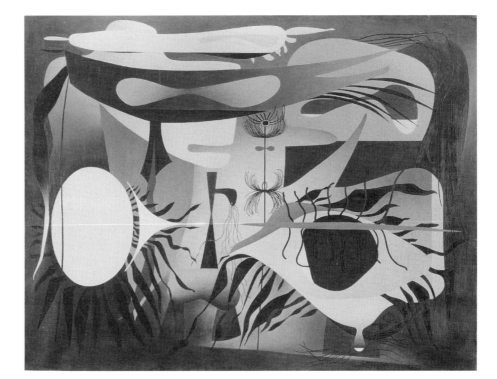

54

Robert Boardman Howard
1896–1983

Fig. 42
Robert Howard in his North Beach studio with *Barnacle,* late 1950s
Photograph courtesy Galen Howard Hilgard

Robert Howard created isolated three-dimensional mythic creatures that bob and shudder in real space. Like his wife, Adaline Kent, he drew inspiration from a lifetime of fascination with the world around him. In contrast to the highly abstracted qualities of Kent's signature work, however, Howard's sculpture retains close ties to the natural world, melding fantastic images drawn from the artist's subconscious with visual fragments gleaned from extensive travels. It was also informed by explorations into mechanical design and new materials.

Born in New York in 1896, Howard was the second of four sons born to John Galen and Mary Howard. His formal training began at the School of the California Guild of Arts and Crafts, Berkeley (now the California College of Arts and Crafts, Oakland); continued at the Art Students League in Woodstock, New York, and New York City; then culminated in studies of anatomy and landscape painting at the Académie de la Grande Chaumière and the Académie Colarossi in Paris. This period of study was peppered with adventurous interludes: trips to the Near East, especially Egypt; a motorcycle sojourn across the United States with his brother Charles; and travels throughout Europe.

After his return to the Bay Area in 1922, Howard expanded his artistic horizons, producing not only paintings but wood carvings and architectural reliefs as well. His commissions, which included reliefs for the San Francisco Stock Exchange (1929) and the Paramount Theater, Oakland (1931), were capped by *Whale Fountain,* created of cast granite for the Golden Gate International Exposition in 1939. In this monumental work the interaction of form and water, the exploitation of negative space, and the simultaneous turning in and opening up of the composition signaled a major development in Howard's art. The forms, though simplified and abstracted, are still firmly grounded in reality.

In the 1940s Howard's work moved away from specific natural references and into the realm of biomorphic fantasy. In *Eyrie,* executed in 1945, his forms, attenuated and bearing only vestiges of natural allusion, encompass an open central core and sinuously reach out to embrace the surrounding space. By 1947 he had replaced implied movement with real motion. He designed and crafted precision joints that allowed elements to swing and oscillate, not only emphasizing the work's encroachment into the external spatial environment but also creating new interactions with the viewer. Howard continued to develop and hone his by now fully articulated sculptures. He experimented with numerous materials, including composites of wood, linen, and gypsum and fiberglass compounds, searching for a formula that was tough but flexible and lightweight.

In the late 1940s and early 1950s Howard produced a series of sculptural beasts in which dream and myth are set in motion by the reality of engineering. They contain references to his many travels to the Near East and Europe as well as his forays to the High Sierra. In *Scavenger* (1949; cat. no. 57) a skeletal bird perches atop a segmented pole, its bony, upright form precariously balanced by a pierced ovoid tenuously dangling from its claws. Simultaneously Romanesque and Giacomettian in its angularity, this vulturous creature with fingered wings, podlike head, and ominous visage is set afloat on extended legs, bobbing and swaying in space. This slight movement interjects an undertone of whimsy that becomes more assertive in Howard's later work.

In *Night Watch* (1949–50; cat. no. 58), which depicts a humorous tentacled creature with uplifted tail, Howard emphasizes the silhouette set off in space. Whereas *Scavenger* rests on a telescoping pedestal and seems securely grounded, *Night Watch* exploits a sense of lift. A hard-shelled black form floats above an unexpectedly red open base poised precariously on four points. Like an underwater crustacean tiptoeing along the sea bottom, it extends its appendages out and up, reaching for prey.

Inspector (1950; cat. no. 59) moves further into ambient space. Streamlined and gaunt, with arcing spines that propel it forward, it darts and lunges, activated by the slightest stirring of air or prompting from the viewer. *The Miscreant* (1950; cat. no. 60) conjures up antecedents in the art of the Near East and the tendriled biomorphs of Joan Miró. This abstracted mythic beast—its body dissected, with the sharply delineated anatomical parts cantilevered out from a curvilinear backbone—is set in motion by the curved rockers on which it rests. A lyrical silhouette drawn in space, *The Miscreant* is imbued with lighthearted wit.

Throughout the remainder of his life, Howard continued to explore movement and materials, later developing sculpture that floated on water.

Katherine Holland

57.
Scavenger, 1949
Composite material
122$^1/_2$ x 72$^1/_2$ x 14 in.
Crown College, University of
California, Santa Cruz

58.
Night Watch, 1949–50
Wood, metal gypsum, and resins
106 x 31 x 9 in.
Collection of Galen Howard
Hilgard

59.
Inspector, 1950
Balsa wood, fiberglass, resin,
steel, lead, sawdust, and glue
17$^1/_2$ x 28 x 8 in.
Collection of Galen Howard
Hilgard

60.
The Miscreant, 1950
Aluminum, balsa wood, linen,
and polyvinyl acetate
31 x 98 x 9 in.
Addison Gallery of American Art,
Phillips Academy, Andover,
Massachusetts

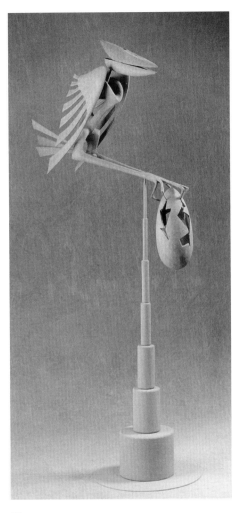

57

58

59

60

Jess (Collins)
b. 1923

Fig. 43
Jess in the 1950s
Photograph courtesy Literary
Estate of Robert Duncan

It was in 1949 that Jess had what he refers to simply as "the dream," a vision that the earth would be destroyed in the year 1975. This fear was undoubtedly part of a more pervasive anxiety experienced by many Americans and Europeans following the devastation of World War II and its horrific conclusion in Hiroshima. A highly intuitive person, Jess found it particularly meaningful that "the bomb" was dropped on his twenty-second birthday, August 6, 1945. His life experiences have led him to create an art that is as ironic and symbol-laden as it is humorous and playful. Although he would not describe himself as a surrealist—he identifies himself only by the broad and somewhat sentimental term *romantic*—his art expresses admiration for his French elders, whose works offer a precedent for his psychological landscapes. But if nothing else, Jess's story has an air of surrealism's spookiness and fantasy.

Born Burgess Collins in 1923, he experienced a middle-class childhood, growing up in Long Beach, California, a southern suburb of Los Angeles. As a student he was attracted to science. He entered the California Institute of Technology as a chemistry major in 1942 but was called into the army in 1943. Between 1944 and 1946 he was assigned to the Special Engineer Corps at the Manhattan Project in Oak Ridge, Tennessee, where he was involved with the production of plutonium for the atomic bomb. The most significant event in his brief army career was his discovery of James Joyce's *Finnegans Wake,* published in 1939. By chance the artist had come across a "skeleton key" guide to Joyce's intertwined metaphors and symbols and became "utterly entranced" by a cross-referencing so dense that meaning is a matter of continual reinvention. For Jess the Irish writer has provided an ambitious model for an art that encompasses a complex constellation of effects.

Following his discharge in 1946, Jess returned to California and completed his bachelor of science degree with honors in chemistry. Shortly after graduation in 1948, he went to work for General Electric Laboratories on the Hanford Atomic Energy Project in Washington, where he was again involved with plutonium production. The following year he had his dream. Some eight weeks later he left his job and moved to the San Francisco Bay Area. He decided to become an artist, convinced that he should use the time he had remaining to rediscover a sense of value in society.

The self-styled Sunday painter entered the California School of Fine Arts at the end of the legendary "MacAgy years." Douglas MacAgy had assumed the directorship of the school in 1945 and assembled a faculty that included Clyfford Still (1946–50), Mark Rothko (1947, 1949), and Ad Reinhardt (1950)

as well as local artists Elmer Bischoff, Edward Corbett, David Park, and Hassel Smith. Thus Jess was initiated into the art world during the tumultuous and heady days of abstract expressionism. While immersing himself in the movement's expressionist ethos and gestural techniques, he eventually moved beyond its pointed theoretical stance. Rather than renouncing European models, as did many abstract expressionists, he was inclined to embrace as many paradigms as possible.

During this period Jess explored the imaginative underworld of abstraction. He appreciated Still's canvases for the charged psychological space they suggested and the mythic clues hidden in them. He was intrigued by the idea of transforming Still's craggy fields of color into romantic fictions. This was a matter not simply of seeing picturesque landscape elements (canyons, cliffs, open prairie, waterfalls) in the images but of interpreting them as extended fantasies or myths. Jess saw back beyond abstract expressionism, not only to its immediate predecessor, surrealism, but also to eighteenth- and nineteenth-century romantic and symbolist painting, itself an ancestor of surrealism.

Jess met the poet Robert Duncan in 1949. Over almost four decades, until Duncan's death in 1988, a remarkable symbiosis developed between the artist and the writer. Duncan's poems inspired Jess's art, which in turn suggested ideas for Duncan's texts. Duncan's library of philosophical works, literature, and poetry contributed significantly to a household filled with books, paintings, sculptures, and classical records. Duncan was raised in California but spent time in New York in the late 1930s and early 1940s, mingling in both literary and artistic circles, moving between Anaïs Nin's entourage and pockets of expatriate surrealists.

For Jess and Duncan, as for many of the surrealists, the term *collage* had special meaning. Duncan saw his writing as part of a "grand collage" that included the heritage of philosophy, mythology, music, art, and literature. At the heart of Jess's art also are the imaginative possibilities of collage. Making scrapbooks with a great-aunt as a child, he discovered a way of entering the imagination through an accessible household craft. Later collage would not only be a favorite artistic medium but would also influence his painting and sculpture, in terms of both strategy and theoretical approach. While so much of art seems to be about learning what to leave out, Jess has spent his career seeing how much he can include. The expansive, fragmented territory of his paste-ups—a term he prefers to *collage* because of its childlike connotations—offers a kaleidoscopic bridge between the imaginings of a child and those of an adult,

61.
Boob #3, 1954
Collage
39 x 35 in.
Courtesy Odyssia Gallery,
New York

between the world of "low" art and popular culture and that of "high" art, and ultimately between that which is invented and that which is given. Jess forges mass-produced images into a melange of Freudian, narrative, and deconstructionist readings, disrupting context in order to create new meanings. The paste-ups offer a spirited mix of opposites: fusion versus anarchy, logic versus absurdity, layering versus flatness, the erotic versus the mechanical.

A number of early collages of the 1950s involve a Joycean splicing of words in which disjunctive headlines from magazine and newspaper advertisements are humorously juxtaposed, often underscored with painted gestures, to poke fun at material culture and advertising jargon. *Boob #3* (1954; cat. no. 61), made in collaboration with Duncan, exemplifies this approach. The somewhat grotesque *Goddess Because Is Is Falling Asleep* (1954) is a dark play on the 1950s advertising campaign "Modess Because . . . ," which depicted beautifully dressed society women promoting sanitary napkins. This theme is elaborated further in *Goddess Because II* (1956; cat. no. 64; color plate 21). The artist's well-known Tricky Cad series also displays his bizarre humor. In the early 1950s he began cutting up Dick Tracy comic strips at the kitchen table, playfully dissecting and rearranging word and image to form a disrupted narrative. The violent melodrama of the detective and his weird gallery of

antagonists—Pruneface, Flattop, the Rodent, Flyface, and B. O. Plenty—is transplanted to the level of surreal absurdity. Such early uses of popular imagery invited critics to see Jess as a pioneer of pop art, an association the artist has always found puzzling.

Jess acknowledges the obvious relationship between the paste-ups and surrealist photomontage, the most basic characteristic of which is the joining of two or more individual photographic images to form a completely different image. This practice had its roots in the composite portrait imagery of photographers working in the mid-nineteenth century. In the early part of this century German dadaists such as Raoul Hausmann, John Heartfield, and Hannah Höch used photomontage as a vehicle for social and political commentary. But it found its greatest popularity in the post-Freudian era, among the surrealists, who sought to liberate images from the unconscious through a free commingling of disparate images and objects. In 1952 Duncan purchased Max Ernst's surrealist collage book *Une semaine de bonté* (1934) as a gift for Jess. In his individual collages Ernst used paint and a wide range of materials, and the act of pasting was not always part of the process. *Une semaine de bonté,* however, was created solely by cutting and pasting pictures from old books and catalogues. Jess's paste-ups of

62.
Love's Captive, 1954
Collage
14 x 18 in.
The Literary Estate of
Robert Duncan

Now, now, Jess!

magazine illustrations, engravings, comic strips, and jigsaw puzzles clearly pay homage to Ernst's hallucinatory collages.

Like Ernst, Jess uses metaphor as his primary means of operating outside the realm of ordinary descriptive meaning, creating structures that are often ironic and paradoxical. One of the surrealist themes that appears consistently in Jess's collages is metamorphic transformation. Familiar images are deftly cut and spliced together with other, seemingly incompatible forms to produce a dreamlike third image. In *The Face in the Abyss* (1955; cat. no. 63) machine elements embedded in the face of a huge cliff form a strange being that combines the man-made with the natural. Civilization's unflagging belief in the "progress" represented by machines in the face of nature's stoic and patient existence is a theme that runs through Jess's art.

In his constant search for new collage materials, Jess haunts secondhand stores and bookshops. During the 1950s and 1960s he was fortunate to discover a collection of high-quality turn-of-the-century etchings and lithographs, which he both coveted and desecrated by cutting and pasting them into new configurations. In *Love's Captive* (1954; cat. no. 62) a delicately blue-tinted early twentieth-century lithograph depicting a group of love-struck women and friendly putti is disrupted by fragments of other lithographs. The artist introduces dissected facial parts and large groping hands where they don't belong, as a flock of curious geese look on. Admonishing himself for his own strangeness, Jess has pasted in the lower right corner the words "Now, Now, Jess!"

Over the past four decades Jess has expanded the possibilities of collage, incorporating whole new generations of visual textures available through contemporary commercial magazine images. He has also demonstrated a new level of fastidiousness in cutting out and assembling his images. While Ernst's collages focus attention on a few key juxtapositions placed centrally within the frame, which acts as a kind of proscenium containing this central action, Jess establishes an overall field of juxtapositions, which he refers to as a flux-image. The eye is encouraged not to focus on a central idea or image, but to move continually through a complex matrix of possible focuses, roaming the surface of the work. (One would view a painting by Pollock or Still in much the same way.) The proliferation of details and iconic energy in the paste-ups suggest a *horror vacui* unparalleled even in surrealist collage.

Michael Auping

63.
The Face in the Abyss, 1955
Collage
30 x 40 in.
The First National
Bank of Chicago

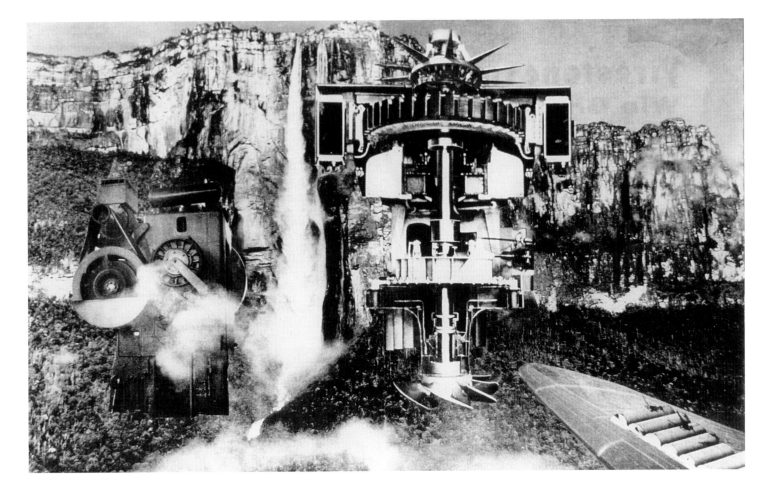

Adaline Kent
1900–1957

Fig. 44
Adaline Kent in her studio, San
Francisco, 1957
Photograph by Harry Redl;
courtesy Galen Howard Hilgard

Adaline Kent's search for the essence of experience led to the creation of deeply personal sculptural works that merge formal power with inventiveness. Guided by an innate love of nature, she produced a body of work informed by images drawn from the organic world—the spiral of a shell imbedded in sedimentary rock, the striated ruffle of a fungus, the torqued and pierced form of a silvered tree trunk in the high elevations of the Sierra Nevada—creating sculpture that transcends the specific and speaks to the universal.

Kent was born into a family dedicated to public service and conservation. Her father, William Kent, was an avid outdoorsman and longtime member of the United States Congress who championed the preservation of virgin redwood forests and the development of state parks in California. Her mother, Elizabeth Thacher Kent, was an outspoken suffragist who treasured her independence. As a girl Adaline Kent was athletic, relishing not only the movement and exhilaration of physical activity but the competitive thrill as well. After graduating from Vassar College, where she minored in art, she studied with Ralph Stackpole in San Francisco at the California School of Fine Arts (now the San Francisco Art Institute) for a year. Stackpole, a sculptor of monumental figures with moderne overtones, advocated "direct-cut," a method of shaping stone directly with chisel and mallet. In 1924 Kent traveled to Paris, where she studied at the Académie de la Grande Chaumière with Emile-Antoine Bourdelle. Bourdelle, who followed the more traditional methods of Auguste Rodin, advocated modeling, modulating the sculptural surface to emphasize light and shadow. Kent immersed herself in the artistic life of Paris, particularly the avant-garde culture of the Left Bank.

In 1929 Kent returned to San Francisco and began digesting what she had seen and learned. She explored the advantages and disadvantages of each technical method, adopting the elements that best suited her purposes. Her subjects, generally the human figure or animal forms, were reduced and purified, pared of detail and imbued with a generalized sense of the ideal. Her surfaces were likewise simplified, becoming smooth and unmodulated.

In 1930 Kent married Robert B. Howard, the sculptor son of architect John Galen Howard and a member of a large artistic family that included three brothers: painter Charles, painter John Langley, and architect Henry as well as their artist wives Madge Knight, Jane Berlandina, and Blanche Phillips. Together the family had a profound impact on the cultural community of the San Francisco Bay Area.

In 1940 Kent and Robert Howard moved into new studios designed for them by Henry Howard. The twin spaces, set side-by-side, allowed each artist independence but also afforded them the proximity to share ideas and discoveries. This move into a fresh, intimate architectural environment—together with the arrival in San Francisco of Robert's brother Charles, who brought with him from Europe a new vocabulary of organic abstract images—marks the beginning of a change of direction in Kent's work. She turned her attention away from the human figure and toward abstraction, utilizing biomorphic shapes suggestive of life and life forces. She concentrated on formal exploration: the use of void as a positive sculptural element, the activation of surrounding space, and the expression of movement through form. After initially experimenting with terracotta, by 1944 she was exploring the plastic possibilities of magnesite and hydrocal, synthetic compounds used in the construction industry, which allowed her the flexibility to build and carve, then rebuild and rework. The resulting smooth surfaces suggest water-worn boulders or ice floes.

Weathereye (1948; cat. no. 67) exemplifies Kent's new concerns. Its strongly defined silhouette encloses rounded cutouts, balancing solid with void. Quietly powerful and dignified in its bearing, its organic core is tempered by an implied angularity that conjures up images of nocturnal searchers. The subdued surfaces of the work, which is constructed of magnesite, are scored with bold linear tracings that emphasize the horizontal elements and suggest natural layering, endowing the whole with a sense of time.

In contrast *Gambler* (1948; cat. no. 65) is exuberant. Expanding on her explorations into dynamic movement of the early 1940s, Kent here expresses imminent action. An awkwardly poised tail balances the angled shape, ready to catapult it into action. Where earlier works bore linear tracings that conveyed a sense of the continuum of natural history, here the lines have thickened to become assertively sportive stripes playing off the vertical-diagonal thrusts of the work. The balance of interlocking positive and negative space remains, but here the triangular shape of the void is echoed.

Never Fear (cat. no. 66), also dated 1948 and sculpted of hydrocal, exhibits a more complex interplay of positive and negative space. As Kent wrote in her notebooks, "Just as a well-integrated person shows consistency from many different angles or aspects—that is: shape of face, hands, voice, writing, way of moving, so one form may express many different aspects of the same subject."[1] *Never Fear* weds the particular with the universal.

65.
Gambler, 1948
Magnesite
31 x 22^{1}/$_{2}$ x 9 in.
Collection of
Galen Howard Hilgard

66.
Never Fear, 1948
Hydrocal and pigment
22^{1}/$_{2}$ x 9 x 8 in.
Collection of
Galen Howard Hilgard

66

65

In the early 1950s Kent delved into the "intruders and phantoms" that hover on the edge of the subconscious. In *White Hand* (1951; cat. no. 68) the emphasis is on the upward thrust of the silhouette and the energy of the primal gesture, but the ghostly surface and veined markings underscore an otherworldly presence.

By 1948 Kent's work was being exhibited outside San Francisco's close-knit art community. It was included in key exhibitions at the Whitney Museum of American Art and the Museum of Modern Art in New York and was shown at the São Paulo Bienal in 1955. One-person exhibitions were presented in both San Francisco and New York. In 1953 she and her husband traveled to Greece and Egypt, where the ancient art and architecture made a great impression on them both. When she returned home, she began to experiment with the new images and forms she had seen. In 1957, while still at the height of her powers, she died in an automobile accident.

Katherine Holland

Notes
1. Adaline Kent, *Autobiography: From the Notebooks and Sculpture of Adaline Kent* (Privately printed, 1958), p. 43.

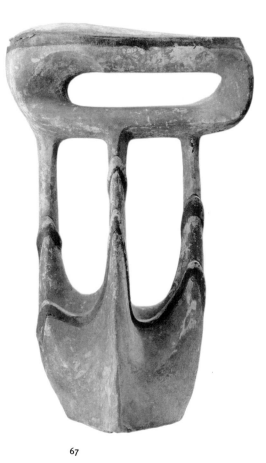

67

67.
Weathereye, 1948
Magnesite
33^1/$_2$ x 21 x 8 in.
The Oakland Museum,
lent by the Robert B.
Howard family

68.
White Hand, 1951
Magnesite
75 x 25^1/$_2$ x 15 in.
Collection of
Galen Howard Hilgard

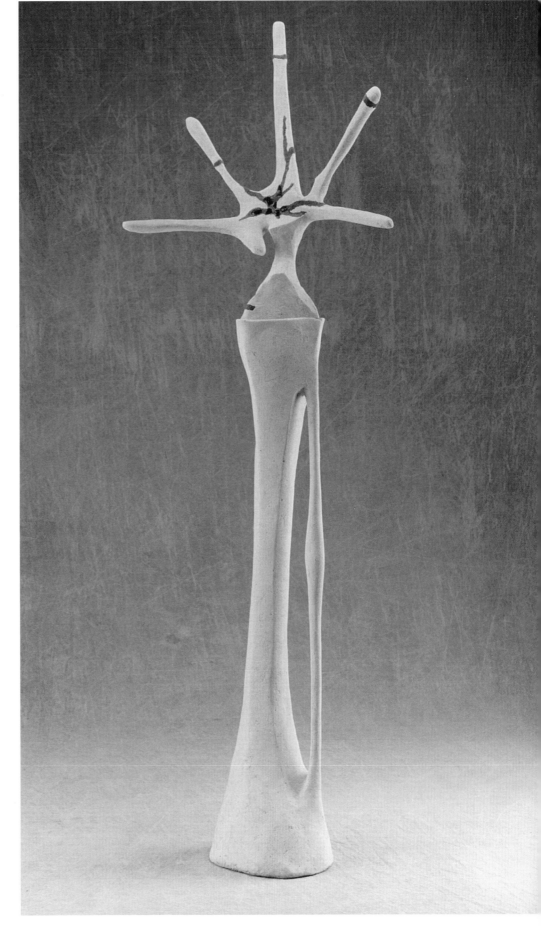

Madge Knight
1895–1974

Fig. 45
Madge Knight in the 1950s
Photograph courtesy Janette
H. Wallace

In Madge Knight's paintings imagination is combined with formal power, and spontaneity is tempered by control, yet intuition and a sense of freedom predominate.

Born in Nottingham, England, in 1895, Knight received her formal art training in both Nottingham and London. Around 1933 she married the American painter Charles Howard, who had already established a reputation for meticulously rendered abstractions exploring forms derived from the unconscious. After their marriage Knight and Howard spent several years in England. Because of World War II they left England in 1940 and resettled in San Francisco, where they remained until 1946.

During her years in the Bay Area, Knight produced a series of small gouaches earmarked by aqueous monochromatic arenas inhabited by fantastic abstract shapes combining planar, volumetric, organic, and geometric elements. Her work during this period has been linked stylistically to that of her husband, and in fact they shared an affinity for formally considered abstractions that position organic shapes within ambiguous settings. But while their styles are closely related, the dissimilarities are readily apparent. Howard's compositions are cool, rational, and precise, utilizing hard-edged, austere forms, sharply colored and carefully placed against seamless, dramatically backlit grounds. In contrast Knight's works are freely constructed, spontaneous forays into the landscape of the mind. Bumptious forms hover or float within striated, washed atmospheres suggestive of a desert wasteland or ocean floor. Where Howard's compositions are stern and foreboding, Knight's are playful and light-filled, bursting with a sense of life and emphasizing interaction, interrelationship, and movement.

In many of Knight's works, including *Bone* (1944, San Francisco Museum of Modern Art), biomorphic forms play against polyhedrons; crisply defined, flatly opaque passages, often of white, punctuate cursorily modeled, seemingly bulging forms. This interplay of organic and geometric, planar and volumetric, is furthered by the frequent interjection of schematic linear elements that intersect, connect, and counterbalance one another or take on a life of their own, becoming sprouting tendrils or waving rootlets.

While Knight and Howard were in San Francisco, World War II raged in both the European and Pacific theaters. Although the actual fighting took place far from the northern shores of California, it cast a physical and psychological shadow over the residents of the San Francisco Bay Area. Since Civil War days the headlands along the Golden Gate had been reserved for military purposes and were the site of many fortifications and gun emplacements. The community lived in an emotionally charged environment clouded by the constant threat of invasion from the Pacific. Many Bay Area artists, including Howard, James McCray, and Clay Spohn, articulated their responses to the horrors of the conflict and the resultant doomsday ambience through their art. Exiled from her native England because of the war, Knight must have been particularly affected. In *Turret* (1944; cat. no. 69), executed in gouache on paper, she utilized forms drawn from military armaments but defused their frightening connotations by personalizing them. Dramatically set against a loosely brushed incandescent dreamscape, a turret and periscope, iron machines of war, become personages, facing each other in a faintly whimsical confrontation.

Knight's small-scaled abstractions attracted the attention of two powerful figures in the local art community: Grace McCann Morley, director of the San Francisco Museum of Art (now the San Francisco Museum of Modern Art), who presented a solo exhibition of her work in 1943, and Jermayne MacAgy of the California Palace of the Legion of Honor, who included Knight's work in the first of her vanguard spring annuals in 1946. At the close of the war the Howards returned to England, where they lived in Suffolk until 1970. Knight spent her final years in Bagni di Lucca, Italy.

Katherine Holland

69.
Turret, 1944
Gouache on paper
18¹/₂ x 21³/₄ in.
Courtesy Campbell-Thiebaud
Gallery, San Francisco

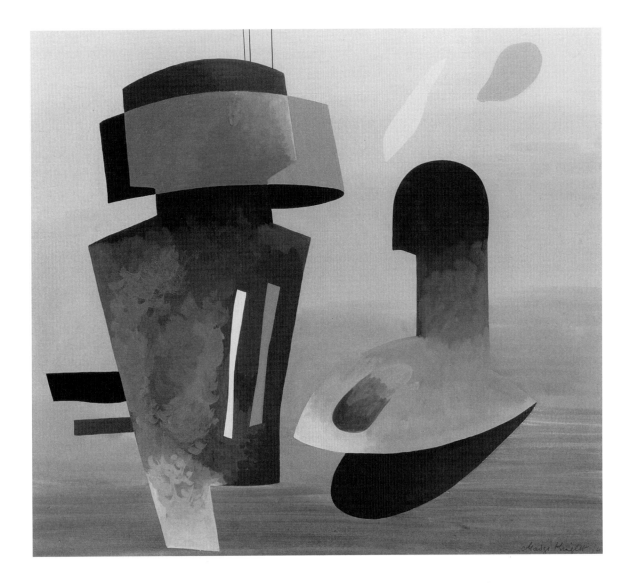

Lucien Labaudt
1880–1943

Fig. 46
Lucien Labaudt in his studio,
mid-1930s
Photograph from the
Santa Fe News
Lucien and Marcelle Labaudt
Papers, Archives of American
Art, Smithsonian Institution

The illusionistic surrealism practiced by Southern California Post-Surrealists in the 1930s had a northern counterpart in the work of San Franciscan Lucien Labaudt. Unlike the majority of his fellow Bay Area artists—whose response to European surrealism took the form of organic abstraction, adopting the biomorphic forms and shallow space that characterize the works of Joan Miró and Yves Tanguy—Labaudt explored the arena of magic realism, filling his canvases with eclectic images drawn from musings and memory. In their seemingly irrational juxtapositions and collaging of images, Labaudt's paintings exhibit close ties to the work of Giorgio de Chirico and Salvador Dali, spiced with a healthy dose of synthetic cubism.

Born in Paris in 1880, Labaudt was trained as a couturier. His talent and creativity in that field took him first to London and then to the United States, where he settled in San Francisco around 1911. While continuing to work in fashion design and production, he soon took up painting and by 1920 was exhibiting frequently. During the ensuing years, his work was included not only in the annual exhibitions organized by the San Francisco Art Association but also in such international shows as the Salon des indépendants and the Salon d'automne in Paris. He often applied his talent for painting to the theatrical arts, designing costumes and stage sets for the lavish Bohemian Club productions and spectacularly bizarre Parilias, pageants put on by the San Francisco Art Association.

Inspired by the work of Paul Cézanne, Labaudt's paintings of the 1920s are characterized by fragmented planes and strong formal concerns. Like Cézanne, Labaudt focused on traditional genres: still life, landscape, the human figure. By 1930 his interest in the female nude had become predominant. Heavy almost to the point of being ponderous, these full-figured forms in classical poses seem to swell to fill the canvas.

In the mid-1930s Labaudt exploded his single-focus compositions, packing his canvases with fragments, sometimes disparate, sometimes related. The images, retrieved from the edge of memory, are layered and superimposed, building up a visionary tapestry with limitless connotative possibilities. Signature works executed in 1935, some of which were included in the landmark Post-Surrealist exhibition shown in San Francisco and Brooklyn in 1935–36, exemplify this disjunctive style. In *Telepathic Travel to Tahiti* (cat. no. 72; color plate 5), a paean to pleasure, multiple images alluding to escape to an earthly paradise are juxtaposed, constantly shifting in scale and perspective. Visual plays serve to relate image to image: telephone wires become guitar strings, dark profile echoes light profile, fruit mimics figure. In direct contrast to the dark carnality

evident in Dali's work, Labaudt's surrealism is informed by California hedonism.

In other works executed in 1935 disparate elements form a larger configuration. *Song of the Seas* (cat. no. 71) features a centralized single figure made up of fanciful segments. Labaudt's theatrical bent is evident; the composite figure is a performer, and stage props abound. *Shampoo at Moss Beach* (cat. no. 70) teems with double entendres. In the middle ground a classically conceived female nude, eyes averted, hovers above a faceless figure fashioned of double images: a compass for an arm, a horse's head for a leg, a pot lid for a breast. Behind this disturbing pair lies a scene—framed by a curtain, which dissolves into clouds—strongly reminiscent of paintings by de Chirico.

During 1936 and 1937 Labaudt painted grand-scale frescoes on the walls of San Francisco's Beach Chalet, facing the ocean at the western end of Golden Gate Park. Offering a glimpse into San Francisco life in the 1930s, these murals stand in direct contrast to the fractured magic realism of the previous years. Labaudt died in 1943 while en route from India to China as an artist-correspondent covering World War II for *Life* magazine.

Katherine Holland

70.
Shampoo at Moss Beach, 1935
Oil on board
60 x 48 in.
Collection of the San Francisco
Art Commission, gift of Marcelle
Labaudt

71.
Song of the Seas, 1935
Oil on panel
48 x 23 in.
Collection of the San Francisco
Art Commission, gift of Marcelle
Labaudt

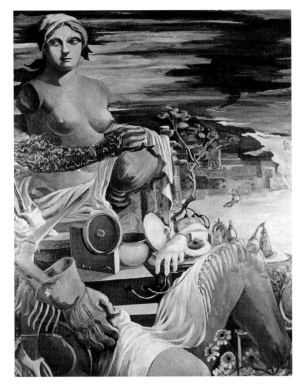

70

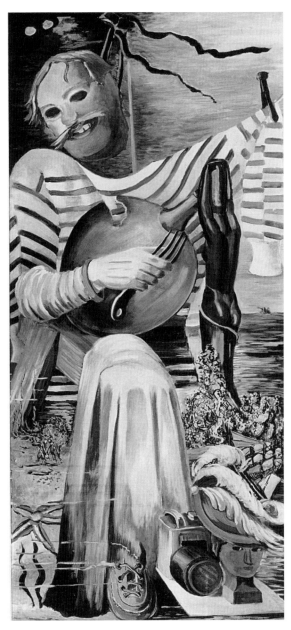

71

Harold Lehman
b. 1914

Fig. 47
Harold Lehman
Self-Portrait, 1935
Oil on canvas
Courtesy Harold Lehman

In 1930, at the age of sixteen, Harold Lehman moved from New York to Hollywood, where he enrolled in Manual Arts High School. With fellow students Philip Guston (then Philip Goldstein) and Jackson Pollock, he studied under modernist artist Frederick John de St. Vrain Schwankovsky. Lehman also befriended Reuben Kadish, with whom he later collaborated on murals in New York. In 1931 Lehman graduated and won a prestigious scholarship to the Otis Art Institute, an award that Guston had won the previous year. At Otis, Lehman, who was then a sculptor, studied with sculptors Roger Noble Burnham and George Stanley (designer of the Oscar).[1]

Lehman's encounter with Lorser Feitelson and David Alfaro Siqueiros in 1932 changed the course of his art. Siqueiros, the well-known Mexican muralist, had just completed a large mural in Los Angeles, *America Tropical.* Lehman joined Siqueiros's Bloc of Painters, a group of artists who sought to promote socially relevant themes in their art. Los Angeles's political climate was not receptive to such art, however, and frescoes by Lehman and others were destroyed when an exhibition at the John Reed Club in Hollywood was raided by the city's "Red Squad." This controversial event, and the positive critical response Lehman had garnered from other exhibitions, brought him early attention; in 1933 he and Guston had a two-person show at the Stanley Rose Gallery in Hollywood.[2]

After Siqueiros left town in 1933, Lehman entered Feitelson's circle, studying with him at the Stickney Memorial School of Art in Pasadena and frequenting his Hollywood studio. Like Helen Lundeberg, Lehman was unusually precocious and talented. He began experimenting with the principles of surrealism during the period in which Feitelson and Lundeberg were formulating their ideas about Post-Surrealism, and in November 1934 he participated in the Centaur Gallery exhibition in Los Angeles which introduced Post-Surrealism to the public.[3] This was followed by an important exhibition at the Paul Elder Gallery in San Francisco.

In *Landscape in Perspective* (1934; cat. no. 73) Lehman's style is inflected by the surrealism of Salvador Dali and René Magritte and the metaphysical paintings of Giorgio de Chirico. Dali had just had his first solo exhibition in the United States, which prompted much interest in his work. At this time Lehman began a study of Freudian and Gestalt psychology and visited the Arensberg collection, which included masterworks of European modernism by artists such as de Chirico, Dali, and Max Ernst—all of whom were to serve as important models for the Post-Surrealists. He also studied such Renaissance masters as Michelangelo and Piero della Francesca. *Landscape in*

Perspective is in fact a witty allegory about the attempt of young modern artists to supplant the greatness of the masters.

The autobiographical *Portrait of a Dancer plus a Sculptor* (1934; cat. no. 74), which includes a self-portrait, is weighty with narrative, perhaps a result of the artist's effort to assimilate several new ideas at once. More freshly conceived and executed is the mixed-media collage *Surveyor* (1934; cat. no. 75), in which a man of practical experience, whose head is nevertheless in the clouds, surveys the moon. Designed to convey a metaphysical idea, the painting is about the interconnectedness of all things, the wonder of the universe. Proficient in his figural studies, Lehman combined the elegance of the late Italian Renaissance with the blocky, muscular approach to the figure popular in the 1930s, which was derived from the Mexican muralists.

In 1935 Lehman had his first solo exhibition at Jake Zeitlin's Book Shop in Los Angeles. Shortly thereafter he returned to New York to participate in the Federal Art Project (WPA) with Kadish and Guston, in an environment he felt would be more conducive to the development of a socially and politically relevant art. In 1936 Lehman helped Siqueiros organize his well-known workshop carrying out experiments with new technologies and tools, such as automobile lacquers, airbrushes, and spray guns. The participants, including Pollock, were concerned with the spontaneous application of paint and such surrealist automatic methods as the drip technique. Lehman also made murals under the Federal Art Project and the Treasury Department's Section of Painting and Sculpture.

Because Lehman had moved to New York, his work was not included in the 1935 exhibition at the San Francisco Museum of Art which brought national recognition to the Post-Surrealist group.

Susan M. Anderson

73.
Landscape in Perspective, 1934
Oil on canvas
30½ x 25 in.
Collection of the artist

74.
Portrait of a Dancer plus a Sculptor, 1934
Oil on wood
54 x 36 in.
Collection of the artist

75.
Surveyor, 1934
Mixed-media collage
24½ x 18 in.
Collection of the artist

73

Notes

1. I am grateful to Harold Lehman, who graciously assisted my research by sending me numerous clippings and other biographical materials. Mr. Lehman was also extremely patient and informative during numerous telephone interviews that took place in fall 1993.
2. For more on the controversy surrounding Lehman's art and the John Reed Club incident, see Arthur Millier, "Conflict on Museum Art Held Deeper than Seems," *Los Angeles Times*, 28 May 1933; idem, "Communists Incited to Stir up Trouble through Artists' Propaganda-Paintings," *Los Angeles Times*, 26 August 1934. For a review of the Stanley Rose Gallery exhibition, see Arthur Millier, "Two Pairs of Painters and Some Singles Offer Shows," *Los Angeles Times*, 17 September 1933. Lehman assisted on a mural in Los Angeles at the Frank Wiggins Trade School in 1933 under the Public Works of Art project; he assisted Leo Katz on another under the Federal Art Project (WPA) in 1935.
3. Diane Moran, "Post-Surrealism: The Art of Lorser Feitelson and Helen Lundeberg," *Arts* 57 (December 1982): 125.

74

75

Helen Lundeberg
b. 1908

Fig. 48
Helen Lundeberg, 1949
Photograph by Lou Jacobs, Jr.;
courtesy Tobey C. Moss Gallery

Every . . . painting has its "method". . . but to what end?
To express, more or less consciously, the intuitive, the
imaginative, the subjective.[1]

Responsive to inner wellsprings of thought, Helen Lundeberg
fashioned visual tropes for subjective states of mind. The excep-
tional body of work that she wrought from her fantasies placed
her in the forefront of American surrealism.

As a youth in Pasadena, California—her family had moved
there from Chicago when she was four years old—Lundeberg
showed a precocious intelligence, and psychologist Louis
Terman described her as gifted. Intending to become a writer,
she majored in English and minored in science at Pasadena City
College, graduating in 1930. Subsequent study at the Stickney
Memorial School of Art with Lorser Feitelson, whom she later
married, convinced her to become an artist.[2]

Within a few years Lundeberg had set her artistic course,
predicated on dreamy introspection, and in 1934 she joined
Feitelson in formulating Post-Surrealism. Fascinated with
human psychology, they tracked the machinations of thought,
but instead of indulging neurotic fixations, as the European sur-
realists often did, they explored theoretical issues with analyti-
cal sobriety. Assuming a classical stance, they opposed the
libertinism of surrealism and sought to counter its excesses
with formal control and emotive restraint. Although they dis-
dained the eroticism of artists such as Salvador Dali, they
admired the eerie tableaux of Giorgio de Chirico and René
Magritte, which cannily juggled fiction and fact in ways that
piqued curiosity.

Intrigued, as Feitelson was, with the ties that bind dis-
parate things, Lundeberg fashioned a series of works built on
chains of associations. In *Plant and Animal Analogies* (1934;
cat. no. 77; color plate 2) directive dashes and gray schemata,
modeled on those found in science texts, establish a train of
organic relationships, connecting a womb-encased embryo to a
pit in a cherry; a child's brain to a bell pepper; and the boughs
of a tree to veins. The painting compares in treatment and
theme to Feitelson's *Genesis #2* (1934; cat. no. 34; color plate 4),
which likewise deploys dotted lines and illustrations in a
didactic scheme of biological affinities. A key work of Post-
Surrealism, *Plant and Animal Analogies* was reproduced in a
1934 treatise in which Lundeberg defined the movement and
declared its aim: "The new aesthetic form is subjective, an
ordered, pleasurable, introspective activity; an arrangement
of emotions or ideas. The pictorial elements function only to

create this subjective-form: either emotional or mood-entity, or
intellectual or idea-entity."[3]

Exemplifying this subjective, ordered form, Lundeberg's
The Mirror (Enigma) (1934; cat. no. 76) presents a wooden chair,
a sketch board with a sheet of paper, a looking glass, and a
shell in the dim light of dusk or awakening day, which grants
them a mysterious air. Implements of the artist's profession,
these objects constitute a surrogate self-portrait and proffer a
disquisition on the symbiosis of art and life, internal and exter-
nal sight. The contiguous placement of the drawing equipment
and mirror suggests art's concern with the visible world, while
the lightbulb signals the inspiration on which creative expres-
sion relies. Reflecting this source of illumination, the mirror,
which symbolizes the psyche or soul, invites us to read it as an
emblem of the artist's imagination.

Lundeberg's probe of identity's guises and verism's wiles
continues in *Double Portrait of the Artist in Time* (1935; cat. no.
78; color plate 1). A remarkable image of psychic growth, the
piece gives visible form to the evolution of a persona and to the
key role of memory in shaping identity. Crystallized in the shad-
ow, memory travels through time to bind the adult and the
child, the former shown as the subject of a painting, the latter
as a full-bodied toddler whose age is announced by the clock at
her side. These inverted realities prompt the viewer to ponder
existential questions: Is the child of bygone days, who abides in
the realm of the mind, more real, as the lifelike youngster would
have us believe, than the woman who enters the scene through
art's contextual frame? Clearly the past governs the present
through the subconscious thought that it generates. In its philo-
sophical probe of the psyche, *Double Portrait* invokes
Bergsonian notions of subjective time, Jungian tenets of holistic
being, and the Freudian creed that in childhood resides the key
to personality. Implicitly, too, it confirms the magic of represen-
tation, which wondrously negates the action of time as it recalls
the fugitive contents of yesteryear.

The artist again treats subjective perception and time in
Relative Magnitude (1936; cat. no. 79; color plate 3), but now
with a fanciful wit, as she allies an ant eyeing a marble with an
astronomer viewing the moon. By dressing her relativity theme
in anthropomorphic garb, she brings issues of status, perspec-
tive, and power into the Einsteinian space-time equation.
Shapes of different hue and dimension bespeak the provisional
nature of form, and a clock dial bereft of units of measure
suggests the contingency of time.

The whimsy in *Relative Magnitude* gives way to a
wistful poignancy in *Inquisitive Rose* (1942; cat. no. 80) and

76.
The Mirror (Enigma), 1934
Oil on Celotex
30 x 24 in.
Nora Eccles Harrison Museum of
Art, Utah State University, gift of
Marie Eccles Caine Foundation

80.
Inquisitive Rose, 1942
Oil on pressed paperboard
8^{1}/$_{8}$ x 5^{1}/$_{2}$ in.
Collection of Dr. Bernard L.
Krause

81.
Abandoned Easel #2, 1943
Oil on cardboard
7 x 5 in.
Private collection; courtesy
Parkerson Gallery, Houston,
Texas

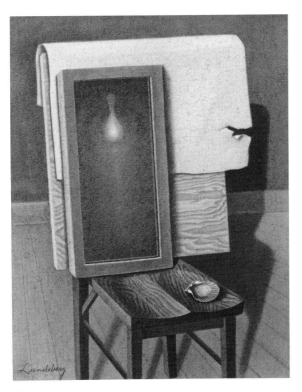

76

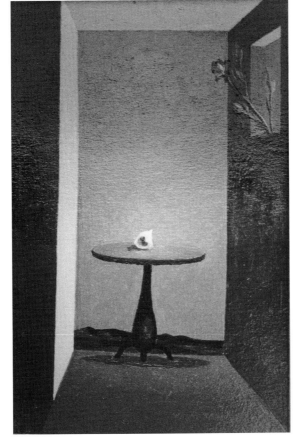

80

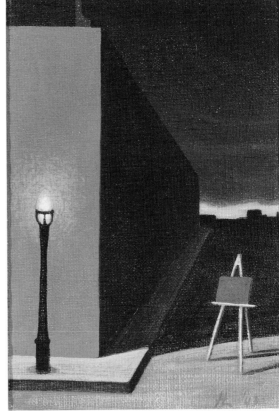

81

Abandoned Easel #2 (1943; cat. no. 81). As "mood-entities" these paintings delineate feelings and enlist the spectator's sympathy through the predicaments that they address. By means of the pathetic fallacy their titular subjects express human sentiments and, in the mode of André Breton's communicant vessels, convey sensations of desire. The voyeuristic bud, peering at an unreachable shell, and the forsaken canvas, stranded at night on a desolate street, speak of yearnings for contact, emotions pervasive during the war.

Reflecting again on veristic depiction and the illusions it perpetrates, Lundeberg painted the engaging *Self-Portrait* (1944; cat. no. 82), wherein she appears before her easel, a brush in one hand, a ball in the other. As Magritte had done in *The Human Condition I* (1933), she places a picture of a landscape before a larger, similar image that suggests a view through a window. A contest thereby ensues between the two representations and, by extension, between the Platonic states of existence that they imply. In another illusional ploy the model globe looms over the tiny moon, thereby reprising issues of scale examined in *Relative Magnitude*.

Plant and Animal Analogies, The Mirror (Enigma), Double Portrait of the Artist in Time, and *Relative Magnitude* appeared in large Post-Surrealist exhibitions at the San Francisco Museum of Art and the Brooklyn Museum during the 1935–36 season. At the latter venue *Double Portrait* captivated *New York Times* critic Edward Alden Jewell, who used it to illustrate his review of the Californians' show.[4] Also impressed with Lundeberg's work, Museum of Modern Art Director Alfred H. Barr, Jr., included one of her oils in his exhibition *Fantastic Art, Dada, Surrealism* in 1936. This, plus Lundeberg's participation six years later in that museum's *Americans 1942: Eighteen Artists from Nine States,* established her as a leading figure in the American surrealist movement.

During the 1940s and 1950s Lundeberg's stature continued to grow. She contributed works to group exhibitions nationwide, among them the Art Institute of Chicago's *Abstract and Surrealist American Art* in 1947–48 and annuals of American art at the University of Illinois at Urbana and the Carnegie Institute in Pittsburgh. Locally, following her 1934 Post-Surrealist debut at the Centaur Gallery in Hollywood, she maintained high visibility, with a solo show at the Stanley Rose Gallery in 1935 and with Post-Surrealist group exhibitions at Rose's gallery and at Feitelson's Hollywood Gallery of Modern Art. Subsequently her works could be seen at, among others, the Stendahl Galleries (1938), the Los Angeles County Museum of History, Science, and Art (1939, 1944, 1945, 1950, 1951, 1953, 1956, 1957), the Los Angeles Municipal Art Commission's Annual at the Greek Theatre (1951), and the Los Angeles Art Association Galleries (1954). Individual exhibitions were held at the Felix Landau Gallery in 1952 and at the Pasadena Art Institute the following year, and her work was presented with Feitelson's at the Art Center School Gallery in 1949 and at the Scripps College Art Galleries in Claremont nine years later.[5] Honored in their own day, Lundeberg's visions of magical realms where truth and fantasy seamlessly bond have retained their psychological fascination over time.

Susan Ehrlich

Notes

1. Helen Lundeberg, in *Sourcebook* 21 (November–December 1974): 20.
2. For an informative study of the artist's work, see Diane Degasis Moran, "Helen Lundeberg," in *Lorser Feitelson and Helen Lundeberg: A Retrospective Exhibition,* exh. cat. (San Francisco: San Francisco Museum of Modern Art; Los Angeles: UCLA Art Council, 1980), pp. 24–30.
3. Helen Lundeberg, "New Classicism," 1934.
4. Edward Alden Jewell, "Brisk Pace in Museums," *The New York Times,* 17 May 1936.
5. Louise Katsman and Patricia Marra provide a chronology, and Karen Lee, a thorough exhibition history in *Lorser Feitelson and Helen Lundeberg,* pp. 36–37, 74–76.

82.
Self-Portrait, 1944
Oil on masonite
16$^{1}/_{2}$ x 27$^{3}/_{4}$ in.
The Jane Voorhees Zimmerli Art
Museum, Rutgers, the State
University of New Jersey, gift of
the Lorser Feitelson/Helen
Lundeberg Feitelson Foundation

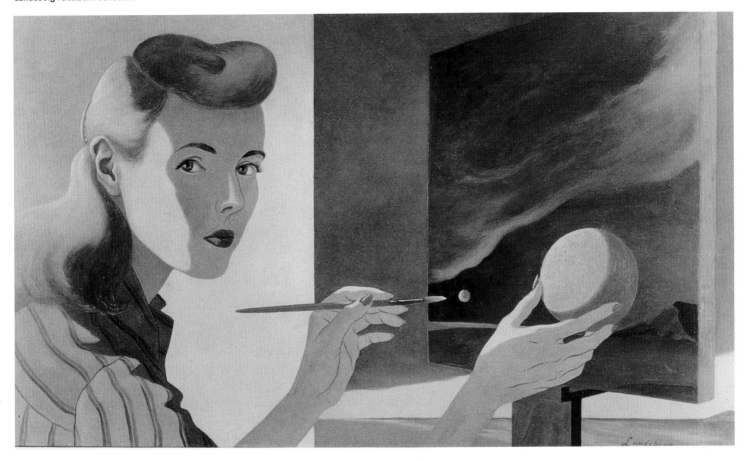

Rose Mandel
b. 1910

Fig. 49
Rose Mandel, 1948
Photograph by Minor White;
courtesy Rose Mandel and
Susan Ehrens

In Rose Mandel's sequence of twenty photographs, On Walls and behind Glass (c. 1947–48; see cat. nos. 83–85), one can identify several aesthetic approaches: symbolism, surrealism, and abstract expressionism. This does not signal indecision on the part of the photographer, however, but rather a coming to terms. Presenting photographs in sequence, like stanzas of a poem or musical movements, allowed her to explore several means of expression at once while addressing the moral dilemmas of a century of innovations and holocausts.

Mandel did not attain this synthesis merely as a photographer; her primary training was in psychology. She was born Rose Reich in 1910 in Czaniec, Poland. Although she had been interested in art since childhood, she received her first substantial exposure to contemporary aesthetics in 1937–39 while living in Paris. In July of 1939, while Mandel was vacationing in Poland with her family, the country began mobilizing for war. Friends and family convinced her to use her visa to travel across Germany before the war annulled it. She did and joined her husband, who was then in Switzerland on business. Although they considered returning to Poland, the Mandels decided to stay in Geneva. He worked for the Red Cross, and she attended the Jean-Jacques Rousseau Institute, studying child psychology with Jean Piaget. By 1942, however, they had immigrated to New York, where friends advised them not to spend their first years as refugees begging for jobs, but to move to California, which promised a better life.

Near Palo Alto Rose found employment as a lathe operator in a munitions factory. Her English was not yet good enough to allow her to pursue a career as a child psychologist or teacher. Around the close of the war, a friend of Mandel's who had owned a gallery in Paris and was now living in Carmel advised her to seek a vocation in the arts. At one of her friend's parties, she was introduced to Edward Weston. Although her own sense of photography as a potential profession was then not much advanced beyond that of flattering clients with retouched studio portraits, she admired Weston's accomplishments and attitude. He agreed to take her on as a student, but by the time she was in a financial position to consider an apprenticeship, he was involved in divorce proceedings, and his health was failing. Weston recommended that Mandel take instruction from a younger photographer, Ansel Adams, who was about to begin teaching at the California School of Fine Arts in San Francisco. She hesitated at first but then decided to become a student in Adams's first classes, in 1946–47.

Adams proved to be the mentor Mandel had hoped for in Weston, opening up the wider creative possibilities of

photography by stimulating her interests in literature, music, and painting. Teaching with Adams was Minor White. Since White was seriously pursuing the larger issue of creativity and mental condition, he and Mandel were perfect complements: her enthusiasm for photography was informed by her advanced studies in psychology, while his open search for spiritual equilibrium was tempered by the exacting medium of photography. In this environment both teacher and student flourished, and in 1948 Mandel mounted her first exhibition, of On Walls and behind Glass, which Adams had titled.

Although Mandel did not insist that viewers accept her own readings of the photographs, in her mind the playful window displays and reflections assumed symbolic meanings. For instance, the first photograph of the sequence (cat. no. 83), with its clock showing the eleventh hour and its copy of the *Rheinlander* magazine, was intended to be not just a chance assemblage but also a warning to those who might think that the world was safe from future holocausts just because armistices had been signed. The second photograph of the series (cat. no. 84) shows a disembodied eye on an empty storefront window which appears eerily isolated in its suspension. Silent and intense, it seems to mimic the photographer, who knowingly faces a world that too easily records itself in superficial shadows and illusive reflections. But lest we content ourselves that the world is either abstracted object or state of mind, the last photograph (cat. no. 85) shows the photographer herself as the agent who has brought about our heightened consciousness.

A subtle metaphysical undertone informed Mandel's next series as well. Errand of the Eye, exhibited in 1954 at the M. H. de Young Memorial Museum and the George Eastman House, concentrated not on urban subjects, but on details of plants and natural landscapes.

In 1967 Mandel was awarded a Guggenheim Fellowship, but within a few years her husband became seriously ill. She devoted herself to his care for more than a decade, which left her little time to refine her interpretive notion of landscape photography. By the time of his death, she had essentially retired both from her job as staff photographer for the art history department of the University of California, Berkeley, and from her creative photography. She currently resides in Berkeley.

David Travis

83.
Untitled, from On Walls and
behind Glass, c. 1947–48
Gelatin silver print
4¹/₂ x 3³/₄ in.
The Art Institute of Chicago,
restricted gift of Lucia Woods
Lindley and Daniel A. Lindley, Jr.

84.
Untitled, from On Walls and
behind Glass, c. 1947–48
Gelatin silver print
4⁵/₈ x 3¹/₂ in.
The Art Institute of Chicago,
restricted gift of Lucia Woods
Lindley and Daniel A. Lindley, Jr.

85.
Untitled, from On Walls and
behind Glass, c. 1947–48
Gelatin silver print
4⁵/₈ x 3³/₄ in.
The Art Institute of Chicago,
restricted gift of Lucia Woods
Lindley and Daniel A. Lindley, Jr.

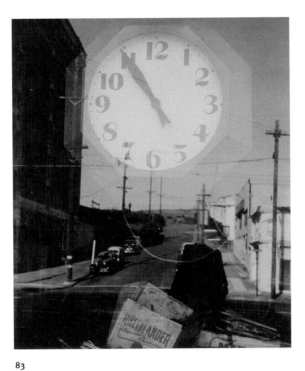

83

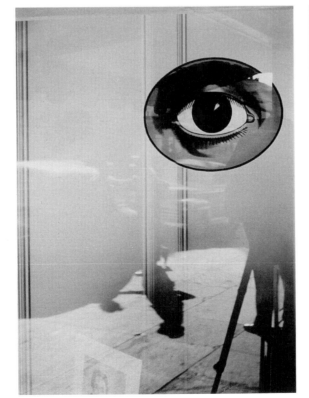

84

85

Knud Merrild
1894–1954

Fig. 50
Knud Merrild at home, 1949
Copyright Lou Jacobs, Jr.

And by chance and accident we live and die. To reflect this I attempt a personal intuitive expression.[1]

With a dada-surrealist faith in the workings of chance and in the creative potential of intuition, Knud Merrild explored subconscious impulses in his art. Born in Jutland, Denmark, in 1894 and apprenticed to a housepainter during his teens, he studied at the Arts and Crafts School and at the Royal Academy of Fine Arts in Copenhagen. A cubist exhibition in 1913 converted him to modernism, whose verities he pursued through Anvendt Kunst, an artists' alliance he organized in 1917, which wed progressive aesthetics to crafts.[2]

His interest in modernism led Merrild to immigrate to New York in the early 1920s and then to Los Angeles in 1923.[3] While supporting himself as a housepainter—a trade that he would parlay into a decorating business by the 1940s—he devoted evenings and weekends to his art, crafting collages, wall-mounted constructions, and paintings in gesso and wax, watercolor, and oil.

By the mid-1930s, when he affiliated with the Post-Surrealist movement, Merrild had begun to incorporate personal symbols and totemic forms associated with surrealism into his synthetic cubist works. In *Exhilaration* (1935; cat. no. 86; color plate 6) sunbathers and divers attest to the artist's love of swimming (a sport in which he earned a Scandinavian championship), and wallpaper scraps, perhaps gleaned from his workday supplies, lend the field a decorative flair. Moreover, within its cubist structure, replete with layered conflations of women and curves, the piece invokes California's holiday aura and surrealism's fixation on sensory delights, from the taste of tea and the trills of a bird to the fragrance of flowers and citrus fruits.

A key piece in the artist's oeuvre, *Exhilaration* graced Merrild's first solo show in California, at the Hollywood Gallery of Modern Art in July 1935, and appeared in the *Post-Surrealist Exhibition* at the San Francisco Museum of Art the following December. In the spring of 1936 that show traveled, with slight modifications, to the Brooklyn Museum, where it caught the eye of Museum of Modern Art Director Alfred H. Barr, Jr., who selected a painting by Merrild for inclusion in the exhibition *Fantastic Art, Dada, Surrealism*, which he mounted at the museum later that year.

Merrild's investigation of surrealism blossomed in the early 1940s into an automatist painting method that he called flux. First successfully realized in 1942, his flux technique involved splashing and puddling pigments onto a wet support without the intervention of brushes or palette knives. This manner of "painting by remote control," as the artist described it, capitalized on accidental effects and enabled him to capture motion in pools and splatters of flowing enamel.[4] Like Jackson Pollock's drip paintings, which they predated, Merrild's fluxist conceptions expressed romantic abandon as they recorded the artist's reflexive engagement with his mutable imagery.

From such impromptu means Merrild wrought *Perpetual Possibility* (1942; cat. no. 88), a work whose writhing currents of paint seem to embody impetuosity. Shimmying and slithering throughout the field, these rivulets yield what art critic Clement Greenberg hailed in the work of Pollock, an "allover" web of linear tracery.[5] Unlike Pollock, however, Merrild did not pursue this "edge-to-edge" calligraphy, but rather preferred—as in *Flux Bleu* (1942; cat. no. 87), *Asymmetric Symmetry* (1943; cat. no. 89), *Resignation* (1945; cat. no. 90), and *Chain Reaction* (1947; cat. no. 91)—to let his oils congeal into evocative configurations. These irregular forms in turn provided grist for the artist's imagination, which reveled in metaphor. Typically, as art critic Jules Langsner observed,[6] Merrild drew analogies between these random concretions and nature's creations and, conversely, found within them evidence of a microcosmic-macrocosmic paradigm. "A flux painting has the dual nature of the microcosmic-macrocosmic world," he wrote. "Seen under a magnifying glass or a microscope, dots or details are not merely enlarged, but reveal a new world of intriguing designs."[7]

87

87.
Flux Bleu, 1942
Oil flux and enamel on paper
6 x 10 in.
The Buck Collection, Laguna
Hills, California

88.
Perpetual Possibility, 1942
Enamel on composition board
mounted on plywood
20 x 16¹/8 in.
The Museum of Modern Art,
New York, gift of Mrs. Knud
Merrild, 1960

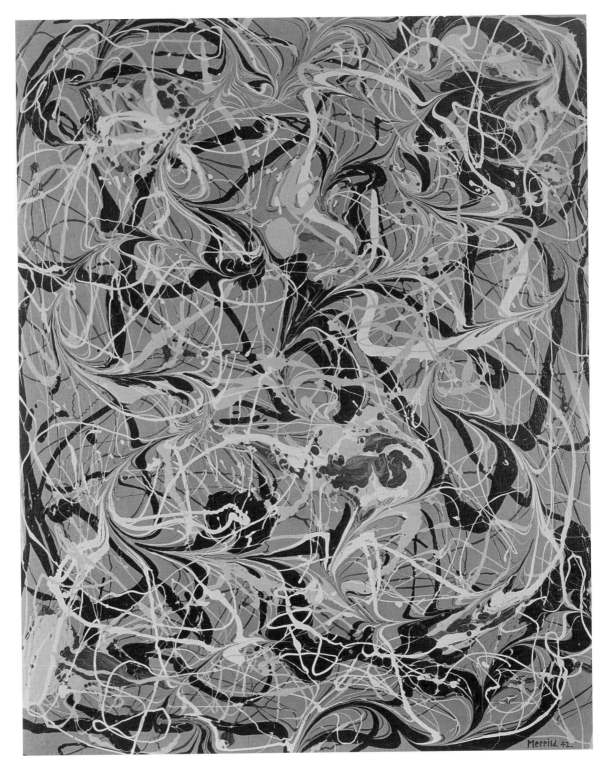

The microbial world had also served as a source of inspiration for the European surrealists, who populated their paintings with biomorphic forms. While contributing to this tradition, Merrild refrained from fashioning biomorphs in the mode of Joan Miró and instead coaxed paint into accretions—at times with a nod to Max Ernst's frottages—that evoked natural forces. In *Resignation* and *Chain Reaction* these forms suggest liquid eruptions—in the former organic, in the latter volcanic—and as they mutate they put one in mind of elemental energies beyond control. Conceived in the wake of World War II, they seem to look, Janus-like, to both the past and the future, hinting at primal evolution and the recent detonations of the atom bomb.

Merrild won support for his venturesome art from such kindred free spirits as Man Ray and novelist Henry Miller, both of whom paid him tribute in magazine articles.[8] Miller, in an essay penned for the literary journal *Circle,* allied Merrild's abstractions with Ernst's and traced their origins to the Los Angeles painter's involvement with swimming and "the watery principle."[9] As Miller explained it, this principle, which the flux paintings embodied, gave intuition free reign and thereby imbued the act of creation with a spirited joy. Indeed, as the writer correctly perceived, Merrild's fluxist conceptions encode a sense of play, their streams and eddies of gleaming enamel reflecting a housepainter's penchant for tactile effects, a surrealist's delight in improvisation, and a swimmer's enjoyment of water.[10]

In 1944 Merrild's flux paintings premiered at the American Contemporary Gallery in Hollywood, and four years later they were featured in a retrospective at the Modern Institute of Art in Beverly Hills. His works appeared in numerous group exhibitions during the 1940s, including the California Palace of the Legion of Honor's *Golden Gate International Exposition* (1940), the Museum of Modern Art's *Americans 1942: Eighteen Artists from Nine States,* the Pepsi Cola Company's touring *Paintings of the Year* (1946), the Whitney Museum of American Art's annual *Contemporary American Painting* (1946–47), and the Art Institute of Chicago's traveling *Abstract and Surrealist American Art* (1947–48). In 1952 Merrild had solo shows at the Pasadena Art Institute and the Bertha Schaefer Gallery in New York. That year, after suffering a heart attack, he returned to Denmark, where he died in 1954.[11]

Eleven years after his death Merrild was honored with a retrospective at the Los Angeles County Museum of Art. In subsequent years his abstractions appeared in group exhibitions organized by the San Francisco Museum of Modern Art (1976); Rutgers University Art Gallery (1977); the Fisher Gallery of the University of Southern California (1983); the Wight Art Gallery of the University of California, Los Angeles (1989); and the Santa Barbara Museum of Art (1990–92).

Susan Ehrlich

Notes

1. Knud Merrild, in *Contemporary American Painting,* exh. cat. (Urbana: University of Illinois, 1952), pp. 214–15.
2. Biographical data was obtained from Jules Langsner's pioneering *Knud Merrild, 1894–1954,* exh. cat. (Los Angeles: Los Angeles County Museum of Art, 1965).
3. Before his cross-country tour brought him to Los Angeles in May 1923, Merrild spent time with D. H. Lawrence at the novelist's ranch in Taos, New Mexico. Discussions with Lawrence provided him with material for a book, *A Poet and Two Painters: A Memoir of D. H. Lawrence* (New York: Viking Press, 1939).
4. Merrild, in *Contemporary American Painting,* pp. 214–15.
5. Clement Greenberg, "The Crisis of the Easel Picture," in *Art and Culture* (Boston: Beacon Press, [1961]), pp. 154–57. For a discussion of the relationship between Merrild's fluxist abstractions and Pollock's drip paintings, see Susan Ehrlich, "Knud Merrild: To Be Transformed in the Flux," *Los Angeles Institute of Contemporary Art Journal* 39 (September–October 1981), pp. 22–25.
6. Langsner, *Knud Merrild, 1894–1954,* p. 8.
7. Merrild, in *Contemporary American Painting,* pp. 214–15.
8. Man Ray, "Knud Merrild: A Letter to the Artist from Man Ray," *California Arts and Architecture* 60 (January 1943): 26–27, 46; Henry Miller, "Knud Merrild: A Holiday in Paint," *Circle* 6 (1945): 39–47.
9. Miller attributed this term to painter Jean Varda, who shared a studio in the Bay area with Dynaton cofounder Gordon Onslow Ford ("Knud Merrild," p. 45).
10. In *A Poet and Two Painters,* Merrild expressed his fondness for the Pacific Ocean and mentioned that he frequented Santa Monica beach (pp. 296, 392–94).
11. Knud Merrild, *Twenty-five-Year Retrospective,* Modern Institute of Art, Beverly Hills, California, 2 June–4 July 1948.

89.
Asymmetric Symmetry, 1943
Oil flux on canvas mounted on
masonite
18¹/₄ x 15¹/₄ in.
The Buck Collection, Laguna
Hills, California

90.
Resignation, 1945
Oil flux on canvas
17⁷/₈ x 13⁷/₈ in.
The Brooklyn Museum, gift of
Alexander Bing (52.77)

91.
Chain Reaction, 1947
Oil on canvas over composition
board
17¹/₂ x 13¹/₂ in.
The Museum of Modern Art,
New York, gift of Alexander M.
Bing, 1951

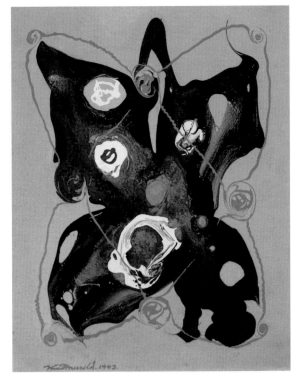

89

90

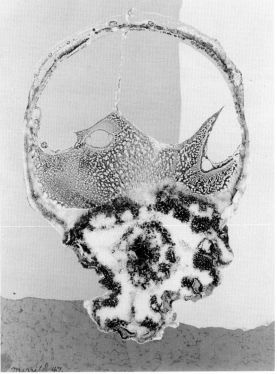

91

William Mortensen
1897–1965

Fig. 51
Self-portrait of William
Mortensen as a magician,
c. 1945
The William Mortensen Estate
Collection; courtesy Deborah
Irmas

Born in Park City, Utah, in 1897, William Mortensen belonged to the same generation as the French surrealists, whose collective vision was shaped in part by the horrific events of World War I.[1] Rather than witnessing bloody European battlefields, however, he spent his one-year army stint at Fort Merritt in New Jersey. Following his discharge he attended classes at the Art Students League in New York, where he learned basic drawing, painting, and traditional rules of composition and pictorial structure. These conventional ideas formed the core of his lifelong attitude toward making art. Unlike many of his contemporaries, who ventured into the territory of symbolic abstraction to create a new pictorial order—as if they were critiquing contemporary society—Mortensen remained committed to a classic, realistic picture-making strategy. The camera became his primary tool and allowed him to construct scenes without having to create them from the beginning by hand.

The collective despair that tormented Mortensen's peers prompted him to infuse his subject matter with a sense of morbidity. There is implicit danger in his photographs, which often include evil male characters and beautiful, fragile women who are portrayed as if in physical jeopardy—the clichéd damsel in distress. In nine books and scores of articles Mortensen proposed an ideology whereby picture-making strategies such as these were espoused as a means of creating dramatic tension. While providing lessons in lighting and complex printing techniques, he counseled readers on the use of costumes and poses, even addressing the question of what types of models to employ. His advice was clothed in an authoritative, bombastic literary voice that today seems exaggerated in both its flourishes and assuredness. Yet in one uncharacteristically concise statement, which appears in his first published book, *Projection Control,* the photographer admits a truth that explains his own work as well as that of others: "All art is distortion!"[2]

The brand of distortion that Mortensen favored was the kind found in Hollywood movies. During the 1920s he worked as a still photographer for epic filmmaker Cecil B. DeMille and opened a portrait studio where he photographed actors Clara Bow, Jean Harlow, and Rudolph Valentino, among others. From DeMille he learned an economical way of constructing a dramatic narrative in a single image, and from the actors he learned how to transform a real person into a fictional character. This manner of working became part of his signature. In the 1930s, after he moved to Laguna Beach, California, where he established the Mortensen School of Photography, he created the complicated pictorial narratives for which he is known today.

L'Amour (c. 1936; cat. no. 95), a photograph of a semi-nude woman in the grass being observed by a drooling, stump-holding gorilla, is one of Mortensen's most frequently reproduced images. His wife, Myrdith, who became his favorite model, is easily recognizable here, even with fake blood dripping daintily from the side of her mouth. Rendered as a Bromoil transfer, a lithography-like ink-on-paper process, *L'Amour* was constructed with several negatives, much handwork, and texture screens (as well as a rather elaborate gorilla costume). *La Chatte* (c. 1935; cat. no. 93) is assembled like a surrealist collage, conceptually linking several disparate objects. Mortensen montaged separate photographs of a mask, an animal, and a pyramid-shaped prop into a single image, which was subsequently printed with a texture screen. *La Chatte* suggests some obscure relationship between ancient cultures and the mysterious powers of women and cats. In both works the women have closed eyes, suggesting a state of sleep (dreaming?) or unconsciousness (with a hint of peril). The defined photographic structure of both images, coupled with the ethereal surface quality, further attests to Mortensen's surrealist sympathies.

By exhibiting widely in Camera Club exhibitions and salons and by regularly publishing articles in *Camera Craft,* Mortensen was able to attract a steady influx of students eager to learn his secrets. *Obsession* (c. 1935; cat. no. 94) and *Shrapnel* (c. 1934; cat. no. 92) are the kind of instructional photographs that he would have shared with his students, for each is a technical tour de force showing how darkroom maneuverings can transform emotional tone. In *Obsession* a looming figure cloaked in black is even more frightening because of its attenuated form, achieved by tilting the negative during exposure.[3] The one-legged man in *Shrapnel,* whose body seems to disintegrate into a kind of visual scrap, is the young Mortensen himself. The expression of terror on his face is reinforced by means of sandwiching multiple negatives together in the darkroom.

In Mortensen's most important published work, *Monsters and Madonnas* (1936), a monograph accompanied by a theoretical text,[4] he lists some of the dangers of making art, including the reliance on machines or modern camera equipment. The greatest danger, however, is the "enemy within the gates, a Monster within the confines of our own skulls. The monster [was] the conscious mind."[5] Mortensen believed that the path to creativity was to explore these subconscious recesses, and even though his results seem more inhibited than those of his surrealist peers, his brand of photographic fantasy and illusion continued to captivate a loyal audience until his death in 1965.

Deborah Irmas

92.
Shrapnel, c. 1934
Vintage silver print
7$\frac{1}{2}$ x 5$\frac{7}{8}$ in.
Collection of Paul Hertzmann
and Susan Herzig; courtesy
Paul M. Hertzmann, Inc.,
San Francisco

93.
La Chatte, c. 1935
Gelatin silver print
4$\frac{1}{2}$ x 5$\frac{7}{8}$ in.
Center for Creative Photography,
the University of Arizona, Tucson

Notes

1. See Deborah Irmas, *The Photographic Magic of William Mortensen,* exh. cat. (Los Angeles: Los Angeles Center for Photographic Studies, 1979).
2. William Mortensen, *Projection Control* (San Francisco: Camera Craft, 1934), p. 64.
3. Myrdith was the model for *Obsession,* which was also entitled *Fear* (see ibid., p. 71).
4. See Deborah Irmas, "Monsters and Madonnas," *Photograph* 1 (Summer 1977).
5. William Mortensen, *Monsters and Madonnas* (San Francisco: Camera Craft, 1936), unpaginated.

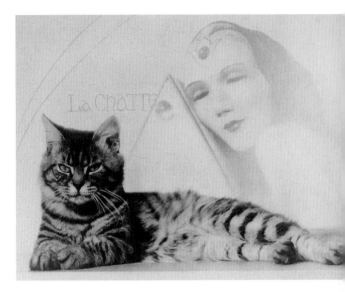

93

92

94.
Obsession, c. 1935
Gelatin silver print
7³/₈ x 5³/₄ in.
Center for Creative Photography,
the University of Arizona, Tucson

95.
L'Amour, c. 1936
Bromoil transfer
11³/₄ x 10³/₈ in.
Center for Creative Photography,
the University of Arizona, Tucson

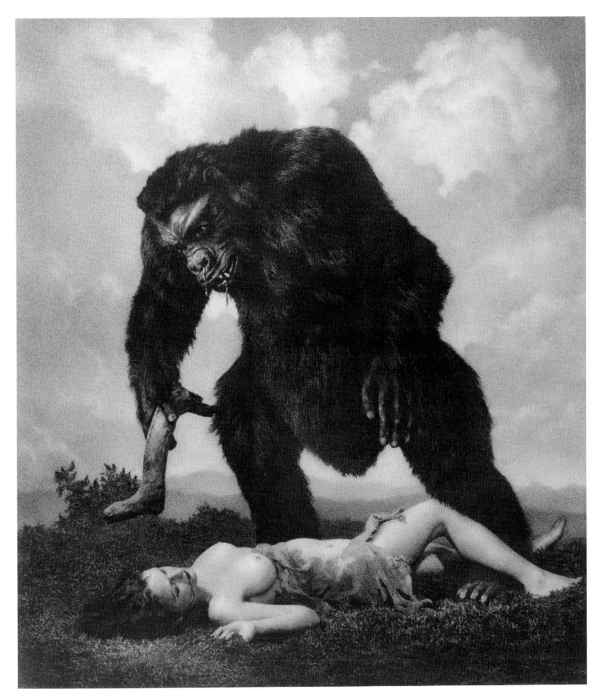

95

Lee Mullican
b. 1919

Fig. 52
Lee Mullican at the Dynaton
exhibition, San Francisco
Museum of Art, 1951
Photograph by Agar; courtesy
Suzanne Royce

Lee Mullican grew up in Chickasha, Oklahoma, the third of four children in a deeply religious family. His father was a business-man trained as a teacher, and his mother, while primarily a housewife, was an amateur painter. His upbringing and school-ing were typical of a rural American community in the 1920s; art education was not a primary consideration. By the age of fif-teen, however, he was dabbling with oil paints and occasionally sketching with his mother.

Mullican enrolled at Abilene Christian College in Texas at the request of his father. College represented an opportunity to get away from Chickasha, and he planned to take at least one art class. He soon transferred to the University of Oklahoma, where he hoped to find better art courses. He did not, and final-ly, overriding family concern, he enrolled in the Kansas City Art Institute. It was 1941, and he had already registered for the draft. He knew that he would soon be inducted, and he wanted to progress as far as possible in his art program.

During these years he traveled to Santa Fe, which rein-forced his attachment to nature and his southwestern origins. He looked at popular publications such as *Life* and *Time,* which gave him insights into cubism and surrealism as well as American regionalism. Attracted to modernism, he pursued recent European art, music, and films.

Mullican's year at the Kansas City Art Institute was domi-nated by Fletcher Martin, a well-known regionalist of the period, who would not permit him to work abstractly but who did teach him technique. Mullican also had access to the William Rockhill Nelson Gallery, where he was exposed to a fine collection of Asian art as well as an exhibition of Pablo Picasso's work, which excited him. Upon graduating, he was drafted into the army. Thanks to his art training, he was attached to the Corps of Engineers as a topographical draftsman.

Like many other young men, Mullican, who was essentially a pacifist by nature, found that his three and a half years in the service were made bearable only by the opportunities for travel and weekend passes that his position offered. This period in his life would nonetheless have a great influence on his develop-ment. His map-making training took place in Virginia, which gave him access to the museums of Washington, D.C., and eventually New York, where he gained firsthand exposure to twentieth-century European art. He was particularly impressed by a Paul Klee exhibition at the Phillips Memorial Gallery in Washington in 1942.

Mullican was then transferred to Paris, Texas, where he met Jack Stauffacher, a letterpress printer from San Francisco who was also in his battalion. They became great friends and planned to meet after the war. Mullican's next posting was in Indio, California. He loved the freedom of the desert environ-ment and the weekend passes that took him to Los Angeles and Palm Springs. His training completed, he was shipped out to Honolulu, where he spent time in the galleries and library of the Academy of Fine Arts. There he discovered *DYN,* a journal pub-lished by Wolfgang Paalen in Mexico. *DYN* opened Mullican's mind to a more sophisticated approach to surrealism and abstraction and especially to a vision of art as a journey into the unknown.

At the end of the war Mullican spent a month in Tokyo, which was devastated, and he traveled to rural Japan, where he gained new cultural awareness. Shipped home in 1946, he was somewhat at a loss for direction, but he renewed his acquain-tance with Stauffacher, who invited him to San Francisco and offered to provide him with living quarters and a place to work. On his way there Mullican stopped in Santa Fe, where he discov-ered santos, painted or carved wooden images of saints indige-nous to Mexico and the southwestern United States. He saw santos as an extension of Picasso's interest in African sculpture but was attracted more to its mythical, ceremonial properties than to its formal elements.

In San Francisco Stauffacher introduced Mullican to a wide circle of sophisticated friends interested in art, literature, and music. Foremost among them was the artist and lecturer Gordon Onslow Ford, who had a fine collection of surrealist art. Onslow Ford had seen a painting of Mullican's at Stauffacher's printshop and contacted him out of sympathetic interest. Shortly afterward Paalen also moved to San Francisco, and the three of them formed the Dynaton group. Their philosophy, while rooted in surrealism's exploration of the unconscious and automatism, reached into new realms through a deep concern with the forces of nature. They studied the art of native peoples in its diverse forms: the transient sand paintings of the Navajo and the ceremonial masks of the Northwest Coast Indians, pre-Columbian art as well as that of the Plains Indians. They also absorbed the influence of Asian philosophy through a study of Zen, the I-Ching, and tarot.

The immediate post-World War II period was a fertile one in the art history of San Francisco. New York abstractionists Clyfford Still and Mark Rothko were teaching at the California School of Fine Arts. Dynaton was in a sense an alternative to the abstract expressionism of Rothko and Still. Onslow Ford, Paalen, and Mullican were given solo exhibitions at the San Francisco Museum of Art, which, under the direction of Grace McCann Morley, was staking out exciting new art territory.

97.
Vestment, 1950
Oil on canvas
57 x 30 in.
Collection of Lee and Eleanor
Kendall

99.
Presence, 1955
Painted wood construction
36^1/$_8$ x 17^3/$_8$ x 1^1/$_4$ in.
The Museum of Modern Art,
New York, Mr. and Mrs. Roy
Neuberger Fund, 1956

Strongly influenced by Gordon Onslow Ford's exhibition at
the San Francisco Museum of Art in 1948, Mullican was led nat-
urally to abstract surrealist manifestations that addressed cos-
mic space in ways that he felt to be more profound than the
approach in the action paintings of Jackson Pollock. Mullican's
Splintering Lions (1948; cat. no. 96; color plate 20) and
Vestment (1950; cat. no. 97) emphasize rich surface treatment
balanced against the void. The surface actions move in and out
of focus as if infused with light. *Ninnekah* (1951; cat. no. 98;
color plate 19) centers on a sun or planetary light source, which
spreads its rays in an all-encompassing pattern. One feels, how-
ever, that this source is drawing energy to itself rather than dis-
persing it.

From the late 1940s on, Mullican built and painted wood
constructions that could serve as masks, shields, or ceremonial
objects from an unknown aboriginal society. *Presence* (1955;
cat. no. 99) is one of these, and it reflects the artist's abiding
interest in the power evoked by the artifacts of untrammeled
tribal cultures.

The Dynaton group had an exhibition at the San Francisco
Museum in 1951, and while it disbanded shortly thereafter, its
philosophy—expounded in the writings of Onslow Ford, Paalen,
and Jacqueline Johnson—remains central to Mullican's life and
art. Paalen died by his own hand in 1959. Onslow Ford turned
away from surrealism and developed a more personal calli-
graphic style. Mullican moved to Southern California, where he
has continued to work, also serving as a professor of art at
UCLA until his retirement in 1991. He currently lives in Santa
Monica and Taos, New Mexico.

Henry T. Hopkins

97

99

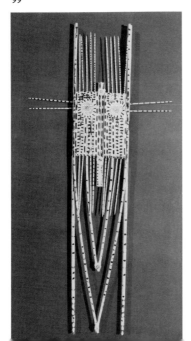

Gordon Onslow Ford
b. 1912

Fig. 53
Gordon Onslow Ford in
San Francisco, c. 1949
Harry Bowden Papers,
Archives of American Art,
Smithsonian Institution

Here on the West Coast of America we face the setting sun. Perhaps the most poignant time of day is when the sun slowly sinks behind the horizon of the Pacific Ocean. It marks the passage of day into night and suggests the passage of the conscious into the unconscious. Here on the West Coast we are well situated to investigate the Inner-Worlds of the unconscious.[1]

This statement accurately reflects the art and life of Gordon Onslow Ford, who, now in his eighties, is facing the setting sun on a career spanning fifty years and whose art has been consistently attuned to the forces of nature. Since 1958 he has lived and worked in a compound in the wilderness of the Bishop Pine Preserve, near Inverness, California, where he continues his rich exploration of the inner world, which began in the 1930s.

Onslow Ford was born on December 26, 1912, in Wendover, England. Like other members of his family, he was destined for a naval career. After attending the naval colleges at Dartmouth and Greenwich, he spent ten years in the Royal Navy. It was during this period that he began to create art. His early works included scenic vistas of ocean voyages. The concept of the voyager, initially on a literal journey and later on a journey of the mind, would become an enduring metaphor in his work.

Leaving Britain for France in 1937, Onslow Ford met the Chilean artist Matta, who was acquainted with many of the surrealists and who introduced him to André Breton, the movement's founder and chief theorist. Breton would, in 1938, induct Onslow Ford, Victor Brauner, Esteban Francès, Matta, and Kurt Seligmann into the movement as the "next wave" of surrealists. Wolfgang Paalen, who would become a lifelong collaborator, had been part of the movement since 1935. During the summer of 1939, in a villa paid for by Gertrude Stein, the group discussed how to meld the principles of automatism with Einstein's conception of "space-time." The idea was to leave behind illusionistic representation as practiced by Salvador Dali and René Magritte and to move into the abstract world of a four-dimensional universe. This is what Onslow Ford refers to as the "Inner-Worlds."[2]

In 1940, coinciding with the onset of World War II, Onslow Ford left Paris for New York at the invitation of the Society for the Preservation of European Culture. He lectured on surrealism at the New School of Social Research, and according to art critic Dore Ashton, his talks inspired many artists, some of whom would become major figures in the New York school. While in New York, he met and then married writer and poet Jacqueline Johnson, a Californian and Stanford graduate. She became a

collaborator whose writing helped to explicate his thoughts and disseminate them to a wider audience.

From 1941 to 1947 the couple lived in Erongaricuaro, Mexico, deep in Tarascan country. Onslow Ford renewed his acquaintance with Paalen, who had also left war-torn Europe for Mexico and was publishing *DYN,* a journal seeking a new vision of the unknown through art, science, and intuition. Paalen had an important collection of the art of native peoples, which he saw as a doorway to the unconscious. Onslow Ford's deep appreciation of nature and of his own intuition was greatly enhanced during this period as he watched the local artisans create clay and stone images out of the living earth.

In 1947 Onslow Ford moved to San Francisco, establishing his studio on a houseboat in Sausalito. He became a force in the burgeoning San Francisco art scene through his art, many lectures, and the presentation of his excellent collection of surrealist art. He was given a solo exhibition of his Inner World paintings at the San Francisco Museum of Art in 1948, and his writing for the catalogue, entitled *Towards a New Subject in Painting,* greatly influenced the work of Lee Mullican, who had just arrived in the city.

The Bay Area proved to be fertile ground for Onslow Ford's ideas, and he urged Paalen to join him there. With their new friend Mullican, the two of them founded Dynaton, which espoused automatism, intuition, and exploration of the unconscious as a means of breaking through to the inner world. A 1951 exhibition of the group's work at the San Francisco Museum of Art presented Dynaton as a West Coast alternative to New York school abstract expressionism, which also emerged from surrealism but emphasized action rather than contemplation.

The paintings by Onslow Ford in the present exhibition represent well his concept of "inner vision," which led to the establishment of Dynaton. His desire was to define a limitless space within which various surreal personages could disport themselves in fanciful ways. This is particularly true of *The Future of the Falcon* (1947; cat. no. 101; color plate 16), which becomes an abstract version of Hieronymus Bosch's *Garden of Delights.* In *Fixed Flight* (1946; cat. no. 100) the vision becomes more abstract, and *Wild Time* (1953; cat. no. 102), cosmic in conception, clearly looks ahead to the "line-circle-dot" paintings, which have consumed much of Onslow Ford's later career.

In 1951, during one of his frequent walks through the redwoods, Onslow Ford had a revelation that the line, circle, and dot were the basis of all art. For the next eleven years he pursued this vision, combining a meditative frame of mind with the dynamism of instant creation. To enhance the immediacy of his

100.
Fixed Flight, 1946
Oil on canvas on panel
21 x 29¹/₂ in.
Collection of Fannie and Alan
Leslie

102.
Wild Time, 1953
Casein and mulberry paper on
canvas
36 x 62 in.
Collection of David and Jeanne
Carlson

brush strokes, he studied calligraphic brush painting with Zen
master Hodo Tobase and Asian philosophy with popularizer
Alan Watts. Onslow Ford found this blending of the spirituality
of West and East tantalizing—at once mysterious, awesome,
marvelous, and unifying. "More than a stylistic device, Onslow
Ford's concept of line, circle, dot is a visual metaphor that
explores the art of human creation and perception itself, creat-
ing a window through which one may pass into the regions of
the unconscious mind."[3] Each day Onslow Ford has tried to
draw even closer to nature in the belief that it holds the key to
his inner visions.

Henry T. Hopkins

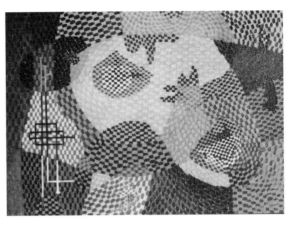

100

Notes
1. Gordon Onslow Ford (July 1992), in *Dynaton: Before and Beyond,* exh.
cat. (Malibu, Calif.: Frederick R. Weisman Museum of Art, Pepperdine
University, 1992), p. 8.
2. Amy Winter, "DYNATON: The Painter/Philosophers," in ibid., p. 38.
3. Kim Eagles-Smith, "Gordon Onslow Ford," in *Modern and
Contemporary Art,* exh. cat. (San Francisco: Harcourt, 1993), p. 2.

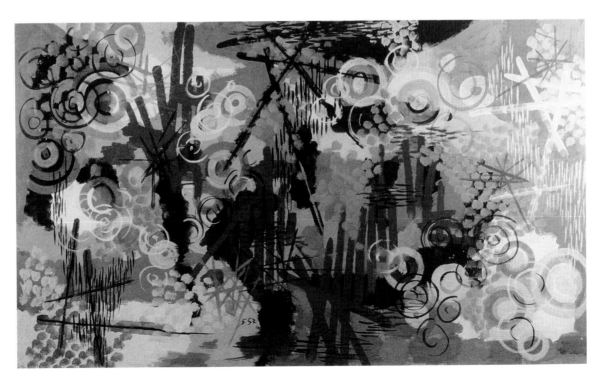

102

Wolfgang Paalen
1905–1959

Fig. 54
Wolfgang Paalen at the Dynaton exhibition, San Francisco Museum of Art, c. 1951, with *Messenger from Three Poles* (1949)

Born in Vienna in 1905, Wolfgang Paalen led a cosmopolitan life, living and painting in Vienna, Tivoli, Berlin, Munich, Paris, Mexico City, and San Francisco.[1] He began his career under the influence of impressionism. He studied with Hans Hofmann in Munich in 1927, then moved to France. In Paris in 1932 he joined the international Abstraction-Création group, and by 1935 he was affiliated with the surrealists.

From 1935 to 1939 Paalen occupied a central place in the surrealist movement, sharing its erudition and visionary intensity. He invented a form of surrealist automatism called *fumage,* which consisted of "passing candle-smoke swiftly over a freshly [primed] surface and then interpreting through new brushwork the design suggested by it."[2] His totemic landscapes, which were "concerned with the fusion of plastic and poetic values," rivaled the dreamscapes of Yves Tanguy and Salvador Dali.[3] With the surrealists he organized international art exhibitions in Paris and London and published, illustrated, and edited catalogues, journals, and books, the most celebrated of which was the art review *Minotaure.* Although he was younger than most of the first-generation surrealists, André Breton viewed Paalen as his intellectual equal and considered him a "painter-philosopher" possessed of "the rarest encyclopedic intelligence of our era, armed with a surplus of all the great insights of passion."[4]

In 1939, four months before the German occupation of Paris, at the invitation of Frida Kahlo and Diego Rivera, Paalen immigrated to Mexico, where he became a major force in the modern art movement.[5] There in 1940, with Breton and the Peruvian poet César Moro, he organized the *Exposición internacional del surrealismo* (International exhibition of surrealism). As Paalen returned to abstraction, his influence grew, shifting emphasis away from the nationalist social realism of the Mexican *muralismo* movement and toward international modernism: universal, primitivistic, and abstract. During this period he broke with surrealism, after first petitioning Breton to join him in a revision of its principles.[6] Following Breton's refusal, Paalen declared his independence, formulated his own theoretical code, and moved on to a new postsurrealist painting style, which he labeled cosmic. His ideas and images of this period — disseminated through his writings in the art review *DYN* and through exhibitions of his work in New York — had a profound influence on the New York school.[7]

After nearly a decade in Mexico City, Paalen moved to the San Francisco Bay Area, where he formed the Dynaton group with Lee Mullican and Gordon Onslow Ford and organized with them a series of exhibitions and lectures at the San Francisco

Museum of Art and Stanford University Art Gallery.[8] For the next four years he remained in California, regularly traveling to Mexico and New York and finally returning to Paris in 1951. In California he continued to develop ideas and images that he had initiated in Mexico during his "cosmic" period, painting in a style first characterized as "mosaic" by the Mexican poet Octavio Paz.[9]

The mosaic style appears in all the works painted during Paalen's California sojourn, accompanied by a complex iconography, which he developed to express his vision of man and the cosmos. Fascinated by post-Einsteinian quantum physics and astrophysics, he synthesized the revelations of science with the utopian social ideals of the avant-garde, producing "a manifesto of creation in an age of destruction."[10] He believed that images could prefigure rather than "re-present" and thereby invoke a new order.[11] To this end he wished to reintegrate the human presence into the universe of space-time. Thus he created the Cosmogons, a group of paintings in which the mute geometric elements of mathematical notation were configured into presences in which "the radiant curves coordinate themselves into great 'personages'" and "the 'planetary sense' becomes a true cosmic consciousness."[12]

Paalen saw paintings such as *Keylords of the Prismatic Situations* (1947; cat. no. 103; color plate 17), *The Possible City* (1947; cat. no. 104), and *Planetary Face* (1947) as emblems of this vision from deep, multidimensional space. Metaphorically akin to the human unconscious, they linked energy and spirit, spirit and matter. While these works referred to models of contemporary science, they were equally inspired by: "the thirteen heavens of the Indian mythology . . . the pyramids of the Sun and of the Moon, the jade and turquoise mosaics on masks with eyes of meteoric iron . . . [whose] hieratic greatness reminded [Paalen] of the Byzantine mosaics."[13] In Paalen's paintings the opaque gems of pre-Columbian artifacts are transformed into transparent and incandescent facets of crystalline stone, radiating and absorbing light, piercing the space of the canvas with the "cosmic rays" of their origins.[14] *Tropical Night* (1948; cat. no. 105; color plate 18), in the same mosaic style, retains the iconography of the Cosmogonic presences in a canvas of lush equatorial color that recalls the physical and spiritual climate of Mexico.

Paalen recognized the change in his work in the New World and used interstellar space as a metaphoric analogue for the freedom and exhilaration of his inner experience. He spoke of the freshness and expansiveness of San Francisco, lauding its "strategic position of inspiration between the currents of the

104.
The Possible City, 1947
Oil on canvas
51 x 24 in.
Collection of Luchita Hurtado

great old cultures of the Pacific and the stirring forces of America" and foresaw that "new trade winds of spirit will rise from a place where such a triumphant arch of space as the Golden Gate links past and future."[15] In the catalogue for the 1951 Dynaton exhibition at the San Francisco Museum of Art, written in Mill Valley, Paalen summarized the group's means and ends: "A work of Art has to bring about an awareness of universal concerns. Awareness of universal human concerns comes only through momentary suspense of purpose; any incitation to immediate action prevents this state of ego-transcending awareness. . . . Art could provide an equivalent for what in the East is called meditation."[16]

From the Old World Paalen brought extensive knowledge of the progressive theories of Viennese and German physics, which anticipated post-Einsteinian physics by nearly half a century. In the New World he cultivated his vision of the complementarity of matter and spirit, art and science, symbolized in his extraordinary paintings and articulated in his prolific writings. These ideas were well received in the San Francisco Bay Area, where parallel developments were unfolding in the cultural and scientific spheres: interest in spirituality and Eastern and Western cosmologies, investigation of relationships between microcosm and macrocosm and concern with the workings of nature, desire to attain transcendental and cosmic consciousness. Today this quintessentially Californian fusion of spirituality and science, reflected in Paalen's art and writings of this period, seems prescient. He regarded the artist as a seer who should be accorded high social status and responsibility, and he believed that art is essential to the survival of civilization. Did Paalen instigate the "New Age," or did it inspire him? Clearly his visionary ideas, generated from the global consciousness of postwar California, still resonate as we approach the twenty-first century.

Amy Winter

Notes

1. For a comprehensive study of Paalen, see *Wolfgang Paalen: Retrospektive*, exh. cat. (Vienna: Museum moderner Kunst, Stiftung Ludwig, 1993).
2. Gustav Regler, *Wolfgang Paalen* (New York: Nierendorf Editions, 1946), p. 32. This monograph appears to have been a close collaboration between Paalen and Regler and was largely written by Paalen himself. For a fuller discussion, see my forthcoming dissertation, "Wolfgang Paalen, *DYN,* and the American Avant-Garde of the 1940s," Ph.D. diss., Graduate Center of the City University of New York.
3. Wolfgang Paalen, undated biographical notes, private papers, courtesy of Señora Isabel Marin de Paalen. For discussion of the biographical and historical significance of these works, see Amy Winter, "Czechoslovakia: Wolfgang Paalen's *Paysage totémique,*" *Vytvarné umení* 6 (Winter 1991): 70–76.
4. André Breton, "Genesis and Perspective of Surrealism," in *Art of This Century,* ed. Peggy Guggenheim (New York: Art of This Century Gallery, 1942), p. 25.
5. On Paalen's Mexican influence, see Leonor Morales, *Wolfgang Paalen: Introductor de la pintura surrealista en México* (Mexico City: Universidad nacional autónoma de México, 1984), and Winter, "Wolfgang Paalen, *DYN,* and the American Avant-Garde of the 1940s."
6. Regler, *Wolfgang Paalen,* p. 44.
7. See Amy Winter, "Wolfgang Paalen, *DYN,* and the Genesis of Abstract Expressionism," in *Wolfgang Paalen: Retrospektive.*
8. These included solo exhibitions at the San Francisco Museum of Art for Paalen (1948), Onslow Ford (1948), and Mullican (1949); a Dynaton group exhibition and series of lectures at Stanford University Art Gallery in 1950; and a Dynaton group exhibition, *Dynaton 1951,* at the San Francisco Museum (1951).
9. Octavio Paz, "La science poétique de Paalen," *XXe siècle* 42–43 (1975).
10. Regler, *Wolfgang Paalen,* p. 44.
11. Wolfgang Paalen, "The New Image," *DYN* 1 (April–May 1942): 7–15.
12. Regler, *Wolfgang Paalen,* p. 54.
13. Ibid., p. 46.
14. Ibid., p. 54: "Brace Lemon,* in his book about cosmic rays, expressed in [i]nvoluntarily poetic grandeur the new scientific concept of being and becoming on the cosmic scale. *Cosmic Rays Thus Far.*"
15. Wolfgang Paalen, in *Lee Mullican,* exh. cat. (San Francisco: San Francisco Museum of Art, 1949).
16. Wolfgang Paalen, "Metaplastic," in *Dynaton 1951,* exh. cat. (San Francisco: San Francisco Museum of Art, 1951), pp. 10, 11.

Man Ray
1890–1976

Fig. 55
Self-portrait of Man Ray, 1946
The J. Paul Getty Museum,
Malibu, California

Assemblage and Painting

A photograph or . . . the object itself . . . is designed to amuse,
bewilder, annoy or to inspire reflection, but not to arouse admi-
ration. . . . The streets are full of admirable craftsmen, but so
few practical dreamers.[1]

With a disdain for convention, Man Ray sought to subvert stan-
dards of taste through provocative works that catalyzed
thought. A self-professed pragmatic dreamer, he expressed in
sculpture, photography, painting, and film a dada-surrealist
ethos in which chance and conceptual humor, libertinism and
play operated preemptively.

Born Emmanuel Radnitsky in Philadelphia in 1890
and raised in New York, Man Ray studied art at the National
Academy of Design and had his first solo show in 1915 at
Manhattan's prestigious Daniel Gallery. That same year he met
and befriended Marcel Duchamp, with whom he helped shape
New York dada and establish two modernist organizations—the
Society of Independent Artists in 1916 and the Société Anonyme
in 1920.[2] When Duchamp moved back to Paris, Man Ray fol-
lowed him in 1921 and there participated in dada and surrealist
groups.

In 1940 Man Ray, fleeing the Nazis, returned to New York
and later that year traveled to Hollywood. Greeted by sunshine,
palm trees, and "exotic natives" and charmed by a young
dancer, Juliet Browner, he opted to settle there.[3] Soon he began
to engage with the community, delivering lectures, tutoring stu-
dents, and socializing with movie stars at the home of producer-
director Albert Lewin. At the same time he pursued his
oft-stated goals of "freedom and pleasure" in photography,
printmaking, painting, and assemblage.[4]

In his constructions, as in his Rayographs (see cat. no.
114), Man Ray delighted in found objects and the frisson that
these items yielded when brought together in novel conjunc-
tions. Like Duchamp's readymades, with which they shared a
dry, intellectual wit, Man Ray's convocations of prosaic things—
"objects of my affection," as he called them—relied on dis-
placement for their effect and aimed to overturn expectations.
Their inventive titles reflect his penchant for wordplay.

Dumb Bells for Light Weight Lifting (1942; cat. no. 109), for
instance, banks on a verbal-visual pun as it slyly maligns
Californians' obsession with fitness and the mindless "belles"
whom it serves. Easy to lift, the misnomered weights permit frail
ectomorphs such as Man Ray to adapt to Hollywood's physical
culture. As duplicitous objects that straddle mundane and

aesthetic spheres, these barbells foretell Jasper Johns's *Painted
Bronze* (1960).

Similarly Man Ray's *Lamp* (1941; cat. no. 107) and *Emak
Bakia Lamp* (1946; cat. no. 113) question the line between life
and art and therein anticipate the bronzed flashlights of Johns.
Bearing memories of their prior lives—as a cable spool and
the neck of a cello—they confound attempts to pin down their
identities. Unlike Johns's, however, Man Ray's appliances actu-
ally function, emitting a glow when plugged into an electric
socket. Compounding the issues, *Emak Bakia Lamp* replicates
a 1926 piece of the same title[5] and thus rejects, in dadaist fash-
ion, art world esteem for originality. Yet even as a reproduction,
it faces the world as a novel construction, suggesting thereby
that value resides less in the object than in the ideas behind
its conception.

Lamp also subsumes contradictions, here shining oxy-
moronically as an electric candle. Perversely too, with its paraf-
fin shade susceptible to heat, it portends self-immolation. In
this regard it reinterprets the artist's obsession with self-
destructive machines, exemplified by his *Object to Be Destroyed*
(1923), a metronome whose pendulum held a photograph of Lee
Miller's eye. While giving new form to this idée fixe, *Lamp* fore-
shadowed Jean Tinguely's suicidal contraption, *Homage to New
York,* which blew itself up in a 1960 performance at the Museum
of Modern Art in Manhattan.

Moreover, in line with surrealism's focus on sex, *Lamp*
bears erotic innuendos, its warm paraffin shaft invoking phallic
arousal. Likewise alluding to carnal desire, *Mr. Knife and Miss
Fork* (1944; cat. no. 110) implicates oral-erotic drives.[6] The eat-
ing implements rest beside a net-covered dish laden with balls
that simulate peas. By means of this simple yet disarming
arrangement, desire is both elicited and decisively denied.
Steeped in erotic frustration and fear of domestic constraint,
this aggregation of tableware and household debris jolts expec-
tations and transports the senses into forbidden domains.

Man Ray further subverts expectations in a 1948 suite of
paintings named after Shakespearean plays. Based on pho-
tographs of mathematical models that he had snapped at the
Poincaré Institute in Paris in the 1930s, the works challenged
André Breton's assumption that mathematics was aesthetically
dry and proved that machine-made goods could spark artistic
creation.[7] In their references to photography, painting, and the-
ater, they prompt speculation about the relationship among the
arts and about the ties that their titles bear to the images that
they presumably serve. Although arbitrarily titled, *Twelfth Night*
(cat. no. 116) suggests the disguised, complex interactions

107.
Lamp, 1941
Wood and paraffin
17 x 8 x 8 in.
Collection of Herbert Stothart

109.
*Dumb Bells for Light Weight
Lifting,* 1942
Wood
10³/₄ x 3 x 2³/₄ in. each
Collection of Herbert Stothart

107

among the play's various protagonists, while *Macbeth* (cat. no. 115) conjures up curtains parting over a dark object—perhaps the cursed spot in Shakespeare's tragedy.[8]

As a pioneer of dada and surrealism, Man Ray won respectful attention from California's art community. Early on, in 1941, he was given solo exhibitions at the M. H. de Young Memorial Museum in San Francisco and at the Frank Perls Gallery in Los Angeles. Subsequently his work appeared in solo shows at the Santa Barbara Museum of Art in 1943, the Pasadena Art Institute the following year, and the Los Angeles County Museum of History, Science, and Art in 1945. In 1946 the Circle Gallery in Hollywood showcased his objects, and two years later the Copley Galleries in Beverly Hills hosted a Man Ray extravaganza, complete with a garden café and recorded French music.[9]

Despite the attention that he commanded, Man Ray felt underappreciated in California. Annoyed with the region's provincialism and vexed by its smog and lurking temblors, he returned to Paris in 1951.[10] Although he lived and worked in Europe until his death in 1976, he showed his art international-ly. His work was seen in Los Angeles at the Paul Kantor Gallery in 1953, at the Esther Robles Gallery seven years later, and at the Los Angeles County Museum of Art in 1966. Celebrated dur-ing his lifetime, Man Ray garnered countless honors posthu-mously, with representation in numerous exhibitions and publications and a major touring retrospective organized by the National Museum of American Art in Washington, D.C., in 1988.

Susan Ehrlich

Notes

1. Man Ray, "Objects of My Affection," *Exhibition: Man Ray,* exh. brochure (New York: Julien Levy Gallery, 1945).
2. Biographical data was obtained from Jules Langsner, *Man Ray,* exh. cat. (Los Angeles: Los Angeles County Museum of Art, 1966).
3. Man Ray, *Self Portrait* (Boston: Little, Brown, 1988), p. 262.
4. Ibid., pp. 268–79.
5. Man Ray made variant editions of this work in the 1970s and fashioned lamps from wildly disparate odds and ends, including a roulette wheel sporting a roll of toilet paper (*La fortune*).
6. The title and image are derived from a tale by surrealist poet René Crevel, in which a child fantasizes that a knife is a man and a fork is a woman. A selection from this 1931 publication, translated by Kay Boyle with illustrations by Max Ernst, appeared in Julien Levy, *Surrealism* (New York: Black Sun Press, 1936; reprint, New York: Arno Press, 1968).
7. Man Ray, "A Note on the Shakespearean Equations," from the portfo-lio of the exhibition *To Be Continued Unnoticed,* Copley Galleries, Beverly Hills, 1948; reprinted in *Man Ray,* pp. 22–23. See also *Self Portrait,* p. 368.
8. Man Ray, as quoted by Arturo Schwarz, in *Man Ray: The Rigour of Imagination* (New York: Rizzoli, 1977), p. 78.
9. Man Ray describes this "Man Ray Cafe" in *Self Portrait,* p. 280.
10. Ibid., p. 293.

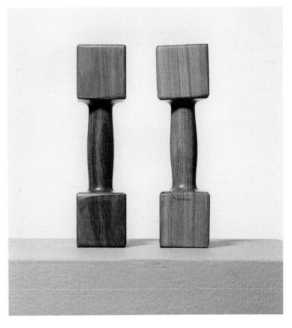

109

110.
Mr. Knife and Miss Fork,
1944/1973
Mixed media
14 x 10 in.
Courtesy Galerie Marion Meyer,
Paris

113.
Emak Bakia Lamp, 1946
Wood, electric lamp wire,
and fittings
30¹/₂ x 13 x 10¹/₂ in.
Collection of James B. and
Barbara C. Byrnes, Los Angeles

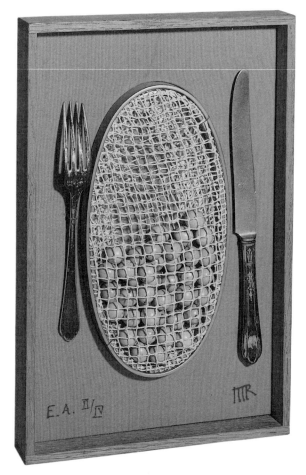

110

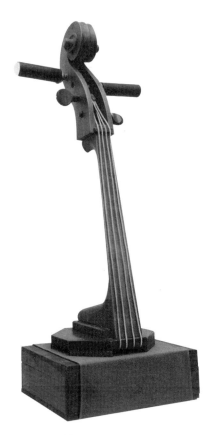

113

115.
Macbeth, 1948, from
Shakespearean Equations
Oil on canvas
30 x 24 in.
SBC Communications, Inc., San
Antonio, Texas

116.
Twelfth Night, 1948, from
Shakespearean Equations
Oil on canvas
34¹/8 x 30¹/8 in.
Hirshhorn Museum and
Sculpture Garden, Smithsonian
Institution, gift of Joseph H.
Hirshhorn, 1972

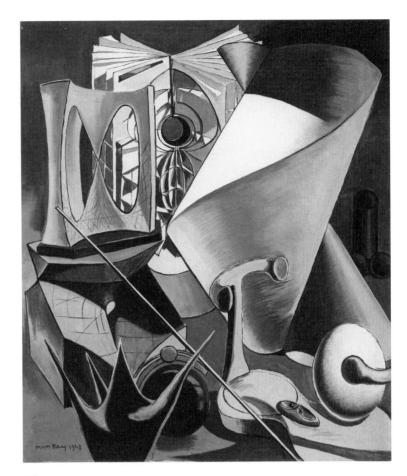

116

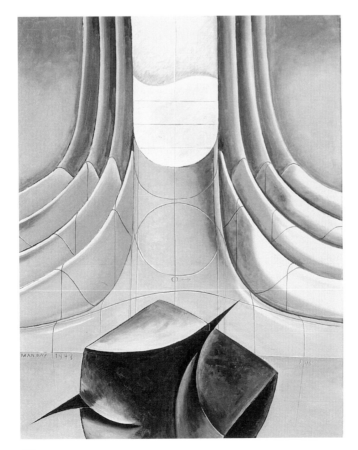

115

Photography[1]

"No plastic expression can ever be more than a residue of experience,"[2] Man Ray remarked in 1922, shortly before the ideological transition from dada to surrealism was consecrated by André Breton in his first surrealist manifesto. Man Ray had been in Paris about two years when he turned away from the cynical and destructive aspects of dada and became one of the first to embrace a new orientation toward an irrational art grounded simultaneously in the imagination and experience. His *Cadeau* (Gift) of 1921, consisting of a flatiron that has been altered by the addition of a row of nails along its working surface, manifests many elements of the new style and demarcates the point of transition between dada and surrealism. About the same time that *Cadeau* was created, he also discovered a more effective and direct form of two-dimensional plastic expression—the photogram—which made it possible to record a maximum of "experience" by using photochemistry to create a cameraless photograph.[3] With this discovery photography became an important vehicle for Man Ray and later disciples of surrealism.

By 1940, when he fled Paris for America, Man Ray had made photography an integral tool of surrealism through photograms and pictures from negatives made with a camera.[4] During the 1930s he had applied surrealist-influenced style and technique to advertising and fashion photographs. Displaced by the German occupation of Paris, he escaped to New York, where he spent a few weeks in the late summer of 1940. The only member of the New York art community he remembered taking the time to visit was Alfred Stieglitz, and their meeting establishes Man Ray's affinity to traditional photography.[5] Dissatisfied with his prospects in New York, he decided to go west to California to sit out the war. He traveled cross-country by automobile with Harry Kantor,[6] a salesman to whom he was introduced by a friend, and arrived in Hollywood in mid-October, reportedly without making any photographs en route. He later recalled the night he arrived: "We had dinner at a drive-in, off trays attached to the doors of the car, a new experience for me."[7] His remark implies that his first impression of Hollywood was one of life imitating (surrealist) art.

When he arrived on the West Coast at the age of fifty, the artist was starting life over. He set up housekeeping with a young dance student named Juliet Browner in an apartment on Vine Street, where he also established a work space. At first he concentrated on drawing and painting to the exclusion of photography, a medium that he felt he had exhausted over ten years (1930–40) of commercial assignments.[8] He had grown

weary of the art world, and he decided that Hollywood was a place where, quietly and in relative isolation, he could try to regain the reputation for painting that he had when he left New York for Paris in 1920.[9] In the early 1940s the new wealth of Southern California was being formed by land developers, aircraft builders, and participants in the movie business; the audience for experimental art was tiny by the standards of New York and Paris. Nevertheless Man Ray decided to reinvent himself as an artist at a time when social realism and topographical impressionism were the dominant styles, in a place where art collecting was a low priority even for those who could afford to do so.

Inspired perhaps by Stieglitz's multipart series Georgia O'Keeffe: A Portrait, Man Ray made Browner almost the exclusive subject of his photographs during this period. His first two years in Hollywood, 1940 and 1941, yielded nothing but snapshots chronicling the good times they shared. Then in 1942 he photographed a still-life arrangement in a manner that represented a genuine creative breakthrough. The image (cat. no. 108) shows a chair with its back and front leg broken. Placed on the broken chair seat is a piece of driftwood; on the floor under the chair rests a pair of ballet slippers, presumably Browner's. The grotesquely shaped driftwood root, which resembles a deformed human torso, is a typical artifact of the beaches and deserts of Southern California. The negative was solarized by exposing it to a quick flash of light during the developing process, which changed the relationship between the highlights and shadows, creating an eerie quality of light and space. The surrealist element lies in the juxtaposition of three unrelated objects in an ambiguous context.

While Man Ray may have been inspired by Stieglitz in conceiving the serial portrait of Browner (see cat. nos. 111, 112), his series, with its snapshot aesthetic, mocks "good" photography. He used gimmicks such as printing the negatives overlaid with a textile filter to create overlapping patterns or textures, as seen in his 1943 study of Browner with an overhanging crown of branches. A self-portrait of the same year taken in his makeshift darkroom shows Man Ray beside his enlarger, holding a device for selectively blocking light from reaching the paper while a print is being exposed. At this time he used processes such as bas-relief, reticulation, and solarization to lend an unnatural appearance to the images on his negatives.

Man Ray's output of photographs and photograms increased in 1944 and 1945, likely spurred by his need to make new work for three exhibitions that included photographic prints: a retrospective at the Pasadena Art Institute in 1944, a

106.
Ruth, Roses, and Revolvers,
1940–49
Gelatin silver print
9⁷/₈ x 7³/₄ in.
The J. Paul Getty Museum,
Malibu, California

106

show of recent work at the Julien Levy Gallery in New York in 1945, and a retrospective at the Los Angeles County Museum of History, Science, and Art, also in 1945.

Man Ray had not lost his skill at making straight prints from normally exposed negatives. *Ruth, Roses, and Revolvers* (1940–49; cat. no. 106), a still-life arrangement showing a glass vase with a single rose that has dropped most of its petals over a chrome toy cap pistol, bears the same title as a story published in *View*, in which the reader is invited to participate in the act of creation by supplying an ending.[10] In like manner the audience for the photograph is invited to invent a scenario to establish its context.

In Hollywood Man Ray was quite hostile to abstract art, even though he occasionally experimented in this area, and his images are typically grounded in strong icons. For example, a 1946 Rayograph, *Frosted Objects (of My Affection)* (cat no. 114), incorporates some of the vocabulary of objects familiar from his earliest photograms, such as keys, scissors, and the gyroscope, which have strong profiles. But he also included some commonplace hardware items that are not so quickly identified. Here he is evidently creating a catalogue of items with strong personal associations and thereby establishing a less objective and more autobiographical voice.

Man Ray's paintings and objects do not seem to have been as much changed by the Hollywood environment as his photographs. The paintings generally incorporate the same palette of bright hues placed against somber ones and the slightly cartoony exaggeration of figures. Objects are often outlined in black and set against a ground of repeated shapes or calligraphic marks that establish an abstract context for them. Often these signature elements are made to look coarse and awkwardly composed, as if the artist were deliberately creating "bad" painting as a mockery of the tastefully abstract "good" painting that flourished in Paris in the 1930s.

Man Ray's photographs of the Hollywood period took this same direction. The advertising and fashion photographs he made in Paris were by necessity professionally finished and imaginative in their use of lighting, composition, and motif, setting an international standard for commercial photography. In California, however, he began to explore methods of manipulating his prints by using the textured screens and high-contrast graphic art materials that were favored by an earlier generation of pictorialist photographers. He may have learned about these techniques through William Mortensen (see cat. nos. 92–95), a Los Angeles photographer who used them in his work (which was influenced by surrealism and the cinema) and whose books explained how to do them.[11] In Southern California Man Ray found a new route to achieving the fantastic and marvelous, an approach that he took back to Paris when he returned there in early 1951. His parting words were: "I was a Surrealist before being a photographer, and I flatter myself I have remained a Surrealist in the deepest sense of the word."[12]

Weston Naef

Notes

1. Man Ray, *Self Portrait* (New York: Little, Brown, 1968), establishes the essential skeleton of the artist's biography in his own words; it was republished in 1988 with an afterword by Juliet Man Ray, a foreword by Merry Foresta, and approximately two hundred additional illustrations researched by an unidentified editor.
2. Man Ray, "The Age of Light," in *Photography and the Modern Era: European Documents and Critical Writings, 1913–1940,* ed. Christopher Phillips (New York: Metropolitan Museum of Art and Harry N. Abrams, 1989), p. 53.
3. See Man Ray, *Self Portrait,* pp. 129–30, for his account of this discovery. *Rayograph* is another word for photogram, which is a process whereby pictures are made without a camera and lens by placing an object or objects on top of a piece of light-sensitive paper and then exposing it to light.
4. Neil Baldwin, *Man Ray: American Artist* (New York: Clarkson N. Potter, 1988), pp. 121–30.
5. Man Ray, *Self Portrait* (1988), pp. 261–62; ibid., pp. 232–33.
6. Baldwin, *Man Ray,* p. 234, supplies a surname for Kantor, who is referred to only as "Harry" in *Self Portrait;* this is exemplary of Baldwin's abundant additions to Man Ray's autobiography.
7. Man Ray, *Self Portrait* (1988), p. 262.
8. Merry Foresta, "Exile in Paradise: Man Ray in Hollywood, 1940–1951," in *Perpetual Motif: The Art of Man Ray,* exh. cat. (Washington, D.C.: National Museum of American Art; New York: Abbeville Press, 1988), pp. 273–310.
9. Man Ray, *Self Portrait* (1988), pp. 259–62.
10. *View,* ser. 4, no. 4 (December 1944): 120–23.
11. See William Mortensen, *Projection Control* (San Francisco: Camera Craft, 1934).
12. In *Encyclopedia of Photography,* ed. Willard Morgan (New York: Greystone Press, 1963–67), vol. 19, p. 3557.

108.
*Broken Chair with Stump and
Ballet Shoes*, 1942
Gelatin silver solarized print
13$\frac{1}{2}$ x 10$\frac{3}{8}$ in.
The J. Paul Getty Museum,
Malibu, California

111.
*Juliet with Crocheted
Headdress*, 1945
Gelatin silver print
13$\frac{7}{8}$ x 10$\frac{7}{8}$ in.
The J. Paul Getty Museum,
Malibu, California

108

111

112.
Juliet with Mud Mask, 1945
Gelatin silver print
14 x 10 3/4 in.
The J. Paul Getty Museum,
Malibu, California

114.
*Frosted Objects (of My
Affection),* 1946
Rayograph
13 7/8 x 10 1/16 in.
Albright-Knox Art Gallery,
Buffalo, New York, Sherman S.
Jewett Fund, 1972

114

112

Clay Spohn
1898—1977

Fig. 56
Clay Spohn in 1949
Clay Spohn Papers,
Archives of American Art,
Smithsonian Institution

The dadaesque assemblages and dream-inspired drawings of Clay Spohn provided an off-the-wall foil for the angst-ridden gestural abstraction that dominated the art produced in the San Francisco Bay Area during the 1940s and early 1950s. Well known in the local art community for his infectious wit and inventiveness, Spohn bounced irrepressibly from idea to idea, inspiring irreverence in his fellow artists and producing work that anticipated the assemblage and funk traditions subsequently interwoven into the art of Northern California.

Born in San Francisco in 1898, Spohn grew up in the Bay Area. He attended the University of California, Berkeley, then studied at the Art Students League in New York from 1922 to 1924. In 1926, eager to explore the avant-garde, he moved to Paris, where he worked under Othon Friesz at the Académie Moderne. A close friend of Alexander Calder during their student years in Paris, Spohn has been credited with suggesting that he construct sculpture out of wire.[1] After returning to San Francisco in 1927, Spohn concentrated on painting, experimenting with and rejecting most of the styles he had encountered in Europe. He exhibited frequently and was awarded several public art project commissions. While the murals he executed under government auspices have a strong foundation in realism, they also contain elements alluding to primitive myth and dream. For example, in a mural depicting an Indian legend painted for a high school in Los Gatos in 1939, Spohn interjected chimerical flying beings and floating icons that presage the freewheeling fantasy that would later predominate in his work.

In 1941 and 1942, haunted by seeringly vivid, recurring dreams about World War II, Spohn created a series of works in which bizarre military inventions and armored warriors wage battle on otherworldly terrains. Shown in 1942 in a solo exhibition at the San Francisco Museum of Art, these Fantastic War Machines and Guerrographs (see cat. nos. 117–19) depict a plethora of fanciful weaponry in settings evocative of Giorgio de Chirico's paintings. *Air-Attack Net Carrier with Magnetic Release Impulses* (c. 1941–42; cat. no. 117) depicts an outstretched web floating earthward, ready to ensnare enemy planes. Like Joan Miró's Catalan compositions of the early 1920s, *The Ramification of War (Guerrograph)* (1941–42; cat. no. 119) is densely packed with images, but in Spohn's version the land is spiked with grenades, poised cannons, and automatons.

Spohn taught at the California School of Fine Arts (now the San Francisco Art Institute) from 1945 to 1950, a period that coincided with Douglas MacAgy's tenure as director. Mark Rothko and Clyfford Still were also on the faculty during these years, and abstract expressionism flourished at the school. In direct contrast to the idealism of the gestural abstractionists, Spohn's outlook was irreverent and spontaneous. In 1949, as part of the San Francisco Art Association's annual costume ball, he and a handful of collaborators, including Richard Diebenkorn and Hassel Smith, exhibited a collection of boisterous sculptural objects fashioned out of found detritus. The display, entitled *The Museum of Unknown and Little-Known Objects* (see fig. 12), alluding to the fete's theme of the unknown, proved so popular that it was subsequently moved to a studio in the school. As MacAgy noted, "The imaginary lens of the mind's-eye employed by Spohn and his collaborators located mines of meaningful imagery in the refuse and wreckage of civilized neglect."[2] In typical tongue-in-cheek fashion Spohn commented on the theme: "It can't be defined, because, by definition, the Unknown becomes the Known. It could be any real truth regarding the Known, for the admission of not knowing is a degree of knowing. Consequently, the Unknown becomes the Known and the Known becomes the Unknown."[3] Utilizing discarded fragments, he expressed his cyclical view of the world: man merely borrows from nature; eventually nature reclaims and recycles. Included in this prankish display of assembled sculpture were forks bent into distorted shapes, specimen jars containing moldy rice and carpet fuzz, and *Precious Objects* (c. 1949; cat. no. 120), a multi-sided dispensing contraption filled with debris, including toothpicks, ashes, cigarette butts, and torn paper fragments.

Spohn moved to Taos, New Mexico, in 1952, and thereafter divided his time between New York and Taos, producing lyrical abstractions until his death in 1977.

Katherine Holland

Notes
1. Mary Fuller, "Clay Spohn," *Art in America* 51 (December 1963): 80.
2. Douglas MacAgy, "Clay Spohn's Museum," press release, 1949.
3. Ibid.

117.
Air-Attack Net Carrier with
Magnetic Release Impulses,
c. 1941–42
Watercolor and pastel on paper
42 x 20 in.
San Francisco Museum of
Modern Art, estate of the artist

118.
Fighting Automatons, 1941–42
Watercolor, graphite, and chalk
on board
14³/₄ x 17³/₄ in.
San Francisco Museum of
Modern Art, estate of the artist

117

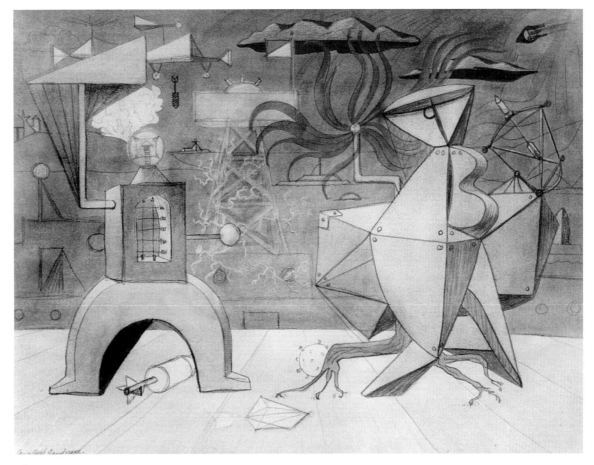

118

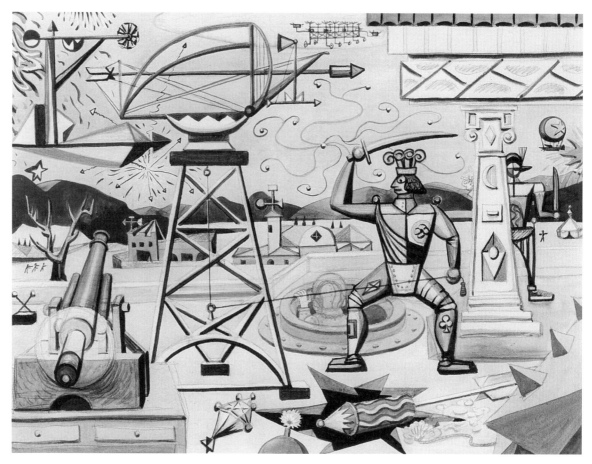

119

119.
*The Ramification of War
(Guerrograph),* 1941–42
Watercolor and gouache on
board
13⁷/₈ x 8¹/₂ in.
San Francisco Museum of
Modern Art, estate of the artist

120.
Precious Objects, c. 1949
Metal and glass gum dispenser
filled with toothpicks, cigarette
butts, ashes, torn postcards,
letter fragments, rhinestones,
and cloth rose
12¹/₄ x 7³/₄ x 7³/₄ in.
The Oakland Museum,
gift of the artist

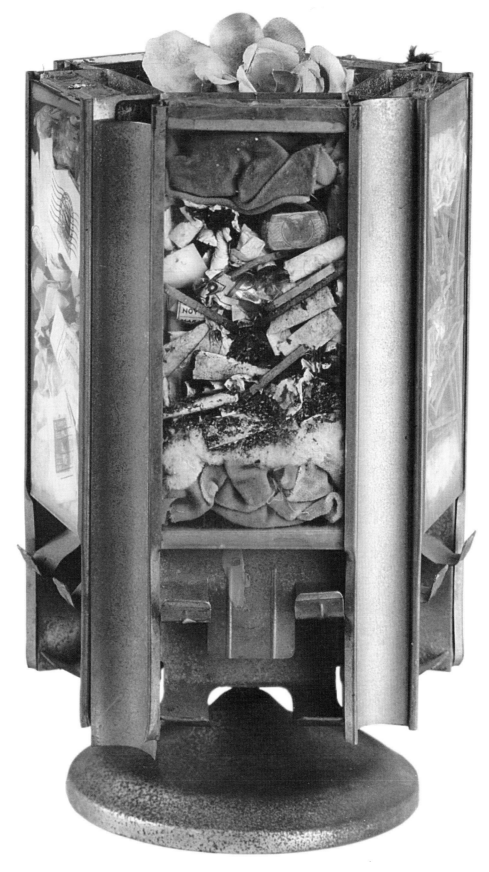

120

Edmund Teske
b. 1911

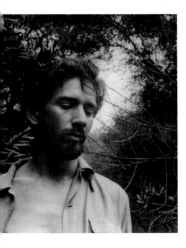

Fig. 57
Edmund Teske at Barnsdall
Park, Olive Hill, Los Angeles,
1945
Photograph by James Whitney;
courtesy Lawrence Bump and
Edmund Teske

In the spring of 1936 Edmund Teske traveled from his home in Chicago to New York, where he met Alfred Stieglitz at his gallery, An American Place, and described his photographic studies of Chicago storefronts and riders on the elevated trains.[1] Encouraged by Stieglitz, he returned to Chicago in mid-1936 and was invited by Frank Lloyd Wright to take up residence as a fellow at Taliesin in Spring Green, Wisconsin, where Teske introduced photography as a form of artistic expression to the other fellows. Meetings with Stieglitz and Wright—acknowledged masters in their respective fields of creative activity—set the stage for a career in which the reconciliation of opposites has been a persistent concern.

Other influences on Teske at this time were Paul Strand, László Moholy-Nagy, Berenice Abbott, and Man Ray, a veritable pantheon of opposites.[2] Teske was first impressed by the photographs of Strand, who in 1933 was the subject of an exhibition covering fifteen years of his work at the Museum of Modern Art in New York. Moholy-Nagy's *Light-Space Modulator* (1930), a kinetic sculpture fabricated from industrial metal parts, was a fixture in his studio at the New Bauhaus Institute of Design, where Teske assisted him in both the darkroom and the classroom. In 1939 Teske spent several months in New York, where he worked for Abbott, who was completing a major body of documentary work published under the title *Changing New York*. About this time Teske saw Man Ray's solarized fashion photographs reproduced in *Vanity Fair* and *Vogue,* and he soon began to experiment with ways to re-create the Sabattier (solarization) effect, in which the final image contains both positive and negative elements.

Inspired by photographs he saw in New York, Teske decided to return to some of his earlier negatives in order to print them in a manner "consistent with a finer feeling of emulsion as plastic pigment."[3] This idea of emulsion as plastic pigment and reliance on the transformative power of printmaking processes became guiding precepts for him.

In 1943 Teske moved to Hollywood, where he found work as a printer in the photographic stills department of Paramount Pictures, harboring the dream of one day becoming an actor. Soon after arriving in Los Angeles, he met a client of Wright's, Aline Barnsdall, who some twenty-five years earlier had commissioned the architect to design a grand residence that she named Hollyhock House, located on Olive Hill, a thirty-six-acre site in the middle of Hollywood, where she wished to establish a center for the arts. By the time Teske arrived, the main house was occupied by a caretaker, and two studio residences designed to be occupied by visual and performing artists had

been abandoned. Teske was the last artist to occupy Studio Residence B before it was demolished, and in that vacant and nearly haunted space his mature style was shaped by a concern with harnessing the forces of accident and chance inherent in nature. He searched for relevance in the minutiae of life through intimate studies of nature's memory—the bark of trees, patterns formed by stones deposited by natural forces, time-eroded wall surfaces, and the decay of abandoned appliances. Teske's impressively crafted contact prints from four-by-five-inch negatives of the early 1950s compare with Strand's in their richness and subtlety, and in 1960 his works were included in the exhibition *The Sense of Abstraction* at the Museum of Modern Art, along with those of Minor White, Aaron Siskind, and Harry Callahan.

Central to Teske's art after about 1956 is the process of returning to negatives that were created sometimes decades earlier and combining them with more recent works to form new composite images made from two or more negatives. One of the first of these, made in 1956 (cat. no. 124), joins a negative showing the demolition in about 1933 of the Madison Avenue Grammar School in Chicago, where the artist had studied, with an image of the face of his friend Shirley Berman. Both subjects are irrationally removed from their original context and given a new one by the power of imagination. Through the photographer's intervention a dreamlike image of an unpleasant memory is united with one expressing tranquil relaxation.

Around 1960 Teske secured a major creative advance while enlarging a recently made negative of his friend Marlene Stark.[4] He had used solarization to achieve startling deviations from the literal negative in the late 1940s and continued to pursue ways to manipulate both negatives and prints, exploring the extreme boundaries of "emulsion as plastic pigment." Teske's method—first called duotone solarization by Edward Steichen—was an application of the principles of solarization and chemical toning which achieved luscious burnt umber tones and a very painterly surface.[5] The technique for producing two or more colors during the process of developing an otherwise standard black-and-white print had been known to photographers for fifty years, but Teske was the first to push it to its experimental limits. Through his manipulations of negatives and prints, he succeeded in making the measurement and passage of time a chief subject of his photographs. His composite images conflate the historical past with the eternal present.

Teske's interest in dreams and his persistent desire to avoid linear thinking in favor of the poetically irrational link his work to surrealism. His photography bears the distinct mark of

121.
Jane Lawrence, 1945
Gelatin silver print
6³/₈ x 5 in.
Collection of Leland Rice

122.
Nude under Image of Weeds,
1947
Composite silver print on board
9¹/₈ x 13 in.
Grunwald Center for the Graphic
Arts, UCLA, purchased with
funds provided by the National
Endowment for the Arts and the
Kress Foundation, Washington,
D.C.

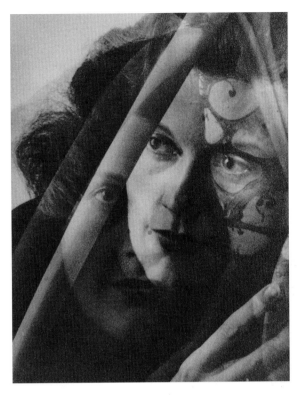

121

122

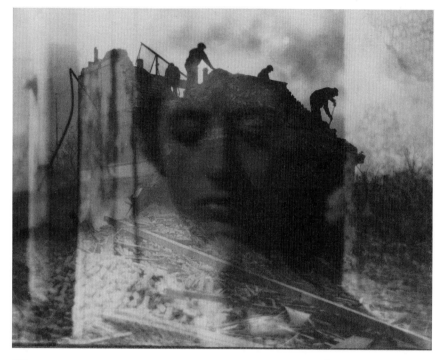

124

California—specifically Hollywood—in its graceful way of hero-izing friends and acquaintances by placing them in larger-than-life fictional settings whose otherworldly atmosphere recalls moving pictures, as exemplified by his 1954 composite study of Kenneth Anger (cat. no. 123). Among the local influences on the formation of Teske's art must be counted William Mortensen (see cat. nos. 92–95), with whom he shared an acquaintance with Cecil B. DeMille, a patron of both artists.

Since about 1965 Teske has been working on a major sum-mary of his work in the sequence of photographs that he calls The Song of Dust.[6]

Weston Naef

Notes

1. Certain biographical information was gathered through interviews held in 1992–93 in preparation for the exhibition *Being and Becoming: Photographs by Edmund Teske*, J. Paul Getty Museum, 8 June–15 August 1993; brochure with text by the author.
2. Susan C. Larsen, "Interview of Edmund Teske," transcription of audio recording made 27 and 30 May 1981, Archives of American Art, Smithsonian Institution.
3. Teske to Frank Lloyd Wright, 11 January 1940, facsimile in Getty Center for the History of Art and the Humanities Library, Special Collections Department.
4. Illustrated in the brochure for *Being and Becoming*. Discovered in 1862 by Armand Sabattier (French, 1834–1910), solarization occurs when a *partially* developed negative or print is briefly exposed to light before fix-ing, which causes the reversal of some tones.
5. According to Teske, he showed his photographs to Steichen and described the process, and it was Steichen who coined the phrase "duo-tone solarization."
6. While the series is still in progress, the photographs have been consol-idated into sets with an accordion-fold binding, requiring their display as a single object.

123.
*Kenneth Anger, Topanga
Canyon,* 1954
Gelatin silver print on board
12⁷/8 x 9¹/8 in.
Grunwald Center for the Graphic
Arts, UCLA, purchased with
funds provided by the National
Endowment for the Arts and the
Kress Foundation, Washington,
D.C.

124.
Untitled, 1956
Gelatin silver combination print
4³/8 x 5⁵/8 in.
San Francisco Museum of
Modern Art, purchased with the
aid of funds from Reese Palley

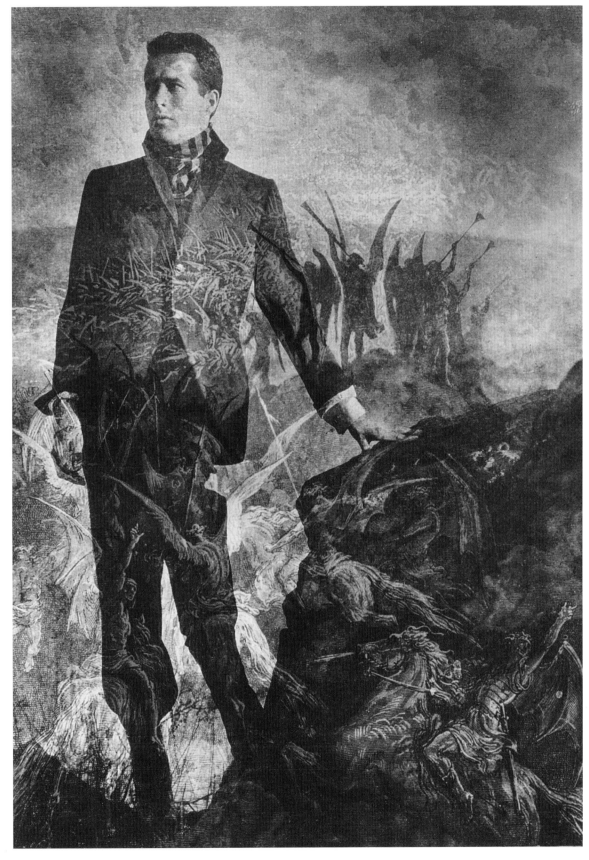

Gordon Wagner
1915—1987

Fig. 58
Gordon Wagner, c. 1960
Photograph by Edmund Teske;
courtesy Tobey C. Moss Gallery

Gordon Wagner was born in the coastal city of Redondo Beach, California. As a young boy his imagination was stimulated by the towns of Los Angeles's South Bay—the ports, junkyards, and especially the amusement parks, with their rides, sideshows, peep shows, and penny arcades. He instinctively loved mechanical ingenuity and make-do inventiveness, and he reveled in "low art" pictorial solutions whose crude rendering and brash color were oddly convincing and psychologically forceful. The carnival atmosphere of fantasy and nightmare, with its confusing crosscurrents of sexuality and violence, helped form his surrealist sensibility and wayward aesthetic.

In the late 1940s Wagner, like many artists of his generation in California, was independently part of the American movement in painting that linked surrealist and expressionist abstraction. Before turning to assemblage sculpture, he developed a spontaneous gestural painting style whose subject matter shared the abstract expressionist preoccupation with Native American myths and legends. He also traveled extensively in Mexico (as did the surrealist painters Wolfgang Paalen and Gordon Onslow Ford), where he was drawn to the Mexican assimilation of European Christian imagery and rituals into a powerful indigenous mysticism. His experiences not only helped palliate existential fears of death and the absurd but also intensified Wagner's feeling for the magic clinging to ordinary objects in extraordinary situations and for the beauty and pathos of the discarded and the debased.

Despite Wagner's self-definition as a painter, he could not abandon his "search for worn, lustrous found objects on beaches and deserts, where nature transforms materials with a marvelous alchemy into new life." Toward the end of his life he wrote: "In a gunny sack I collected unrecognizable objects, polychromed wood, ship and boat parts, rusty machinery, all so battered and twisted by the sea that they became new forms. I stored these pieces in boxes and around the house." Initially these objects were nothing more than "wonderful visual treasures," but then, in the 1950s, he found himself "drifting away from painting to pursue the direction of assemblage."[1]

Two assemblage sculptures from the early 1950s display great economy and insouciant humor. A small untitled work from 1950 (cat. no. 125) is improbably elegant, given its facture from rusted metal parts, most notably the caliper forming the legs of the spare and whimsical figure. It is within the tradition of the totemic imagery of surrealists Max Ernst, Wifredo Lam, and Matta, which in turn was assimilated into the mythopoeic, Jungian-based vocabulary of early New York school paintings

and taken up on the West Coast by the dada-based abstract expressionist Emerson Woelffer.

Made two years later, *Seven Actors* (cat. no. 126) is more complex in its anthropomorphic displacements. Except for an empty head of twisted wire, it is made entirely of fragments of distressed wood and discarded furniture parts. Reminiscent of the constructed still lifes of Picasso (even in its allusions to musical instruments), *Seven Actors* successfully integrates surrealist biomorphism and a cooler cubist analysis into the new assemblage junk aesthetic. These two works, with their emphasis on pedestallike or "staged" presentation, have affinities with the "tabletop" sculptures, primarily made of wood, being done at the same time by Jeremy Anderson in the Bay Area. In their blatant use of junky objects and fragments weathered by time, however, Wagner's pieces display none of Anderson's relish in organic texture and subtle carving touches.

Wagner's aesthetic of the lost-and-found comes to the fore in *"V.R."* (1954; cat. no. 127), a true assemblage of burnt and peeling wood scraps, moldings and finials, rusted metal hardware, and distressed bentwood chair backs—all cobbled together to form an insectlike female figure that is both vulnerable and menacing. *"V.R."* is in the tradition of New York dada "object portraits," but it rejects dada's machine aesthetic in favor of an expressive, even violent, surrealist organicism.

In the 1950s in Southern California and the Bay Area, the traditions of European modernism became especially relevant when they connected with commonplace practices of beachcombing, tinkering, and building "contraptions" and kinetic assemblages. Much independent creative expression gained art historical legitimacy when seen in the context of the European-New York dada fascination with machine imagery; the surrealist desire for objects of magical, fetishistic power; and the new assemblage-junk aesthetic. Wagner was a pioneer among the Southern California bricoleurs who dealt with the heterogeneous but always "given" repertory of things-at-hand. The artists of the California assemblage movement almost always walked the uneasy line between outsider obsessiveness and true surrealist propensities, which folded bricolage back into sophisticated modernist traditions.

Many of Wagner's early assemblages were exhibited in Los Angeles at Edward Kienholz's Now Gallery in 1956. Thereafter his junk assemblages and narrative box constructions have been shown with regular intermittency in Los Angeles, primarily at Silvan Simone Art Gallery (1959–75), and now at the Tobey C. Moss Gallery. A retrospective of his work was held at the

125.
Untitled, 1950
Assemblage
18^7/8 x 3 x 3 in.
Gordon Wagner Estate; courtesy
Tobey C. Moss Gallery, Los
Angeles

126.
Seven Actors, 1952
Assemblage
30^1/2 x 8 x 11 in.
Gordon Wagner Estate;
courtesy Tobey C. Moss Gallery,
Los Angeles

127.
"V.R.," 1954
Assemblage
56 x 24^1/2 x 5 in.
Gordon Wagner Estate;
courtesy Tobey C. Moss Gallery,
Los Angeles

Angels Gate Cultural Center in San Pedro, California, in 1986.
Throughout his long and productive career Wagner was a
beloved mentor to many of California's younger assemblage
artists.

Anne Ayres

Notes

1. Gordon Wagner, artist's statement, in *Firaskew, Gordon Wagner: A
Retrospective Celebrating Fifty-six Years of Work,* exh. cat. (San Pedro,
Calif.: Angels Gate Cultural Center, 1986), pp. 10–11.

126

125

127

Edward Weston
1886–1958

Fig. 59
Edward Weston, 1930
Photograph by Brett Weston
Center for Creative Photography,
The University of Arizona,
Tucson

Edward Weston revealed much that was beautiful during his brilliant career and also much that was strange, not dramatically terrifying but quietly and ineluctably strange. One might argue that there was something aberrant in his ability to invest a humble pepper, a shell, or a halved cabbage with monumentality and wonder, but he achieved this with such authority, such inevitability, that it seems more a revelation of nature than a fiction or a dream. In any case the origin of his phenomenal clear-sightedness probably has more to do with the subtly pervasive influence of American transcendentalism on our cultural life than with anything as remote as European surrealism. Weston remarked in 1930, "I want *the greater mystery of things* revealed more clearly than the eyes can see."[1] He focused squarely upon the perceptible world as a source of potential discoveries. His desire was not to leave the natural world but to know it with extraordinary depth and clarity. He wanted to see "through one's eyes, not with them."[2] How appropriate that he would create a group of photographs that parallel and speak to Walt Whitman's monumentally clear-sighted *Leaves of Grass*.

It is on the fringes of Weston's oeuvre that one finds his moments of alienation from American life, in photographs dwelling upon absurdly inflated icons of popular culture, such as *"Hot Coffee," Mojave Desert* (1937; cat. no. 128), an image of a sign in the form of a giant coffee cup. How puny and inadequate are the creations of men, how soon they decay when exposed to the ordinary ebb and flow of wind and water and time. How inappropriate is the scale of such an object, calculated to catch the eye of a new driving public as it swept by at speeds unnatural for living creatures. How ironic that anyone would crave hot coffee in this parched environment, except perhaps in the cool of the night, when this sign might not be visible. The anomalous scale and the desert landscape recall surrealist dreamscapes, but the practical questions engendered by Weston's image bring us right back to earth.

In Weston's *"Hot Coffee"* we see popular culture creating a three-dimensional parody of its own clichés and offering its strangeness as something friendly and familiar. It is a commonplace that surrealism would have its most pervasive and lasting impact in the realm of popular culture, which would take it to heights literally undreamed of by its gifted originators. Did Weston sense the potential of this unnatural alliance? Perhaps he did and knew that it would co-opt the power of his own images, robbing them utterly of their wonder and dignity. Unlike a funny picture postcard, *"Hot Coffee," Mojave Desert* demands that we stop and consider this object within its improbable context. The interface is no joke; it provokes no laughter but leaves

one with the cold certainty that a cultural battleground has just been defined.

During the same year, 1937, Weston created *Shoe, Moonstone Beach* (cat. no. 129), an image often linked to the surrealist genre of found objects, usually cast-off things showing the patina of wear and neglect. Certainly the stylish lady's shoe, with its broken heel, might tell an interesting tale of erotic display and romantic disappointment. The humble can of beans has met its inevitable fate as an abandoned, valueless item of commerce and consumption. These two, the elevated and the lowbrow, lie together in their entropy and obscurity. The image is made poignant by the implication that human beings, such as the former wearer of the shoe, are cast off as consumables in ordinary life. Here, as in many surrealist works of painting, poetry, and film, a lost object, a fragment of a persona, assumes the role of protagonist in a narrative, which then takes on a new life as the object-fragment asserts a presence of its own.

Perhaps this type of image is an unavoidable outgrowth of photography itself as a visual agency fixing past moments in time. The medium's commemorative and documentary character carries with it an element of morbidity. It cannot show us a living present; it cannot show us a future except by fictional projection. What photography can do and does so very well is to bring us face-to-face with moments past, information long forgotten, details not observed at the time. It involves us unnaturally with past time, past events, past personality; hence its inherently morbid role in human experience. Most often we see the medium as capturing and allowing us to re-create pleasant experiences. If this is so, it is because we so very carefully select those moments, faces, and events to be photographed and we then select from an array of images. Weston the artist is compelled to no such cheerful manipulation of photographic witnessing and provides something truer to the medium's capability and will.

Weston made another excursion into the domain of popular culture in 1939 with his photographs of the back lots of the MGM Studios. They are unforgiving in their dissection of the inherent deception and insubstantiality lurking behind the facade of Hollywood glamour. *Dummies, MGM, Hollywood* (1939; cat. no. 130) is a dark evocation of human form, verging on the macabre. Chillingly prophetic are the corpselike dummies dumped on a shelf behind their stiffly cavorting counterparts. Was Weston immune to the charm of personality and illusion offered by MGM at the height of its influence on American cultural life? It is likely that, having thought quite seriously about the role of illusion in art, he found Hollywood's

128.
"Hot Coffee," Mojave Desert,
1937
Gelatin silver print
7³/₈ x 9¹/₂ in.
The Art Institute of Chicago, gift
of Max McGraw

129.
Shoe, Moonstone Beach, 1937
Gelatin silver print
7¹/₂ x 9¹/₂ in.
Center for Creative Photography,
the University of Arizona, Tucson

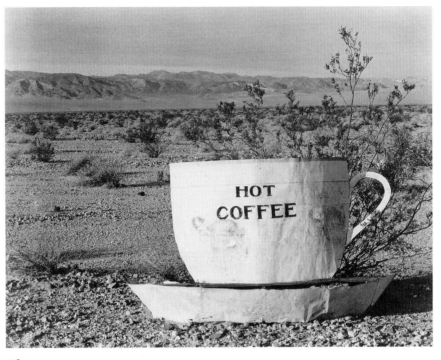

128

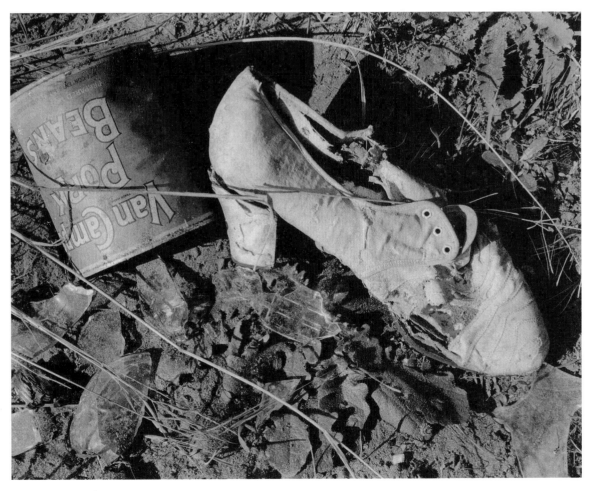

129

130.
Dummies, MGM, Hollywood,
1939
Gelatin silver print
7¹/₂ x 9¹/₂ in.
Los Angeles County Museum of
Art, gift of Dr. and Mrs. L. M.
Maitland (40.15.8)

131.
MGM Storage Lot, 1939
Gelatin silver print
9⁵/₈ x 7⁵/₈ in.
Center for Creative Photography,
the University of Arizona, Tucson

facade thin and unsatisfying and was only too glad to pierce it with his characteristic exactitude.

Closest to surrealist constructions of fictional space is his 1939 photograph *MGM Storage Lot* (cat. no. 131), which features a bizarre landscape of staircases adrift together like an island of contradictory information leading nowhere. Having lost their logical connections to walls, floors, and the interior spaces of buildings, the staircases are three-dimensional fictions ready to be cast in new narratives according to the whims of writers, producers, and directors. They serve at the pleasure of the studio and are as expendable and unreliable as any of its properties. Seen together, in isolation, they are more imposing than they are on film, where their presence goes virtually unnoticed.

When Weston's *Civilian Defense* and *Civilian Defense II* (cat. nos. 132, 133), both made in 1942, were first exhibited, they were often characterized as surrealist images, much to his dismay.[3] It is not altogether surprising that fellow photographers and critics saw these images of Charis Weston in the nude, gazing intently at the viewer through a gas mask, as anomalies within Weston's body of work. That this photographic enterprise had an element of parody and dark humor is indicated by the palm frond draped in front of Charis as she poses as an odalisque: How inappropriate this romantic languor in the midst of World War II. But how else to deal with ultimate terror except to chase the darkness away with an eroticized grimace of false humor? These images recall the gargoyles placed on medieval cathedrals to scare away the minions of the devil or the oriental dragons of ferocious mien invented to stare down similar demons unleashed by the enemy. Weston's nudes are always sexually provocative, but they are also self-possessed and have a strong human presence, particularly the images of his lovers. Charis is not just an actress in a darkly humorous plot but Weston's own dear familiar charged with the task of dispelling the fears that constantly haunted them at this time.

Was Weston a surrealist by inclination or intent? Probably not. There is too much at the center of his enterprise that is clearly at odds with the otherworldly realm of surrealist art and theory. In his life and work Weston was able to embody an enduring and compelling American faith in the hypnotic beauty of manifest forms in nature. This is a transcendental achievement, one that owes nothing to European surrealist art or theory. As time went by, however, and he began to see the American physical and cultural landscape as an incipient ruin, a lost Eden, images and emotions very close to surrealist morbidity entered the fabric of his art. These few images place Weston within the cultural dialogue of his mature years, before and just after

World War II, and are among the manifestations of the surreal that appeared in California during this epoch.

Susan C. Larsen

Notes
1. Edward Weston, "April 26, 1930," in *The Daybooks of Edward Weston,* excerpted in *Edward Weston, Photographer* (New York: Grossman Publishers, 1968).
2. Weston, "August 8, 1930," in ibid., p. 22.
3. Weston, "January 1, 1944," in ibid., p. 75.

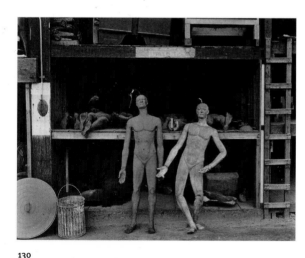

130

131

132.
Civilian Defense, 1942
Gelatin silver print
7⁵/₈ x 9¹/₂ in.
The Art Institute of Chicago, gift
of Max McGraw

133.
Civilian Defense II, 1942
Gelatin silver print
9⁵/₈ x 7⁵/₈ in.
The Lane Collection; courtesy
Museum of Fine Arts, Boston

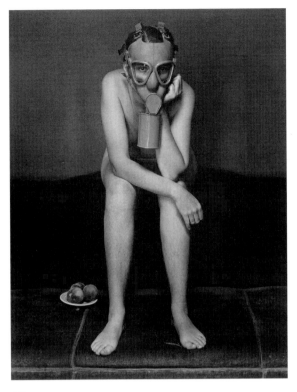

133

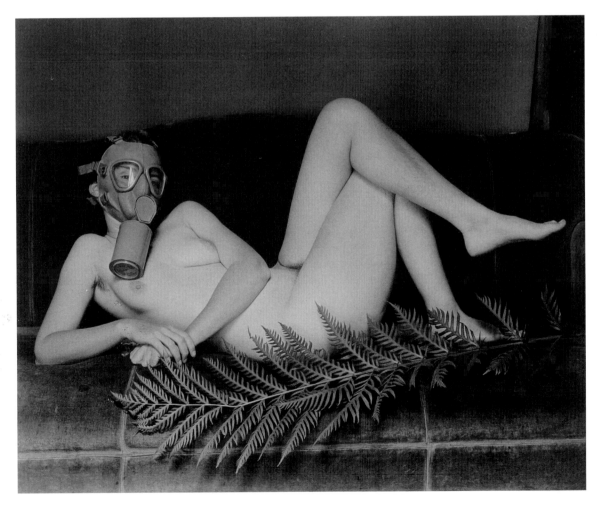

132

Minor White
1908–1976

Fig. 60
Minor White in San Francisco,
1948
Photograph by Tom Murphy;
courtesy Princeton University
Art Museum, Minor White
Archive

Minor White created a poetics out of his lifelong meditations on the vulnerability of nature, photographing tide pools, shore birds, weathered fragments of driftwood, the worn faces of hills and mountains, and the expressive bodies of men. His is a body of work dedicated to biological and spiritual metamorphosis, tolerant of entropy and decay, indeed celebrating their relentless force. Exultant even when approaching transformation and demise, he captured nature in the fullness of its power, shadowed by an ominous darkness.

White graduated from the University of Minnesota with a degree in botany in 1933, having spent much of his spare time studying literature and writing poetry. In his photographic and written work he constantly referred to the biological while employing a powerful poetic imagination. He also understood and appreciated the dialectical nature of photography, that the photographer must find his subjects in the physical world and find them intact, offering themselves to the acquisitive and transformative gaze of the human eye. He cultivated in himself a state of complete receptivity, his self-described "blank state of mind,"[1] as an essential prelude to the act of discovery. Photography became a mental and spiritual adventure played out in the world of tangible forms, which would be not only revealed but also transfigured by the human imagination. Thus many images acquired a talismanic, symbolic meaning that transcended the literal subject of the photograph.

In his interest in metamorphosis, in his eroticism, and in his working method, which privileged the role of private spiritual revelation, White had much in common with the surrealists. His dedication to telling details of the observed world parallels the optical transformations of veristic surrealists such as Salvador Dali and René Magritte, who substituted parts for wholes and derived improbable landscapes from fragments of reality. Their somber mood links some of White's more pessimistic works to surrealist evocations of suffering and decay existing in perpetuity on an inescapable astral plane.

White's insistence that the photograph is found, not willed, was an important precept in his work and his teaching. "It is time we recalled that 'man seen' or 'man found' is just as expressive of creativeness as 'man made.'"[2] His goal was the documentation not of commonplace experience but of the unexpected, surprising encounter with the marvelous. Much of White's work and thought supports André Breton's assertion that "the marvelous is always beautiful, anything that is marvelous is beautiful, indeed, nothing but the marvelous is beautiful."[3] White believed that it was the task of the photographer to be open to unanticipated revelations and that this enterprise

was centered in the photographic. He wrote, "I am still unable to understand a dream until I have either a diagram or a photograph of it."[4]

White's awareness of the symbiotic relationship between his imaginative life and his activity as a photographer began when he was drafted into the U.S. Army in April 1942 and his camera was taken away. "I stopped seeing. . . . When camera was available again, Stieglitz' concept of the Equivalent opened the way to materialize these impressions and thus 'release' myself from their tight grasp. For this long term effort the metamorphosing power of camera was ideal."[5] In this passage White credits the camera itself with transformative powers beyond the mere optical differences between the perceptions of the human eye and what is seen through a ground-glass lens. He also acknowledges that the photograph is not an object of nature but a cultural document created by the human mind, concluding that "creative understanding is more camera-like than invention."[6]

White converted to Catholicism in 1943, following his wartime experiences of suffering and death. His Catholicism is another link between White and the European surrealists. Breton, Luis Buñuel, Dali, and others satirized the faith of their childhood, often employing the Church's powerful imagery and iconography in depicting novel spiritual experiences, political allegories, and erotic fantasies. White embraced the Catholic faith in his early adulthood despite his homosexuality and its inevitable conflict with church doctrine. In time he would create poignant images of suffering, loss, and isolation, recalling the spiritual journeys of Christian ascetics. Some of these are the direct expression of his homosexual experience and his unfulfilled needs for affection and companionship.

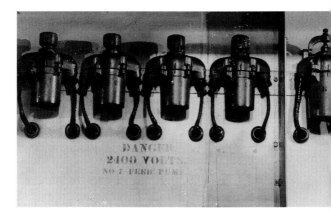

134.
Pump Switches, San Francisco,
1947
Gelatin silver print
4³/₄ x 8³/₈ in.
Courtesy of Minor White
Archive, Princeton University

135.
Tom Murphy, San Francisco,
1947
Gelatin silver print
3¹/₈ x 3¹/₈ in.
Courtesy of Minor White
Archive, Princeton University

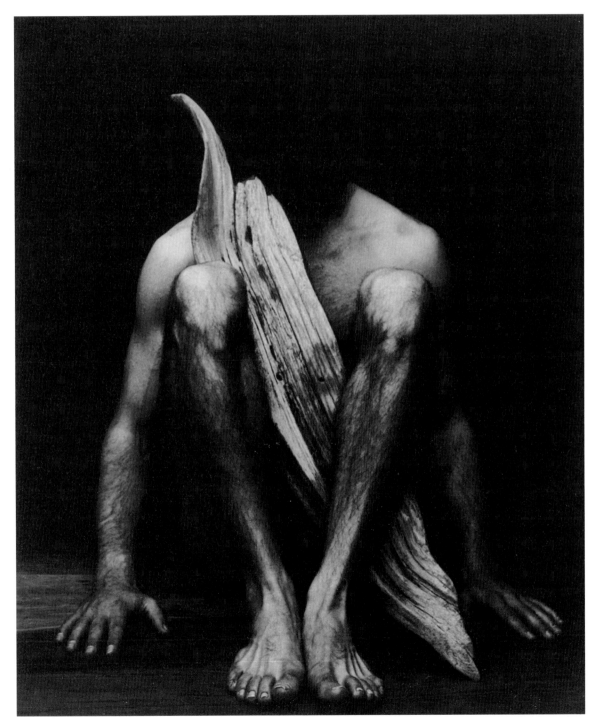

135

An early outgrowth of this process of personal transformation was White's Amputations series, scheduled to be shown at the California Palace of the Legion of Honor in San Francisco in August 1947 but canceled because of its poetic and emotional text. This group of photographs and poems represents White's attempt to come to terms with his combat experiences and those of his comrades, "to amputate the pain I've seen endured."[7] A work that stands out among the tender portraits of fellow servicemen in the series is *Pump Switches, San Francisco* (1947; cat. no. 134), labeled with the dire warning "Danger 2400 Volts." The pump handles have a clearly anthropomorphic—and possibly also homoerotic—form and connotation. Their mechanical-humanoid presence is evocative of the human "fighting machines" White knew to be vulnerable young men hoping to survive the terror of warfare.

Feet, Tom Murphy, San Francisco (1947), a study of the ample, expressive feet of a barefoot friend standing on a wooden platform, is redolent of religious asceticism. The subject appears to be a mendicant, a wanderer on a solitary journey. This postwar image was included in the Amputations sequence, appearing above White's lament: "To Crompone sorrowing for his buddy, Killed beside him, I leave my mystic son, Born of seed as dry as leaves."[8] With *Tom Murphy, San Francisco* (1947; cat. no. 135) White's narrative structure widens to embrace essential mysteries of metamorphosis, sexuality, and death. He dissolved Murphy's face into deep shadow, showing an apparently headless male nude locked in an erotic embrace with a lyrically beautiful piece of driftwood. Bones; flesh; the textures of hair, skin, water-worn wood; the silky darkness of the photographic emulsion all combine in a sonorous, sensuous rapture. The image is amplified by White's poetic fragment: "To Death, I leave. My breath. To die."[9]

White's grounding in biology is also oddly evident in *San Francisco* (1949; cat. no. 136), an image of a tractor that looms like a monstrous force in the tightly bound urban landscape. Here, as in the earlier *Pump Switches,* technology is presented as an actively malevolent force. White consistently portrayed technological elements as intruders in an otherwise complete world with its own spiritualized elemental powers. It is indeed paradoxical that he found such a perfect partner in a product of technology, the camera, which he lovingly acknowledged as the mediating eye between one person's sensibility and a vast audience of sensitive perceivers.

It is apparent from White's extensively documented biography that his awareness of surrealist concepts came from the general artistic environment of the 1940s in New York and San Francisco rather than from any direct contact with European surrealists or any specific, documented influence. Nevertheless his fundamental grounding in an aesthetic of individual revelation, his belief in the power of unseen forces emanating from the biological realm, and his celebration of the erotic in the face of death and entropy all resonate with the surrealist vision born in Europe, which was current in the American artistic community in which he lived and worked. Contemporary critics of White's work and teaching often comment upon his rather old-fashioned faith in the sensate world and his reluctance to engage in manipulations of the print or negative which were common even in his time. Perhaps we can better understand his fundamental affinity with surrealist sensibilities if we note how important his poetry was to his artistic and personal life throughout his long career. His early transformation from botanist to poet to photographer set the stage for a career that would enable him to explore the world as a revelation rather than as a collection of scientific or sociological facts. His was essentially a romantic commitment and not merely an intellectual one, and while that may be an old-fashioned path for an artist to take, it is at least a well-traveled one.

Susan C. Larsen

Notes
1. Minor White, "The Camera Mind and Eye," *Magazine of Art* 45 (January 1952): 17.
2. Ibid., p. 18.
3. André Breton, "What Is Surrealism?" excerpted in *Theories of Modern Art,* ed. Herschl Chipp (Berkeley and Los Angeles: University of California Press, 1968), p. 414.
4. Minor White, "Memorable Fancies," in *Mirrors, Messages, Manifestations* (New York: Aperture, 1969), p. 194.
5. Ibid.
6. White, "Camera Mind and Eye," p. 18.
7. Minor White, "Amputations: Last Will and Minor Testament," in *Mirrors, Messages, Manifestations,* p. 33.
8. Ibid, p. 38.
9. Ibid, p. 39.

136.
San Francisco, 1949
Gelatin silver print
7 1/8 x 9 1/8 in.
Courtesy of Minor White
Archive, Princeton University

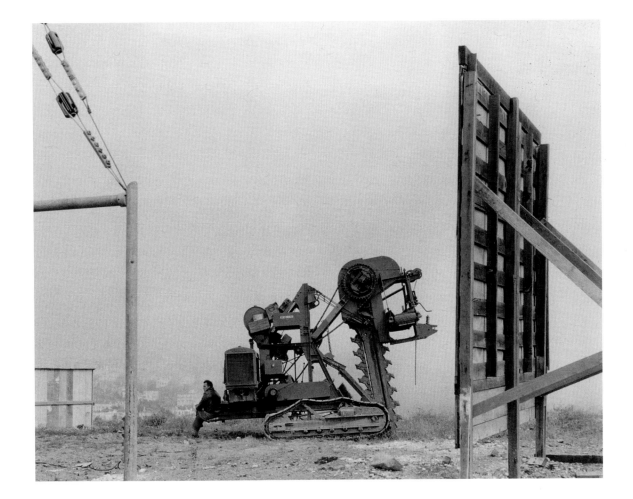

Beatrice Wood
b. 1893

Fig. 61
Beatrice Wood at her shop at
Crossroads of the World in
Hollywood, 1940
Photograph by Sherril Shell;
courtesy Tami Lipsey and
Beatrice Wood's studio

"If I have ever worked as a surrealist," Beatrice Wood recently remarked, "it was in the same way that I worked as a dadaist— without knowing it."[1] Despite this forceful disclaimer, there are aspects of Wood's creative production that can be readily associated with both art movements. The consciously naïve style and subject matter of her drawings and figurative ceramic sculptures can be convincingly traced to her familiarity with dada art and her friendship with dada artists in New York during World War I. And the fanciful, often ambiguous titles that she gave these works, as well as their intentionally primitive appearance, are characteristics that can be readily associated with tendencies in surrealism.

Are these similarities merely coincidental, or did Wood draw inspiration from the same sources as the dada and surrealist artists? This question can be answered satisfactorily only by accepting the probability of both options. Wood was intrigued by dreams and dream analysis and had a lifelong fascination with "primitive" art forms, interests that emerged during her early years in New York. A dream state represents a period of uncontrolled thought, something that was of special interest to both the dada and surrealist artists. Moreover, in their investigation of tribal art, the surrealists, like the dada artists before them, sought alternatives to modern society's emphasis on logic and reasoning, which they believed had caused human beings to become a destructive force to themselves and their environment.

In 1916 Wood met the French painter Marcel Duchamp and, through him, the wealthy collectors Walter and Louise Arensberg, who for a six-year period, from 1915 through 1921, frequently opened their lavishly furnished apartment on West Sixty-seventh Street in Manhattan to nighttime gatherings, informal parties that offered plenty of food, drink, music, chess, and lively conversation.[2] The Arensberg home was filled with examples of the most current art as well as with select works of African and pre-Columbian sculpture, objects that invited comparison with the modern pieces in their collection (particularly the work of the Rumanian sculptor Constantin Brancusi). It was at one of these soirées that Wood met the noted psychiatrist Elmer Ernest Southard (1876–1920), a former classmate of Walter Arensberg's from Harvard who was then director of the Boston Psychopathic Hospital.[3] Southard, a frequent houseguest of the Arensbergs, would ask visitors to recount their dreams, which he then submitted to analysis. Wood was often asked to participate in this process, an experience she deftly recorded in a small sketch, *Beatrice lisant ses rêves aux Arensbergs* (Beatrice reading her dreams to the Arensbergs, c.

1917–18; Philadelphia Museum of Art). These sessions with Dr. Southard may also have inspired her *Nuit blanche* (Sleepless night, sometimes called *Nightmare,* 1917; Philadelphia Museum of Art), a painting on board that Wood submitted to the first exhibition of the Society of Independent Artists in 1917. The picture depicts a stick figure awakening to the vision of a similarly unarticulated apparition hovering at the foot of its bed. When asked to recount her work of hanging pictures for the Society of Independents exhibition, Wood described the entire experience as if it were a dream, and her account appeared in a dada publication under the title "Dream of a Picture Hanger."[4]

In the late 1920s Wood settled in California, where she resumed her friendship with the Arensbergs, who had moved there a few years earlier. Through correspondence she maintained contact with Duchamp in Paris, who during these years became a friend and colleague of some of the most prominent surrealist artists and writers of the day, including the movement's spokesman, André Breton. It was through Duchamp that the Arensbergs acquired some of their most important surrealist pictures during these years, and Wood was among the first of their friends on the West Coast to see the works installed in their home. Through her subscriptions to various art magazines, she became familiar with the work of other surrealists, and she recalls attending a number of surrealist exhibitions. She especially remembers a show of paintings by Salvador Dali (which so impressed her that she named her dachshund after the artist).[5] Outside these miscellaneous contacts, however, she confesses to having taken little interest in surrealist art or theory.

Although Wood's figurative works are often based on the events of her life, their design and construction are usually pure fantasy. For example, *Carte de Noël: What the Doctor Took Out* (cat. no. 137; color plate 13), a mixed-media assemblage from 1937 that she made as a Christmas card for a friend (but never sent), refers to a hysterectomy that she had recently undergone. She pasted a black paper silhouette miming the shape of her own body to beige construction paper. A piece of red paper defines the body cavity, while internal organs are represented by an assortment of objects Wood found lying about on her desk: a white string echoes the twisting shape of the intestine, a tack marks the place where a tumor was removed, a paper clip and washer indicate the reproductive system, with a locket key thrown in for good measure.

Whimsy and humor are also central ingredients in Wood's figurative ceramic sculpture. *Decoy* (c. 1948; cat. no. 138), for example, depicts a fully dressed man flanked by six women, five of whom are nude. It does not take long to notice that the man's

138.
Decoy, c. 1948
Glazed earthenware
9 x 18¹/₂ x 3¹/₂ in.
Collection of the artist

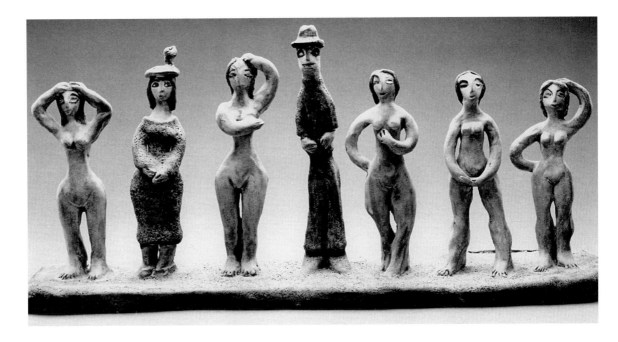

averted eyes look in the direction of the only clothed woman in the group, revealing her identity as the "decoy."

These works share a dreamlike quality that is characteristic of Wood's oeuvre. To this day she sketches only the rough outline of a drawing and then turns the entire sheet upside down to complete the image, a process that allows her to concentrate on the formal aspects of the design. This technique not only makes the process of completing a drawing more enjoyable but also gives her plenty of time to daydream, an activity that—like the surrealist method of psychic automatism—serves to free her mind from the laborious process of making art while at the same time liberating recognizable images from the restrictions of conventional representation.

Francis M. Naumann

Notes

1. Conversation with the author, 24 November 1993.
2. On the Arensbergs and their circle, see Francis M. Naumann, *New York Dada, 1915–23* (New York: Harry N. Abrams, 1994).
3. On Southard, see Frederick P. Gay, *The Open Mind: Elmer Ernest Southard, 1876–1920* (Chicago: Normandie House, 1938).
4. Published in *The Blindman*, no. 1 (10 April 1917): 6–7.
5. Wood does not recall the place or date of this exhibition, though it was probably in the mid-1940s. For a humorous account of an incident involving her dog, see Michael Gregg Michaud, "Salvador Dali: The Spy Who Went to the Dogs," *The Salvador Dali Collectors Magazine* 2, no. 5 (1992): 6.

Checklist of
the Exhibition

Dimensions are given in the following order: height, width, depth. Unless otherwise noted, dimensions for photographs indicate image size. Works reproduced in color are indicated by an asterisk (*).

Jeremy Anderson (1921–1982)

1. *Untitled #100.6*, 1953
 Redwood
 26 x 23 x 8 in. (66.0 x 58.4 x 20.3 cm)
 Courtesy Braunstein/Quay Gallery

2. *Untitled #100.11*, 1953
 Redwood
 20 x 8¹/₂ x 7 in. (50.8 x 21.6 x 17.8 cm)
 Courtesy Braunstein/Quay Gallery

3. *Untitled #85*, 1954
 Redwood
 41³/₄ x 13 x 17 in. (106.0 x 33.0 x 43.2 cm)
 Sheldon Memorial Art Gallery, University of Nebraska, Lincoln, F. M. Hall Collection, 1989 (H-2892)

4. *Untitled #100.3*, 1955
 Wood
 7¹/₄ x 14³/₄ x 6 in. (18.4 x 37.5 x 15.2 cm)
 Collection of Sam and Jo Farb Hernandez; courtesy Braunstein/Quay Gallery

Ben Berlin (1887–1939)

*5. *Profiles*, c. 1937
 Casein on firtex board
 15¹/₄ x 14¹/₂ in. (38.7 x 36.8 cm)
 The Buck Collection, Laguna Hills, California

*6. *Birds, Sky, Water, and Grass*, 1938
 Casein on firtex board
 39 x 23³/₄ in. (99.0 x 60.3 cm)
 Nora Eccles Harrison Museum of Art, Utah State University, gift of Kathryn Caine Wanlass in memory of Ralph Page Wanlass

7. *Untitled (Surreal Abstraction)*, 1939
 Oil on canvas
 20 x 24 in. (50.8 x 61.0 cm)
 Los Angeles County Museum of Art, gift of Herman and Regina Cherry (AC 1992.301.1)

Eugene Berman (1899–1972)

8. *Portrait Fantasy of Ona Munson*, 1941–42
 Oil on canvas
 44³/₄ x 34 in. (113.7 x 86.4 cm)
 McNay Art Museum, San Antonio, Texas, gift of Robert L. B. Tobin

9. *Muse of the Western World*, 1943
 Oil on canvas
 50⁷/₈ x 37³/₄ in. (129.3 x 95.9 cm)
 The Metropolitan Museum of Art, George A. Hearn Fund, 1943 (43.159.2)
 (Oakland and Los Angeles only)

*10. *Nike*, 1943
 Oil on canvas
 58³/₈ x 38³/₈ in. (148.3 x 97.5 cm)
 Hirshhorn Museum and Sculpture Garden, Smithsonian Institution, gift of Joseph H. Hirshhorn, 1972

Wallace Berman (1926–1976)

11. *Untitled*, c. 1943–47
 Pencil on paper
 14¹/₂ x 11¹/₂ in. (36.8 x 29.2 cm)
 Collection of Tosh Berman; courtesy L.A. Louver Gallery, Venice, California

12. *Untitled*, c. 1947
 Pencil on paper
 12³/₄ x 10 in. (32.4 x 25.4 cm)
 Collection of Shirley Berman; courtesy L.A. Louver Gallery, Venice, California

Ruth Bernhard (b. 1906)

13. *Creation*, 1936
 Gelatin silver print
 10¹/₂ x 12¹/₂ in. (26.7 x 31.8 cm)
 Collection of Page Imageworks: Merrily and Tony Page

14. *Puppet, Hand and Foot, Hollywood*, 1938
 Gelatin silver print
 7¹/₂ x 9³/₈ in. (19.0 x 23.8 cm)
 Collection of the artist

15. *Dead Sparrow*, 1946
 Gelatin silver print
 10¹/₄ x 13³/₈ in. (26.0 x 34.0 cm)
 Collection of the artist

Dorr Bothwell (b. 1902)

16. *The Primrose Path*, 1938
 Oil on canvas
 24 x 20 in. (61.0 x 50.8 cm)
 The Schoen Collection, New Orleans

*17. *Family Portrait*, 1940
 Oil on canvas
 34 x 24 in. (86.4 x 61.0 cm)
 Courtesy Tobey C. Moss Gallery, Los Angeles

18. *We Sleep with Our Feet at the Head of Our Four-Footed Bed*, 1940
 Oil on canvas
 16 x 20 in. (40.6 x 50.8 cm)
 Collection of James and Linda Ries

*19. *Table in the Desert*, 1942
 Oil on masonite
 23¹/₂ x 19³/₄ in. (59.7 x 50.2 cm)
 The Buck Collection, Laguna Hills, California

Hans Burkhardt (1904–1994)

20. *Abstraction*, 1941–42
 Oil on canvas
 48³/₄ x 29³/₄ in. (123.8 x 75.6 cm)
 Courtesy Jack Rutberg Fine Arts, Los Angeles
 (Los Angeles and Logan only)

21. *Woman with a Wine Glass*, 1947
 Oil on canvas
 37 x 46 in. (94.0 x 116.8 cm)
 Courtesy Jack Rutberg Fine Arts, Los Angeles

22. *Black Cloud over Vineyard*, 1953
 Oil on canvas
 41$\frac{1}{2}$ x 54 in. (105.4 x 137.2 cm)
 Courtesy Jack Rutberg Fine Arts, Los Angeles

Grace Clements (1905–1969)

23. *Reconsideration of Time and Space*, 1935
 Oil on canvas
 41$\frac{3}{4}$ x 34$\frac{1}{4}$ in. (106.0 x 87.0 cm)
 The Oakland Museum, gift of the artist

Will Connell (1898–1961)

24. *Make-up*, c. 1933
 (Print by Peter Stackpole, c. 1980, from original negative)
 Gelatin silver print
 12$\frac{1}{2}$ x 10 in. (31.8 x 25.4 cm)
 Will Connell Archive, California Museum of Photography,
 University of California, Riverside

25. *Opticman*, 1936
 Gelatin silver print
 9$\frac{1}{2}$ x 7$\frac{1}{2}$ in. (24.1 x 19.1 cm)
 Courtesy Stephen White Associates

26. *Props*, 1937
 Gelatin silver print
 11$\frac{1}{2}$ x 9$\frac{1}{2}$ in. (29.2 x 24.1 cm)
 Courtesy Stephen White Associates

27. *Still Man*, 1937
 Gelatin silver print
 13$\frac{1}{2}$ x 10$\frac{1}{2}$ in. (34.3 x 26.7 cm)
 Department of Special Collections,
 University Research Library, UCLA

Salvador Dali (1904–1989)

28. *Harpo Marx*, 1937
 Pencil on paper
 16$\frac{1}{4}$ x 12$\frac{3}{4}$ in. (41.2 x 32.4 cm)
 Philadelphia Museum of Art, Henry P. McIlhenny Collection,
 in memory of Frances P. McIlhenny
 (Oakland and Los Angeles only)

*29. *Untitled (Study for "Destino," Jupiter's Head)*, 1946
 Oil on masonite
 25 x 20 in. (63.5 x 50.8 cm)
 The Walt Disney Company

30. *Untitled (Surreal Cityscape)*, 1946
 Oil on masonite
 19 x 23 in. (48.3 x 58.4 cm)
 The Walt Disney Company

31. *Portrait of Colonel Jack Warner*, 1951
 Oil on canvas
 42$\frac{1}{2}$ x 50$\frac{1}{2}$ in. (108.0 x 128.3 cm)
 Syracuse University Art Collection

Claire Falkenstein (b. 1908)

32. *Fertility*, 1940
 Painted ash wood
 38 x 12 x 17 in. (96.5 x 30.5 x 43.2 cm)
 Collection of the artist

33. *Game*, 1947
 Tempera on X-ray film
 11$\frac{1}{4}$ x 14$\frac{1}{4}$ in. (28.6 x 36.2 cm)
 Collection of the artist

Lorser Feitelson (1898–1978)

*34. *Genesis #2*, 1934
 Oil on fiberboard
 40$\frac{1}{4}$ x 47$\frac{7}{8}$ in. (102.2 x 121.6 cm)
 National Museum of American Art, Smithsonian Institution

35. *Life Begins*, 1936
 Oil and collage on masonite
 22$\frac{1}{2}$ x 26$\frac{1}{2}$ in. (57.2 x 67.3 cm)
 Feitelson Arts Foundation; courtesy Tobey C. Moss Gallery,
 Los Angeles

36. *Filial Love*, 1937–42
 Oil and casein on Celotex
 24 x 36 in. (61.0 x 91.4 cm)
 The Jane Voorhees Zimmerli Art Museum, Rutgers, the State
 University of New Jersey, gift of the Lorser Feitelson/Helen
 Lundeberg Feitelson Foundation

37. *Magical Forms*, 1944
 Oil on canvas
 30 x 36 in. (76.2 x 91.4 cm)
 Feitelson Arts Foundation; courtesy Tobey C. Moss Gallery,
 Los Angeles

38. *Magical Forms*, c. 1949
 Oil on canvas
 30 x 36 in. (76.2 x 91.4 cm)
 Feitelson Arts Foundation; courtesy Tobey C. Moss Gallery,
 Los Angeles

Philip Guston (1913–1980)

39. *Mother and Child*, c. 1930
 Oil on canvas
 40 x 30 in. (101.6 x 76.2 cm)
 Private collection; courtesy McKee Gallery, New York
 (Oakland and Los Angeles only)

40. *Nude Philosopher in Space Time*, 1935
 Oil on canvas
 45$\frac{3}{4}$ x 24$\frac{3}{4}$ in. (116.2 x 62.9 cm)
 Estate of Philip Guston, New York; courtesy McKee Gallery,
 New York

Gerrie von Pribosic Gutmann (1921–1969)

41. *Self-Portrait*, 1946
Colored pencil on paper
16 x 13 in. (40.6 x 33.0 cm)
Private collection

42. *Jan*, 1950
Pencil on paper
8¹/₂ x 11 in. (21.6 x 27.9 cm)
Private collection

43. *Reunion*, 1958
Casein on board
16 x 20 in. (40.6 x 50.8 cm)
Collection of David and Jeanne Carlson

John Gutmann (b. 1905)

44. *Death Stalks Fillmore*, 1934
Gelatin silver print
13¹/₄ x 9³/₈ in. (33.7 x 23.8 cm)
Collection of the artist

45. *Monument to Chicken Center of the World,
Petaluma, California*, 1936
Gelatin silver print
10¹/₄ x 12 in. (26.0 x 30.5 cm)
Collection of the artist

46. *Double Portrait*, 1938
Gelatin silver print
13¹/₄ x 9³/₈ in. (33.7 x 23.8 cm)
Collection of the artist

47. *Seance*, 1939
Gelatin silver print
13¹/₄ x 9¹/₂ in. (33.7 x 24.1 cm)
Collection of the artist

48. *Father Doll*, 1951
Gelatin silver print
11⁵/₈ x 10¹/₈ in. (29.5 x 25.7 cm)
Collection of the artist

49. *Father Doll Watching Lovers on Swing*, 1951
Gelatin silver print
13¹/₈ x 10¹/₈ in. (33.3 x 25.7 cm)
Collection of the artist

Charles Houghton Howard (1899–1978)

50. *Bivouac*, 1940
Oil on board
16 x 20 in. (40.6 x 50.8 cm)
Collection of Dr. Peter B. Fischer

51. *The Bride*, 1942
Oil on canvas
10 x 8 in. (25.4 x 20.3 cm)
Private collection; courtesy Parkerson Gallery, Houston, Texas

52. *Prescience*, 1942
Oil on canvas
28¹/₄ x 40¹/₂ in. (71.8 x 102.9 cm)
The Metropolitan Museum of Art, Arthur Hoppock Hearn Fund,
1942 (42.163)
(Oakland and Los Angeles only)

53. *Wild Park*, 1944
Oil on canvasboard
13⁷/₈ x 17⁷/₈ in. (35.2 x 45.4 cm)
Munson-Williams-Proctor Institute, Museum of Art, Utica,
New York

54. *Dove Love*, 1945
Oil on canvas
18 x 24 in. (45.7 x 61.0 cm)
The Menil Collection, Houston

*55. *Chain of Circumstance*, 1946
Oil on canvas
12¹/₈ x 24¹/₈ in. (30.8 x 61.3 cm)
Private collection; courtesy Hirschl and Adler Galleries

*56. *The First Hypothesis*, 1946
Oil on canvas
16¹/₄ x 22¹/₈ in. (41.3 x 56.2 cm)
The Menil Collection, Houston

Robert Boardman Howard (1896–1983)

57. *Scavenger*, 1949
Composite material
122¹/₂ x 72¹/₂ x 14 in. (311.2 x 184.2 x 35.6 cm)
Crown College, University of California, Santa Cruz

58. *Night Watch*, 1949–50
Wood, metal gypsum, and resins
106 x 31 x 9 in. (269.2 x 78.7 x 22.9 cm)
Collection of Galen Howard Hilgard

59. *Inspector*, 1950
Balsa wood, fiberglass, resin, steel, lead, sawdust, and glue
17¹/₂ x 28 x 8 in. (44.5 x 71.1 x 20.3 cm)
Collection of Galen Howard Hilgard

60. *The Miscreant*, 1950
Aluminum, balsa wood, linen, and polyvinyl acetate
31 x 98 x 9 in. (78.7 x 248.9 x 22.9 cm)
Addison Gallery of American Art, Phillips Academy, Andover,
Massachusetts

Jess (Collins) (b. 1923)

61. *Boob #3*, 1954
Collage
39 x 35 in. (99.0 x 88.9 cm)
Courtesy Odyssia Gallery, New York

62. *Love's Captive*, 1954
Collage
14 x 18 in. (35.6 x 45.7 cm)
The Literary Estate of Robert Duncan, State University of
New York, Buffalo, Rare Books and Poetry Collection

63. *The Face in the Abyss*, 1955
Collage
30 x 40 in. (76.2 x 101.6 cm)
The First National Bank of Chicago

*64. *Goddess Because II*, 1956
Collage
26 x 29³/₄ in. (66 x 75.6 cm)
Courtesy Odyssia Gallery, New York

Adaline Kent (1900–1957)

65. *Gambler*, 1948
Magnesite
31 x 22¹/₂ x 9 in. (78.7 x 57.2 x 22.9 cm)
Collection of Galen Howard Hilgard

66. *Never Fear*, 1948
Hydrocal and pigment
22¹/₂ x 9 x 8 in. (57.2 x 22.9 x 20.3 cm)
Collection of Galen Howard Hilgard

67. *Weathereye*, 1948
Magnesite
33¹/₂ x 21 x 8 in. (85.1 x 53.3 x 20.3 cm)
The Oakland Museum, lent by the Robert B. Howard family

68. *White Hand*, 1951
Magnesite
75 x 25¹/₂ x 15 in. (190.5 x 64.8 x 38.1 cm)
Collection of Galen Howard Hilgard

Madge Knight (1895–1974)

69. *Turret*, 1944
Gouache on paper
18¹/₂ x 21³/₄ in. (47.0 x 55.2 cm)
Courtesy Campbell-Thiebaud Gallery, San Francisco

Lucien Labaudt (1880–1943)

70. *Shampoo at Moss Beach*, 1935
Oil on board
60 x 48 in. (152.4 x 121.9 cm)
Collection of the San Francisco Art Commission,
gift of Marcelle Labaudt

71. *Song of the Seas*, 1935
Oil on panel
48 x 23 in. (121.9 x 58.4 cm)
Collection of the San Francisco Art Commission,
gift of Marcelle Labaudt

*72. *Telepathic Travel to Tahiti*, 1935
Oil on masonite
42³/₄ x 37³/₄ in. (108.6 x 95.9 cm)
The Oakland Museum, gift of Marcelle Labaudt

Harold Lehman (b. 1914)

73. *Landscape in Perspective*, 1934
Oil on canvas
30¹/₂ x 25 in. (77.5 x 63.5 cm)
Collection of the artist

74. *Portrait of a Dancer plus a Sculptor*, 1934
Oil on wood
54 x 36 in. (137.2 x 91.4 cm)
Collection of the artist

75. *Surveyor*, 1934
Mixed-media collage
24¹/₂ x 18 in. (62.2 x 45.7 cm)
Collection of the artist

Helen Lundeberg (b. 1908)

76. *The Mirror (Enigma)*, 1934
Oil on Celotex
30 x 24 in. (76.2 x 61.0 cm)
Nora Eccles Harrison Museum of Art, Utah State University,
gift of Marie Eccles Caine Foundation

*77. *Plant and Animal Analogies*, 1934
Oil on Celotex
24 x 30 in. (61.0 x 76.2 cm)
The Buck Collection, Laguna Hills, California

*78. *Double Portrait of the Artist in Time*, 1935
Oil on fiberboard
47³/₄ x 40 in. (121.3 x 101.6 cm)
National Museum of American Art, Smithsonian Institution

*79. *Relative Magnitude*, 1936
Oil on masonite
30 x 24 in. (76.2 x 61.0 cm)
The Buck Collection, Laguna Hills, California

80. *Inquisitive Rose*, 1942
Oil on pressed paperboard
8¹/₈ x 5¹/₂ in. (20.6 x 14.0 cm)
Collection of Dr. Bernard L. Krause

81. *Abandoned Easel #2*, 1943
Oil on cardboard
7 x 5 in. (17.8 x 12.7 cm)
Private collection; courtesy Parkerson Gallery, Houston, Texas

82. *Self-Portrait*, 1944
Oil on masonite
16¹/₂ x 27³/₄ in. (41.9 x 70.5 cm)
The Jane Voorhees Zimmerli Art Museum, Rutgers, the State
University of New Jersey, gift of the Lorser Feitelson/Helen
Lundeberg Feitelson Foundation

Rose Mandel (b. 1910)

83. *Untitled*, c. 1947–48, from On Walls and behind Glass
 Gelatin silver print
 4¹/₂ x 3³/₄ in. (11.5 x 9.3 cm)
 The Art Institute of Chicago, restricted gift of Lucia Woods
 Lindley and Daniel A. Lindley, Jr.

84. *Untitled*, c. 1947–48, from On Walls and behind Glass
 Gelatin silver print
 4⁵/₈ x 3¹/₂ in. (11.9 x 9.0 cm)
 The Art Institute of Chicago, restricted gift of Lucia Woods
 Lindley and Daniel A. Lindley, Jr.

85. *Untitled*, c. 1947–48, from On Walls and behind Glass
 Gelatin silver print
 4⁵/₈ x 3³/₄ in. (11.8 x 9.4 cm)
 The Art Institute of Chicago, restricted gift of Lucia Woods
 Lindley and Daniel A. Lindley, Jr.

Knud Merrild (1894–1954)

*86. *Exhilaration*, 1935
 Mixed-media collage on wood-pulp board
 14⁷/₈ x 18³/₄ in. (37.8 x 47.6 cm)
 The Buck Collection, Laguna Hills, California

87. *Flux Bleu*, 1942
 Oil flux and enamel on paper
 6 x 10 in. (15.2 x 25.4 cm)
 The Buck Collection, Laguna Hills, California

88. *Perpetual Possibility*, 1942
 Enamel on composition board mounted on plywood
 20 x 16¹/₈ in. (50.8 x 41.1 cm)
 The Museum of Modern Art, New York,
 gift of Mrs. Knud Merrild, 1960
 (Los Angeles and Oakland only)

89. *Asymmetric Symmetry*, 1943
 Oil flux on canvas mounted on masonite
 18¹/₄ x 15¹/₄ in. (46.4 x 38.7 cm)
 The Buck Collection, Laguna Hills, California

90. *Resignation*, 1945
 Oil flux on canvas
 17⁷/₈ x 13⁷/₈ in. (45.4 x 35.2 cm)
 The Brooklyn Museum, gift of Alexander Bing (52.77)

91. *Chain Reaction*, 1947
 Oil on canvas over composition board
 17¹/₂ x 13¹/₂ in. (44.5 x 34.3 cm)
 The Museum of Modern Art, New York,
 gift of Alexander M. Bing, 1951
 (Los Angeles and Oakland only)

William Mortensen (1897–1958)

92. *Shrapnel*, c. 1934
 Vintage silver print
 7¹/₂ x 5⁷/₈ in. (19.0 x 14.8 cm)
 Collection of Paul Hertzmann and Susan Herzig;
 courtesy Paul M. Hertzmann, Inc., San Francisco

93. *La Chatte*, c. 1935
 Gelatin silver print
 4¹/₂ x 5⁷/₈ in. (11.4 x 14.8 cm)
 Center for Creative Photography,
 the University of Arizona, Tucson

94. *Obsession*, c. 1935
 Gelatin silver print
 7³/₈ x 5³/₄ in. (18.6 x 14.7 cm)
 Center for Creative Photography,
 the University of Arizona, Tucson

95. *L'Amour*, c. 1936
 Bromoil transfer
 11³/₄ x 10³/₈ in. (29.7 x 26.3 cm)
 Center for Creative Photography,
 the University of Arizona, Tucson

Lee Mullican (b. 1919)

*96. *Splintering Lions*, 1948
 Oil on canvas
 50 x 40 in. (127.0 x 101.6 cm)
 Collection of Lee and Luchita Mullican

97. *Vestment*, 1950
 Oil on canvas
 57 x 30 in. (144.8 x 76.2 cm)
 Collection of Lee and Eleanor Kendall

*98. *Ninnekah*, 1951
 Oil on canvas
 50 x 25 in. (127.0 x 63.5 cm)
 Nora Eccles Harrison Museum of Art, Utah State University,
 gift of Marie Eccles Caine Foundation

99. *Presence*, 1955
 Painted wood construction
 36¹/₈ x 17³/₈ x 1¹/₄ in. (91.8 x 44.1 x 3.2 cm)
 The Museum of Modern Art, New York, Mr. and Mrs. Roy
 Neuberger Fund, 1956
 (Los Angeles and Oakland only)

Gordon Onslow Ford (b. 1912)

100. *Fixed Flight*, 1946
 Oil on canvas on panel
 21 x 29¹/₂ in. (53.3 x 74.9 cm)
 Collection of Fannie and Alan Leslie

*101. *The Future of the Falcon*, 1947
 Gouache on paper
 24 x 38 in. (61.0 x 96.5 cm)
 Collection of David and Jeanne Carlson

102. *Wild Time*, 1953
 Casein and mulberry paper on canvas
 36 x 62 in. (91.4 x 157.5 cm)
 Collection of David and Jeanne Carlson

Wolfgang Paalen (1905–1959)

*103. *Keylords of the Prismatic Situations*, 1947
Oil on canvas
81¹/₂ x 31³/₄ in. (207.0 x 80.6 cm)
University of Kentucky Art Museum, gift of Richard B. Freeman

104. *The Possible City*, 1947
Oil on canvas
51 x 24 in. (129.5 x 61.0 cm)
Collection of Luchita Hurtado

*105. *Tropical Night*, 1948
Oil on canvas
58¹/₂ x 55 in. (148.6 x 139.7 cm)
Collection of Mr. and Mrs. Robert Anthoine

Man Ray (1890–1976)

106. *Ruth, Roses, and Revolvers*, 1940–49
Gelatin silver print
9⁷/₈ x 7³/₄ in. (24.9 x 19.8 cm)
The J. Paul Getty Museum, Malibu, California

107. *Lamp*, 1941
Wood and paraffin
17 x 8 x 8 in. (43.2 x 20.3 x 20.3 cm)
Collection of Herbert Stothart

108. *Broken Chair with Stump and Ballet Shoes*, 1942
Gelatin silver solarized print
13¹/₂ x 10³/₈ in. (34.2 x 26.2 cm)
The J. Paul Getty Museum, Malibu, California

109. *Dumb Bells for Light Weight Lifting*, 1942
Wood
10³/₄ x 3 x 2³/₄ in. (27.3 x 7.6 x 7.0 cm) each
Collection of Herbert Stothart

110. *Mr. Knife and Miss Fork*, 1944/1973
Reconstruction of 1944 original; edition of 4
Mixed media
14 x 10 in. (35.6 x 25.4 cm)
Courtesy Galerie Marion Meyer, Paris

111. *Juliet with Crocheted Headdress*, 1945
Gelatin silver print
13⁷/₈ x 10⁷/₈ in. (35.2 x 27.7 cm)
The J. Paul Getty Museum, Malibu, California

112. *Juliet with Mud Mask*, 1945
Gelatin silver print
14 x 10³/₄ in. (35.6 x 27.2 cm)
The J. Paul Getty Museum, Malibu, California

113. *Emak Bakia Lamp*, 1946
Wood, electric lamp wire, and fittings
30¹/₂ x 13 x 10¹/₂ in. (77.5 x 33.0 x 26.7 cm)
Collection of James B. and Barbara C. Byrnes, Los Angeles

114. *Frosted Objects (of My Affection)*, 1946
Rayograph
13⁷/₈ x 10¹/₈ in. (35.2 x 25.6 cm)
Albright-Knox Art Gallery, Buffalo, New York,
Sherman S. Jewett Fund, 1972

115. *Macbeth*, 1948, from Shakespearean Equations
Oil on canvas
30 x 24 in. (76.2 x 61.0 cm)
SBC Communications, Inc., San Antonio, Texas
(Oakland and Los Angeles only)

116. *Twelfth Night*, 1948, from Shakespearean Equations
Oil on canvas
34¹/₈ x 30¹/₈ in. (86.7 x 76.5 cm)
Hirshhorn Museum and Sculpture Garden, Smithsonian
Institution, gift of Joseph H. Hirshhorn, 1972

Clay Spohn (1898–1977)

117. *Air-Attack Net Carrier with Magnetic Release Impulses*,
c. 1941–42
Watercolor and pastel on paper
42 x 20 in. (106.5 x 50.8 cm)
San Francisco Museum of Modern Art, estate of the artist

118. *Fighting Automatons*, 1941–42
Watercolor, graphite, and chalk on board
14³/₄ x 17³/₄ in. (37.5 x 45.1 cm)
San Francisco Museum of Modern Art, estate of the artist

119. *The Ramification of War (Guerrograph)*, 1941–42
Watercolor and gouache on board
13⁷/₈ x 8¹/₂ in. (35.2 x 21.6 cm)
San Francisco Museum of Modern Art, estate of the artist

120. *Precious Objects*, c. 1949
Metal and glass gum dispenser filled with toothpicks, cigarette
butts, ashes, torn postcards, letter fragments, rhinestones, and
cloth rose
12¹/₄ x 7³/₄ x 7³/₄ in. (31.1 x 19.7 x 19.7 cm)
The Oakland Museum, gift of the artist

Edmund Teske (b. 1911)

121. *Jane Lawrence*, 1945
Gelatin silver print
6³/₈ x 5 in. (16.2 x 12.7 cm)
Collection of Leland Rice

122. *Nude under Image of Weeds*, 1947
Composite silver print on board
9¹/₈ x 13 in. (23.3 x 33.0 cm)
Grunwald Center for the Graphic Arts, UCLA, purchased with
funds provided by the National Endowment for the Arts and
the Kress Foundation, Washington, D.C.

123. *Kenneth Anger, Topanga Canyon*, 1954
Gelatin silver print on board
12⁷/₈ x 9¹/₈ in. (32.7 x 23.2 cm)
Grunwald Center for the Graphic Arts, UCLA, purchased with
funds provided by the National Endowment for the Arts and
the Kress Foundation, Washington, D.C.

124. *Untitled*, 1956
Gelatin silver combination print
4³/₈ x 5⁵/₈ in. (11.1 x 14.3 cm)
San Francisco Museum of Modern Art, purchased with the
aid of funds from Reese Palley

Gordon Wagner (1915–1987)

125. *Untitled*, 1950
Assemblage
18⁷/8 x 3 x 3 in. (47.9 x 7.6 x 7.6 cm)
Gordon Wagner estate; courtesy Tobey C. Moss Gallery,
Los Angeles

126. *Seven Actors*, 1952
Assemblage
30¹/2 x 8 x 11 in. (77.5 x 20.3 x 27.9 cm)
Gordon Wagner estate; courtesy Tobey C. Moss Gallery,
Los Angeles

127. *"V.R.,"* 1954
Assemblage
56 x 24¹/2 x 5 in. (142.2 x 62.2 x 12.7 cm)
Gordon Wagner estate; courtesy Tobey C. Moss Gallery,
Los Angeles

Edward Weston (1886–1958)

128. *"Hot Coffee," Mojave Desert*, 1937
Gelatin silver print
7³/8 x 9¹/2 in. (18.7 x 24.1 cm)
The Art Institute of Chicago, gift of Max McGraw

129. *Shoe, Moonstone Beach*, 1937
Gelatin silver print
7¹/2 x 9¹/2 in. (19.1 x 24.1 cm)
Center for Creative Photography,
the University of Arizona, Tucson

130. *Dummies, MGM, Hollywood*, 1939
Gelatin silver print
7¹/2 x 9¹/2 in. (19.0 x 24.1 cm)
Los Angeles County Museum of Art, gift of Dr. and
Mrs. L. M. Maitland (40.15.8)

131. *MGM Storage Lot*, 1939
Gelatin silver print
9⁵/8 x 7⁵/8 in. (24.4 x 19.3 cm)
Center for Creative Photography,
the University of Arizona, Tucson

132. *Civilian Defense*, 1942
Gelatin silver print
7⁵/8 x 9¹/2 in. (19.3 x 24.3 cm)
The Art Institute of Chicago, gift of Max McGraw

133. *Civilian Defense II*, 1942
Gelatin silver print
9⁵/8 x 7⁵/8 in. (24.4 x 19.3 cm)
The Lane Collection; courtesy Museum of Fine Arts, Boston

Minor White (1908–1976)

134. *Pump Switches, San Francisco*, 1947
Gelatin silver print
4³/4 x 8³/8 in. (12.0 x 21.3 cm)
Courtesy of Minor White Archive, Princeton University

135. *Tom Murphy, San Francisco*, 1947
Gelatin silver print
3¹/8 x 3¹/8 in. (7.9 x 7.9 cm)
Courtesy of Minor White Archive, Princeton University

136. *San Francisco*, 1949
Gelatin silver print
7¹/8 x 9¹/8 in. (18.1 x 23.2 cm)
Courtesy of Minor White Archive, Princeton University

Beatrice Wood (b. 1893)

*137. *Carte de Noël: What the Doctor Took Out*, 1937
Mixed-media collage on paper
11 x 8³/4 in. (27.9 x 22.2 cm)
The Oakland Museum, gift of the Collector's Gallery

138. *Decoy*, c. 1948
Glazed earthenware
9 x 18¹/2 x 3¹/2 in. (22.9 x 47.0 x 8.9 cm)
Collection of the artist

Selected Bibliography

Selected

Bibliography

General

Books and Catalogues

Albright, Thomas. *Art in the San Francisco Bay Area, 1945–1980*. Berkeley and Los Angeles: University of California Press, 1985.

American Federation of Arts. *A History of the American Avant-Garde Cinema*. New York: American Federation of Arts, 1976.

Amon Carter Museum of Western Art. *The Artist's Environment: West Coast*. Fort Worth, Tex.: Amon Carter Museum of Western Art, 1962.

Anderson, Susan M. *Pursuit of the Marvelous: Stanley William Hayter, Charles Howard, and Gordon Onslow Ford*. Exhibition catalogue. Laguna Beach, Calif.: Laguna Art Museum, 1990.

Baird, Joseph A., ed. *From Exposition to Exposition: Progressive and Conservative Northern California Painting, 1915–1939*. Sacramento: Crocker Art Museum, 1981.

Barr, Alfred H., Jr., ed. *Fantastic Art, Dada, Surrealism*. New York: Museum of Modern Art, 1936. Reprint. New York: Arno Press, 1968.

Brakhage, Stan. *Film at Wit's End: Eight Avant-Garde Filmmakers.* Kingston, N.Y.: McPherson, 1989.

Breton, André. *Manifestoes of Surrealism*. Translated by Richard Seaver and Helen R. Lane. Ann Arbor: University of Michigan Press, 1972.

———. *Surrealism and Painting*. Translated by Simon Watson Taylor. New York: Harper and Row, 1965.

The Brooklyn Museum. *Oil Paintings and Watercolors by California Moderns: The Post Surrealists*. Exhibition brochure. Brooklyn: Brooklyn Museum, 1936.

Caws, Mary Ann, Rudolf E. Kuenzli, and Gwen Raaberg. *Surrealism and Women*. Cambridge: MIT Press, 1991.

Center for Creative Photography. *Decade by Decade: Twentieth-Century American Photography*. Tucson: Center for Creative Photography, University of Arizona, 1989.

Chadwick, Whitney. *Women Artists and the Surrealist Movement*. Boston: Little, Brown, 1985.

Copley, William. *CPLY: Reflections on a Past Life*. Houston, Tex.: Rice Museum, Institute for the Arts, Rice University, 1979.

Curtis, David. *Experimental Cinema*. New York: Universe Books, 1971.

de Menil, Dominique. *Jermayne MacAgy: A Life Illustrated by an Exhibition*. Houston, Tex.: University of St. Thomas, 1968.

Earle, William. *A Surrealism of the Movies*. Chicago: Precedent, 1987.

Fahey, David, and Linda Rich. *Masters of Starlight: Photographers and Hollywood*. Exhibition catalogue. Los Angeles: Los Angeles County Museum of Art, 1987.

Fisher Gallery. *Ceci n'est pas le surréalisme: California: Idioms of Surrealism*. Exhibition catalogue. Los Angeles: Fisher Gallery, University of Southern California, 1983.

Green, Jonathan. *American Photography: A Critical History, 1945 to the Present*. New York: Harry N. Abrams, 1984.

Grundberg, Andy, and Kathleen McCarthy Gauss. *Photography and Art: Interactions since 1946*. Fort Lauderdale, Fla.: Museum of Art; Los Angeles: Los Angeles County Museum of Art; New York: Abbeville Press, 1987.

Halpern, Nora, and Amy Winter. *Dynaton: Before and Beyond: Works by Lee Mullican, Gordon Onslow Ford, and Wolfgang Paalen*. Exhibition catalogue. Malibu, Calif.: Frederick R. Weisman Museum of Art, Pepperdine University, 1992.

Heimann, Jim, and Rip Georges. *California Crazy*. San Francisco: Chronicle Books, 1980.

Hopkins, Henry. *Fifty Paintings by Thirty-seven Painters of the Los Angeles Area*. Los Angeles: University of California, 1961.

Janis, Sidney. *Abstract and Surrealist Art in America*. New York: Reynal and Hitchcock, 1944.

Jean, Marcel. *The History of Surrealist Painting*. New York: Grove Press, 1959.

Karlstrom, Paul J., and Susan Ehrlich. *Turning the Tide: Early Los Angeles Modernists, 1920–1956*. Exhibition catalogue. Santa Barbara, Calif.: Santa Barbara Museum of Art, 1990.

Katzman, Louise. *Photography in California, 1945–1980*. New York: Hudson Hills Press; San Francisco: San Francisco Museum of Modern Art, 1984.

Krauss, Rosalind, and Jane Livingston. *L'amour fou: Photography and Surrealism*. Washington, D.C.: Corcoran Gallery of Art; New York: Abbeville Press, 1985.

Kuenzli, Rudolph E., ed. *Dada and Surrealist Film*. New York: Willis, Locker, and Owens, 1987.

Kuh, Katherine, and Frederick A. Sweet. *Abstract and Surrealist American Art: Fifty-eighth Annual Exhibition of American Painting and Sculpture*. Exhibition catalogue. Chicago: Art Institute of Chicago, 1947.

Lader, Melvin Paul. "Peggy Guggenheim's Art of This Century: The Surrealist Milieu and the American Avant-Garde, 1942–1947." Ph.D. diss., University of Delaware, 1981. (University Microfilms International.)

Langsner, Jules. *Post-Surrealists and Other Moderns*. Exhibition brochure. Los Angeles: Stanley Rose Gallery, 1935.

Levy, Julien. *Memoir of an Art Gallery*. New York: G. P. Putnam's Sons, 1977.

———. *Surrealism*. New York: Black Sun Press, 1936. Reprint. Arno Press, 1968.

Lippard, Lucy, ed. *Surrealists on Art*. Englewood Cliffs, N.J.: Prentice-Hall, 1970.

Los Angeles County Museum of Art. *California: Five Footnotes to Modern Art History*. Exhibition catalogue. Los Angeles: Los Angeles County Museum of Art, 1977.

———. *California Centennial Exhibition of Art: Section II, Artists of California*. Exhibition catalogue. Los Angeles: Los Angeles County Museum, 1949.

McChesney, Mary Fuller. *A Period of Exploration: San Francisco, 1945–1950.* Exhibition catalogue. Oakland: Oakland Museum, 1973.

Matthews, J. H. *Surrealism and Film.* Ann Arbor: University of Michigan Press, 1971.

Moss, Stacey. *The Howards, First Family of Bay Area Modernism.* Exhibition catalogue. Oakland: Oakland Museum, 1988.

Moure, Nancy. *Painting and Sculpture in Los Angeles, 1900–1945.* Exhibition catalogue. Los Angeles: Los Angeles County Museum of Art, 1980.

Muchnic, Suzanne, and Leland Rice. *Southern California Photography, 1900–65: An Historical Survey.* Exhibition catalogue. Los Angeles: Photography Museum; Los Angeles County Museum of Art, 1981.

The Museum of Modern Art. *Americans, 1942: Eighteen Artists from Nine States.* Exhibition catalogue. New York: Museum of Modern Art, 1942.

The Oakland Museum. *The Art of California: Selected Works from the Collection of the Oakland Museum.* Exhibition catalogue. Oakland: Oakland Museum; San Francisco: Chronicle Books, 1984.

Painting and Sculpture of the San Francisco Art Association. Berkeley: University of California Press, 1952.

Philadelphia Museum of Art. *The Louise and Walter Arensberg Collection.* Exhibition catalogue. Philadelphia Museum of Art, 1951.

Plagens, Peter. *Sunshine Muse: Contemporary Art on the West Coast.* New York: Praeger Publishers, 1975.

Ritchie, Andrew Carnduff. *Abstract Painting and Sculpture in America.* New York: Museum of Modern Art, 1951.

Rowe, Carel. *The Baudelairean Cinema: A Trend within the American Avant-Garde.* Ann Arbor: University of Michigan Research Press, 1982.

Rubin, William S. *Dada and Surrealist Art.* New York: Harry N. Abrams, 1968.

————. *Dada, Surrealism, and Their Heritage.* Exhibition catalogue. New York: Museum of Modern Art, 1968.

Rutgers University Art Gallery. *Realism and Other Realities: The Other Side of American Painting, 1940–1960.* Exhibition catalogue. New Brunswick: Rutgers, the State University of New Jersey, 1982.

San Francisco Museum of Art. *Dynaton 1951.* Exhibition catalogue. San Francisco: San Francisco Museum of Art, 1951.

San Francisco Museum of Modern Art. *The Painting and Sculpture Collection.* New York: Hudson Hills Press, 1985.

————. *Painting and Sculpture in California: The Modern Era.* Exhibition catalogue. San Francisco: San Francisco Museum of Modern Art, 1977.

Schimmel, Paul, ed. *The Interpretive Link.* Exhibition catalogue. Newport Beach, Calif.: Newport Harbor Art Museum, 1986.

Sitney, P. Adams, ed. *The Avant-Garde Film: A Reader of Theory and Criticism.* Anthology Film Archives, Series 3. New York: New York University Press, 1978.

————. *Visionary Film: The American Avant-Garde.* New York: Oxford University Press, 1974.

Soby, James Thrall. *After Picasso.* Hartford: Edwin Valentine Mitchell; New York: Dodd, Mead and Company, 1935.

Solnit, Rebecca. *Secret Exhibition: Six California Artists of the Cold War Era.* San Francisco: City Lights Books, 1990.

Starr, Sandra Leonard. *Lost and Found in California: Four Decades of Assemblage Art.* Exhibition catalogue. Santa Monica, Calif.: James Corcoran Gallery, 1988.

Stauffacher, Frank, ed. *Art in Cinema: A Symposium on the Avant-Garde Film.* San Francisco: Art in Cinema Society, San Francisco Museum of Art, 1947. Reprint. New York: Arno Press, 1968.

Tuchman, Maurice. *The Spiritual in Art: Abstract Painting, 1890–1985.* Exhibition catalogue. Los Angeles: Los Angeles County Museum of Art; New York: Abbeville Press, 1986.

Tyler, Parker. *Underground Film: A Critical History.* New York: Grove Press, 1969.

Wechsler, Jeffrey. *Surrealism and American Art, 1931–1947.* New Brunswick: Rutgers, the State University of New Jersey, 1977.

Wight Art Gallery. *Forty Years of California Assemblage.* Exhibition catalogue. Los Angeles: Wight Art Gallery, University of California, 1989.

Williams, Linda. *Figures of Desire: A Theory and Analysis of Surrealist Film.* Urbana: University of Illinois Press, 1981.

Articles

Breton, André. "The Latest Tendencies in Surrealist Painting." *Minotaure,* 3d ser., nos. 12–13 (1939): 16–17. Reprinted in Breton, *Surrealism and Painting.*

Byrne, Barry. "Surrealism Passes." *Commonweal,* 2 July 1937, p. 262.

Campbell, Blendon Reed. "Surrealism, New School of Native Art." *Literary Digest,* no. 118 (15 December 1934): 19.

Caspers, Frank. "Surrealism in Overalls." *Scribner's Magazine* 104 (August 1938): 17–20.

Danieli, Fidel. "Nine Senior Southern California Painters." *Los Angeles Institute of Contemporary Art Journal* 2 (October 1972): 32–33.

Eggener, Keith L. "An Amusing Lack of Logic: Surrealism and Entertainment." *American Art* 7 (Fall 1993): 32.

Ehrlich, Susan. "Early Los Angeles Modernists: 1920–1956." *Art of California* 3 (September 1990): 32–39.

————. "Los Angeles Painters of the 1940s." *Los Angeles Institute of Contemporary Art Journal* 28 (September–October 1980): 59–69.

————. "Southern California's Modernist Dawn." *Artspace* 16 (Fall 1991): 78–82.

Fischer, Lucy. "American Experimental Cinema: Breaking Away." In *The Museum of Modern Art Circulating Film Catalogue.* New York: Museum of Modern Art, 1984.

Foster, Hal. "L'amour faux." *Art in America* 74 (January 1986): 116–29.

"Freudian Psychology Appears in First American Surrealist Show." *Art Digest* 6 (15 January 1932): 32.

Hopkins, Henry. "Visionaries: The Art of the Dynaton." *Antiques and Fine Art* 9 (March–April 1992): 74.

Jewell, Edward Alden. "Brisk Pace in Museums." *The New York Times*, 17 May 1936.

Karlstrom, Paul J. "Los Angeles in the 1940s: Post-Modernism and the Visual Arts." *Southern California Quarterly* 69 (Winter 1987): 301–28.

Lader, Melvin. "Howard Putzel: Proponent of Surrealism and Early Abstract Expressionism in America." *Arts* 56 (March 1982): 86.

Lane, John. "Surrealism in Theory and Practice in France and America." *Artforum* 35 (September 1966): 86–87.

Millier, Arthur. "Surrealists Take Time by the Forelock and Stage Exhibit." *Los Angeles Times*, 25 November 1934, sec. 2.

Moran, Diane Degasis. "Post-Surrealism." *Arts* 57 (December 1982): 124–28.

Rice, Leland. "Los Angeles Photography: c. 1940–60." *Los Angeles Institute of Contemporary Art Journal*, no. 5 (April–May 1975): 28–37.

Solman, Joe. "The Post Surrealists of California." *Art Front* 2 (June 1936): 12.

"Surrealism on Parade." *Life*, (14 December 1936), pp. 24–27.

"Surrealist Movie." *Life*, (2 December 1946), pp. 86–88.

Tyler, Parker. "Sidney Peterson." *Film Culture* 19 (1959): 38–43.

Zlotsky, Deborah. "'Pleasant Madness' in Hartford: The First Surrealist Exhibition in America." *Arts* 60 (February 1986): 55–61.

Individual Artists

Jeremy Anderson

Albright, Thomas. "Founding Fathers." *The Museum of California*. (Oakland) 6 (July–August 1982): 8–9.

Baker, Kenneth. "Toys with a Surrealist Slant." *San Francisco Chronicle*, 29 April 1989.

Brunson, Jamie. "Celebrations of Cyclical Reality." *Artweek* 20 (6 May 1989): 5.

Frankenstein, Alfred. "Art Show Review: Painting, Sculpture at Three Galleries." *San Francisco Chronicle*, 23 January 1964.

Monte, James. "Jeremy Anderson Retrospective at the San Francisco Museum," *Artforum* 5 (February 1967): 50.

Nordland, Gerald. *Jeremy Anderson*. Exhibition catalogue. San Francisco: San Francisco Museum of Modern Art, 1966.

Ben Berlin

Fort, Ilene Susan. "Ben Berlin." In *American Art: A Catalogue of the Los Angeles County Museum of Art Collection*, pp. 312–13. Los Angeles: Los Angeles County Museum of Art, 1991.

Moure, Nancy Dustin Wall. *Dictionary of Art and Artists in Southern California before 1930*. Publications in Southern California Art, no. 3. Los Angeles: Publications in Southern California Art, 1975.

Eugene Berman

Frankfurter, Alfred M. "The Berman of the Western World." *Art News* 41 (15 February 1942): 27.

Frost, Rosamund. "Berman the Baroque Boy." *Art News* 11 (1–14 March 1941): 26–27, 38–39.

Levy, Julien. *Eugene Berman*. Freeport, N.Y.: Books for Libraries Press, 1947.

McNay Art Museum. *Eugene Berman and the Theatre of Melancholy*. San Antonio: McNay Art Museum, 1984.

Soby, James Thrall. *Eugene Berman*. Boston: Institute of Modern Art, 1941.

Wallace Berman

Albright, Thomas. "Influential Visions of Wallace Berman." *San Francisco Chronicle*, 24 September 1979, Datebook section.

Ayres, Anne Bartlett. "Berman and Kienholz: Progenitors of Los Angeles Assemblage." In *Art in Los Angeles: Seventeen Artists in the Sixties*, pp. 11–19. Exhibition catalogue. Los Angeles: Los Angeles County Museum of Art, 1981.

Glicksman, Hal. *Wallace Berman Retrospective*. Exhibition catalogue. Los Angeles: Otis Art Institute Gallery, 1978.

Greene, Merril. "Wallace Berman: Portrait of the Artist as an Underground Man." *Artforum* 16 (February 1978): 53–61.

Institute of Contemporary Art. *Wallace Berman: Support the Revolution*. Exhibition catalogue. Amsterdam: Institute of Contemporary Art, 1992.

McClure, Michael. "Wallace Berman Interview." *Third Rail: International Arts and Literature* 9 (1988): 3–19.

Ruth Bernhard

Alinder, James. *Collecting Light: The Photographs of Ruth Bernhard*. Carmel, Calif.: Friends of Photography, 1979.

"American Aces: Ruth Bernhard." *U.S. Camera* 4 (June 1939): 52–55.

Bernhard, Ruth. *Ruth Bernhard: A Retrospective from the Ginny Williams Collection*. Denver: Ginny Williams Foundation, 1993.

Lufkin, Liz. "Ruth Bernhard." *American Photographer* 20 (April 1988): 60–66.

Mitchell, Margaretta. *Recollections.* New York: Viking Press, 1979.

Raedeke, Paul. "Portfolio: Ruth Bernhard." *Photo Metro* 2 (August 1983): 3–9.

Dorr Bothwell

Curtis, Cathy. "Art Review: Personal Feel in Bothwell's '40s Work." *Los Angeles Times,* 29 April 1991, Calendar section.

Kamerling, Bruce. "Dorr Hodgson Bothwell." In *One Hundred Years of Art in San Diego.* San Diego: San Diego Historical Society, 1991.

Moss, Tobey C. *Dorr Bothwell: Surreal/Abstract.* Exhibition brochure. Los Angeles: Tobey C. Moss Gallery, 1989.

Moure, Nancy. "Dorr Bothwell." In *A Time and Place: From the Ries Collection of California Painting.* Exhibition catalogue. Oakland: Oakland Museum, 1990.

Hans Burkhardt

Brown, Betty Ann. "Issues for an Expressionist." *Artweek* 18 (31 January 1987): 5.

Curtis, Cathy. "My Soul Is in These Paintings." *Art News* 91, no. 2 (May 1993): 112–13.

Einstein, Susan. Interview with Hans Burkhardt. Oral History Program, University of California, Los Angeles, 1976.

Gardner, Colin. Interview with Hans Burkhardt. In *Hans Burkhardt: The War Paintings.* Northridge, Calif.: Santa Susana Press, 1984.

Goodall, Donald. "Los Angeles." *Art Digest* 28 (June 1954): 12–13.

Rutberg, Jack V. *Hans Burkhardt, 1950–1960.* Exhibition catalogue. Los Angeles: Jack Rutberg Fine Arts, 1987.

San Diego Art Institute. *Hans Burkhardt.* San Diego: San Diego Art Institute, 1966.

Wilson, William. "Honoring L.A.'s 'Secret' Art Pioneer." *Los Angeles Times,* 19 May 1992, Calendar section.

Grace Clements

Armitage, Merle. *An Exhibition of Modern Paintings by Grace Clements.* Exhibition catalogue. Los Angeles: Los Angeles County Museum, 1931.

Clements, Grace. "New Content—New Form." *Art Front* 11 (March 1936): 8–9.

Will Connell

Connell, Will. *In Pictures: A Hollywood Satire.* New York: T. J. Maloney, 1937.

Coke, Van Deren. *Photographs by Will Connell: California Photographer and Teacher (1898–1961).* Exhibition catalogue. San Francisco: San Francisco Museum of Modern Art, 1981.

Halsman, Philippe, and Ed Hannigan. "Will Connell." *U.S. Camera: International Pictures* 1 (1963): 107–10.

Salvador Dali

Ades, Dawn. *Dali and Surrealism.* New York: Harper and Row; London: Thames and Hudson, 1982.

Bigwood, James. "Salvador Dali, Reluctant Filmmaker." *American Film* 5 (November 1979): 62–63.

————. "Solving a *Spellbound* Puzzle." *American Cinematographer* 72, no. 6 (June 1991): 34–40.

Dali, Salvador. "Surrealism in Hollywood." *Harper's Bazaar,* June 1937, pp. 68–70.

"Dali and Miró Jar New York with Visions of the Subconscious." *Art Digest* 16 (1 December 1941): 5–6, 14.

"Dali's Surrealistic Dream House at the World's Fair." *Vogue,* 1 June 1939, pp. 55–59.

Descharnes, Robert. *Salvador Dali: The Work, the Man.* New York: Harry N. Abrams, 1989.

Descharnes, Robert, and Gilles Néret. *Salvador Dali: The Paintings.* Vol. 1, *1904–1946.* Hohenzollernring: Benedikt Taschen Verlag, 1994.

Etherington-Smith, Meredith. *The Persistence of Memory: A Biography of Dali.* New York: Random House, 1993.

Frankenstein, Alfred. "It Is Something of a Jump from Burbank to Pasadena." *San Francisco Chronicle,* 24 February 1946.

Montreal Museum of Fine Arts. *Salvador Dali.* Exhibition catalogue. Montreal: Montreal Museum of Fine Arts, 1990.

"Mr. Dali Goes to Town." *Art Digest* 16 (1 December 1941): 3.

Seton, Marie. "S. Dali + 3 Marxes =." *Theatre Arts* 23 (October 1939): 734–44.

Shannon, Leonard. "When Disney Met Dali." *Modern Maternity* 21 (December 1978–January 1979): 50–52.

Soby, James Thrall. *Salvador Dali.* Exhibition catalogue. New York: Museum of Modern Art, 1941.

"World's Fair." *Life,* 3 July 1939.

Young, Jordan. "Disney and Dali's Destino: A Tale of Two Visionaries." *Los Angeles Times,* 29 January 1989.

Claire Falkenstein

Brown, Betty Ann. "The Decentered Artist: Claire Falkenstein at Jack Rutberg." *Artweek* 29 (7 December 1989): 16.

Curtis, Cathy. "Wilshire Center." *Los Angeles Times,* 24 November 1989, Calendar section.

Henderson, Maren Henry. *Claire Falkenstein: Chance and Choice.* Exhibition catalogue. Los Angeles: Jack Rutberg Fine Arts, 1989.

——. "Claire Falkenstein: Problems in Sculpture and Its Redefinition in the Mid-Twentieth Century." Ph.D. diss., University of California, Los Angeles, 1991.

Lorser Feitelson

Danieli, Fidel. Interview with Lorser Feitelson. Oral History Program, University of California, Los Angeles, 1974.

Dunham, Judith L. "Lorser Feitelson and Helen Lundeberg: Collaborative Lives, Individual Achievement." *Artweek* 11 (2 November 1980): 1.

Fort, Ilene Susan. "Post-Surrealism: The Art of Lorser Feitelson and Helen Lundeberg." *Arts* 57 (December 1992): 124–28.

Langsner, Jules. "Permanence and Change in the Art of Lorser Feitelson." *Art International* 7 (25 September 1963): 73–76.

Moran, Diane Degasis. "The Painting of Lorser Feitelson." Ph.D. diss., University of Virginia, 1979. (University Microfilms International.)

——. *Lorser Feitelson and Helen Lundeberg: A Retrospective Exhibition.* Exhibition catalogue. San Francisco: San Francisco Museum of Modern Art; Los Angeles: UCLA Art Council, 1980.

Seldis, Henry. "Lorser Feitelson." *Art International* 14 (May 1970): 48–52.

Stofflet, Mary. "Double View: Helen Lundeberg and Lorser Feitelson." *Images and Issues* 1 (Summer 1981): 16–17.

Philip Guston

Ashton, Dore. *Yes, but . . . A Critical Study of Philip Guston.* New York: Viking Press, 1976.

Dabrowski, Magdalena. *The Drawings of Philip Guston.* Exhibition catalogue. New York: Museum of Modern Art, 1988.

de Lima Greene, Alison. "The Artist as Performer: Philip Guston's Early Work." *Arts* 63 (November 1988): 55–56.

Mayer, Musa. *Night Studio: A Memoir of Philip Guston by His Daughter.* New York: Alfred A. Knopf, 1988.

San Francisco Museum of Modern Art. *Philip Guston.* Exhibition catalogue. New York: George Braziller, 1980.

Gerrie von Pribosic Gutmann

Frankenstein, Alfred. "Three Ladies of Fantasy Share Gallery Billings." *San Francisco Chronicle,* 28 January 1962, This World section.

Hodel, Emilia. "Portraying Extravagant World of Dreams." *San Francisco News–Call Bulletin,* February 1959, Art section.

M. H. de Young Memorial Museum. *Gerrie Gutmann: Paintings and Drawings.* Exhibition brochure. San Francisco: M. H. de Young Memorial Museum, 1952.

——. *Gerrie Gutmann.* Exhibition brochure. San Francisco: M. H. de Young Memorial Museum, 1962.

Reed, Judith Kaye. "Gerrie von Pribosic" (review of Bonestell Gallery show). *Art Digest* 22 (15 February 1948): 14.

John Gutmann

Humphrey, John. *As I Saw It: Photographs by John Gutmann.* Exhibition catalogue. San Francisco: San Francisco Museum of Modern Art, 1976.

Kozloff, Max. *The Restless Decade: John Gutmann's Photographs of the Thirties.* Edited by Lew Thomas. New York: Harry N. Abrams, 1984.

Mitchell, Margaretta. "Profile: John Gutmann: American Icons." *35-MM Photography* (Winter 1977): 30–39, 105–6.

Phillips, Sandra. *Beyond the Document.* Exhibition catalogue. San Francisco: San Francisco Museum of Modern Art, 1989.

Raedeke, Paul. "Introduction and Interview with John Gutmann." *Photo Metro* 4 (September 1985): 3–17.

Sutnik, Maia-Mari. *Gutmann.* Exhibition catalogue. Toronto: Art Gallery of Ontario, 1985.

Charles Houghton Howard

Cullinan, Gerald. "Novel Exhibition Reflects Reactions of San Francisco Artists to Total." *San Francisco News–Call Bulletin,* 10 January 1942.

Dreishpoon, Douglas. *Charles Howard, 1899–1978: Drama of the Mind.* Exhibition catalogue. New York: Hirschl and Adler Galleries, 1993.

Howard, Charles. "What Concerns Me." *Magazine of Art* 39 (February 1946): 64.

MacAgy, Douglas. *Charles Howard: Retrospective Exhibition, 1925–1946.* Exhibition catalogue. San Francisco: California Palace of the Legion of Honor, 1946.

——. "The Art of Charles Howard." *Critique* 1 (January–February 1947): 36–39.

Reavey, George. "Charles Howard." *London Bulletin* 13 (15 April 1939): 14.

Robert Boardman Howard

Albright, Thomas. "Sculptured World of Robert Howard." *San Francisco Chronicle,* 26 November 1979.

——. "Robert Howard, Master of Motion." *San Francisco Chronicle,* 24 February 1983.

Frankenstein, Alfred. "Some Masterpieces of Articulated Sculpture." *San Francisco Chronicle,* 24 October 1956, Lively Arts section.

——. "Music and Art." *San Francisco Chronicle,* 16 January 1949.

Hayes, Bartlett H., Jr. *The Naked Truth and Personal Vision.* Andover, Mass.: Addison Gallery of American Art, 1955.

San Francisco Art Association Gallery. *Robert Howard.* Exhibition brochure. San Francisco: California School of Fine Arts, 1956.

Jess (Collins)

Auping, Michael. *Jess: A Grand Collage.* Exhibition catalogue. Buffalo: Albright-Knox Art Gallery, 1992.

——. *Jess: Paste-ups (and Assemblies), 1951–1983.* Exhibition catalogue. Sarasota, Fla.: John and Mable Ringling Museum of Art, 1983.

——. "Songs of Innocence: The Art of Jess." *Art in America* 75 (January 1987): 118–27.

Duncan, Michael. "Maverick Modernist." *Art in America* 82 (November 1994): 57, 93–96.

Duncan, Robert Edward. *Paste-ups by Jess.* Exhibition catalogue. San Francisco: San Francisco Museum of Modern Art, 1968.

Solnit, Rebecca. "Phantoms of Delight." *Artweek* 20 (8 April 1989): 7.

Adaline Kent

B.K., "Reviews and Previews: Adaline Kent." *Art News* 18 (Summer 1949): 56.

Ferling, Lawrence. "Coast-to-Coast: San Francisco." *Art Digest* 27 (15 May 1953): 11.

Greenberg, Clement. "Art." *The Nation,* no. 168 (28 May 1949): 621–22.

Kent, Adaline. *Autobiography: From the Notebooks and Sculpture of Adaline Kent.* Privately printed, 1958.

Reed, Judith Kaye. "Fifty-seventh Street in Review: Whimsy and Experimentation." *Art Digest* 23 (15 May 1949): 17.

San Francisco Museum of Art. *Adaline Kent Exhibition.* Exhibition catalogue. San Francisco Museum of Art, 1958.

Madge Knight

Holland, Katherine Church. *Resource/Reservoir: From the Collection: The Gifts of Jermayne MacAgy.* San Francisco: San Francisco Museum of Modern Art, 1983.

Lucien Labaudt

Hailey, Gene, ed. *California Art Research Monographs.* Vol. 19. San Francisco: Works Progress Administration, 1937, pp. 1–28.

San Francisco Museum of Art. *Lucien Labaudt, 1880–1943: Memorial Exhibition.* Exhibition catalogue. San Francisco: San Francisco Museum of Art, 1944.

Harold Lehman

"Angelenos in Exhibit at Elder's." *Los Angeles Times,* 16 September 1935.

Millier, Arthur. "Two Pairs of Painters and Some Singles Offer Shows." *Los Angeles Times,* 17 September 1933, pt. 2.

——. "Young Surrealist." *Los Angeles Times,* 26 May 1935, pt. 2.

Helen Lundeberg

Danieli, Fidel. Interview with Helen Lundeberg. Oral History Program, University of California, Los Angeles, 1974.

Ehrlich, Susan. "Helen Lundeberg: Between Reality and Dream." *Artspace* 15 (January–February 1991): 35–39.

Fort, Ilene Susan. *A Birthday Salute to Helen Lundeberg.* Exhibition catalogue. Los Angeles: American Art Council of the Los Angeles County Museum of Art, 1988.

Hagberg, Marilyn. "Poetic Mysteries." *Artweek* 3 (8 January 1972): 1.

La Jolla Museum of Contemporary Art. *Helen Lundeberg: A Retrospective Exhibition.* Exhibition catalogue. La Jolla, Calif.: La Jolla Museum of Contemporary Art, 1971.

Lundeberg, Helen. *New Classicism.* Exhibition brochure for the Post-Surrealism exhibition. 1934.

——. Statement in *Sourcebook* 21 (November–December 1974): 20.

Moran, Diane. *Lorser Feitelson and Helen Lundeberg: A Retrospective Exhibition.* Exhibition catalogue. San Francisco: San Francisco Museum of Modern Art; Los Angeles: UCLA Art Council, 1980.

Munro, Eleanor. "Helen Lundeberg." *Originals: American Women Artists.* New York: Simon and Schuster, 1979.

Wilson, William. "Lundeberg: Painting the Problems." *Los Angeles Times,* 21 January 1979, Calendar section.

Young, Joseph. "Helen Lundeberg: An American Independent." *Art International* 15 (September 1971): 46–53.

Rose Mandel

"The Errand of the Eye." *Aperture* 4, no. 3 (1956): 126–33.

Foerstner, Abigail. "Encore Long Overdue for Rose Mandel." *Chicago Tribune,* 30 October 1992, sec. 7.

Frankenstein, Alfred. "The Art Galleries." *San Francisco Chronicle,* 12 September 1948, This World section.

——. "Touring the Galleries." *San Francisco Chronicle,* 24 January 1954, This World section.

Knud Merrild

Ehrlich, Susan. "Knud Merrild: To Be Transformed in the Flux." *Los Angeles Institute of Contemporary Art Journal* 39 (September–October 1981): 22–25.

Fitzsimmons, James. "All Is Flux." *Art Digest* 26 (25 March 1952): 18.

Langsner, Jules. *Knud Merrild, 1894–1954.* Exhibition catalogue. Los Angeles: Los Angeles County Museum of Art, 1965.

Merrild, Knud. *A Poet and Two Painters.* London: G. Routledge and Sons, 1938.

———. Untitled statement. *Contemporary American Painting*. Exhibition catalogue. Urbana: University of Illinois, 1952.

Modern Institute of Art. *Knud Merrild: Twenty-five-Year Retrospective*. Exhibition catalogue. Beverly Hills: Modern Institute of Art, 1948.

William Mortensen

Coleman, A. D. "The Directorial Mode: Notes toward a Definition." *Camera 35* 20 (September 1976): 55–61.

———. "Disappearing Act." *Camera Arts* 2 (January–February 1982): 30–38, 108–9.

Irmas, Deborah. "Monsters and Madonnas." *Photograph* 1 (July 1977): 24–25.

———. "A Mortensen Sampler." *Camera Arts* 2 (January–February 1982): 30–38.

———. *The Photographic Magic of William Mortensen*. Exhibition catalogue. Los Angeles: Los Angeles Center for Photographic Studies, 1979.

Mortensen, William. *Monsters and Madonnas*. San Francisco: Camera Craft, 1936.

———. *Projection Control*. San Francisco: Camera Craft, 1934.

Scully, Ed. "Pictorialism: Bodine and Mortensen, Two Extremes of This Approach." *Modern Photography* (January 1971): 94–99.

Lee Mullican

Los Angeles Municipal Art Gallery. *Lee Mullican: Selected Works, 1948–1980*. Exhibition catalogue. New York and Basel: Galerie Schreiner, 1980.

Larsen, Susan. "Lee Mullican." In *Moderns in Mind: Gerome Kamrowski, Lee Mullican, Gordon Onslow-Ford*. Exhibition catalogue. New York: Artists Space, 1986.

Mullican, Lee, and Merle Schipper. *Visions of Inner-Space: Gestural Painting in Modern American Art*. Los Angeles: Wight Art Gallery, University of California, 1988.

Phillips, Joan. "Los Angeles Art Community: Lee Mullican." Oral History Program, University of California, Los Angeles, 1977.

San Francisco Museum of Art. *Lee Mullican*. Exhibition catalogue. San Francisco: San Francisco Museum of Art, 1949.

Wilson, William. "The Stick-to-itiveness of Lee Mullican." *Los Angeles Times*, 9 November 1980, Calendar section.

Gordon Onslow Ford

Baker, Kenneth. "A Painter of Surrealism: Onslow Ford Show." *San Francisco Chronicle*, 6 June 1993, Datebook section.

Harcourts Modern and Contemporary Art. *Gordon Onslow Ford: Paintings of the Inner-Worlds*. Exhibition catalogue. San Francisco: Harcourts Modern and Contemporary Art, 1993.

Jones, Harvey L., ed. *Gordon Onslow-Ford: Retrospective Exhibition*. Exhibition catalogue. Oakland: Oakland Museum, 1977.

Nierendorf Gallery. *Gordon Onslow-Ford*. New York: Nierendorf Gallery, 1946.

Onslow Ford, Gordon. *Surrealism and Painting*. New York: Harper and Row, Icon Editions, 1972.

———. *Towards a New Subject in Painting*. Exhibition catalogue. San Francisco: San Francisco Museum of Art, 1948.

Sawin, Martica. "Gordon Onslow-Ford." In *Moderns in Mind: Gerome Kamrowski, Lee Mullican, Gordon Onslow-Ford*. Exhibition catalogue. New York: Artists Space, 1986.

———. "The Third Man, or Automatism American Style." *Art Journal* 47 (Fall 1988): 181–85.

Wolfgang Paalen

Art of This Century. *Wolfgang Paalen*. New York: Art of This Century, 1945.

Filipacchi, Jose Pierre. *Wolfgang Paalen*. Tiburon, Calif.: Harold Allen Parker, 1980.

Museo de Arte Moderno. *Hommage to Wolfgang Paalen*. Mexico: Museo de Arte Moderno, 1967.

Paalen, Wolfgang. *Form and Sense*. New York: Wittenborn, Schultz, 1945.

Regler, Gustav. *Wolfgang Paalen*. New York: Nierendorf Editions, 1946.

Winter, Amy. *Wolfgang Paalen Retrospective*. Exhibition catalogue. Vienna: Museum moderner Kunst, 1993.

Man Ray

Baldwin, Neil. *Man Ray, American Artist*. New York: Clarkson N. Potter, 1988.

Clements, Grace. "Art." *California Arts and Architecture* 60 (November 1943): 8–10.

Copley Galleries. *Man Ray*. Beverly Hills: Copley Galleries, 1949.

Julien Levy Gallery. *Man Ray*. Exhibition brochure. New York: Julien Levy Gallery, 1945.

Knight, Christopher. "Man Ray: A Minor Player in the Major League." *Los Angeles Herald Examiner*, 26 March 1989.

Langsner, Jules. *Man Ray, 1966*. Los Angeles: Los Angeles County Museum of Art, 1966.

McKenna, Kristine. "A Look at Man Ray in L.A." *Los Angeles Times*, 19 March 1989.

Martin, Jean-Hubert, and Man Ray. *Man Ray Photographs*. New York: Thames and Hudson, 1982.

National Museum of American Art. *Perpetual Motif: The Art of Man Ray*. Washington, D.C.: National Museum of American Art, Smithsonian Institution, 1988.

Ray, Man. "Photography Is Not an Art." *View*, ser. 3, no. 3 (October 1943): 77–78, 97.

———. "Ruth, Roses, and Revolvers." *View*, ser. 4, no. 4 (December 1944): 120–23.

———. *Self Portrait*. 1968. Rev. ed. New York: Little, Brown, 1988.

Schwarz, Arturo. *Man Ray: Rigour of the Imagination*. New York: Rizzoli, 1977.

Sers, Philippe, ed. *Man Ray: Objets de mon affection*. Paris: Philippe Sers, 1983.

Clay Spohn

Beasley, David. "Life of a Painter." *Bulletin of Research in Humanities* 86 (Summer 1983): 162–215.

"Fantastic War Machines to Go on Display." *Oakland Tribune*, 8 March 1942, Society-Clubs section.

Frankenstein, Alfred. "Around the Art Galleries: The Inspiration Was War." *San Francisco Chronicle*, 22 March 1942, This World section.

Fuller, Mary. "Portrait, Clay Spohn." *Art in America* 51 (December 1963): 78–85.

MacAgy, Douglas. "Clay Spohn's War Machines." *Circle* 6 (1945): 38–43.

St. John, Terry. *Clay Spohn*. Exhibition catalogue. Oakland: Oakland Museum, 1974.

Edmund Teske

The Friends of Photography. *Images from Within: The Photographs of Edmund Teske*. Carmel, Calif.: Friends of Photography, 1980.

Larsen, Susan. "Interview with Edmund Teske," Archives of American Art, Smithsonian Institution, May 1980.

Los Angeles Municipal Art Gallery, *Edmund Teske*. Exhibition catalogue. Los Angeles: Los Angeles Municipal Art Gallery, 1974.

Marable, Darwin. "Introduction" and "Interview with Edmund Teske." *Photo Metro* 6 (May 1988): 3–15.

Naef, Weston. *Being and Becoming: Photographs by Edmund Teske*. Exhibition catalogue. Malibu: J. Paul Getty Museum, 1987.

Gordon Wagner

Folkart, Burt. "Gordon Wagner Created Art from Junk." *Los Angeles Times*, 9 December 1987, pt. 1.

Hoffberg, Judith. "Gordon Wagner: Magician and Mythmaker." *Los Angeles Institute of Contemporary Art Journal* 4 (Summer 1983): 65–69.

Smith, Richard Candida. *Firaskew, Gordon Wagner: A Retrospective Celebrating Fifty-six Years of Work*. Exhibition catalogue. San Pedro, Calif.: Angels Gate Cultural Center, 1986.

Edward Weston

Conger, Amy. *Edward Weston: Photographs from the Collection of the Center for Creative Photography*. Tucson: University of Arizona, 1992.

Danly, Susan, and Weston J. Naef. *Edward Weston in Los Angeles*. Exhibition catalogue. San Marino, Calif.: Huntington Library; Malibu: J. Paul Getty Museum, 1989.

Grundberg, Andy. "Edward Weston Rethought." *Art in America* 63 (July–August 1975): 29–31.

Maddow, Ben. *Edward Weston: His Life*. New York: Aperture, 1989.

Newhall, Beaumont. "Edward Weston in Retrospect." *Popular Photography* 19 (March 1946): 42.

Roth, Paul. *Weston and Surrealism*. Exhibition catalogue. Tucson: Center for Creative Photography Library, University of Arizona, 1990.

"Way out Weston." *Modern Photography* 29 (November 1965): 78–81.

Weston, Edward. *The Daybooks of Edward Weston*. Vol. 2. Millerton, N.Y.: Aperture, 1973.

Minor White

Bunnell, Peter C. *Minor White: The Eye That Shapes*. Princeton, N.J.: Art Museum, Princeton University, 1989.

"Minor White." *Camera*, no. 1 (January 1972): 14–23.

White, Minor. *Minor White: Rites and Passages*. Millerton, N.Y.: Aperture, 1980.

———. *Mirrors, Messages, Manifestations*. Millerton, N.Y.: Aperture, 1969.

Wilson, William. "The Eye That Reinterprets." *Los Angeles Times*, 30 April 1989, Calendar section.

Beatrice Wood

California State University. *Beatrice Wood Retrospective*. Exhibition catalogue. Fullerton, Calif.: California State University, 1983.

Naumann, Francis M. *New York Dada, 1915–1923*. New York: Harry N. Abrams, 1994.

———. *Intimate Appeal: The Figurative Art of Beatrice Wood*. Exhibition catalogue. Oakland: Oakland Museum, 1989.

Wood, Beatrice. *I Shock Myself: The Autobiography of Beatrice Wood*. Edited by Lindsay Smith. Ojai, Calif.: Dillingham Press, 1985.

Photography Credits

Photography Credits

We wish to thank the owners and custodians for permitting the reproduction of the works of art in their collections. The photographers and/or sources of the illustrations, whose courtesy is gratefully acknowledged, are listed alphabetically below, followed by catalogue or figure numbers.

Jack Abraham: cat. no. 36
Agar: cat. no. 98
Anthology Film Archives: figs. 21, 24
Archives of American Art, Smithsonian Institution: figs. 46, 53, 56
The Arizona Board of Regents, Center for Creative Photography: figs. 30, 38
The Art Institute of Chicago: cat. nos. 83–85, 128, 132
Artists Rights Society: cat. nos. 28, 31
Artservices, Inc.: fig. 6
Herbert Bayer, copyright Joella Bayer: fig. 15
Copyright Ruth Bernhard, all rights reserved: cat. nos. 13–15; fig. 30
Ben Blackwell: cat. nos. 2, 62
Richard Blue: fig. 27
Stan Brakhage: fig. 22
Braunstein/Quay Gallery: cat. nos. 1, 2, 4; fig. 26
Charles Brittin: fig. 29
James Broughton: fig. 23
Bruce White Photography: cat. nos. 134, 135
Lawrence Bump and Edmund Teske: fig. 57
Center for Creative Photography, University of Arizona, Tucson: cat. nos. 129, 131; figs. 15–18
City of Hope Medical Center and Beckman Research Institute, Duarte, California: fig. 6
Will Connell, Jr.: cat. nos. 25–27
Grey Crawford: fig. 14
Anthony Cunha: cat. no. 138
D. James Dee: fig. 4
Lee Fatheree: cat. nos. 57, 58, 65–68; fig. 11
Mike Fischer: cat. no. 77
The Frances Loeb Art Center, Vassar College: fig. 4
Rick Gardner, Houston: cat. no. 81
Geoffrey Clements, Inc.: cat. nos. 61, 64; fig. 2
John Gutmann: cat. nos. 44–49; figs. 39, 40
Hearst Newspaper Collection, Special Collections, University of Southern California Library: fig. 35
Helga Photo Studio: cat. nos. 51, 55
Galen Howard Hilgard: cat. nos. 58, 60, 65, 66, 68; fig. 42
E. Bruce Howell: fig. 36
The Huntington Library, San Marino, California: fig. 1
Deborah Irmas: fig. 51
The J. Paul Getty Museum: cat. nos. 106, 108, 111, 112

Jack Rutberg Fine Arts: cat. nos. 20–22, fig. 32
Lou Jacobs, Jr.: figs. 28, 37, 48, 50
McKee Gallery: cat. nos. 39, 40; fig. 38
Rose Mandel and Susan Ehrens: fig. 49
Man Ray Trust/A.D.A.G.P., Paris, 1992: cat. nos. 106–16; figs. 10, 55
Robert E. Mates: cat. nos. 73–75; fig. 47
Lou Meluso: cat. nos. 18, 25, 26, 32, 33, 97, 107, 109, 122, 123, 125–27; fig. 25
Metro Pictures: fig. 19
The Minor White Archive, Princeton University; copyright 1982 by the Trustees of Princeton University, all rights reserved: cat. nos. 134, 135; copyright 1994: cat. no. 136
Craig Mole: cat. no. 71
Mortensen Estate Collection, Copyright 1980: cat. nos. 93–95; fig. 23
Mystic Fire Video: fig. 25
Harry Redl: fig. 44
The Robert Duncan Literary Estate, State University of New York, Buffalo: cat. no. 62; fig. 43
Suzanne Royce: figs. 52, 54, 113
Maurine Saint Gaudens and Thomas J. Turner: fig. 27
San Diego Historical Society: fig. 31
San Francisco Museum of Modern Art: cat. nos. 117–19; fig. 3
F. W. Seiders: cat. no. 54
Michael Jay Smith: cat. no. 8
Lee Stalsworth: cat. no. 116
Steven White Associates: cat. nos. 25, 26; fig. 20
Dorothea Tanning: fig. 5
Edmund Teske: cat. nos. 121–24
Tobey C. Moss Gallery: cat. nos. 17, 35, 37, 38; figs. 8, 33, 37, 48, 58
University of California, Los Angeles, Department of Special Collections, University Research Library: fig. 34
Virginia Lust Gallery: fig. 12
Janette H. Wallace: figs. 41, 45
The Walt Disney Company: cat. nos. 29, 30; figs. 8, 9
Brett Weston, the Estate of Brett Weston: fig. 21
James Whitney: fig. 57
The Whitney Museum of American Art: fig. 2
Will Connell Archive, California Museum of Photography, University of California, Riverside: cat. no. 24
William Nettles Photography: cat. nos. 20–22
Marco P. Zecchin/Image Center: fig. 26

Index of Artists

Editor: Karen Jacobson

Designer: Bryan Coopersmith

Printing: Donahue Printing, Los Angeles, California

This book was designed and produced on a Macintosh
Computer using QuarkXPress and Adobe Photoshop
software with Emigre Dead History, Adobe Minion, and
Fontshop Meta+ type fonts.